NEW ARCHITECTURE
AN INTERNATIONAL ATLAS

FRANCISCO ASENSIO

ABRAMS, NEW YORK

For Atrium:

Author
Francisco Asensio

Coordination and texts
Silvana Díaz, architect

Art Director
Sheila Pontis

Design and Layout
Jordi Calleja

Photographic Documentation
Astrid Marteen, Robert Grau

Production Director
Ricard Vilaseca

Translation
Mark Holloway, Henry Sire

Editorial Director
Alejandro Asensio

Copyright © 2005 Atrium
Group de ediciones y
publicaciones S.L. 2 Barcelona

English translation copyright ©
2007 Abrams, New York

For Abrams:

Editor, English-language
edition: **Sheila Friedling**

Jacket design, English-
language edition:
Jonathan Sainsbury

Production Manager, English-
language edition:
Jacquie Poirier

originally published in Spanish under the title *Atlas: La nueva arquitectura* by Atrium Group, Barcelona, 2005

Library of Congress Control Number: 2006937134
ISBN 13: 978-0-8109-9282-5
ISBN 10: 0-8109-9282-5

Printed and bound in China
10 9 8 7 6 5 4 3 2 1

HNA
harry n. abrams, inc.
a subsidiary of La Martinière Groupe

115 West 18th Street
New York, NY 10011
www.hnabooks.com

*We have tried our best to contact all copyright holders. In individual cases
where this has not been possible, we request that copyright holders con-
tact the publishing house.*

PHOTOGRAPHERS

Hervé Abbadie

Fernando Alda

Tadao Ando

Archivo fotográfico de Expo 92

Aschau et C. H.

John Berkel

Tom Bonner

Richard Bryant/Arcaid

Busam/Richter Architekturphoto

David Cardelús

Cesar Pelli Associates

Richard Davies

Michael Denancé

Dominique Perrault Architectes

Drexel

DSD Dillinger Stahblau GmBH

Engelhardt/Stelin

H. G. Esch

Feichtinger architectes

Emilio Rodríguez Ferrer

George Fessy

Flint & Neill Partnership

Foster and Partners

Klaus Frahm

Freyssinet

K. Furudate

Oscar García

A. A. Garreta

Gas Natural SDG

Denis Gilbert

G. Grimmenstein

Halcrow Group Ltd.

Hedrich-Blessing Photography

Hiroyuki Hi

Ronald Holbe

Honshu-Shikoku Bridge Authority

Timothy Hursley

Lourdes Jansana

Jean Nouvel Architectes

J. C. Ballot, P. Marechaux, M. Péna

Jumeirah International

Angelo Kaunat

Kokyu Miwa Architectural

Taizo Kuruka

Jean-Michel Landecy

Heiner Leiska

John Linden

Lock Images

Mitsuo Matsuoka

Paul Maurer

Nick Merrick

Jordi Miralles

Osamu Murai

Nácasa & Partners, Inc.

Voitto Niemelä

Shigeo Ogawa

Tomio Oshashi

Eugeni Pons

Moisés Puente

Ralph Richter/Architekturphoto

Christian Richters

Paolo Rosselli

Philippe Rualt

Eric Saillet

Luis Sans

Jürgen Schmidt

Shinkenchiku-sha

Sigurgeir Sigurjónsson

Grant Smith/VIEW

S. Soane/Architekturphoto

Rupert Steiner

Musao Sudo

Jussi Tiainenwa

Hiroshi Tsujitami

Frances Tur I Pardró

Herman H. van Doorn

Andrew Ward

Yukio Yoshimura

Zaha Hadid Architects

CONTENTS

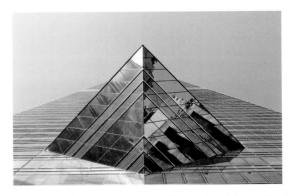
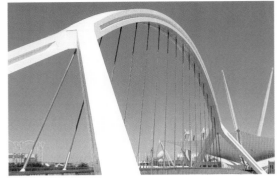

CONTENTS: BY THEME

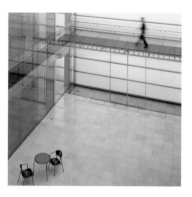

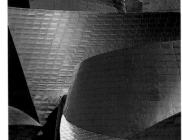

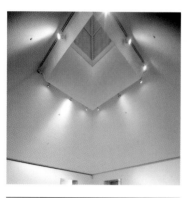

CONTENTS: LIST OF ARCHITECTS

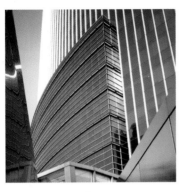

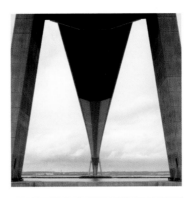

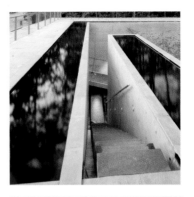

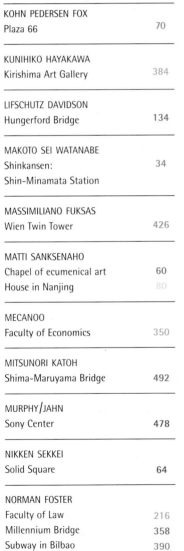

Following the postmodernist debate that had previously
dominated the architectural scene, the 1990s saw the
beginning of extensive political, social, and cultural change;
and this within a short time brought with it a rapid suc-
cession of tendencies—deconstructivism, minimalism,
light construction, for example—most of them derived
from the construction of some very spectacular architec-
tural projects.

The new demographic context, its urban distribution,
new political tensions on a world scale, economic glob-
alization, the international reach of cultural trends, and
technological development have contributed to a com-
plex and heterogeneous artistic environment. From the
late 1980s, thanks to the possibilities that information
technology was beginning to offer, the deconstructivists
began to explore a great diversity of architectural
devices never before imagined, making use of curves,
diagonals, wefts, volumetric meshes, superimpositions,
and asymmetries. In 1988 the landmark exhibition
"Deconstructivist Architecture" was presented at the
Museum of Modern Art (MoMA) in New York City. In
1995 another MoMA exhibition, "Light Construction,"
revealed a new mode of architectural expression, redis-
covering the aesthetic potential of light, transparent,
and simple forms.

Critics of these new architectural tendencies accuse

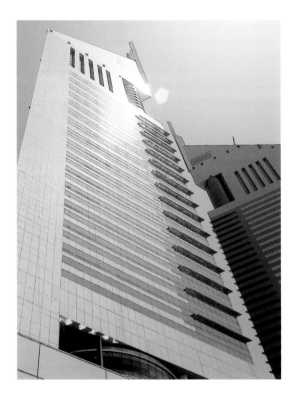

them of being eminently political and propagandistic, employing formal resources of an easy-to-use visual character as opposed to a real resolution of the new challenges coming our way. They are dismissed as empty architecture, without significance, identity, or sense of context. The result is a trend toward international uniformity indifferent to the particular distinctions of the physical, social, and natural environment; it produces a neutral architecture, in which external form ceases to reveal anything about function.

Despite everything, in the age of globalization, the architects of the so-called star system share the stage with other professionals who pursue their work on a less ambitious scale, but with great rigor and quality, remote from the fame provided by the media. Paying special attention to landscape and context, and with a wise choice of materials, this other architecture manifests itself in clean and conclusive volumes, generating complex spaces along with quality finishes and execution.

However, far from setting itself up as arbiter or judge of the contemporary architectural scene, this book provides a broad sample of the significant international architecture created during the last fifteen years, bringing together a large selection of projects developed by architects throughout the world, regardless of their philosophical or intellectual affiliation. Profusely illustrated with images, plans, and new graphic techniques, and enriched with texts by professional architects, it is presented as the first volume of a new architectural series, directed toward a diverse readership with a shared

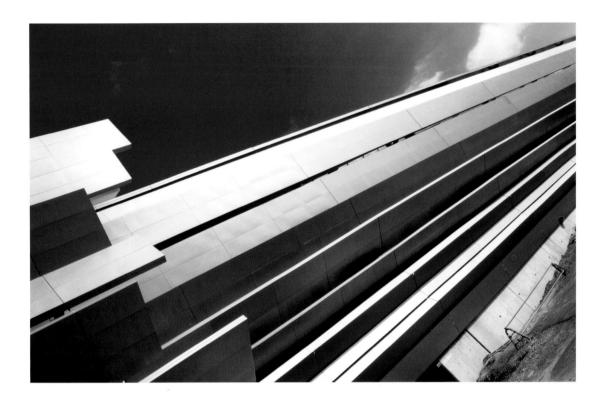

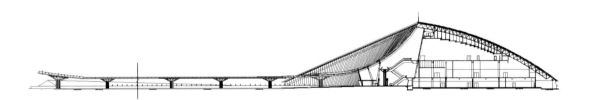

interest in the world of architecture, engineering, and interior design.

This book is organized according to nine major topics or themes that are explored within a broad international context, presenting a wide variety of important architectural projects and forms, including corporate and multi-use towers, cultural and entertainment complexes, sports arenas, museums, opera houses, bridges, airports, industrial buildings, urban renewal programs, parks, and residences. The interplay of diverse settings and projects highlights cross-cultural contact, the influence of context on structure and design, as well as the significance of each project as a unique architectural work.

BUSINESS ARCHITECTURE

Architectural projects associated with the business world, commercial exchange, and international exhibitions are explored as a point of cultural and ideological contact between different countries. These projects focus on spaces designed for the enjoyment of technological advances characteristic of contemporary societies.

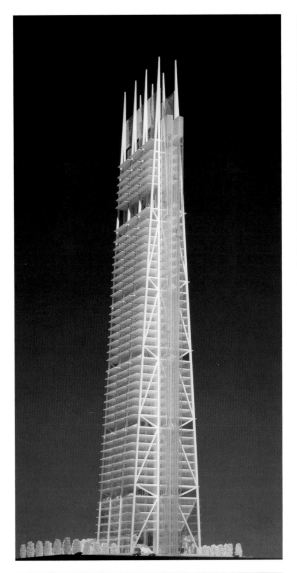

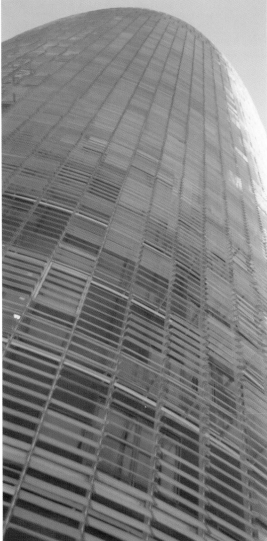

THE GREAT BUILDINGS

Many great buildings have been constructed recently, ranging from high-rise structures that have been built in Asia and America to designs of a smaller scale carried out in Europe. These buildings have been designed to function as spaces incorporating the activities of business, leisure, and services, although additional functions often tend to become major attractions.

ARCHITECTURE FOR LIVING

This book examines the most important solutions to the formal concerns posed by residential architecture, focusing on prototype dwellings that illustrate contemporary research and theoretical issues. These residential works reveal how architects resolve formal problems by deep reflection on the structure's integration into the landscape and environment.

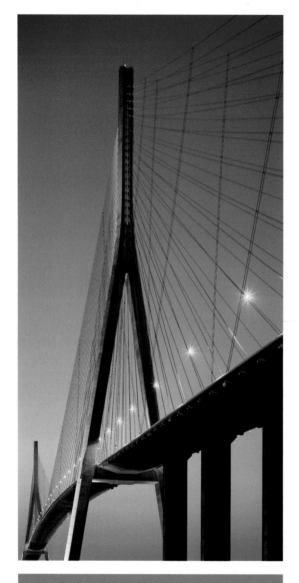

THE ARTS IN ARCHITECTURE

This theme focuses on diverse international proposals centered on building spaces for the performing arts, often in large-scale cultural and entertainment complexes. The tour takes in projects for innovative multi-use civic centers, auditoriums, and opera houses with great visual impact that have become civic and cultural landmarks throughout the world.

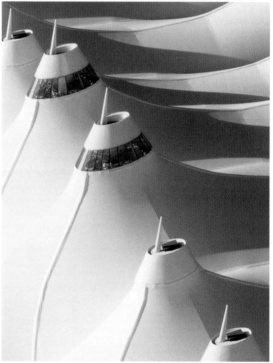

ARCHITECTURE IN TRANSPORT

In an age in which new modes of communication have transformed personal, social, and cultural relations at every level, this overview of recent innovations in transport spaces explores inventive new approaches to airport and railway design as well as smaller-scale subway projects.

URBAN & SPORTS INFRASTRUCTURE

In an era of great change, the city has become a major site of contemporary architectural debate. New social complexities are often tackled through urban planning; the creation of new zones, often focused on a dominant theme, in order to revitalize abandoned or deteriorating districts; and through the construction of public spaces and facilities that offer specific solutions to the cultural or leisure requirements of each place.

MUSEUMS

This book explores an international range of museums, taking special note of projects located in Asia, which reveal a special way of understanding the essentials of art exhibition. These museums include nature itself as an exhibited object; and their buildings, containing large multifunctional spaces, are conceived as authentic works of art created to hold artworks. Architecture is understood as a sculptural hollow sheltering cultural displays of every kind.

RELIGIOUS & FUNERARY ARCHITECTURE

The small sample of projects selected in this book are works of great architectural value and, although geographically far apart, share the same intellectual point of origin, perhaps an outgrowth of the spirituality they seek to transmit. Revealing an exquisite respect for and organic unity with the landscape, they generate spaces for introspection and reflection in a nurturing natural setting.

BRIDGES: ARCHITECTURE & ENGINEERING

Uniting art and science, monumental bridges are works of inventive engineering and structural form that often become iconic landmarks and symbols of the places in which they are built. Colonizing a transitional space that did not exist until they were constructed, bridges—both large spans and simpler footbridges—establish a link between nearby areas that were previously unrelated. As such, they are civic structures that revitalize public life.

The swan

Tianjin Great Museum

SHIN TAKAMATSU, ARCHITECT & ASSOCIATES + KAWAGUCHI & ENGINEERS

Tianjin, China

The Tianjin Great Museum is located in one of China's largest cities, 140 kilometers (87 miles) from the capital, Beijing. At the moment Tianjin is sharing in the unprecedented building boom that the country is experiencing. This museum is the biggest in the city, and it is completely surrounded by a large park. The analysis project received first prize in the international competition held in 2000, in which Kawaguchi and Takamatsu jointly participated. The building joins three existing museums into one synthetic space including a multifunctional space for exhibitions and a storage place. The structure is based on a geometry of spherical surfaces, which facilitated the design of the whole building

Below: Plan of the envelope of the building, with its surrounding park

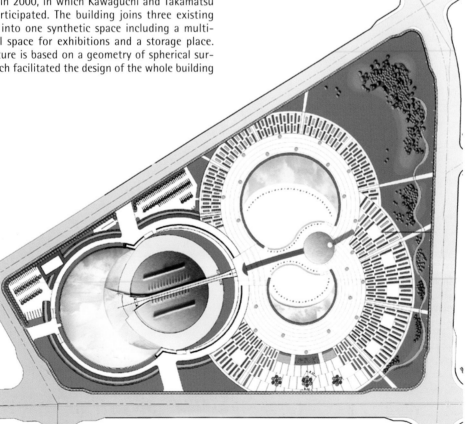

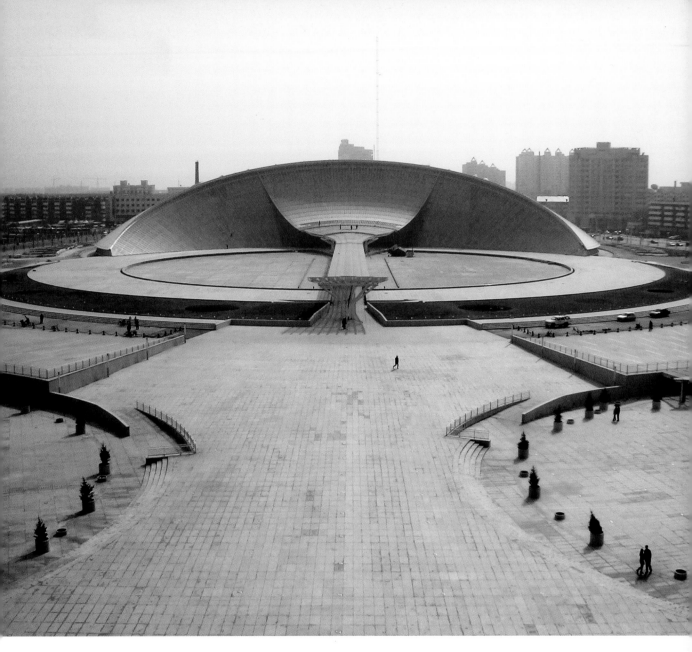

Above: View of the façade, showing the play of the envelope closing in on itself

Below: A longitudinal section of the building

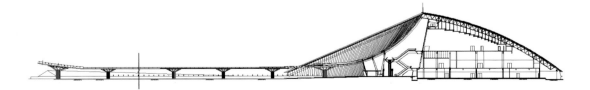

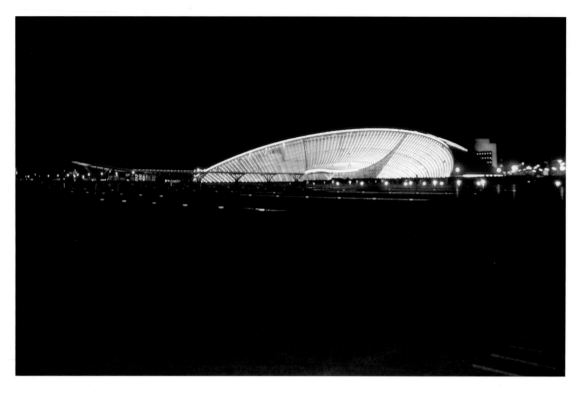

as a single system. It consists of an envelope 200 meters (656 feet) in diameter and 34 meters (112 feet) high, which closes in upon itself as it reaches the water. The final shape unexpectedly turned out like a swan, which gave rise to the decision to clad the building in white ceramic tiles and to call it *Swanium.*

Overall night view of the building

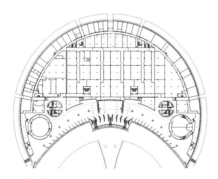

Above: First floor of the building

Opposite top: Night view of the access bridge

Opposite bottom: Second and third floors of the building

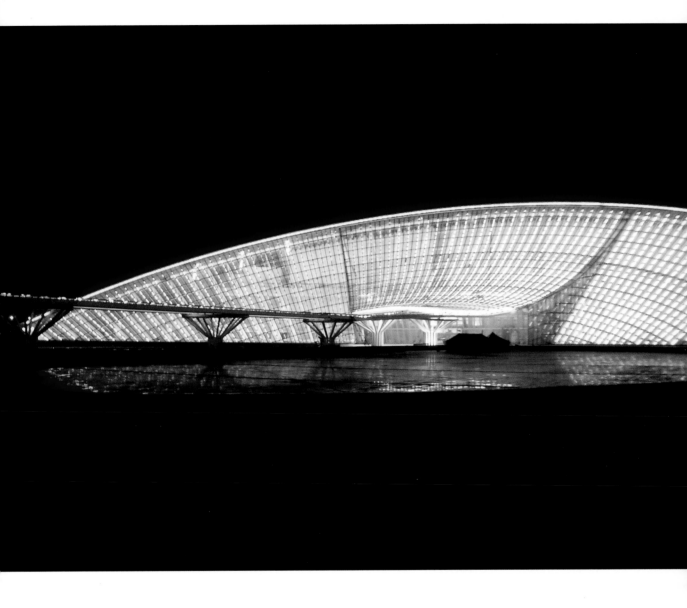

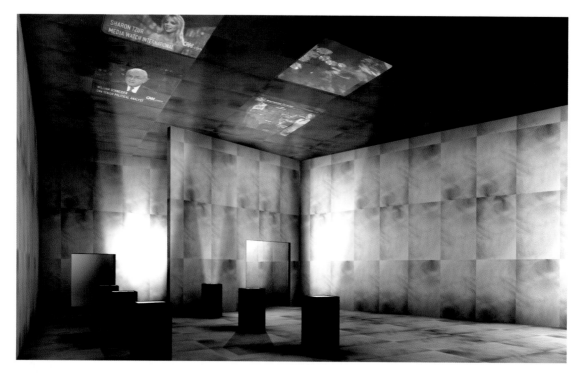

Interior views of the museum and, below, the different exhibition rooms

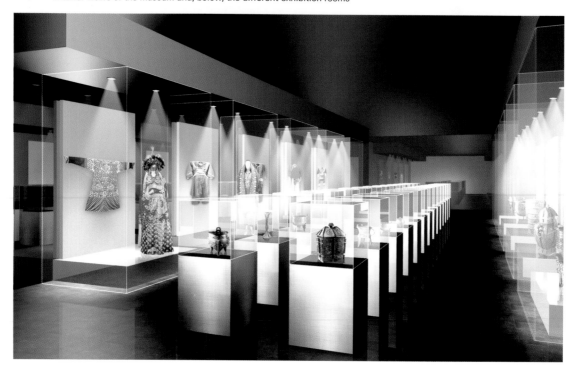

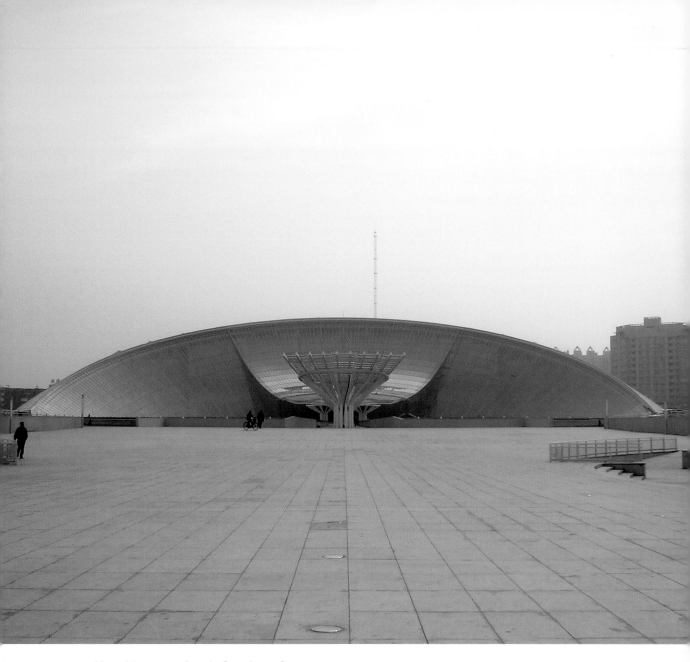

View of the museum from the Great Access Court

A boomerang return

Ribble Way Footbridge

**WILKINSON EYRE ARQ,
FLINT & NEILL PARTNERSHIP ING**
London, England
Photographs: Flint & Neill Partnership

The proposal is for a bridge to be installed at the intersection of the Ribble and Calder rivers, where the junction known as the Hacking Ferry has existed since the 14th century and forms part of Ribble Way. In the 1950s, when the ferry ceased to function, this junction became a complicated and dangerous crossing. It was for this reason that the Lancashire County Council announced a competition to restore the original route and to include it in a network of a larger scale. A design that would become a landmark of modernity was sought.

The project establishes a three-directional crossing, in response to the three directions of the riverbanks, in one unique structure. The bridge consists of a set of arches of equal stretches, with a 120-degree separation over the

base. Each arm of the bridge has a span of 43.5 meters (143 feet) and the structure behaves as if it were a true arch of only 8 meters (26 feet) in height. The arms rest over simple reinforced steel supports. The highest point of the bridge is above the authentic confluence of the rivers and allows for the habitual river swellings registered in the area. Thanks to its three supports, the structure gains stability that helps it resist the arrival of trunks during periods of flooding.

The access of construction machinery into the rural environment in question is complicated. As a result, it has been decided to construct a reinforced glass fiber structure away from the site and to transport it in one piece by means of helicopter. Once set over its supports, the structure is to be filled with concrete during a highly controlled process. This option will lead to a highly finished bridge surface and will do away with the usual maintenance required by surfaces finished in concrete itself.

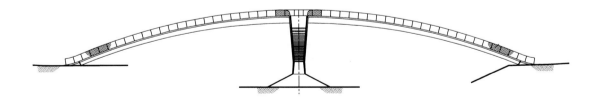

Above: Elevation of the bridge

Opposite: Rendered view of the bridge in it surroundings

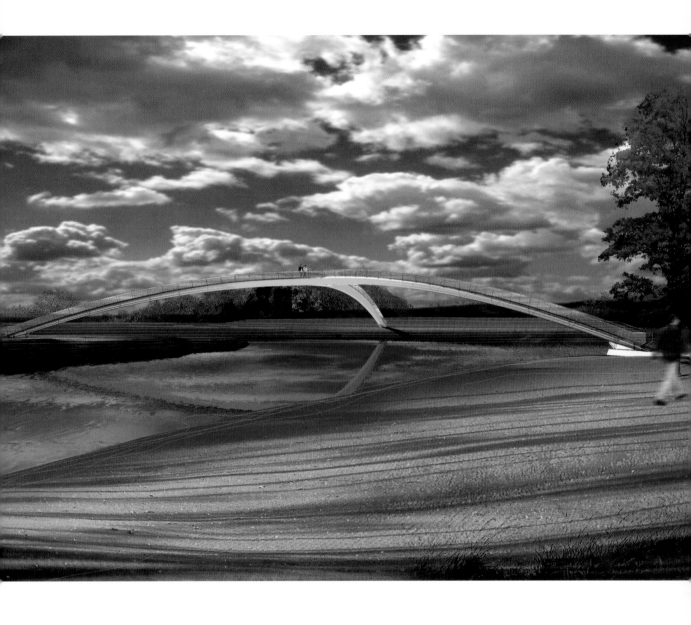

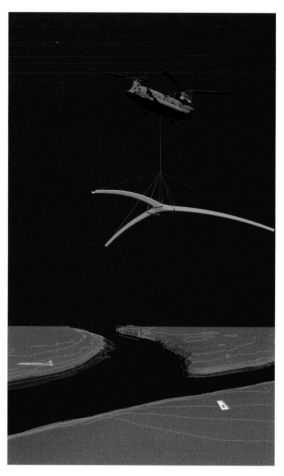

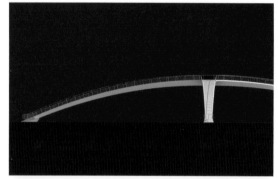

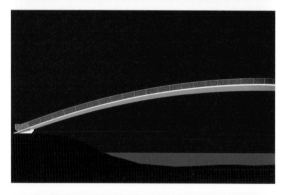

Plan, elevation, transportation, and site plan of the bridge

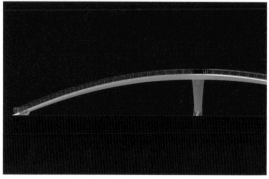

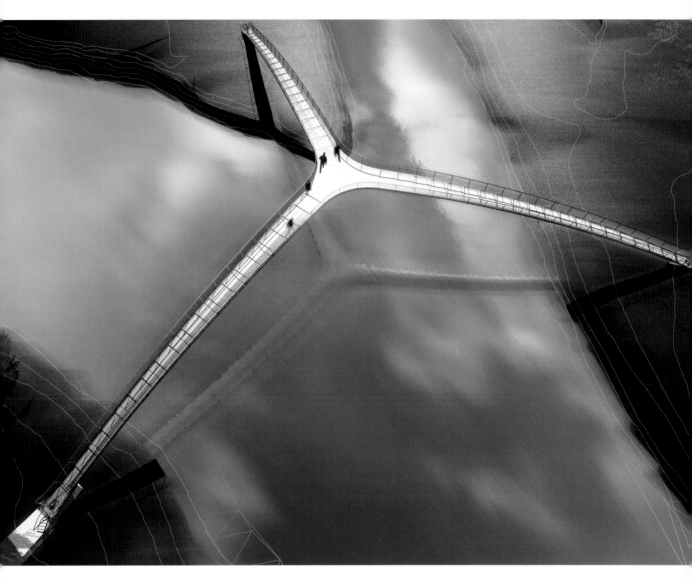

Rendered aerial view of the proposal

Dubai aiming high

Emirates Towers

NORR LIMITED

Dubai, United Arab Emirates
Photographs: Jumeirah International,
Hedrich-Blessing Photography

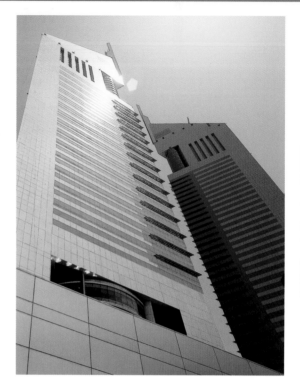

Their height and presence have made the towers a key reference point in Dubai, the second largest city in terms of inhabitants and surface area in the United Arab Emirates. They are located in the financial district of the city and are a symbol of its growing economic worldwide power. The project includes an office tower 355 meters (1,165 feet) high and another of 305 meters (1,000 feet) containing a luxury hotel.

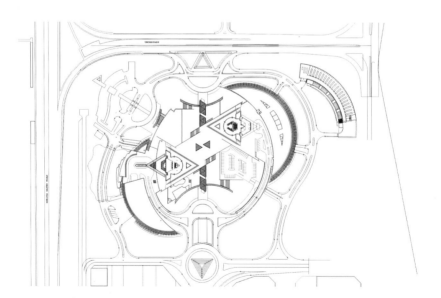

Above: Site plan

Opposite: Night view of the complex

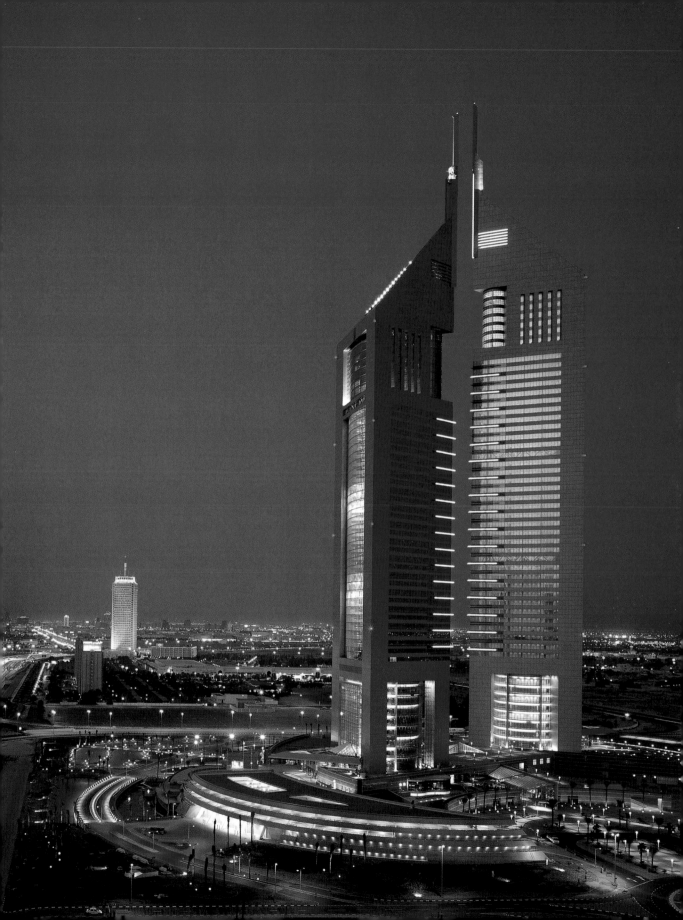

Right: Cross section of the towers

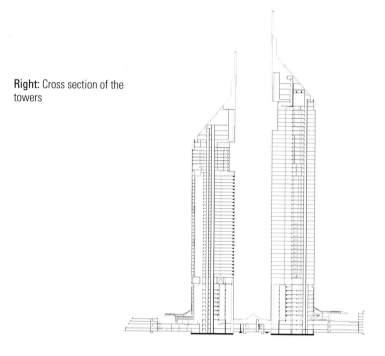

Bottom left: Aerial view of the complex **Bottom right:** Detail of the hotel façade

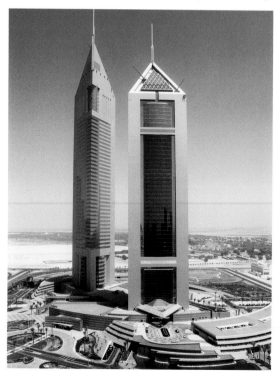

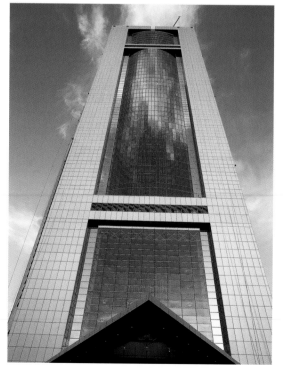

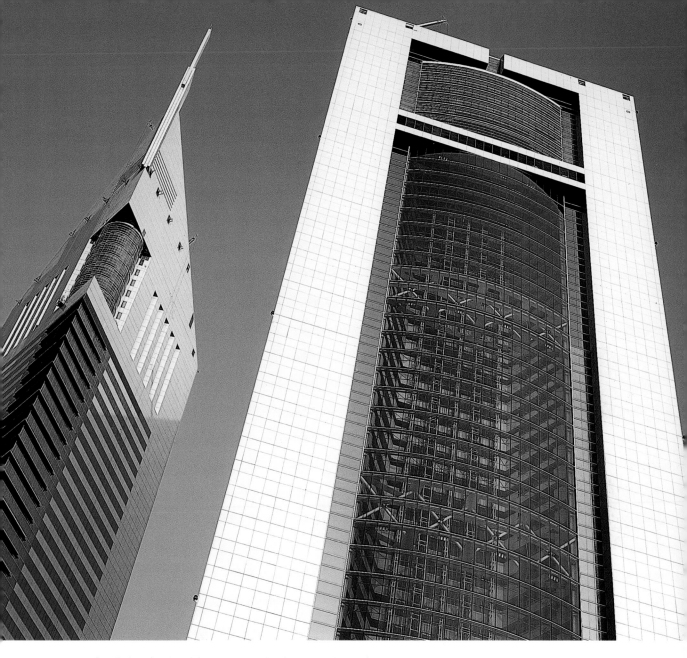

Detail of the façades of the two towers showing the relationship between them

Top: View of one of the hotel reception areas, revealing the role of natural lighting that enters through the skylights

Bottom: An interior view of the hotel

The towers are arranged symmetrically over a horizontal three-story granite base in which the common public activities of the complex are found. Large corridors illuminated by skylights and panoramic elevators link a variety of services such as commercial galleries, bars, restaurants, the leisure areas of the hotel, and the parking areas situated in an annex below an undulating structure, echoing the forms of sand dunes, with a capacity for 1,800 vehicles.

The triangular floor plan of both towers was inspired by Islamic geometric motifs, a resource that is repeated in other elements of the project: the shape of the flat roofs, the pergolas, the skylights, and the motifs in the flooring. The rigidity of the geometry is broken by the smoothness of the curves in the base covered in granite; the siting of the commercial galleries in the towers; or the water fountain in the entrance to the hotel. The main access to the office tower is by wheeled vehicle over a ramp that follows the circular outline of the base. The water fountains also find their inspiration in Islam.

The lobby is organized around a central core with a battery of elevators grouped in four units. The first floors of the towers have a geometry that is different from the standard floors; they function as support floors for the main activities of the towers, for example, conference halls. They occupy a glass cylinder eight floors high, with a high porch on the ground floor.

The main entrances to the towers are located on the most important street of the city, dominated by a large fountain. On the standard floor plan of the hotel, a central body of elevators is organized around an atrium of thirty-one floors, and the rooms are arranged along the perimeter of the façade. The seven top floors are connected by three private elevators that serve fifty-seven special rooms for executives, four presidential suites, and a restaurant with exclusive views of the coast. The towers are primarily finished in glass and lustrous metals that produce luminous effects that change throughout the day. At night, the artificial illumination highlights the silhouettes and reinforces the idea of a unique figure. The peaks of the towers culminate in aerials that rise toward the heavens, emphasizing the total sensation of height created by the complex.

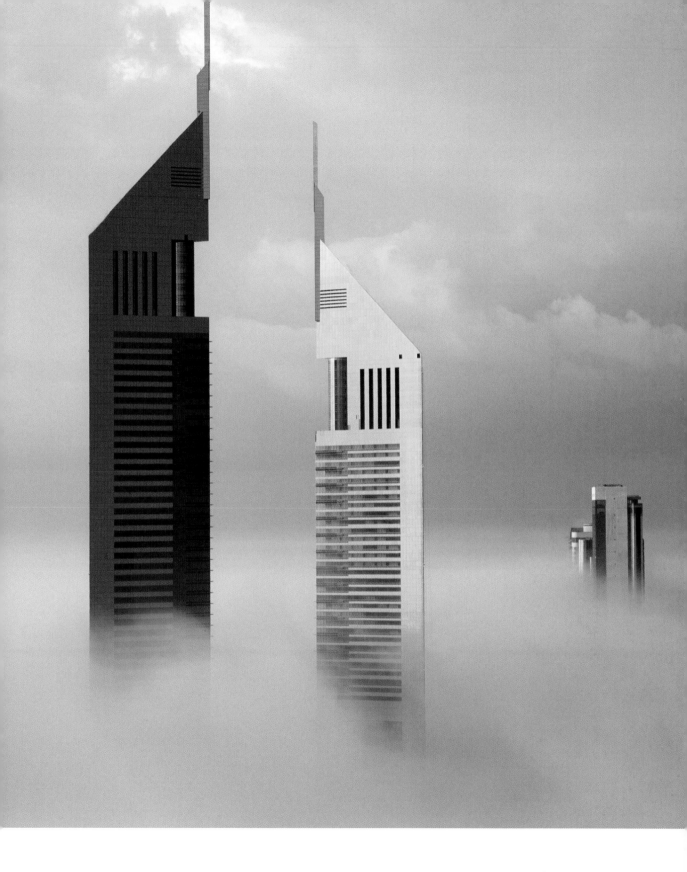

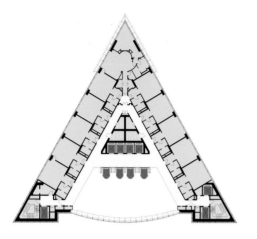

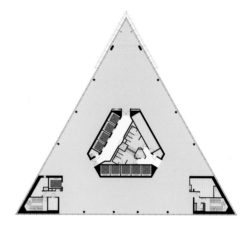

Floors of the two towers

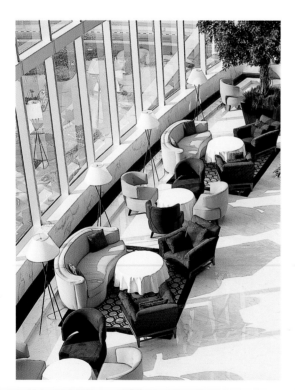

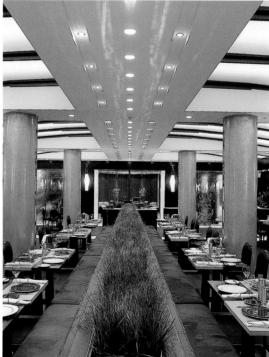

Above: Interior views of the lobbies and reception areas

Opposite: Night view of the towers with the city in the background

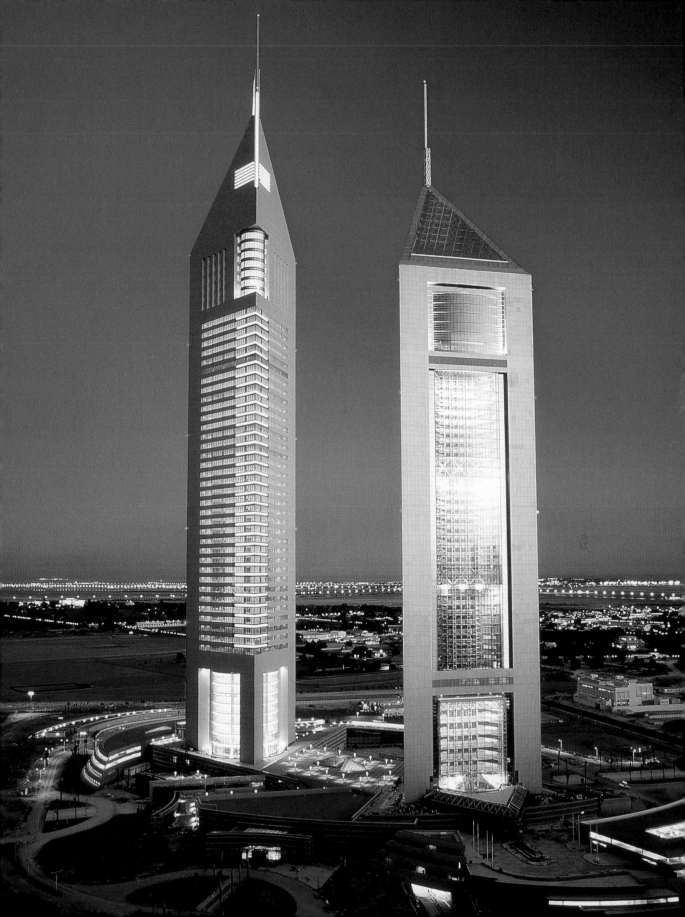

The plates of a metal tube

Shinkansen: Shin-Minamata Station

MAKOTO SEI WATANABE

Minamata, Japan

Shin-Minimata Station has linked Tokyo to Osaka since 1964. Located in the south of Kyushu island, it is one of four works constructed when the high-speed train was expanded.

The proposal aims at tackling the characteristic features of a railway station from the perspective of two central concepts: the continuity of the inside-outside space and requirements for shelter from the weather.

The station is defined formally by a series of continuous rectangular plates forming the roof and the façade, and serving to regulate wind, modulate the incidence of sunlight, keep out rain, and reduce levels of noise coming from outside, without losing visual transparency inside.

Above: Ground plan of the station

Opposite top: The great tube of regulated plates showing the effects of sunlight

Opposite bottom: Effect of interior lighting at night in the station

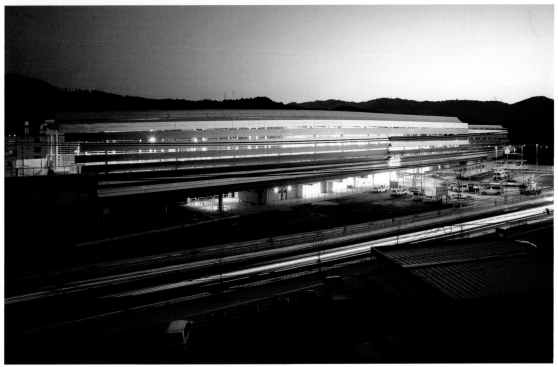

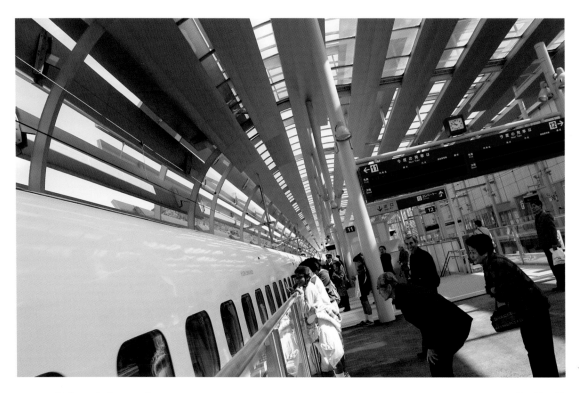

Railway platforms under cover

The plates give off a reflected light that dissolves into their surroundings, minimizing the presence of the station in its site. The entrance, on the other hand, is strongly illuminated emphasizing its location.

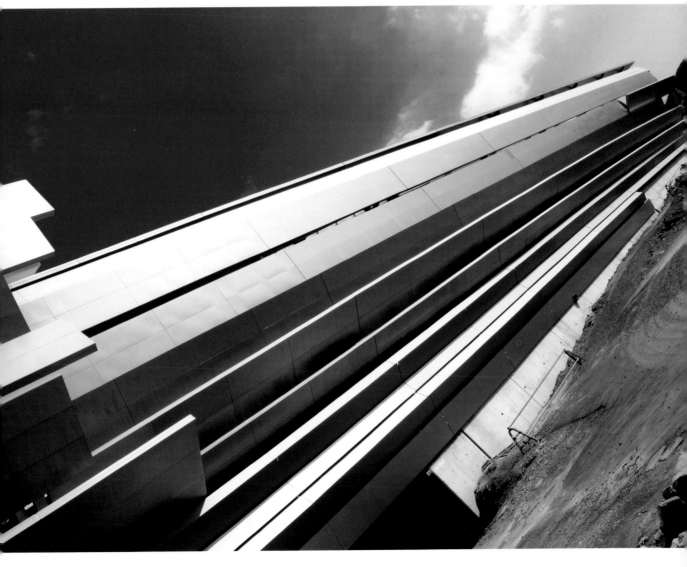

Top: External appearance of the roof plates

Bottom: Façade of the station

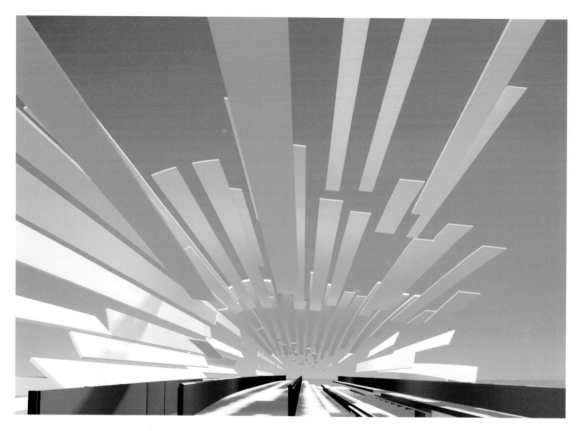

Above: Conceptual image of the transition space between the station's interior and exterior

Below: Schemes of the shelter factoring sun and wind (left), and visual continuity through gaps between the plates (right)

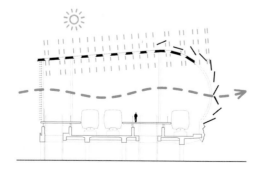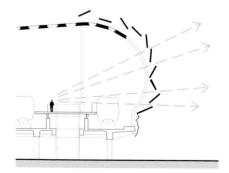

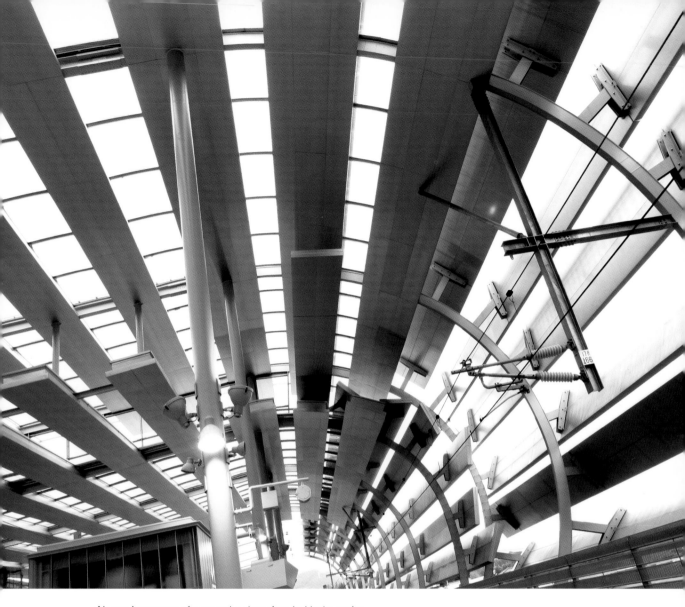

Above: Appearance of rectangular plates from inside the station

Below: Schemes of the shelter factoring rain (left), and visual opaqueness from inside (right)

The four corners of a place

The French National Library

DOMINIQUE PERRAULT

Paris, France
Photographs: Michael Denancé, George Fessy

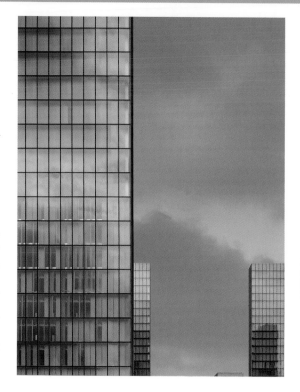

Situated on the shores of the River Seine, to the east of Paris, the project was intended to respond to the lack of public buildings in this part of the city and to counterbalance the attraction of the city center. The construction perfectly combines monumental scale with a more intimate and human scale where the central courtyard becomes the spirit of the entire project, constantly challenging the rules of common sense. To the same effect and as a paradox, the volumetric integrity of the towers has been resolved with the use of glass surfaces, through which the interior wooden shutters can be seen.

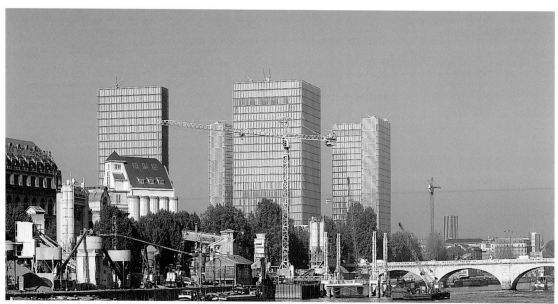

Above: Perspective of Paris with the National Library of France in the background

Opposite: Perspective of the towers over the entrance block

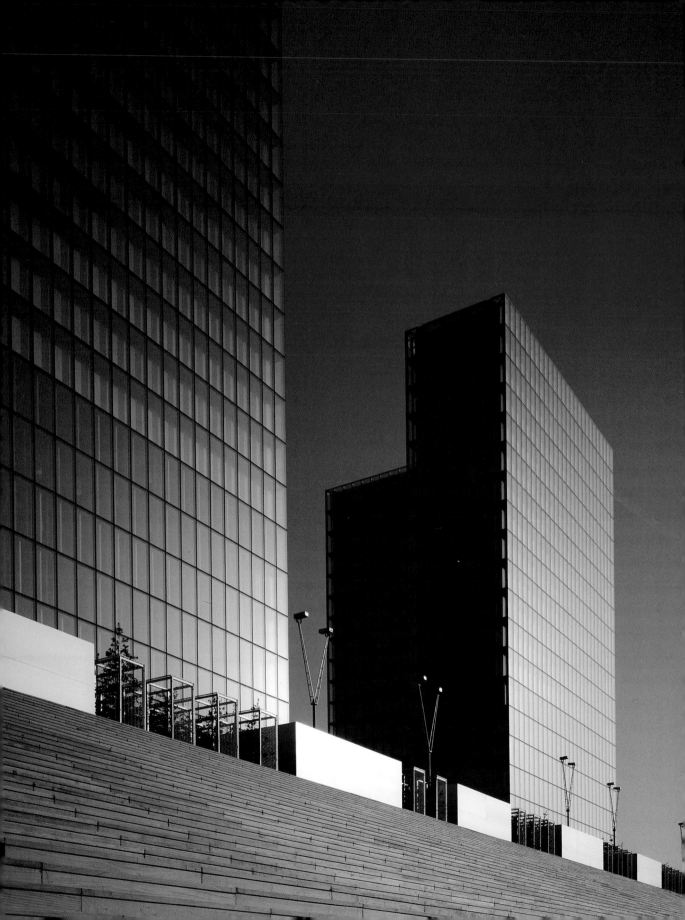

Below: Section of the building

Right: Perspective of the snow-covered courtyard with the towers in the background

Bottom: Interior of the building

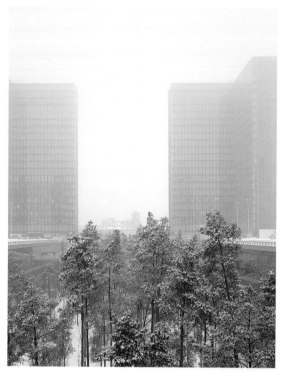

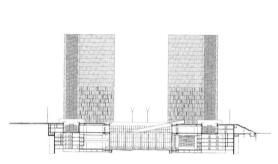

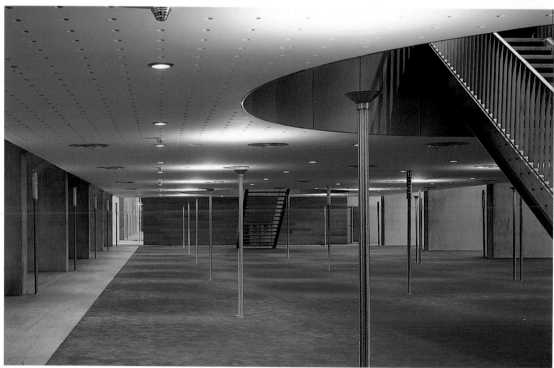

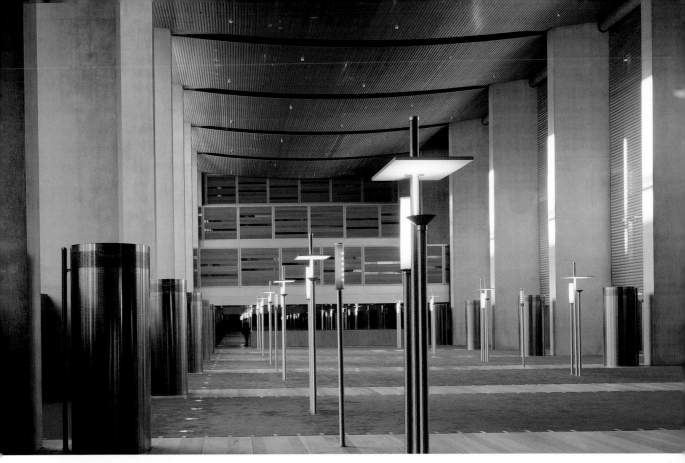

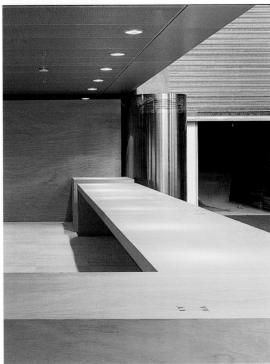

Interior images of the building

Right and below: Interior views of the complex

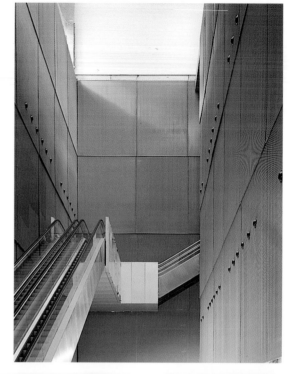

In their interiors, the towers house offices and book storage areas on the upper floors. The central block, in the form of a podium, is open to the public and forms the roof of the reading rooms that are found below. In the center, the forest-courtyard, like a medieval cloister, gives light and calmness to the interior of the library. In the same way that the building has four corners, four materials are used in its construction: glass, wood, steel, and concrete. The building also includes an exhibition center, auditorium, conference halls, and restaurants, along with all of the necessary services required by the computerized system used by all of the libraries in France.

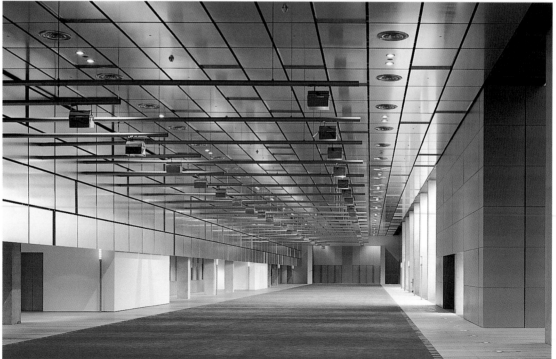

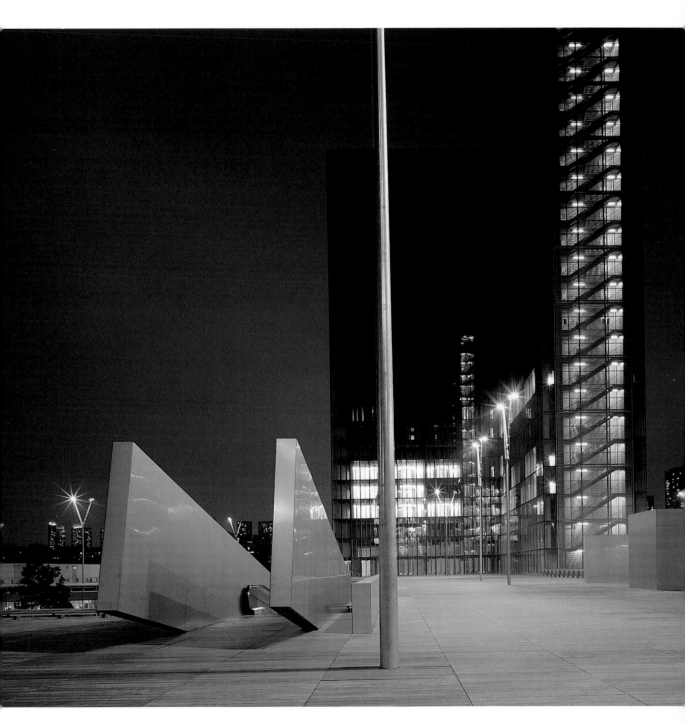

Night view of the complex

A pair of compasses

Normandy Bridge

CHARLES LAVIGNE
Honfleur-Le Havre, France
Photographs: DSD Dillinger Stahlbau GmbH,
S. Soane/Achitekturphoto, Freyssinet

The bridge was built between Le Havre and Honfleur in order to avoid the 58-kilometer deviation necessary to cross the River Seine by the Tancarville Bridge.

This new connection forms part of the Estuary Route, a motorway network that connects the most important ports and towns of Western Europe from London and Antwerp to Spain. The plan is intended to open up Normandy and contribute to the development of Le Havre as a strategic center; it would help enlarge the industrial base of the city and reinforce its position as a port suitable for estuary activities.

Because of the instability of the land under and around the Seine, the creation of a tunnel was ruled out and the

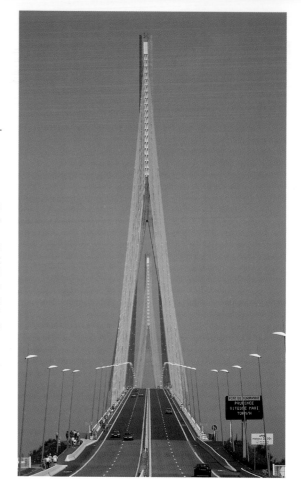

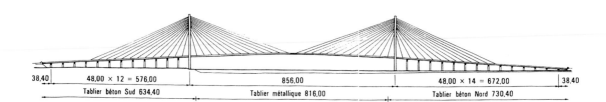

38,40 | 48,00 × 12 = 576,00 | 856,00 | 48,00 × 14 = 672,00 | 38,40

Tablier béton Sud 634,40 | Tablier métallique 816,00 | Tablier béton Nord 730,40

Above: Longitudinal section of the bridge

Opposite: Night view of the bridge

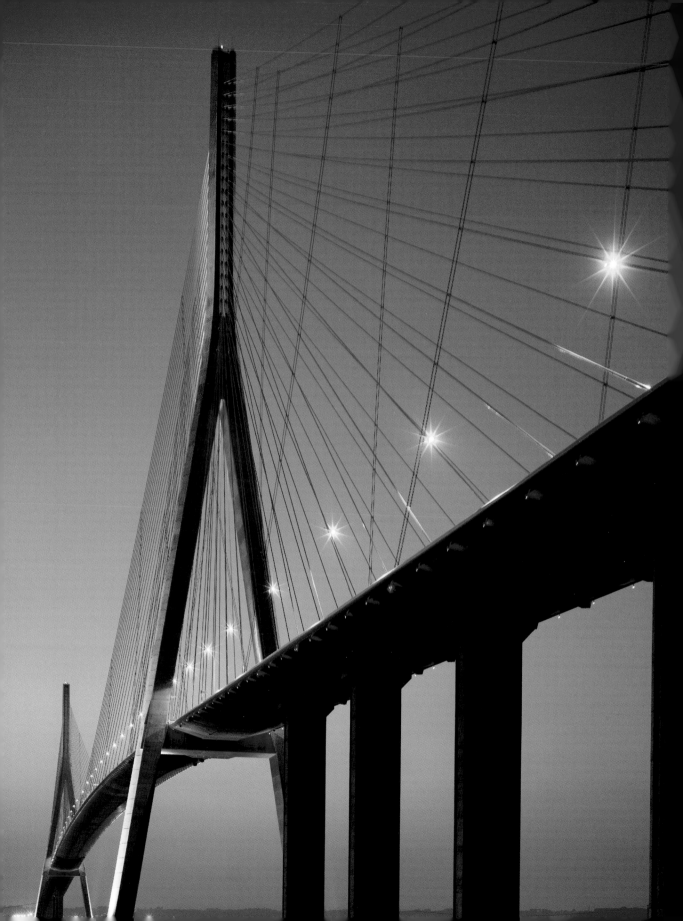

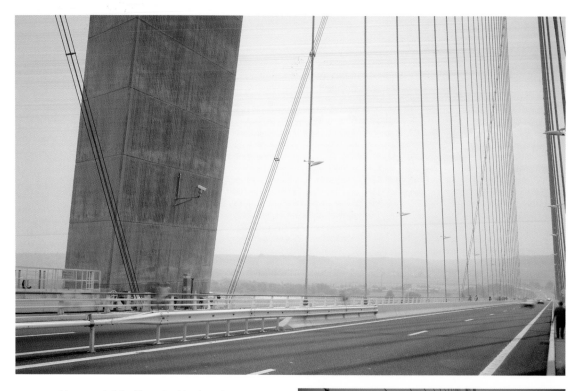

Above and right: View of cables from the pavement

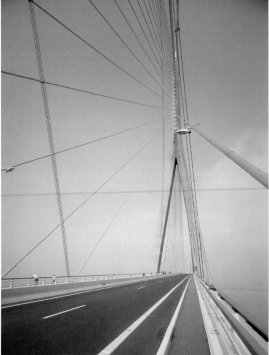

idea of the bridge came into being. So as not to alter the stability of the navigable zone of the channel with a large number of supports for a bridge, it was decided to erect a cable-stayed bridge with central supports of a span of 856 meters (2,808 feet), the longest bridge of this type ever built. The proposal in question is more resistant to the wind than a suspension bridge and cheaper to build.

The bridge has two differentiated parts: the cables that support the roadways in the central part, and that are tensioned from two towers; and the sides where the cables are combined with a series of pillars below the roadways.

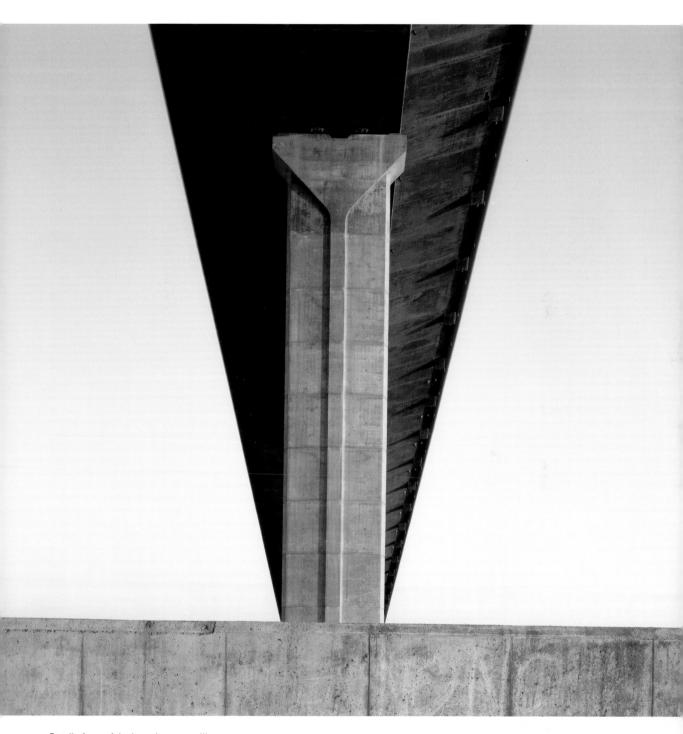

Detail of one of the lateral support pillars

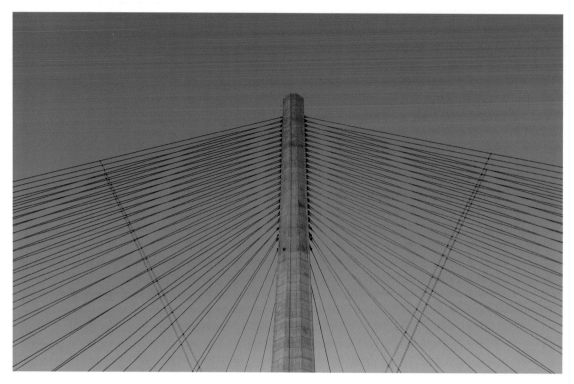

Detail of the mast with tensioned cables

BARRIERE DE SECURITE

Cross section of the bridge (**above left**) and cable anchorage (**above right**)

Opposite: Detail of supports in the form of a pair of compasses

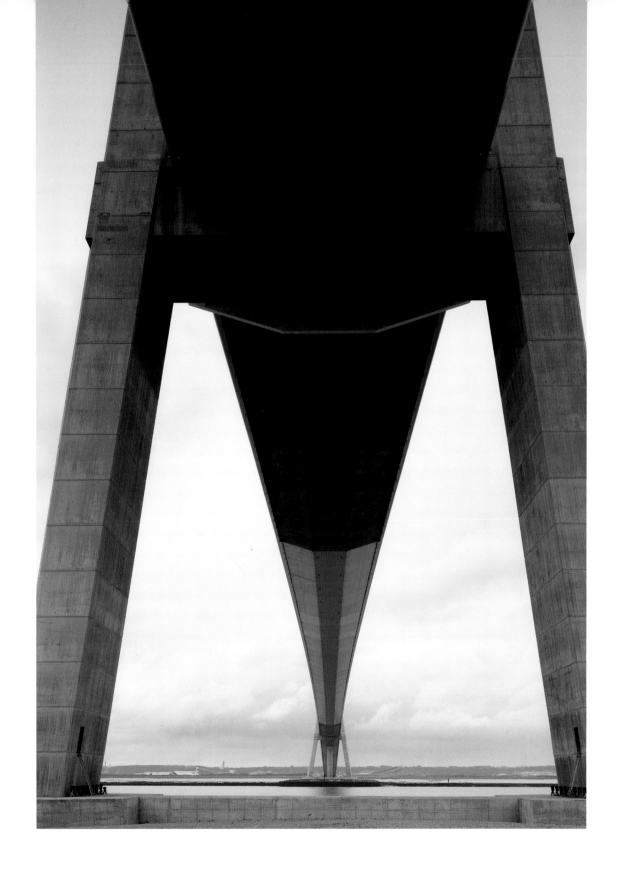

It was considered essential for the gradient to not exceed 6 percent over the complete distance and for the cross section of the bridge to be identical in the pretensioned concrete zones as in the central metal part. The perimeter of the bridge is finished with a covering of blue aluminum, which improves the aerodynamics and unifies the structures. The towers take the form of a pair of compasses supported on the ground by two legs that allow the traffic to pass through and that later become one unique mast 210 meters (689 feet) high in pretensioned concrete and combined head in steel.

In the port of Le Havre, the tower and northern roadway are supported by a protection platform as the base of the tower. The metal sections are the two beams and a series of prefabricated vertical diaphragms that fit into the panels constituting the ribs, allowing the cross vibrations to be absorbed, providing anchorage for the cables.

Since it was opened in 1995, the Normandy Bridge has received numerous visitors, including cyclists and pedestrians. The bridge is served by large car parks as well as restaurants and exhibition areas, among other services.

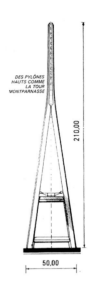

Above: Elevation and dimensions of the supports in the form of a pair of compasses
Below: View of the bridge and the river at sunset

Opposite: View of the bridge from the riverbank

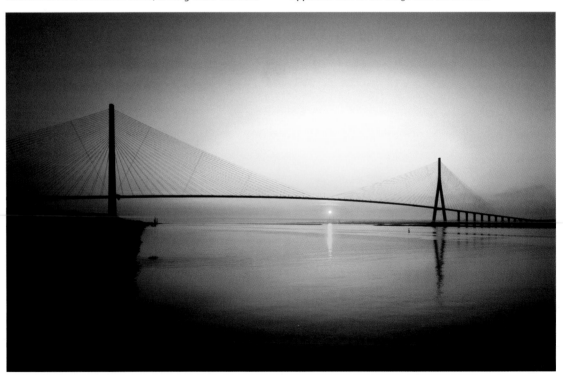

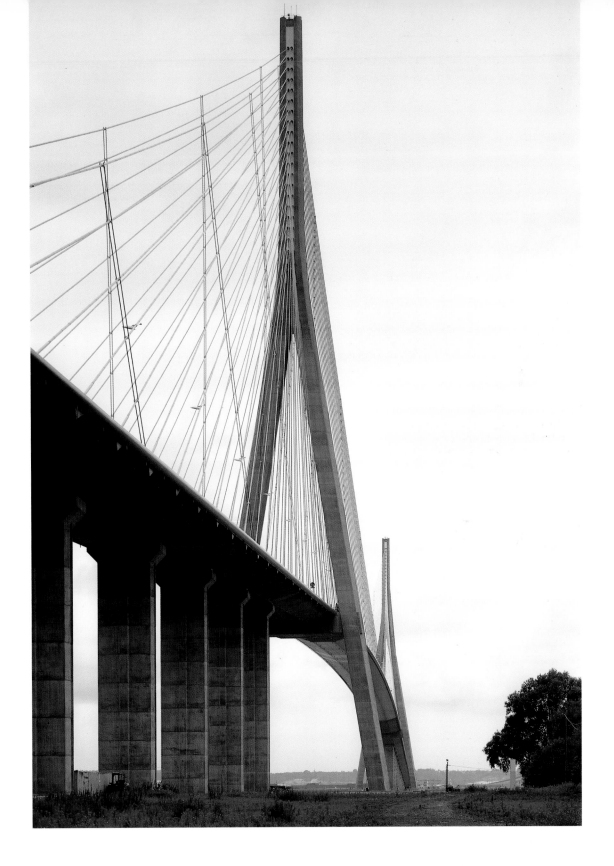

Ando versus Kahn

Modern Art Museum of Forth Worth

TADAO ANDO

Forth Worth, Texas
Photographs: M. Matsuoka, Tadao Ando

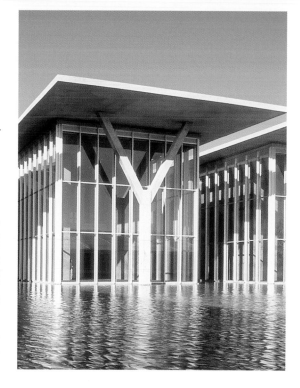

The result of an international competition held in 1997, the museum is situated in a suburb of Forth Worth, Texas. The main challenges of the project lay in the new museum's relationship with the adjacent Kimbell Art Museum, a masterpiece of the architect Louis Kahn and a classic of modern architecture. In addition, the vastness of the plot—44,000 square meters (144,357 feet)—had to be confronted. The project proposed a new garden with a large artificial lake that was to come into dialogue with Kahn's building: powerfully simple spaces blurred clear divisions between inside and outside in favor of an artistic experience.

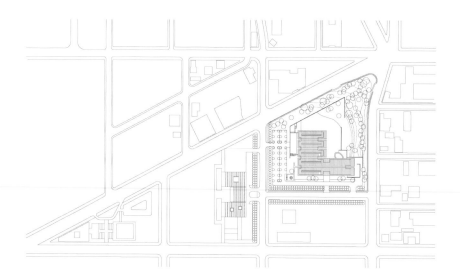

Above: Plan of the museum complex

Opposite: Perspective of the complex

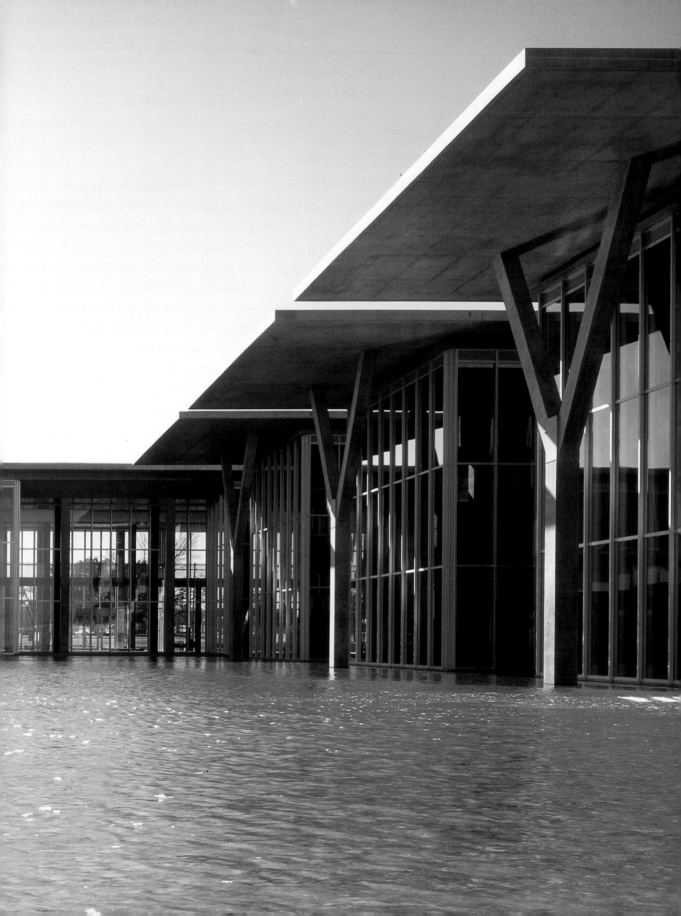

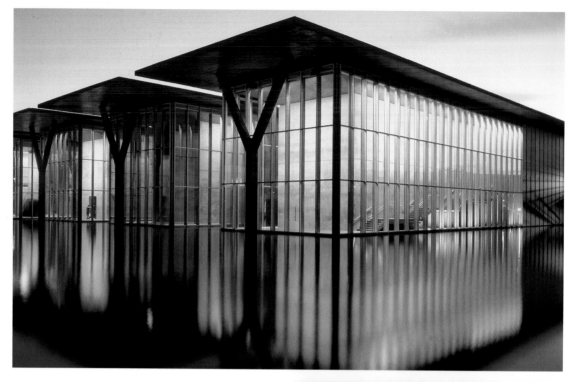

Above: Night view of the complex

Right: Detail of the building from the water

Opposite: Views from the interior

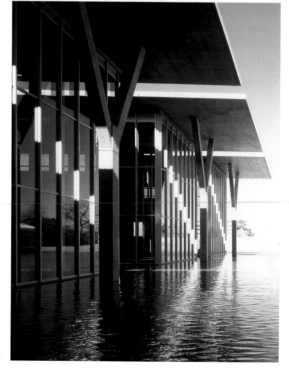

The museum consists of six rectangular volumes that have been placed in line along the waterside of the artificial lakes: four buildings contain exhibition spaces and two larger ones are designed for a variety of public activities. These volumes have double skins that play on the qualities of their materials: concrete boxes inside glass showcases; lightness versus heaviness; transparency versus opacity; stability versus change; ethereal reflections on water; glass encompassing the immediate surroundings.

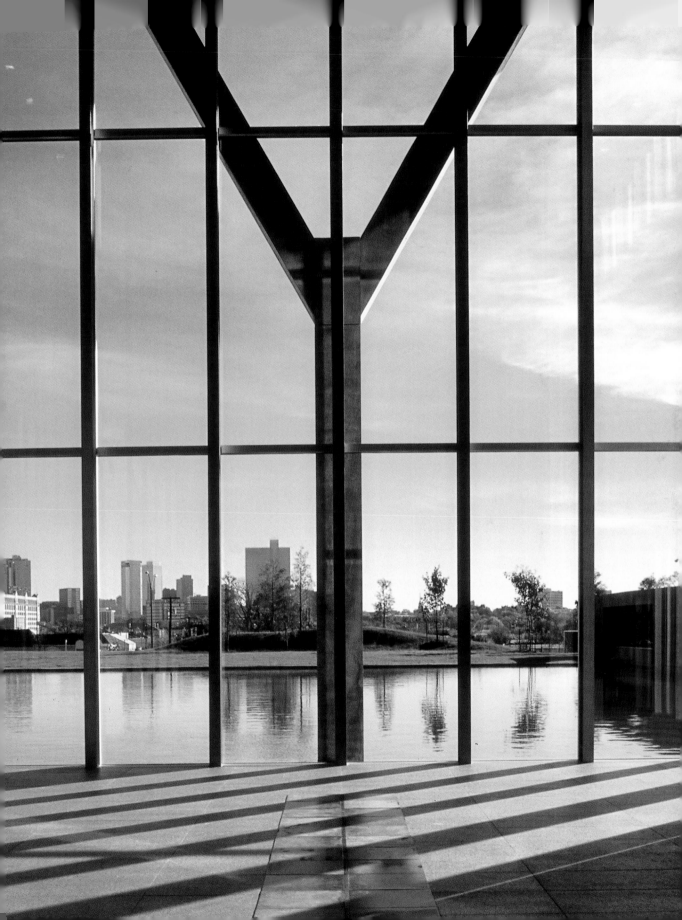

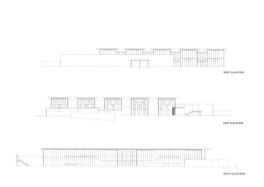

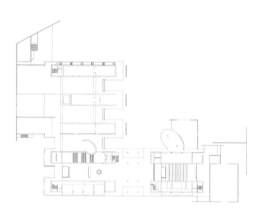

Top: Façades (left) and floor plan (right) of the building

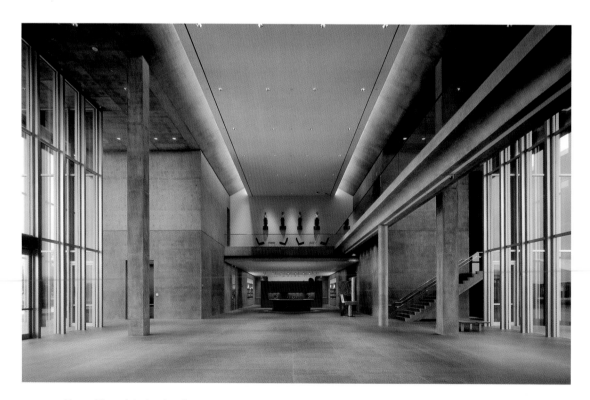

Above: View of the interior of one structure

Opposite: Detail of the interior materials

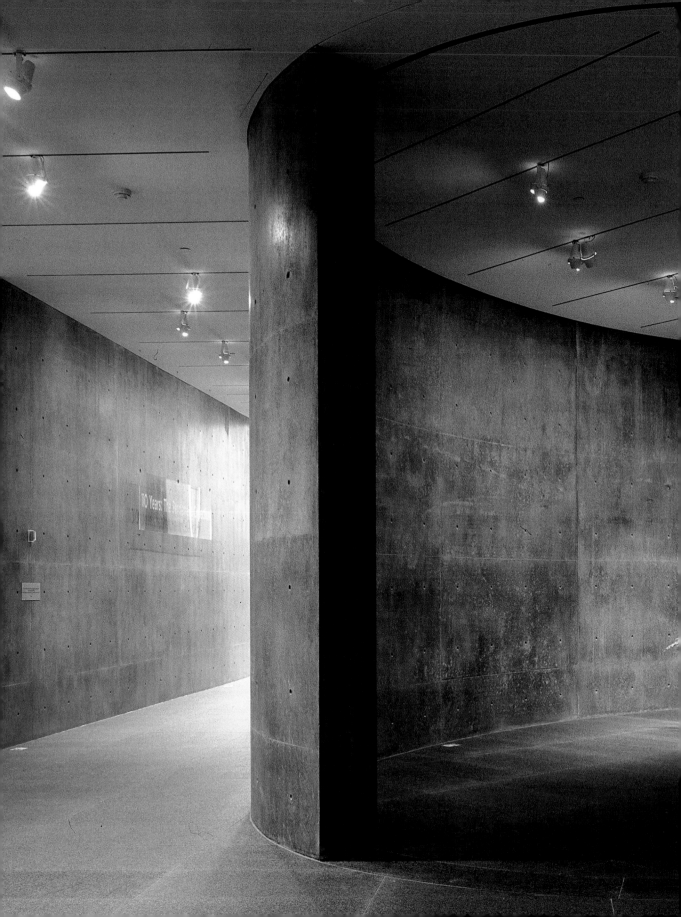

A cabin in the woods

Chapel of ecumenical art

MATTI SANAKSENAHO

Turku, Finland

The winning proposal in a 1995 competition, construction of the chapel did not begin until February 2004; and it opened in 2005. This chapel stands on the top of a hill, following an East-West orientation. The finish of the outside surface integrates it perfectly into its site, a green copper patina on the whole envelope generating a perfect harmony between architecture and landscape.

The project starts from a sculptural conception of the structure, setting down a work of art in nature. From the entrance, we pass into a small lobby lit by a skylight, where a corridor leads to a large space, some 12 meters (39 feet) high, in which the gallery and, at the end of the space, the chapel are located. The structure is based on

beams resembling the wooden ribs of a great marine skeleton. There is a strong indirect light on the chapel, coming from two side windows of painted glass, the creation of the artist Hannu Konola. The interior cladding is entirely of wood; and the benches and altar are solid pieces carved by the sculptor Kain Tapper.

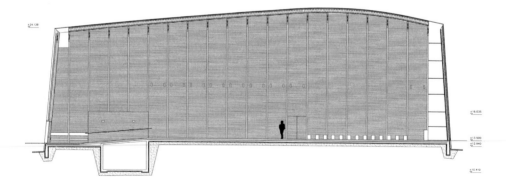

Above: Longitudinal section of the building

Opposite top: Volumetric model of the building

Opposite bottom: Plan of the chapel

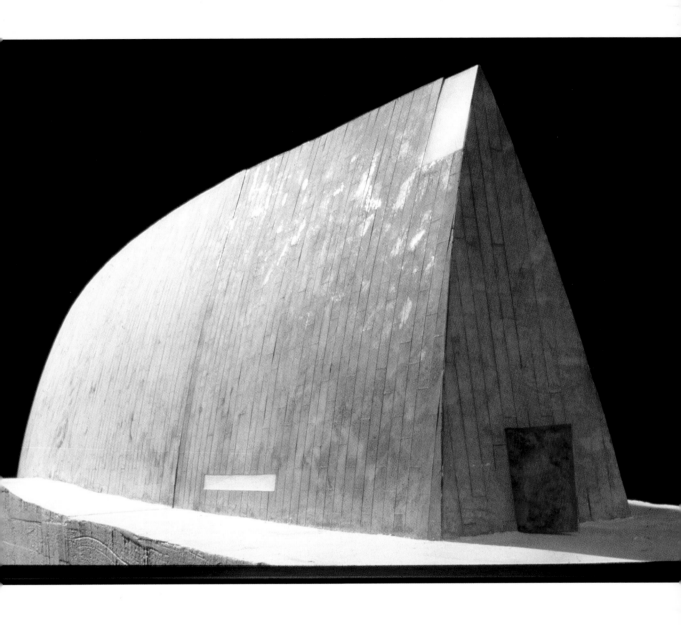

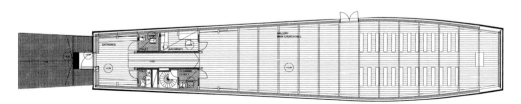

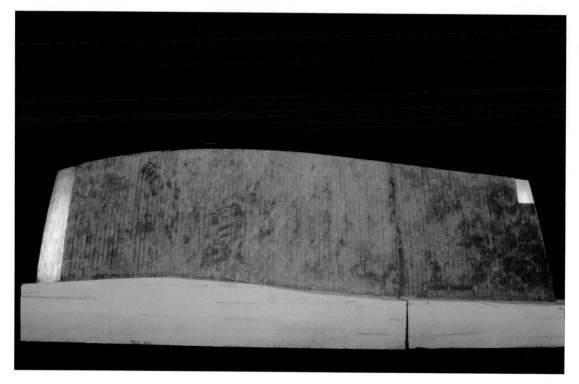

Above: Model of the chapel lit from the inside

Below: Longitudinal elevation of the chapel

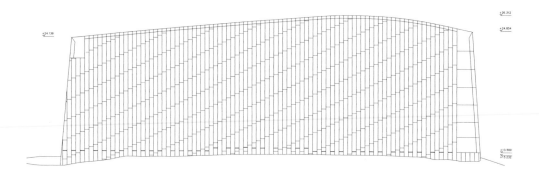

Opposite: Interior view of the chapel showing the illuminating effect of the windows on the altar

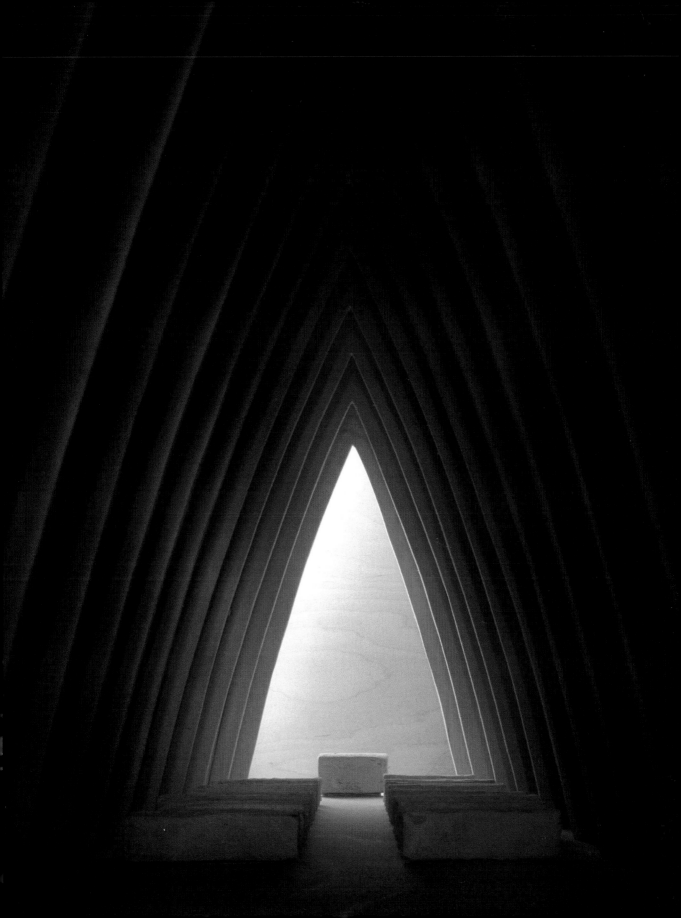

The squareness of a circle

Solid Square

NIKKEN SEKKEI

Kanagawa, Japan
Photographs: Kokyu Miwa Architectural

Solid Square forms part of a complex of offices, apartments, and other services close to Kawasaki Station in the Japanese city of Kanagawa, twenty minutes from Tokyo. Without being a perfect square, it functions as an atrium for the 100-meter-high (328 feet) office block and as a transition zone from the interior to its surroundings. The North American landscape architect Peter Walker, of Nikken Sekkei, took part in remodeling the surrounding landscape in a district of the city that has heavy traffic because of its proximity to a railway station. Within the atrium, a pool 27 meters (89 feet) in diameter and seven centimeters deep dominates the space, breaking the silence on the hour with its gurgling sounds.

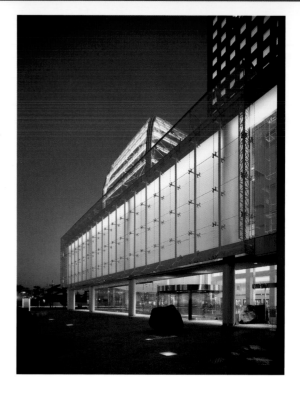

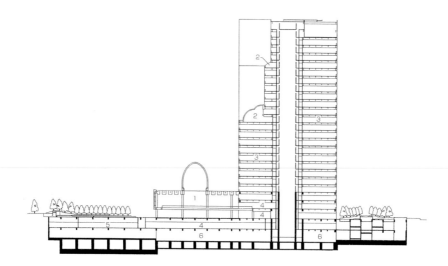

Above: Section of the proposal

Opposite: View of the surroundings immediately before entering Solid Square

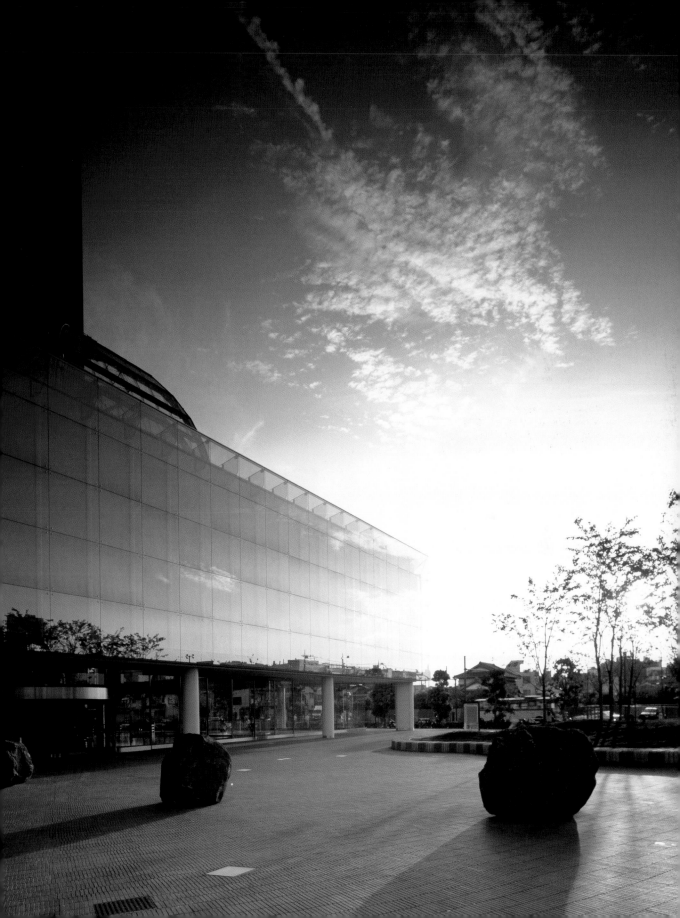

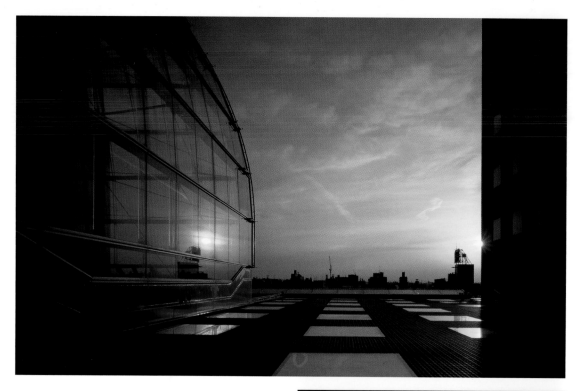

Above: View of the atrium skylights from the roof with its central dome

Right: View of the interior of the atrium with the glazed dome in the center illuminating the pool

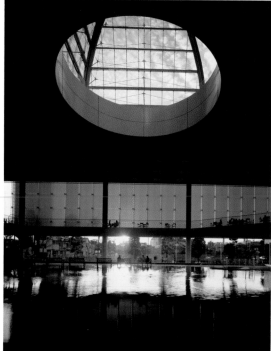

Opposite: Since there are no dramatic exterior views, the gallery focuses the visitor's attention to the interior of the atrium.

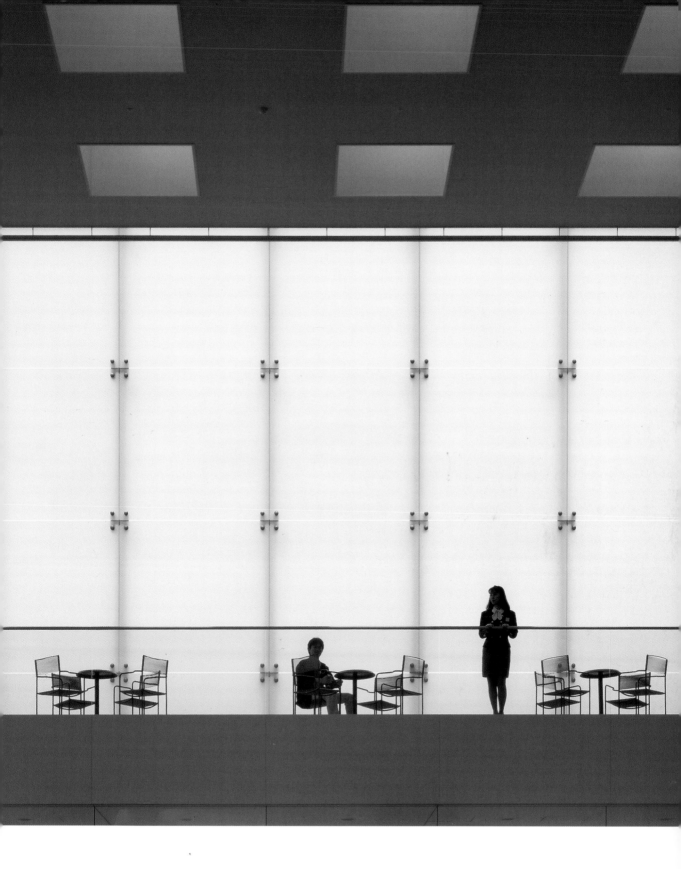

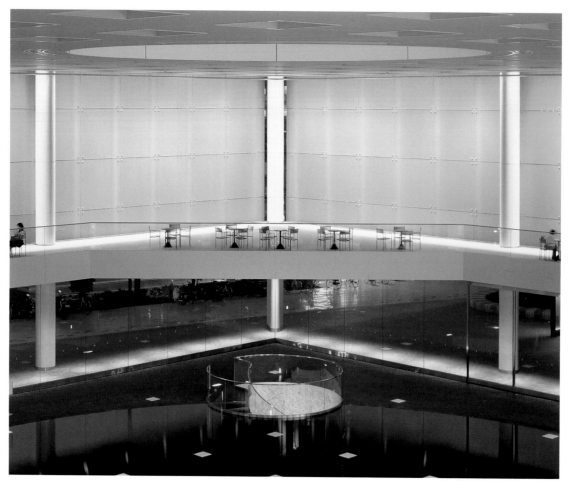

When necessary—entertainment, for example—the pool can be emptied to provide additional space.

The other outstanding feature of the atrium is the light that penetrates through the entire glazed surface of the ground floor enabling the senses to perceive architectural space, including the relationship between the interior and exterior. On the first floor, a double surface area of glass filters light through the translucent glass of the exterior layer to focus the visitor's attention on the pool, the light, the reflections, and the sounds. On the roof, a glazed dome that can be opened and closed highlights the interplay of light, wind, snow, rain, and water. Skylights embedded in the roof complete the entrance of natural light into the atrium. On the floor, a grid of lights interacts with reflections from the skylights on the sheet of water— in short, a perfect fusion of interior space and exterior sheltered from any vagaries of climate.

Above: In the gallery, diffused light creates an intimate atmosphere.

Opposite: The benches around the pool seem to float on the water.

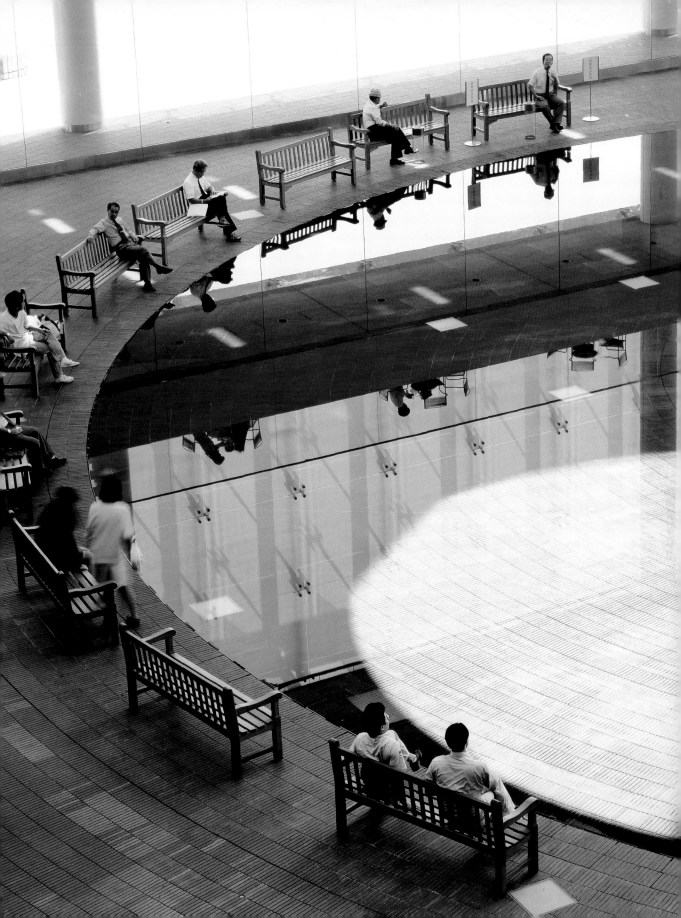

The charm of Shanghai

Plaza 66

KOHN PEDERSEN FOX
ASSOCIATES PC

Shanghai, China

Popularly know as Nanjing Xi Lu, this building is located on the most commercial street in the heart of Shanghai. Plaza 66 aspires to be one of the most important financial and cultural centers of Asia, basing its image on the visual impact of this type of skyscraper on a traditional Asian city. In order to integrate the skyscraper into the urban context, the design, like a collage, mixes together a series of volumes in disregard of the conventional forms of sky-scraper architecture.

The concept of the building focuses on a five-story retail center, which relates to the traditional profile of the city; the complex is situated on the street and interrupted by two office towers of forty-seven and sixty-six floors each.

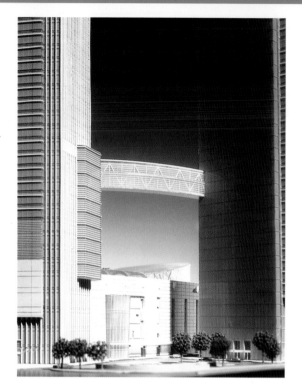

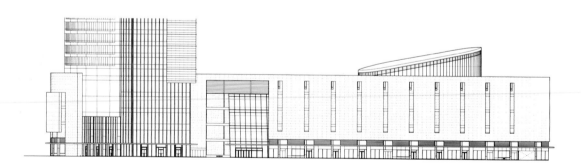

Above: North elevation at the base of the towers constituting the recreational and retail core of Plaza 66

Opposite: Night view of the complex from a neighboring skyscraper

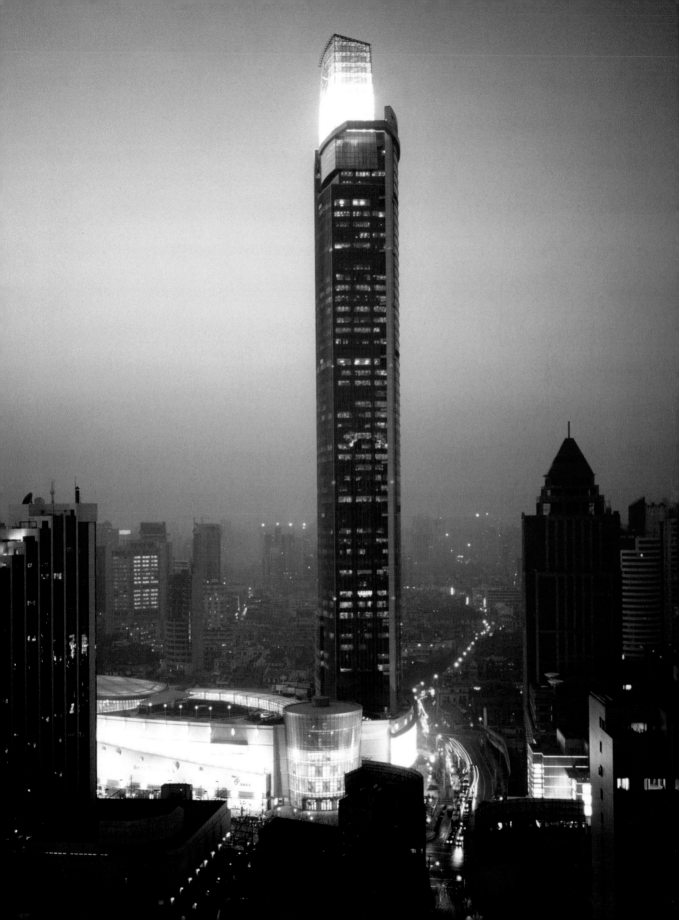

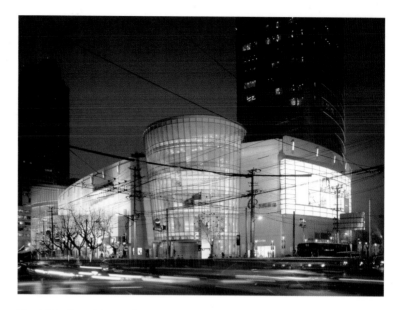

Top: Night view of the retail center and its activities

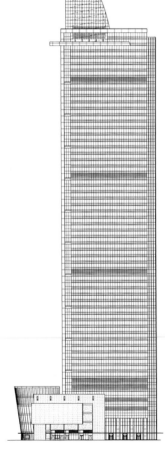

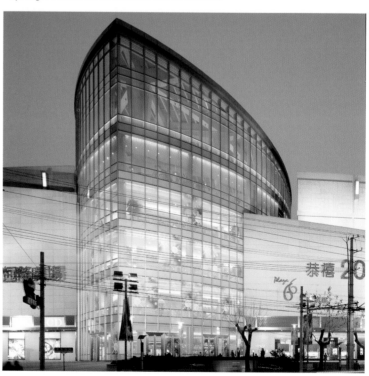

Above left: Elevation of one of the towers with its lantern
Above right: One of the glass volumes of the retail center
Opposite: Image of the complex at sunset

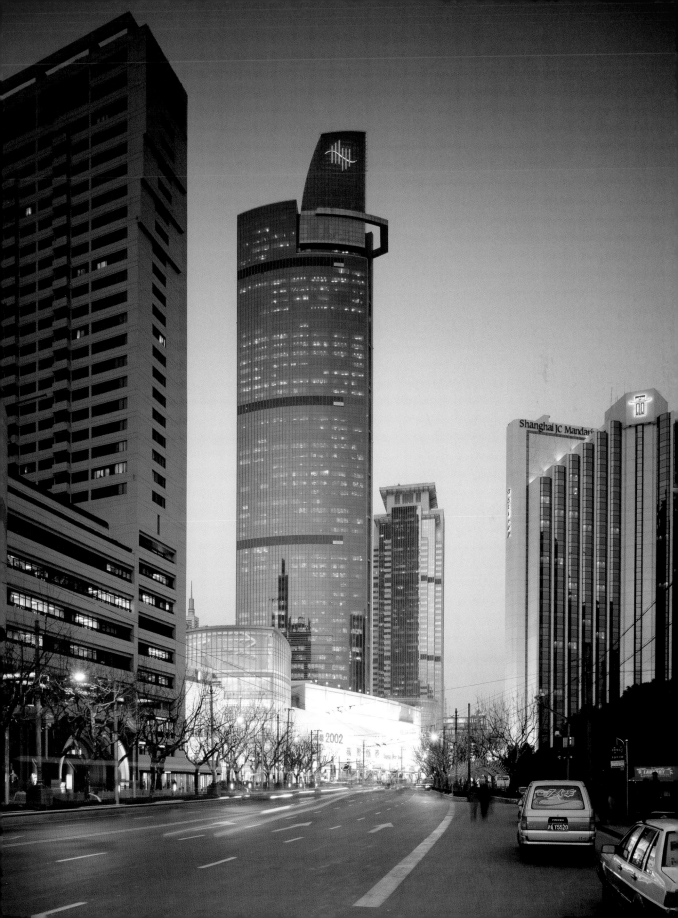

Top right: Scale model of the complex showing illumination effects

Bottom right: Interior of the retail center in scale model

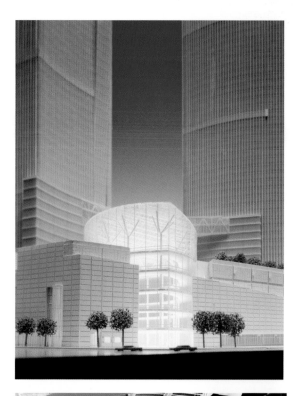

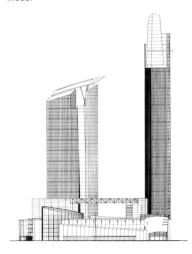

Above: Elevation of the complex with the two towers and base

Opposite: Detail of a ground-floor entrance showing the prominence of glass and stainless steel in the construction

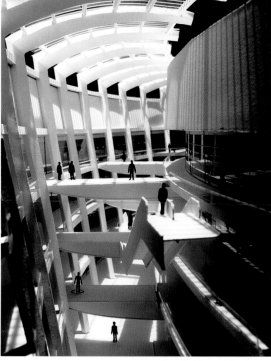

A covered pedestrian bridge connects the two towers. A rear view emphasizes the autonomy of each of the volumes; yet they are part of a coherent commercial complex. In the sense of collage, the commercial building responds to a juxtaposition of various volumes of curved geometric forms, maintains itself as a closed building at all times, and has two lateral glass appendices in each of its extremes. These spaces are open to the exterior, becoming enormous street lamps at night. Inside are galleries, ramps, and staircases that invite a visit to the building. As in all buildings of this sort, the weight of the structure spreads out to encompass the façade and elevator-staircase core. Each building has its independent entrance on the ground floor, which separates the main activities of the complex. The façades of the towers are clad in glass and aluminum. On the lower floors, the use of stone materials provides a sense of solidity. At night, the towers emit beams of light from the lanterns on their peaks.

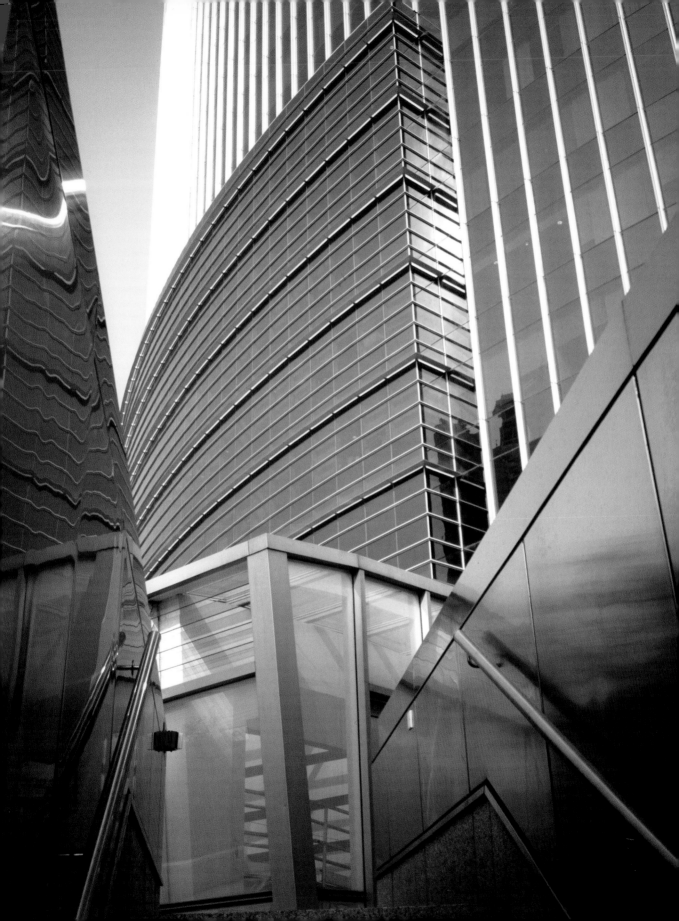

The big eye

Oita Stadium: Big Eye

KISHO KUROKAWA

Oita Prefecture, Japan

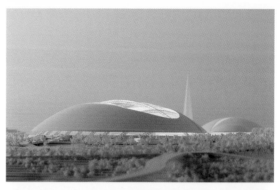

This stadium was completed for the 2002 FIFA World Cup, but is part of a long list of facilities that will be finalized in 2008 for the Japanese athletics championships. In a third phase, the entire complex will form part of a large sports park. The total area of the complex is 255 Ha. (630 acres), including the following facilities planned as complements to the main stadium: a fitness center, a training center with residential accommodation, a botanical garden, two multidisciplinary athletics tracks, two training pitches for football and Rugby, a baseball stadium, eleven tennis courts, and a large open field, among other spaces.

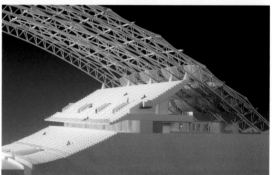

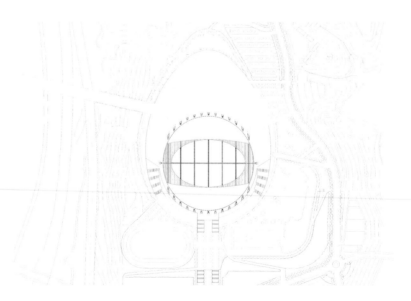

Perspective of the stadium's covered area, with the great elliptical eye in the center

Opposite: Model of the complex forming part of a large park devoted to sports

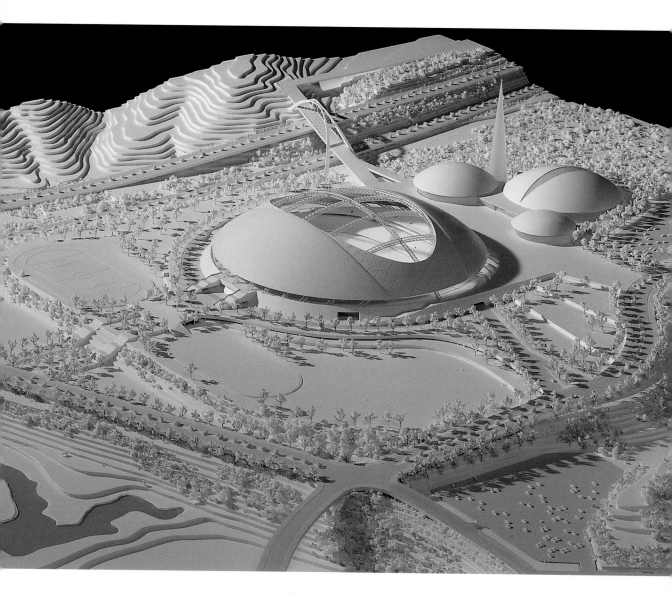

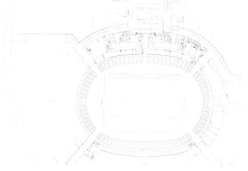

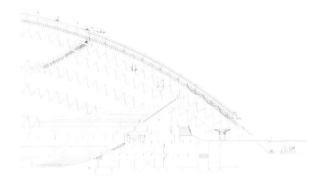

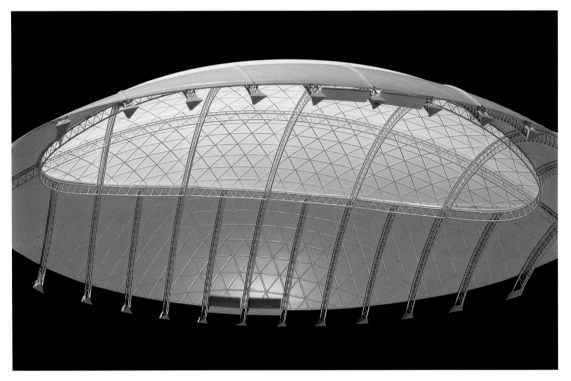

The structure of the elliptical roof consists of great girders forming the principal arch as well as horizontal secondary girders. The tubular structure is very well adapted to large-scale constructions.

The stadium contains a sports field for activities such as football and Rugby, and can also be adapted to other kinds of events such as concerts or celebrations thanks to its retractable seats. The closeness of the spectator area to the playing field allows the spectator to feel actively involved in the spectacle. The moving roof bestows versatility, enabling the central space of the stadium to be completely covered.

Opposite: Outside view of the stadium, with the roof closed (top), and (bottom) interior view with the roof open

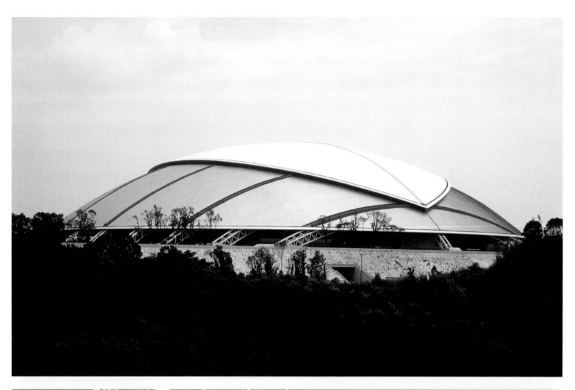

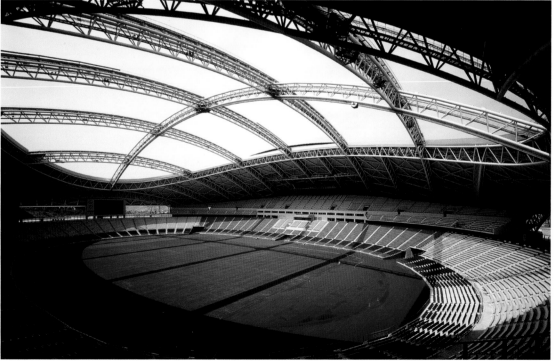

New Malaparte covering in China

House in Nanjing

MATTI SANAKSENAHO

Nanjing, China

This house was built as part of the China International Exhibition of Architecture (CIPEA). It stands in the central area of the exhibition, on the shore of a lake and surrounded by a green leafy environment. The green patina of its copper cladding integrates the house into its landscape without robbing it of prominence.

The house is conceived as a holiday home for small groups and families, incorporating workshops for visiting artists and meeting rooms. The two lower levels are devoted to the suite-workshop. The middle floor contains the bedrooms, and the fourth level, coinciding with the entrance to the dwelling, combines most of the public functions. The living room is at the end of the floor,

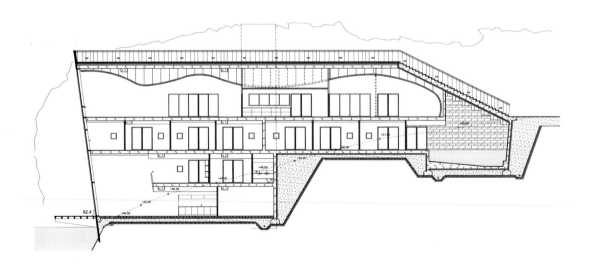

Above: Longitudinal section

Opposite: View of the house from the opposite lake shore

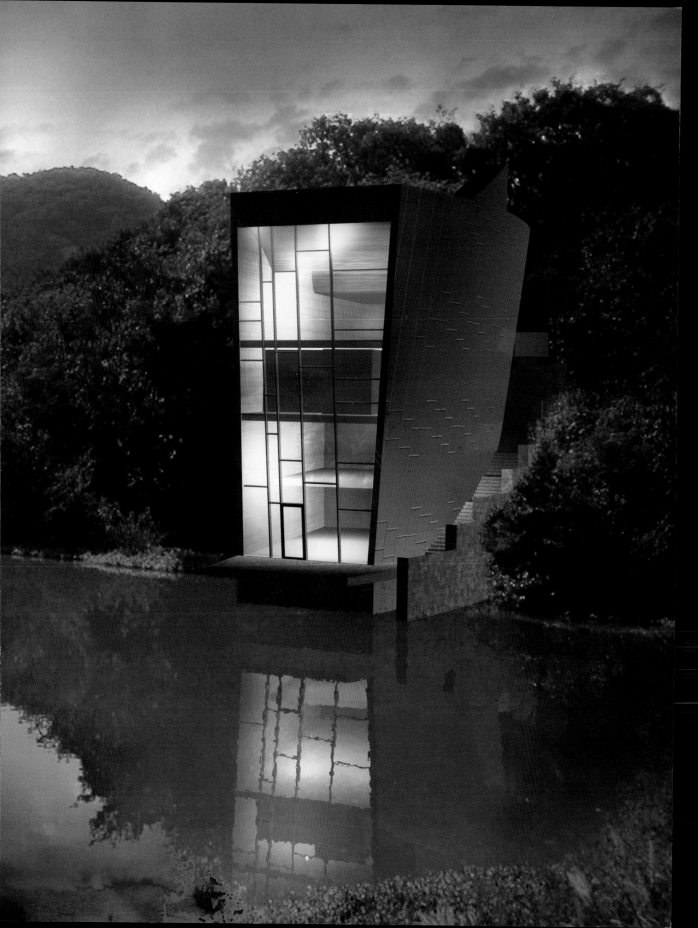

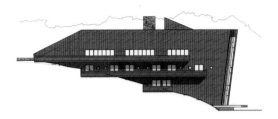

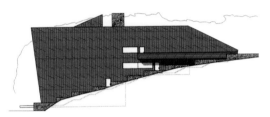

Northeast (top) and southeast façades

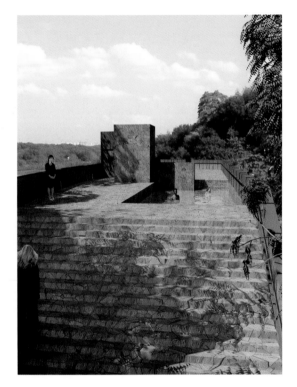

Detail of the terrace

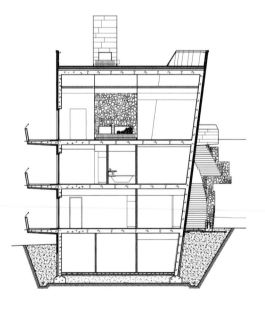

with views onto the lake through a great window and sliding doors leading into the conference room. The terrace located on the roof of the building offers one more space for open-air activities.

Above: Transverse section of the house

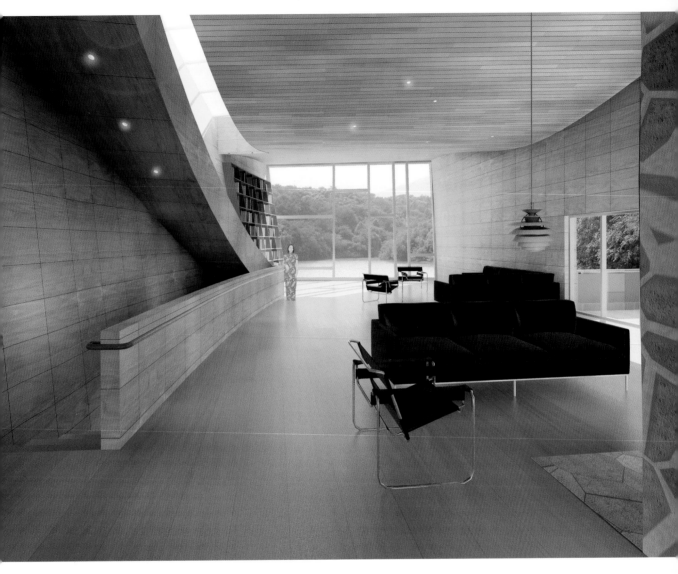

View of the living room showing a large window facing the lake

Los Angeles in color

LAX: Los Angeles International Airport

TED TOKIO TANAKA, TTTA

Los Angeles, California

This project was undertaken to improve both the aesthetics and function of the international entrance to Los Angeles Airport by means of architecture, graphics, landscape, light, and public art. Currently, this innovative city project has succeeded in turning the airport into a brand image, symbolizing the city's cultural identity.

The work was carried out in two different phases. The first involved collecting information about Los Angeles; identifying problems, establishing priorities aimed at improving circulation and the airport's image; and drawing up final documentation. The second phase focused on design and execution of the proposal. The project emphasizes the prominence of Century Boulevard.

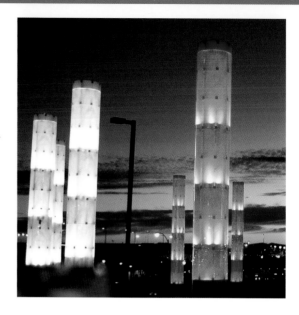

Below: Aerial view of the end circle at night, showing the highest pylons, 100 feet (30 meters) high.

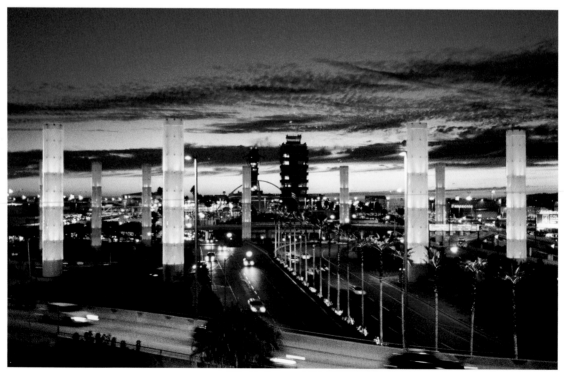

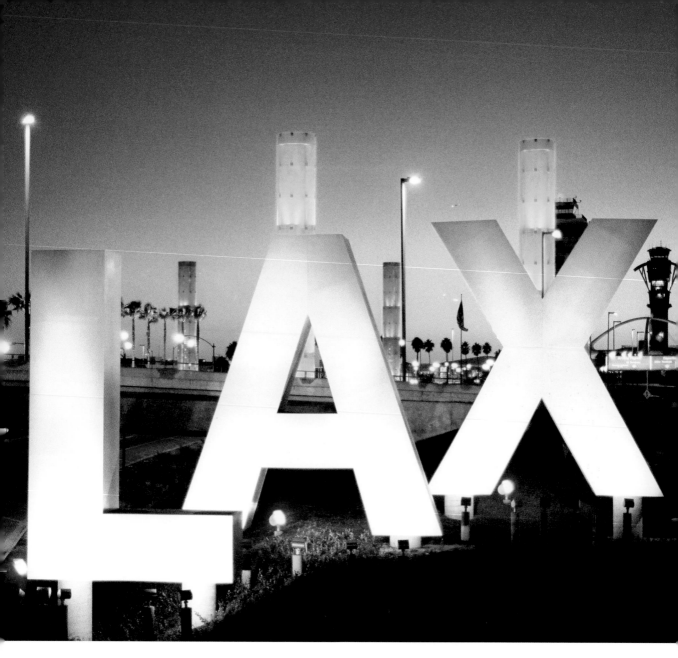

The welcome sign

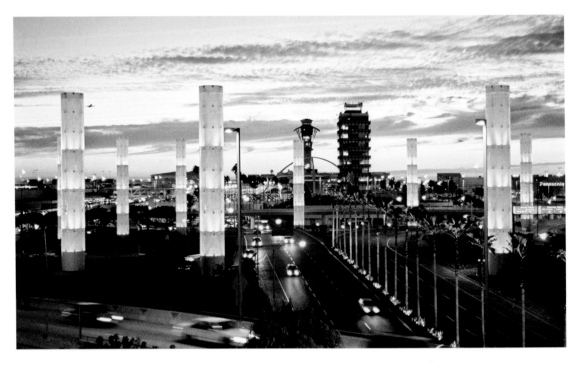

Top: Aerial view of the circle at evening

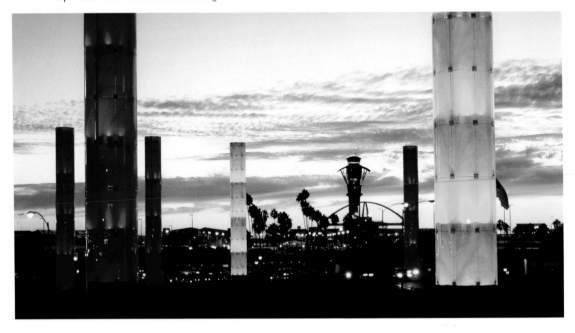

Bottom: Different evening colors for the pylons of the circle

Opposite: Pylons and trees as features of the landscape

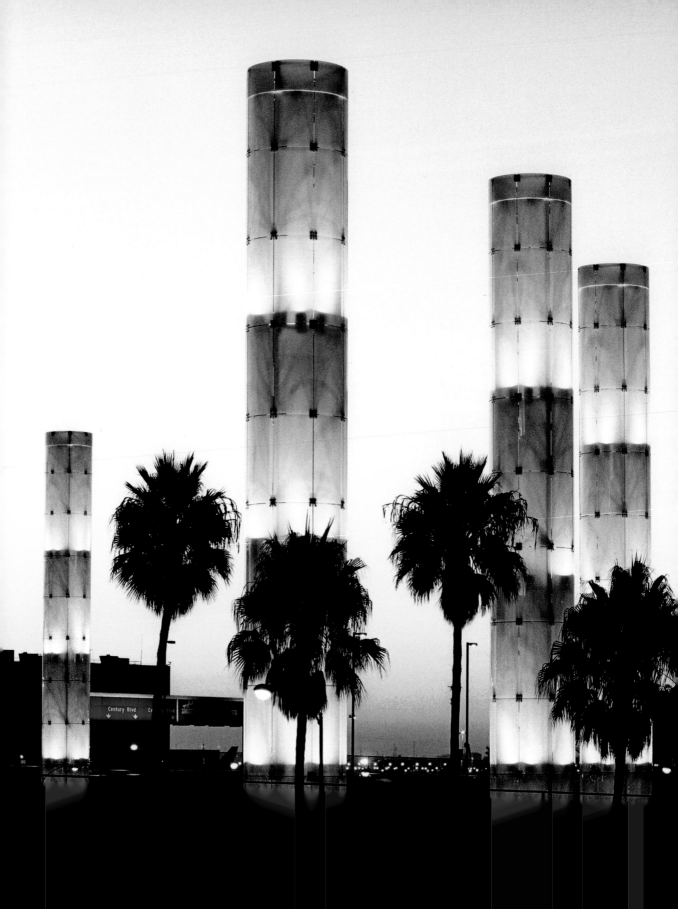

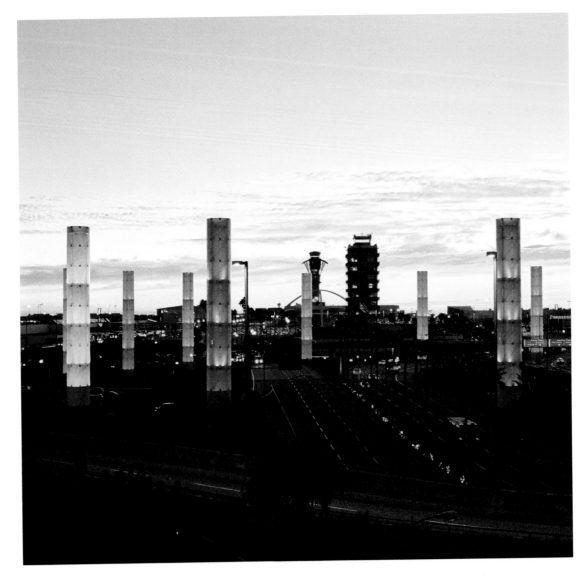

Above: A touch of color on the dark asphalt

Multicolored lighting is used on large glass pylons—25 to 100 feet high (7 to 30 meters)—that are adapted to the topography of Los Angeles. The pylons mark the course of the boulevard, culminating in a circulating arrangement, a clear evocation of Stonehenge. Technological ingenuity allows up to 300 different colors to be displayed in three hours, representing the multicultural richness of the city of Los Angeles.

Opposite: View of pylons along Century Boulevard, showing its hectic activity

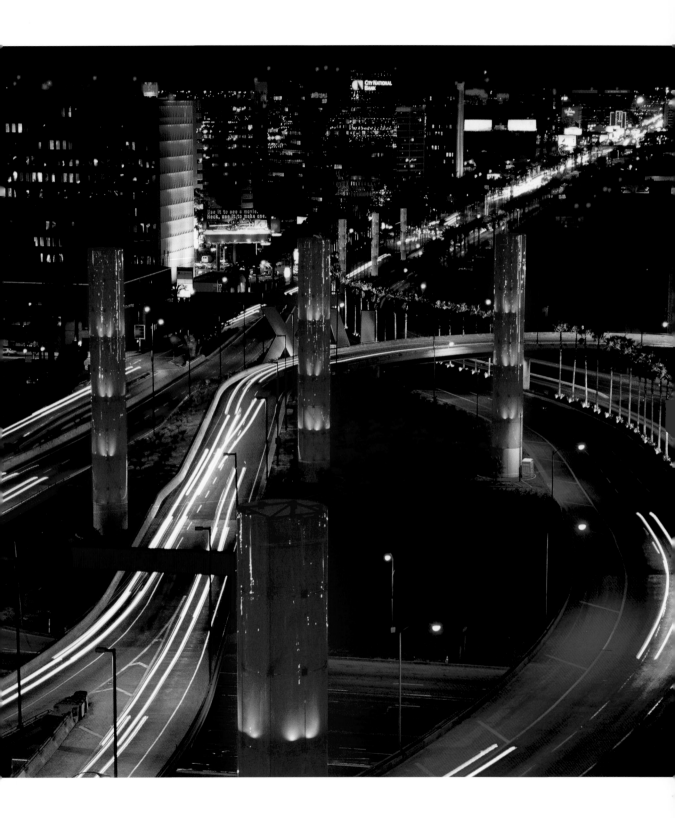

A skeleton in Tokyo

International Forum

RAFAEL VIÑOLY
Tokyo, Japan
Photographs: Nacása & Partners Inc.,
Timothy Hursley

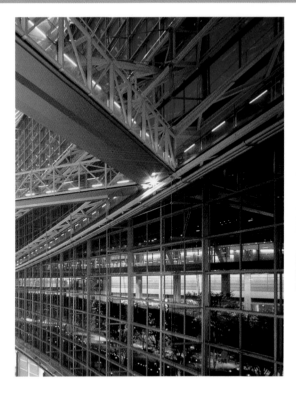

The project by Uruguayan architect Rafael Viñoly was the winner among 395 proposals submitted in the international competition for the construction of a new metropolitan forum in the city of Tokyo in 1989. Located in the business area of the central Maruncuchi district and close to the Ginza commercial district, the plot is connected to the subway and rail systems. It lies close to the imperial palace gardens, where the old town hall and other municipal buildings were built in 1957, following the designs of Kenzo Tange; those structures were demolished in 1991. The town council was transferred to new skyscrapers, also by Tange, in the financial district of Shinuku.

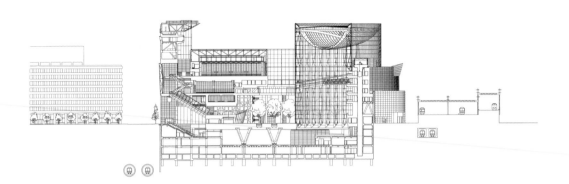

West-east section of the complex

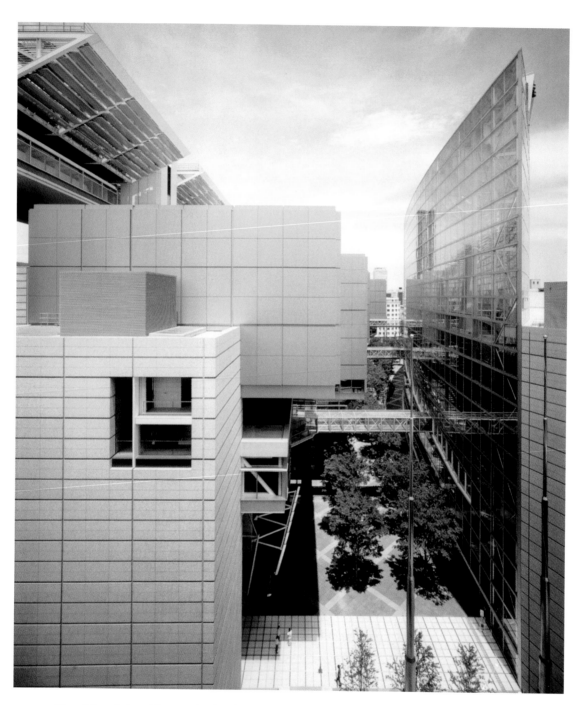

View of the exterior public space that functions as a square

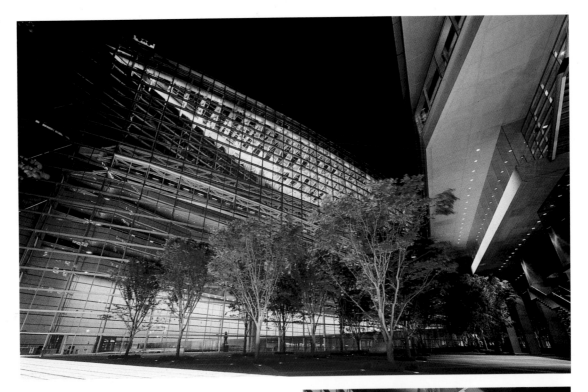

Above: View of the exterior space with vegetation

Right and opposite: Interior view of the atrium showing walkways and braces appear

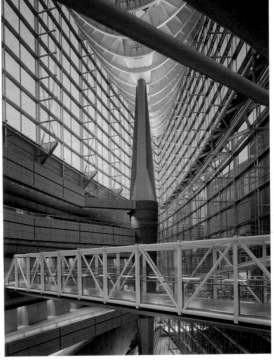

Viñoly's project configures an important public space into differentiated modules. The four large halls to the west, intended for concerts, exhibitions, and conferences, adapt to the urban texture of the surroundings, varying in size and integrated into the city through a common façade. The large hall on the opposite side of the plot follows the line of the nearby railroad, adapting to the fusiform perimeter of the parcel. It faces a wide street that functions as a square that relates the different parcels to the city.

The glazed hall is the focal point of the complex. It contains a large block of conference and meeting rooms that open to the interior, and an almost completely closed

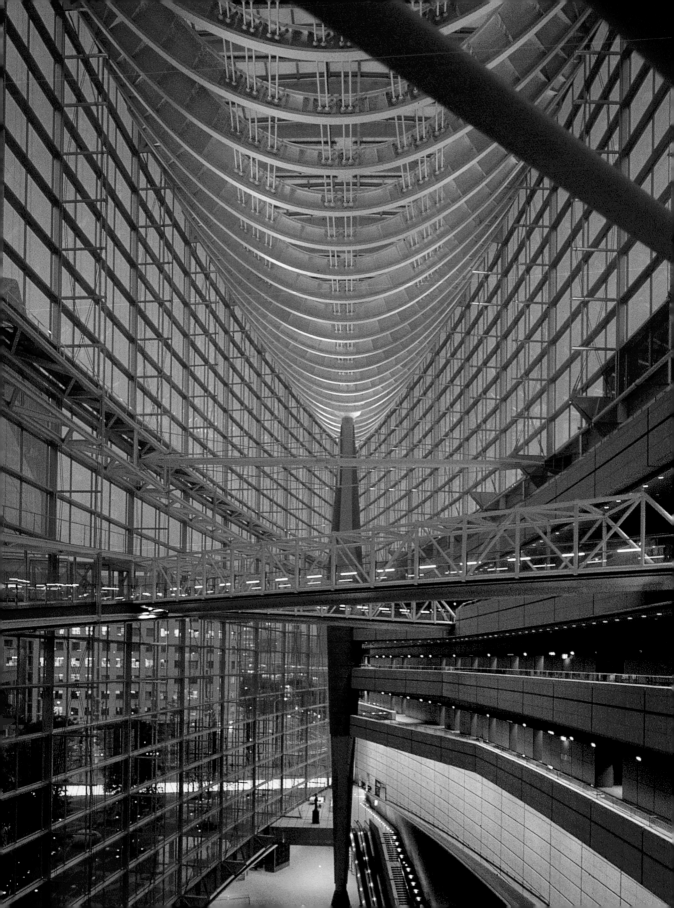

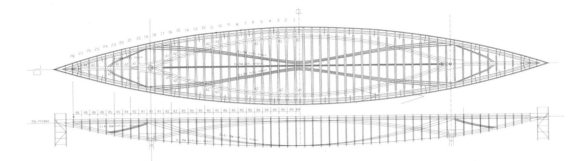

Top: Development of the atrium's roof structure

Right: Interior views of the roof structure showing clear osseous references

Opposite: Detail of the atrium's interior showing one of the pillars, which reach a maximum diameter of 4.5 meters (14.7 feet)

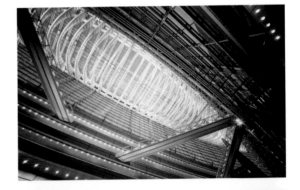

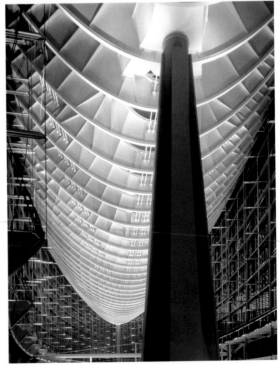

façade that gives onto the railway line. On the upper level, there is a large glazed atrium.

Originally, Viñoly's proposal was less daring structurally, but collaboration with the engineer Kunio Watanabe reduced the quantity of pillars to only two at the extremes to support the entire 124-meter-long structure (407 feet). By means of technical ingenuity, lateral stability against tremors, earthquakes, and winds was resolved by uniting the block of conference rooms to the columns: a glazed construction is unusual in Japan. The 57-meter-high (187 feet) curtain wall, made of 16-millimeter-laminated glass, is stabilized with an auxiliary braced structure that is independent of the roof structure. In order to stabilize the façades and make them more rigid, a large ramp for traffic was designed for the western façade. The pedestrian walkways of levels 6 and 7 transmit the lateral pushes received by the conference-room façade.

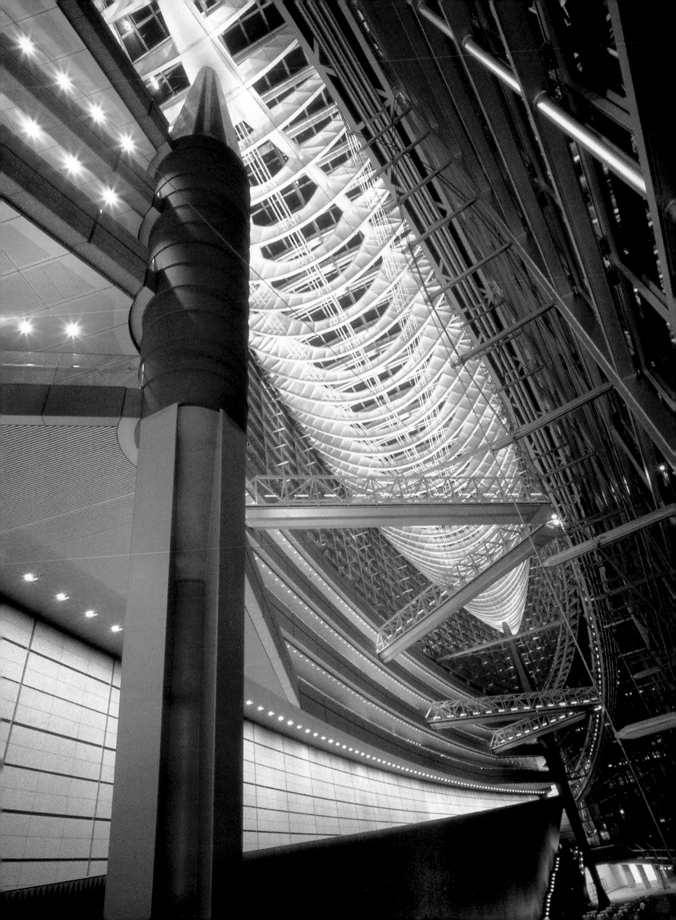

Gehry in his pure state

Guggenheim Museum, Bilbao

FRANK O. GEHRY

Bilbao, Spain
Photographs: Eugeni Pons

Bilbao is characterized by its dour urban landscape, owing to the importance of industry in the city's past. Industrial conversion caused obsolete installations to be abandoned. The Basque government then promoted a plan to renovate the area of the Nervión River—which traverses the entire city—and convert the existing industrial spaces to commercial, financial, and service uses. The plan has enjoyed the participation of Norman Foster, Santiago Calatrava, Federico Soriano, César Pelli, and Michael Wildford.

Frank O. Gehry's Guggenheim Museum forms part of this plan, and the building exceeds the cultural requirements for which it was created, having turned into a veritable symbol of Bilbao's enormous metamorphosis.

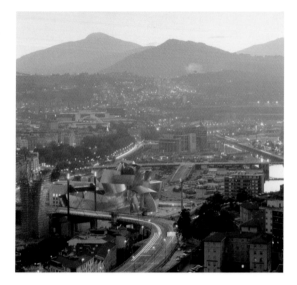

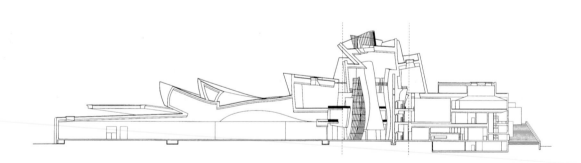

Above: Longitudinal section of the center

Opposite: Exterior (top) view of the museum showing its reflection in Nervión River

Opposite: Section (bottom) through the central atrium

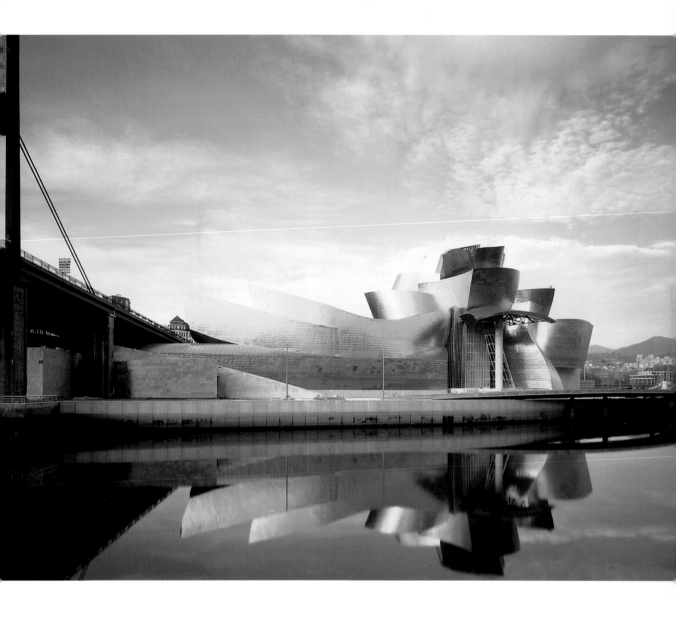

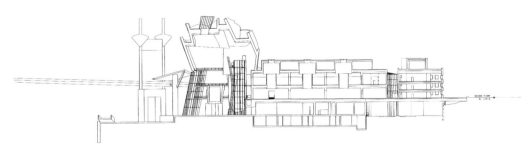

Top: Constructive section of the building

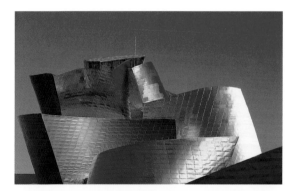

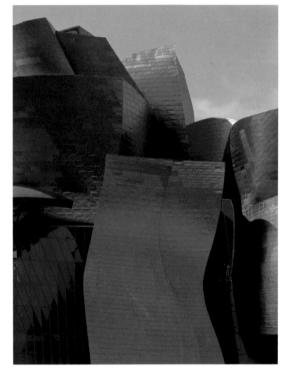

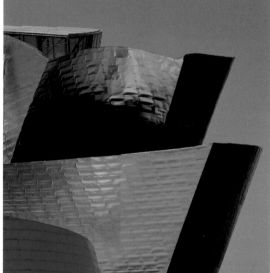

Above and right: The museum's curved surfaces are covered with a coat of titanium, whereas the other façades are clad with calcareous stone.

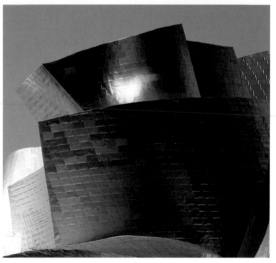

Opposite top: The titanium flower with its petals

Opposite bottom: Section through the auditorium

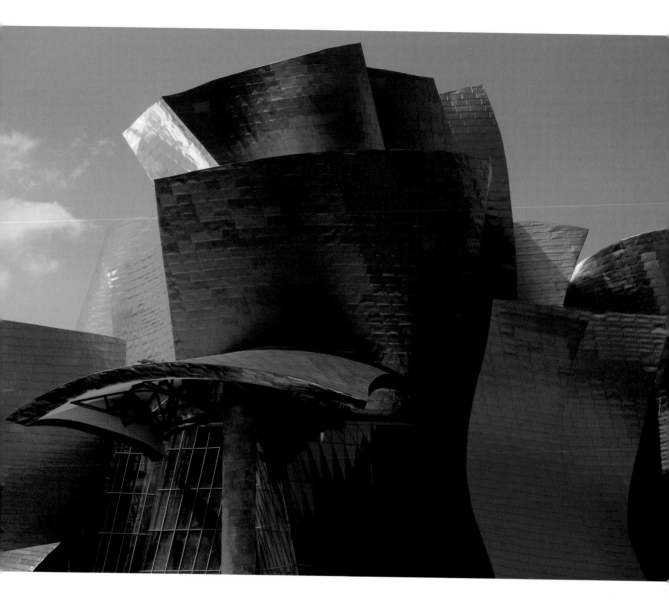

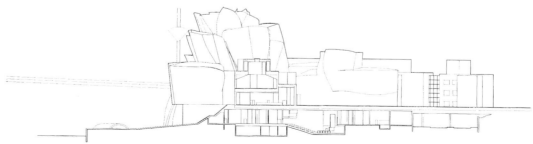

View of Bilbao with the completed Guggenheim Museum

Gehry was selected in a restricted competition, in which Arata Isozaki and Coop Himmelbau also presented proposals. The Basque authorities and the Guggenheim Foundation wanted a unique, iconoclastic building that could attract international attention to modern art, and become a symbol of the city. The museum is located on the bank of the Nervión, near a frequented suspension bridge, which the author took into account from the beginning of the project.

According to Gehry, the work is influenced by Fritz Lang's film *Metropolis*, the sculptures of Brancusi, the image of a quarry, and above all by the power that the city of Bilbao projects. Nevertheless, the image that has the

Opposite: The central atrium, one and a half times higher than that of the Guggenheim Museum in New York

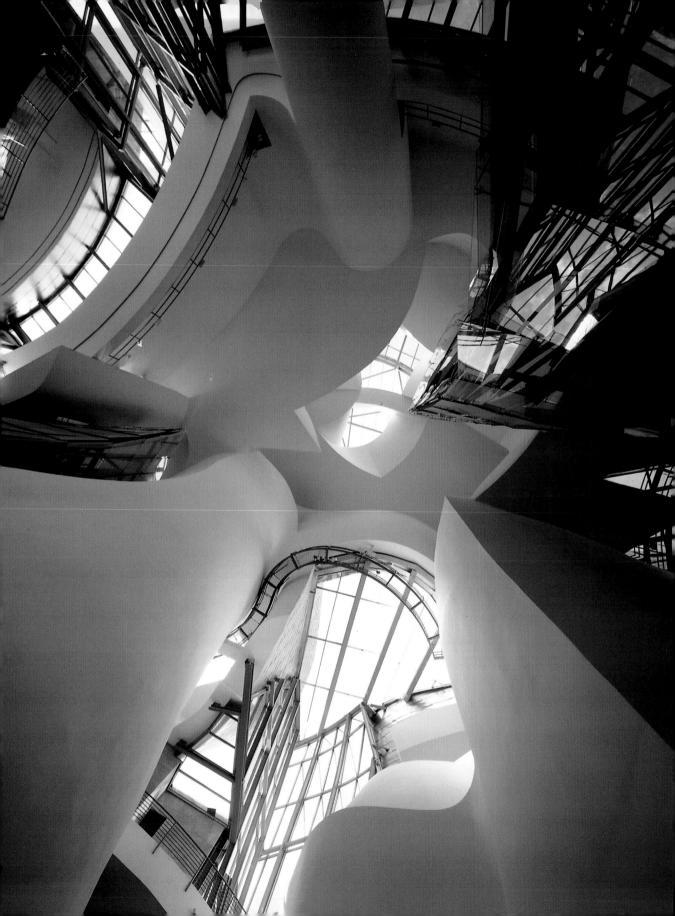

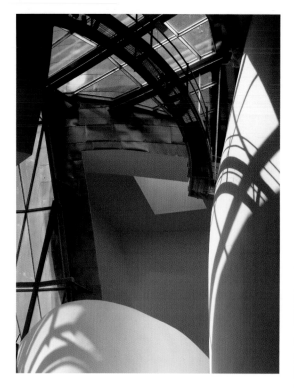

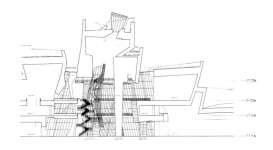

Top: Section of the museum

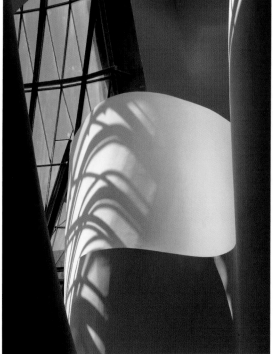

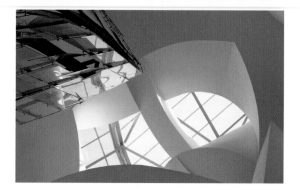

Above and right: Various images of the museum interior

Opposite: Interior view of the central atrium

greatest impact on the spectator is the Gehry seal. His sketches seem directly transferred to the computer, where they are analyzed mathematically to resolve technical and structural details.

The museum consists of a great central hall 50 meters (160 feet) high crowned with a metal flower, and three wings pointing east, south, and west. To the north runs the river, and a large glazed entrance lobby functions like a fourth wing. Each of the wings has been designed to house a different kind of exhibition. The auditorium, restaurant, and shops, on the ground floor, are accessible from the square in front of the museum, so that they can function independently. The auxiliary services are in the basement, which is reached by a service street.

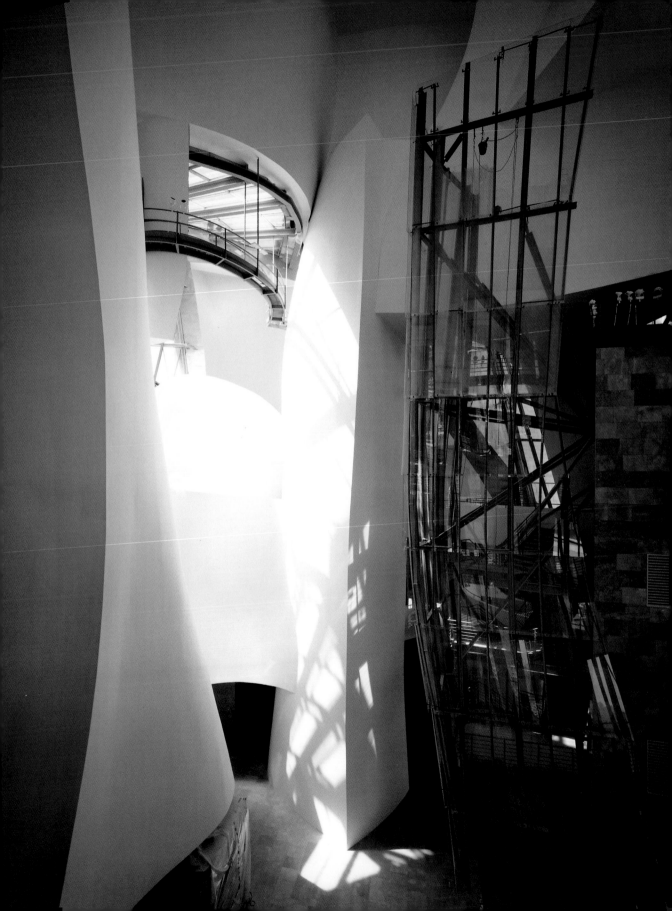

A garden in Hong Kong

The Center

DENNIS LAU & NG CHUN MAN
ARCHITECTS + ENGINEERS (H.K.) LTD
Hong Kong, China

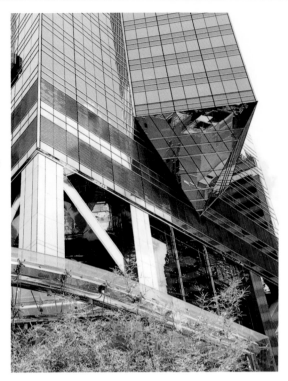

Following Hong Kong's independence from Great Britain, a large construction boom was preceded by the construction of this building, which is currently the third highest skyscraper in the city. Although the expansion in construction of the 1970s and 1980s had focused on new cities in the interior, in the 1990s, a large number of skyscrapers were raised that revitalized the Hong Kong skyline.

In response to the forest of concrete towers that have risen in the city, the elegant building known as The Center was built in the city's dynamic business district. The design was intended to offer a new quality public space to the city and to reduce costs by making the most of every bit of

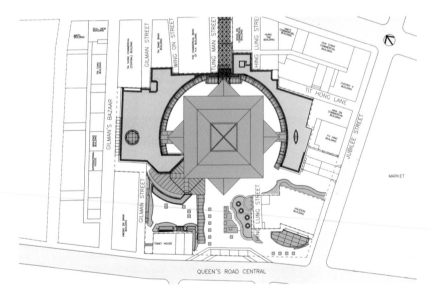

Above: Site plan showing the treatment of public space in front of the main entrance. The undulating forms break with the rigid geometry of the building.

Opposite: Aerial view of the building surrounded by a forest of skyscrapers

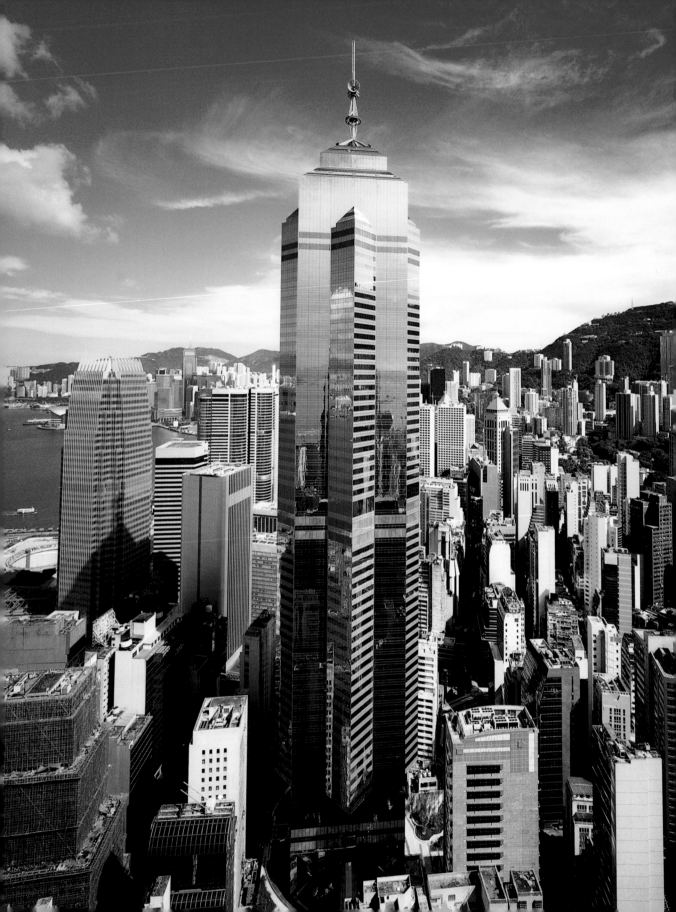

Top: View of the building from the square that faces its main entrance, Queen's Road Central

Bottom: Elevation-section of the building, revealing its formal construction from the ground floor to the classical gesture of topping it with an antenna

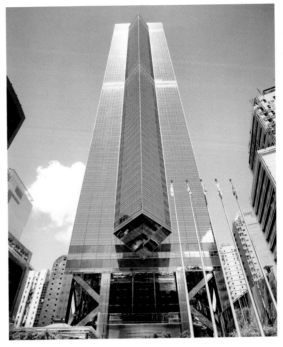

ground available, given the shortage of surface area in the city.

The illumination, central heating, air conditioning, and security systems in the building are all controlled by domotics. This was also the first building in the city to use a hanging basket for maintenance and cleaning of the façades. Its 346 meters (1,135 feet) of height include the antenna that tops the building, which along with the reflective glass façade and nocturnal illumination leaves no spectator indifferent. The pure volumes and curtainwall with no visible fixings or profiling emphasizes its regular geometry. The floor plan is the result of a 45-degree rotation of two identical squares that form a star-shaped polygon. The stair-elevator core is situated in the center in the form of a cross surrounded by emtpy space. The seventy-three floors are elevated above a large 15-meter (49 feet) entrance atrium finished in granite, glass, vegetation, and water; some retail premises are situated there. An itinerary through the interior garden leads to the entrance in the form of a cylindrical shaft.

The building has been inspired by the purest classical tradition of the North American skyscrapers of the 1930s and 1940s. This is somewhat unusual in a Hong Kong where technological culture invades the buildings through their architecture.

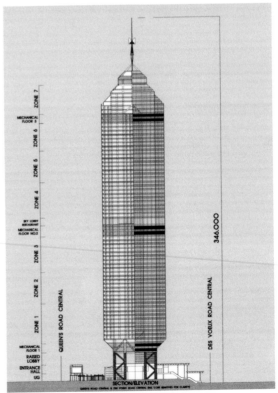

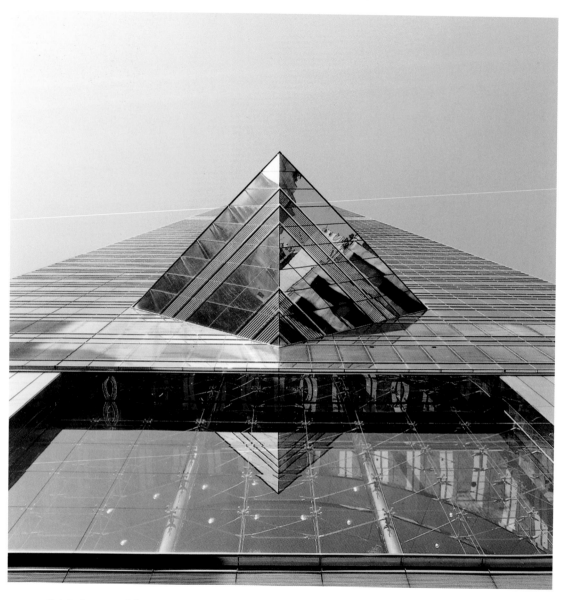

Detail of a corner of the tower at its intersection with the ground floor

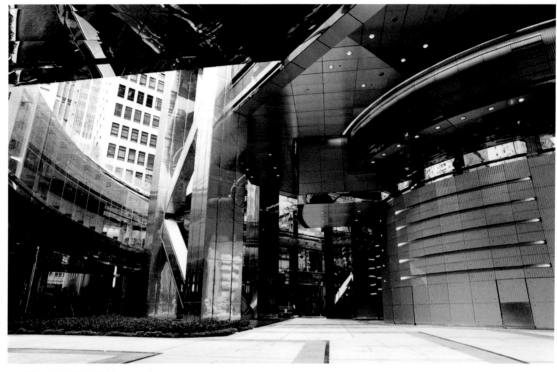

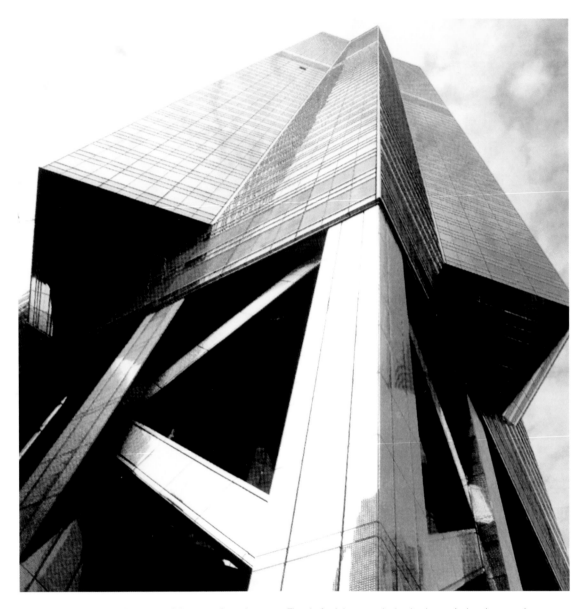

Above: View of a corner of the tower from the street. The shaft of the tower is detained on arrival at the ground floor where only the structure continues to the pavement and beyond into the subsoil. The hollow of the constructed mass creates a large public space.

Opposite: Detail (left) of the ground floor and main entrance characterized by the use of granite and stainless steel. The use of vegetation and water surfaces (right) in the public spaces creates an atmosphere of peace far removed from the noise of the streets.

The pearl necklace

Akashi Kaikyo Bridge

HONSHU-SHIKOKU BRIDGE AUTHORITY
Honshu-Shikoku, Japan
Photographs: Honshu-Shikoku Bridge Authority

With its six-lane span, the Akashi Kaikyo Bridge is currently the longest suspension bridge in the world. Each of its cables weighs about 25,000 tons and consists of a cluster of 36,830 treads. Each tread is 5.23 millimeters in diameter. The cables were developed by the international steel manufacturer, Nippon Steel Corporation, to satisfy the strict quality controls and standards adopted by Japanese manufacturers of automobiles and electrical appliances. Currently, there are projects under development for two bridges that will be longer than the Akashi Kaikyo. First, there is the bridge that will span the Messina Straits in Italy, and then a bridge that will span the Straits of Gibraltar between Spain and the African Continent.

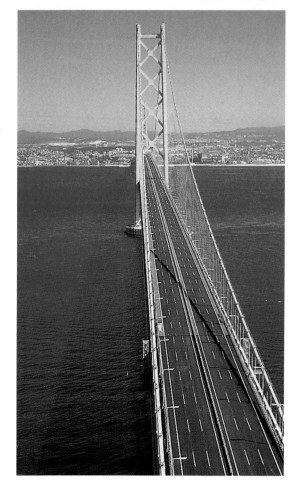

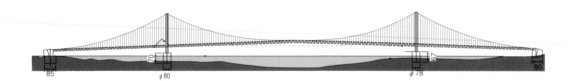

Above: Elevation of the bridge

Opposite: Night view of the bridge from one of the masts

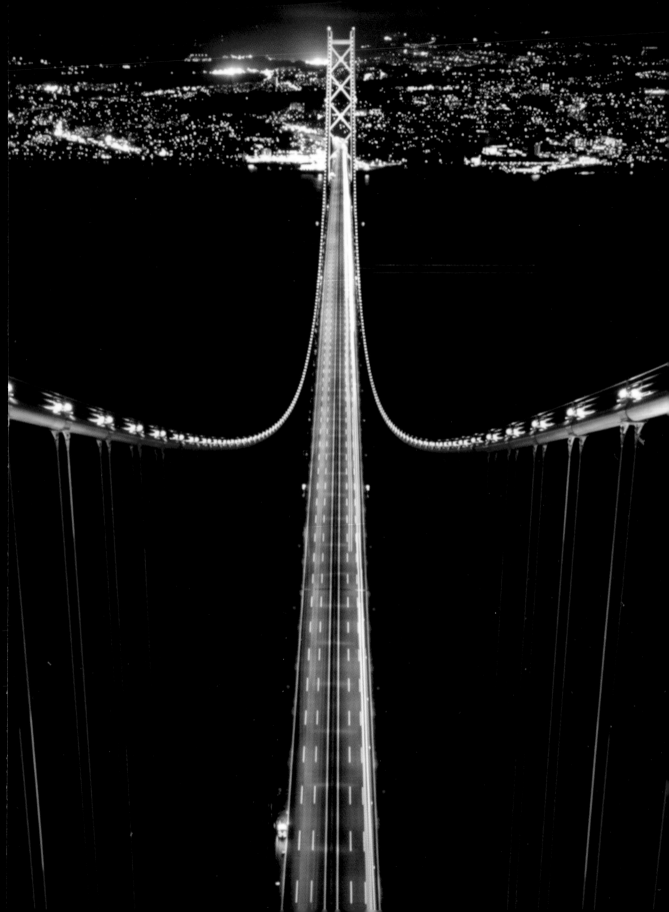

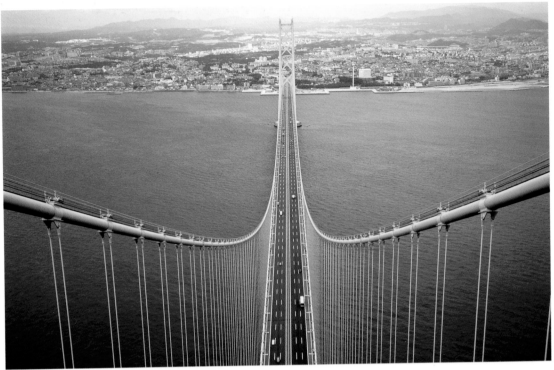

Above: Daytime view of the bridge from one of the masts

Right: Elevations of the mast-pillars

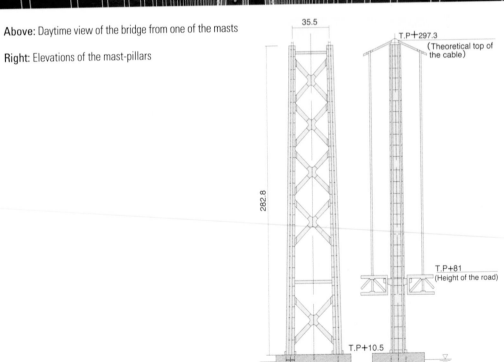

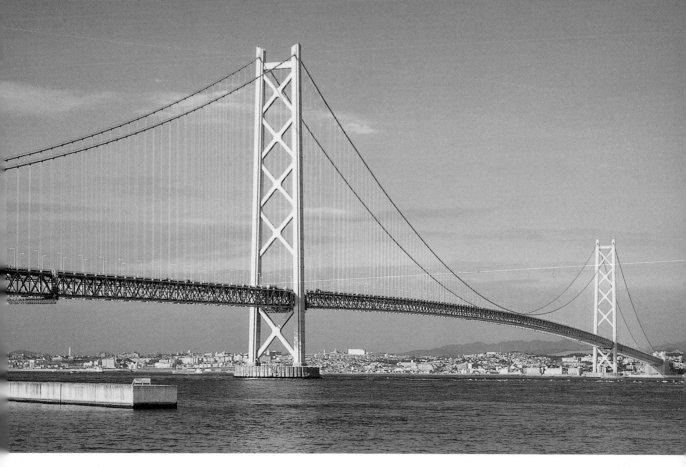

Above: A panoramic view of the bridge
Below: Graphics showing the effects of the earthquake on its structure

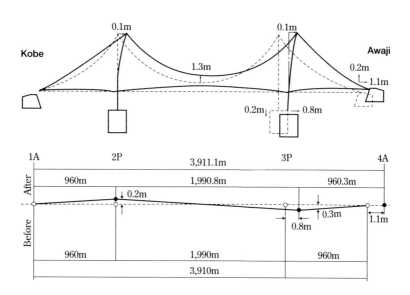

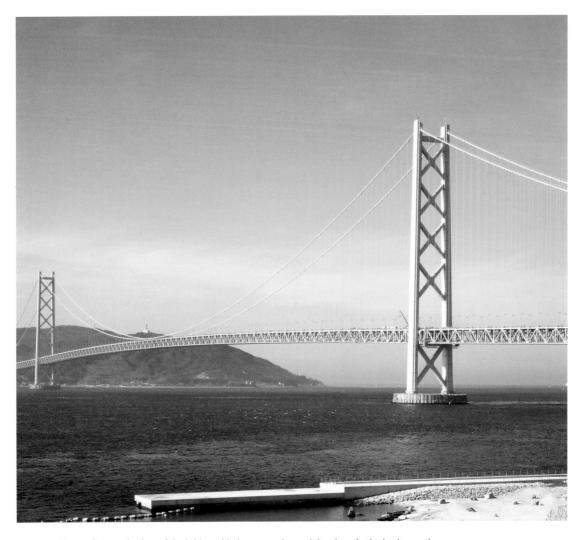

Above: Panoramic view of the bridge with the mountains and the shore in the background
Below: Night view of the illuminated bridge emphasizing the masts

In 1995, the Hanshin earthquake hit the Honshu-Kaikyu structure that was under construction at the time. Although the length (3,911 meters; 12,831 feet) and its central span (1,991 meters; 6,532 feet) have been increased by one meter each with respect to the original project, the overall structure suffered no consequences. Originally, the deck of the bridge was intended to carry a railway line. However, in 1995, it was decided to limit the span to a highway for road traffic.

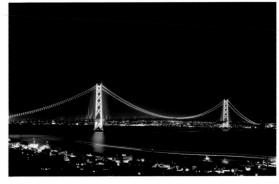

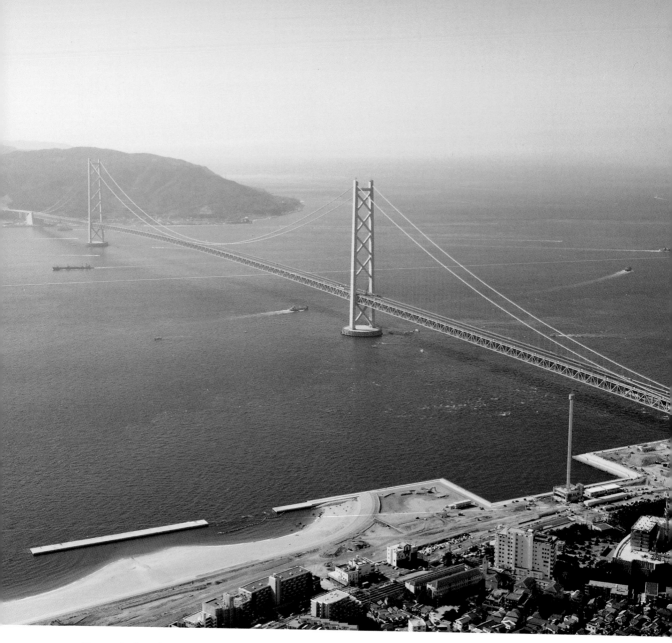

Panoramic view of the bridge

An urban carpet in Cincinnati

The Rosenthal Center of Contemporary Art

ZAHA HADID

Cincinnati, Ohio, USA
Photographs: Ronald Holbe

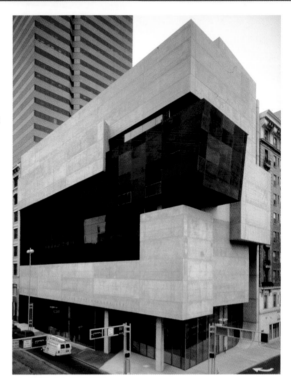

The museum building is conceived to accommodate temporary exhibitions, specific installations, and performances. It also contains lecture rooms, workshops, offices, and public spaces such as a lobby, café, and store. The spatial complexity of the building is illustrated by the concepts of "urban carpet" and "stacking boxes."

The urban carpet attracts pedestrians into the building by manipulation of the ground, creating a sense of spatial dynamism by bringing the exterior surroundings into play with the undulating surfaces of the lobby and entrance. The ground slopes on the corner of Sixth and Walnut streets, curving into the interior until it is transformed into a zigzagging ramp that slices through the lobby.

Above: Floor plan of the complex

Opposite: Interior perspective of the building's back wall

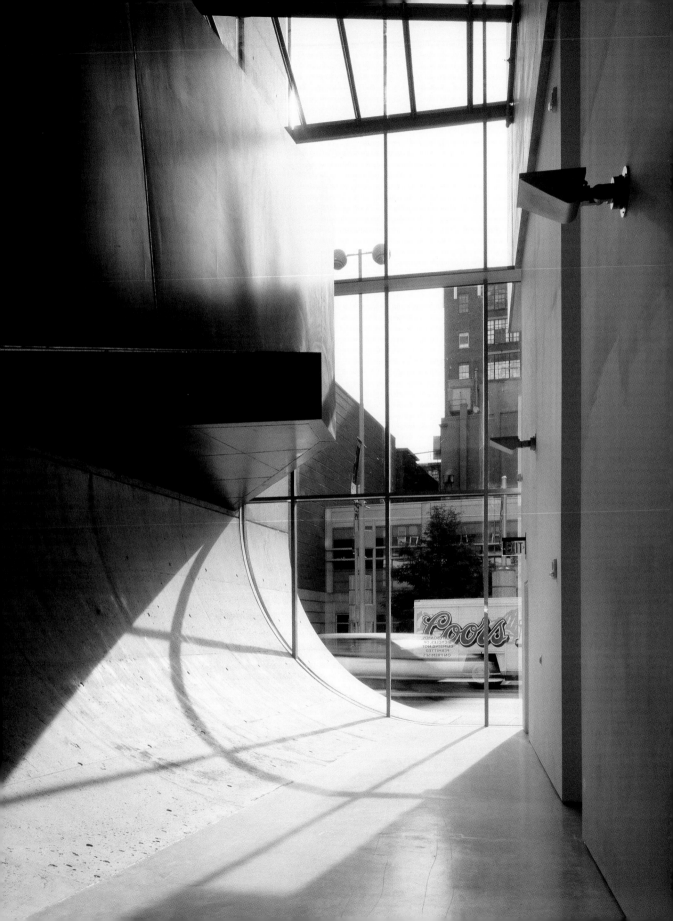

Right: Detail of the interplay of volumes in the east façade

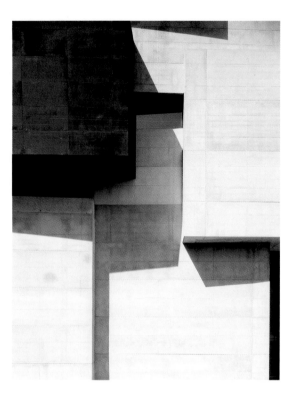

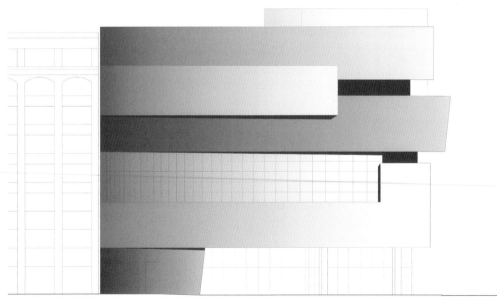

Above: South façade

Opposite: Details and perspective of the interior ramps

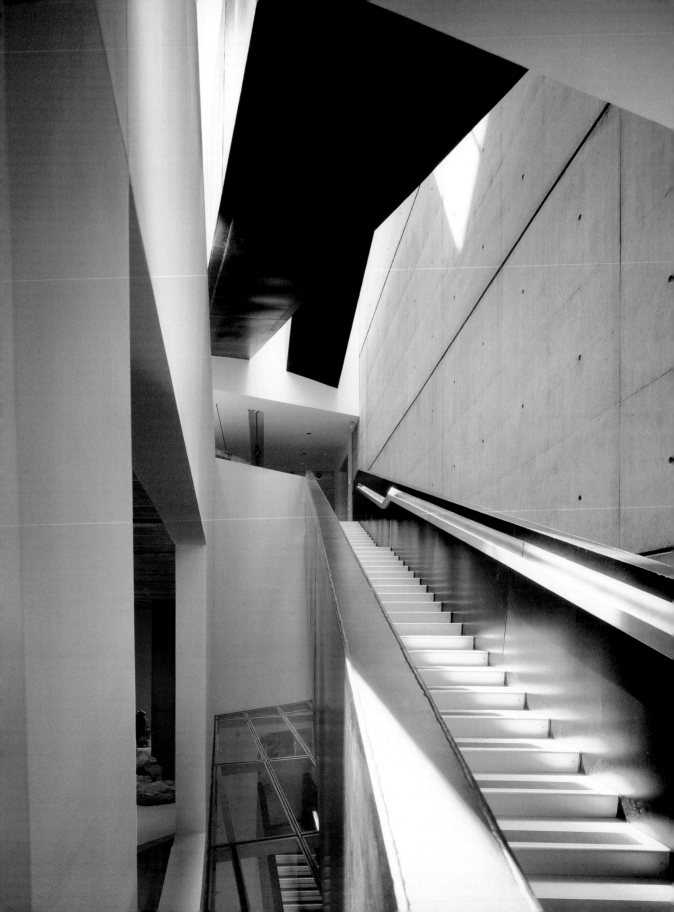

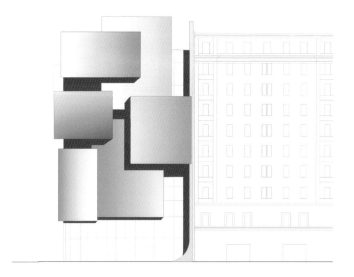

Above: East façade

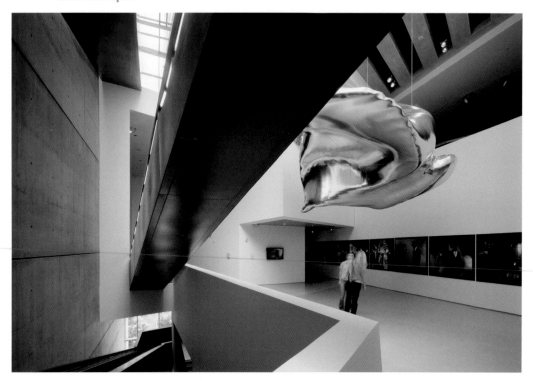

Interior perspective of a gallery

Opposite: Details of the lobby showing the ramp slicing through space

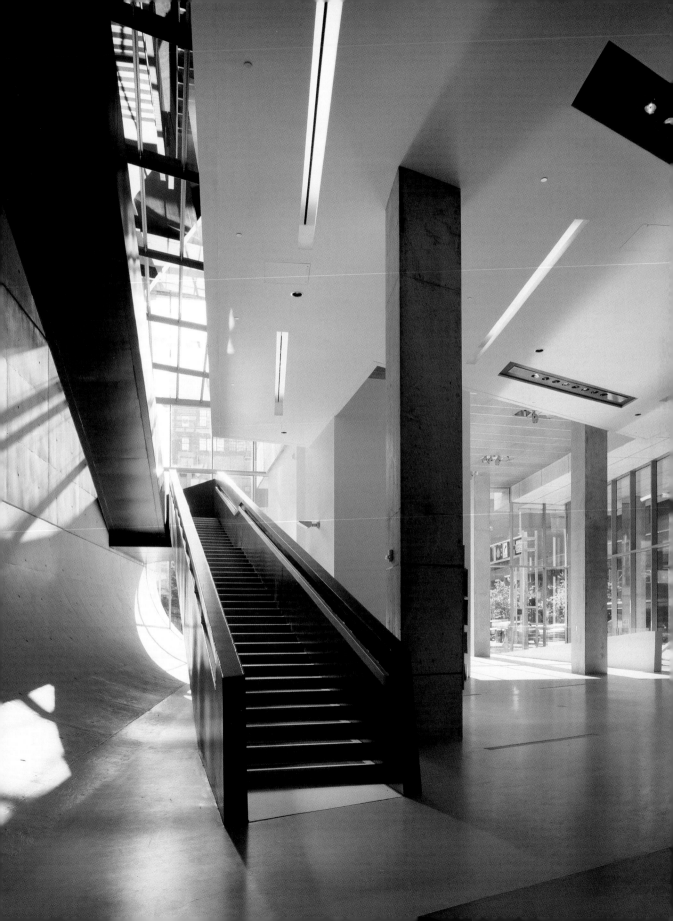

Right: Details and perspectives (top and bottom) of the interior ramps

Above: Cross-section of the building

Opposite: Detail of the curving back wall

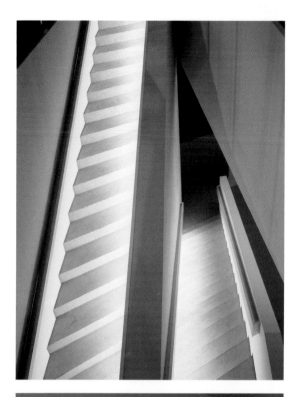

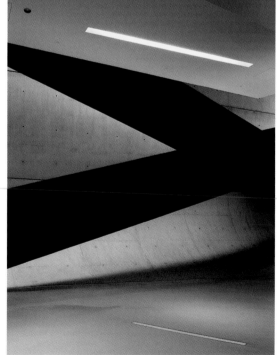

The concept of stacking boxes responds to the multiplicity of spaces, sizes, and requirements for illuminating galleries that look as if they are excavated out of a single block of concrete. Hanging suspended over the lobby, they create a complex puzzle of negative and positive forms.

The corner placement of the building leads to the use of two formal vocabularies to resolve the façades. The south façade, more translucent, reveals the central space and its activities. The east façade, more opaque and tectonic, reflects the interplay of forms in the galleries.

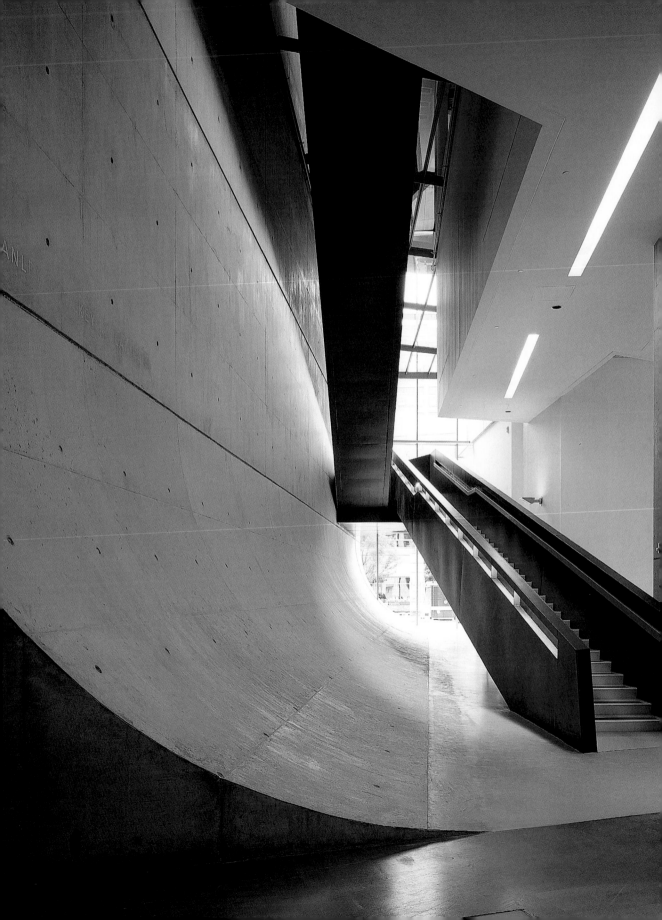

Shigeru's refuge for Paper

PAM-Paper Art Museum

SHIGERU BAN

Mishima, Shizuoka, Japan
Photographs: Hiroyuki Hi

Shigeru's fascination with materials has led him to dedicate his career to experimenting with structures and methods of construction. After the devastating Kobe earthquake in 1995, Shigeru became assessor to the United Nations High Commission of Refugees. He developed the Paper Church and the prototype of the Paper Cabin, a temporary solution made of cardboard cylinders for those having found themselves homeless. In the same year, he also proposed new paper shelters for the refugees of Rwanda.

The Paper Art Museum, situated on the outskirts of Tokyo, consists of two parts: PAM A is a private museum of paper manufacture; PAM B is a gallery of contemporary art. The façades are made of reinforced glass fiber panels.

Below: Roof floor of the complex

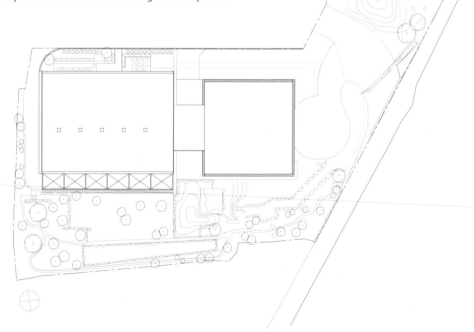

Opposite: View of the façade of PAM A with awnings open

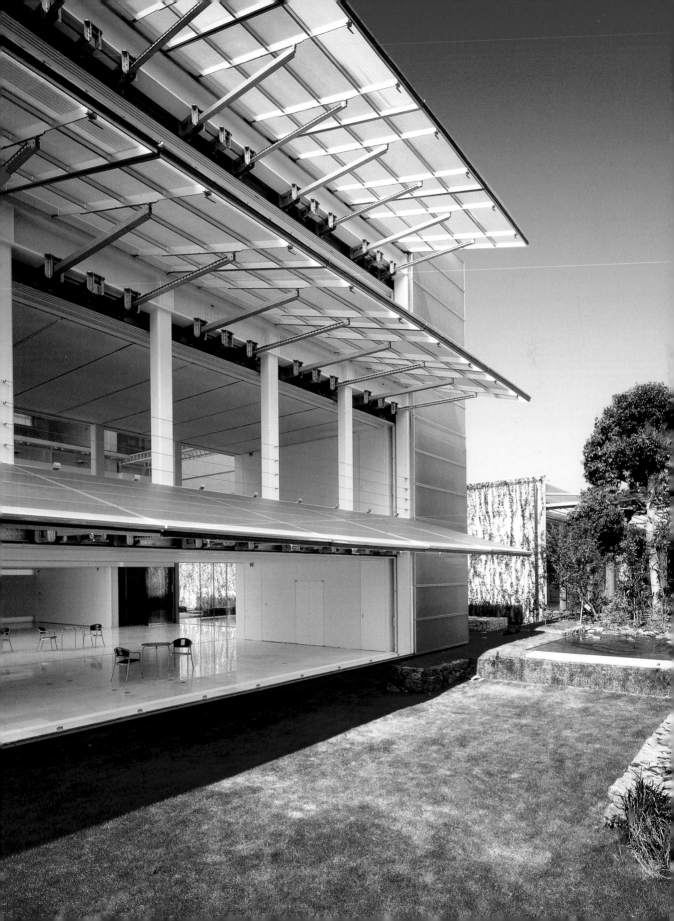

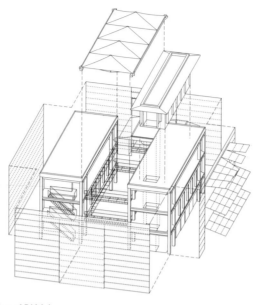

Above: Axonometric drawing of PAM A

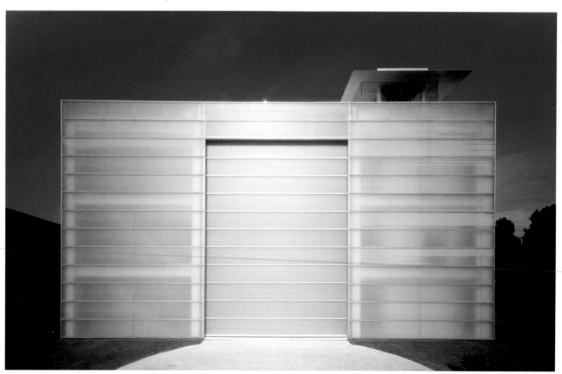

Entrance façade to the atrium of PAM A with the sliding doors closed

Opposite: Façade of the museum with awnings closed

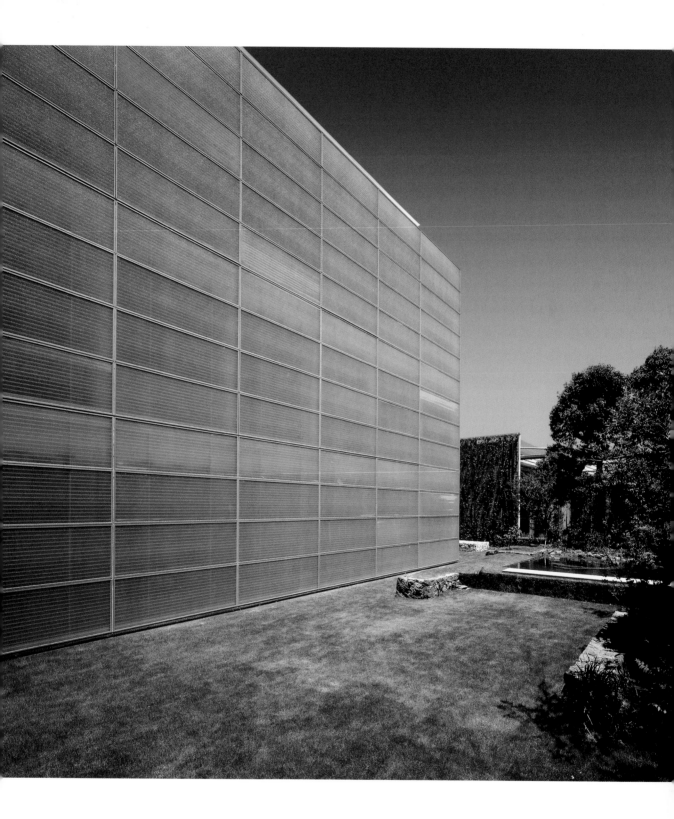

Cross sections of
PAM B

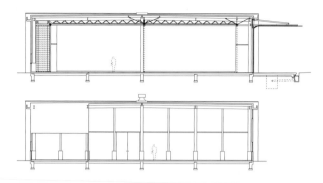

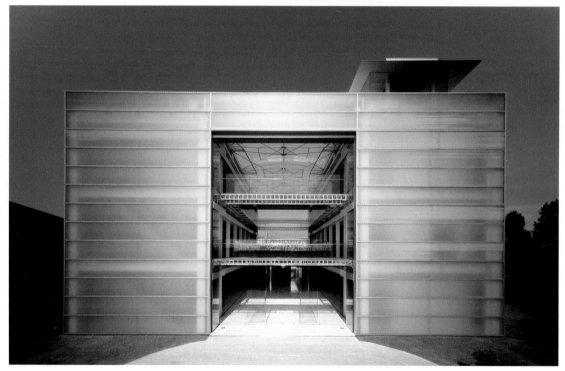

The building has a square floor plan divided into three files, with the one in the center forming an atrium three floors high. The continuity between interior and exterior is revealed by opening the large blinds so that they form canopies inspired by shoji screens. Originally, PAM B was a laboratory. However, it now functions as a gallery of contemporary art. The existence of sliding screens and large translucent doors that can be converted into canopies creates the possibility of spaces protected from direct sunlight. The complex aims to re-create spaces for contemporary life through the use of contemporary materials, but according to spatial premises and relationships that belong to traditional Japanese architecture.

Above: Entrance façade to the atrium of PAM A with the sliding doors open

Opposite: View of the atrium of PAM A from the interior

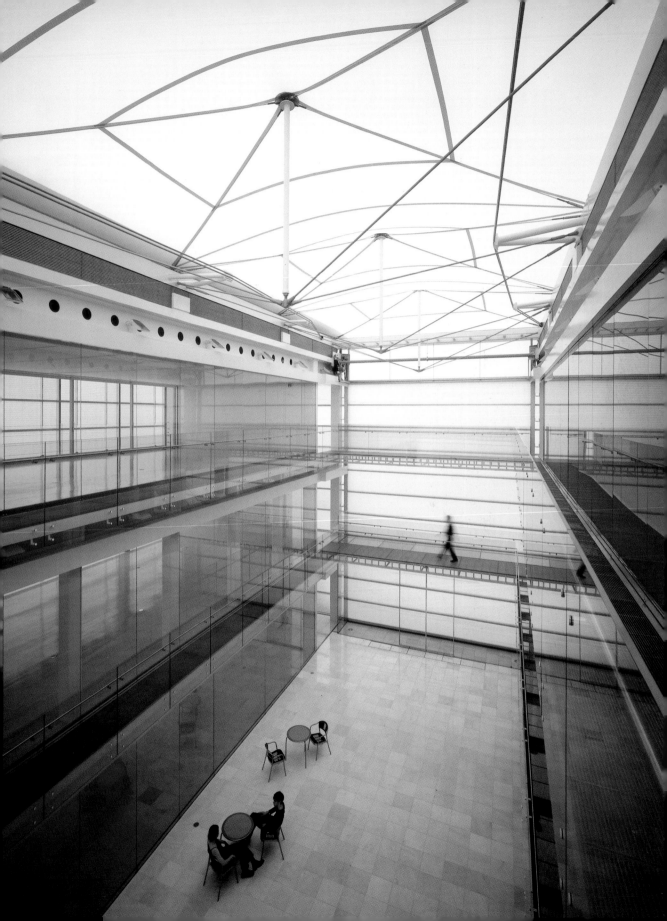

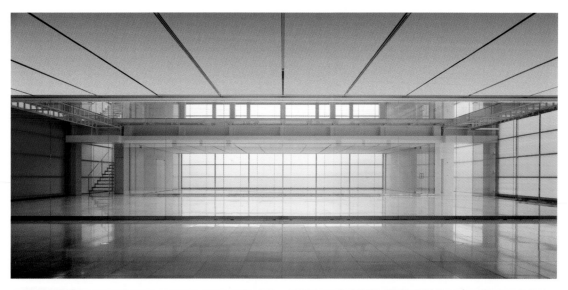

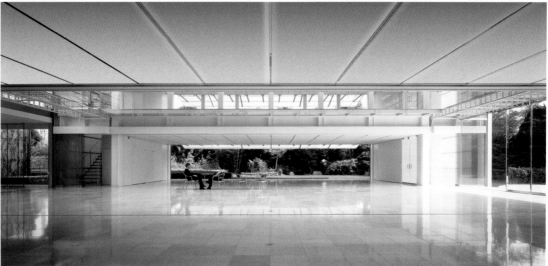

Above: Interior views of PAM A with doors open and closed

Opposite top: Façade of PAM B with awnings open

Opposite below: Longitudinal section of the complex

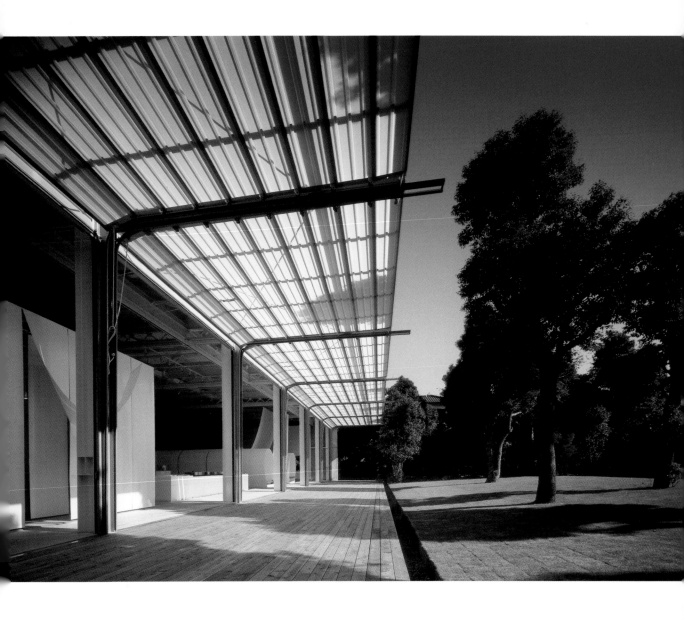

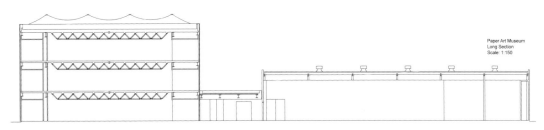

Paper Art Museum
Long Section
Scale: 1:150

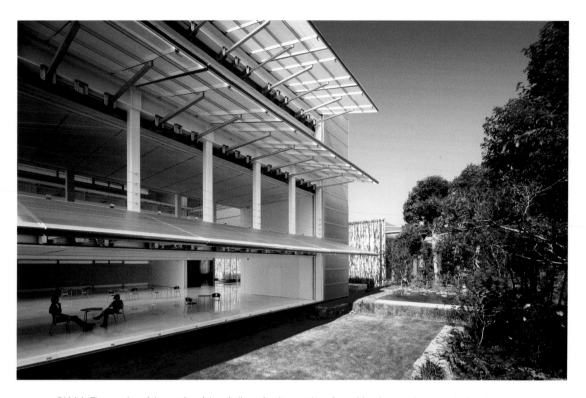

PAM A: The opening of the awnings (above) allows for the creation of transitional spaces between the interior and exterior.

Below: First floor of PAM A

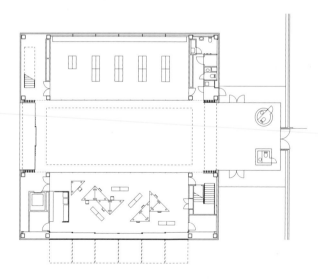

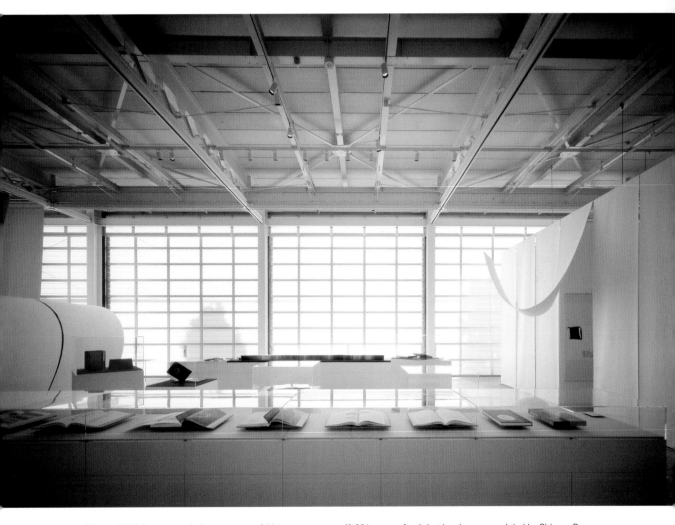

Above: PAM B was an existing structure of 924 square meters (3,031 square feet) that has been remodeled by Shigeru Ban.

Below: View from the interior of the first floor of PAM A

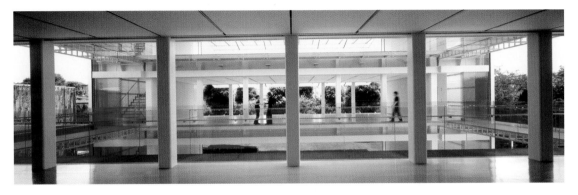

A bridge over the River Thames

Hungerford Bridge

LIFSCHUTZ DAVIDSON
London, England
Photographs: Mandy Bates + Lifschutz Davidson
+ Hayes Davidson / Nick Wood

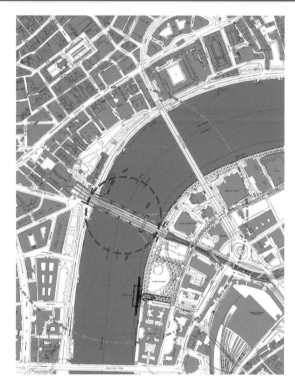

This bridge is part of London's Millennium Project, which also includes the Tate Modern and the Jubilee Line of the underground system. The competition was organized in 1996 by the Westminster City Council in the name of Cross River Partnership (an entity formed by public and private companies with the objective of promoting connections across the River Thames). It was aimed at an integration of the pre-existing Charing Cross railway bridge.

The winning team was formed by the WSP Group of engineers and the architects Lifschutz Davidson. A plan for one of the most important operations undertaken in this area, the proposal consisted of a pair of pedestrian bridges that would flank the existing railway bridge in order to

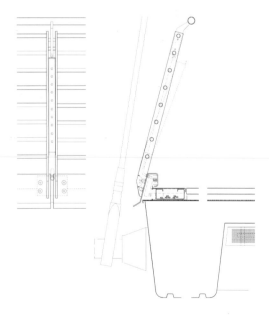

Above and right: Details of the walkway

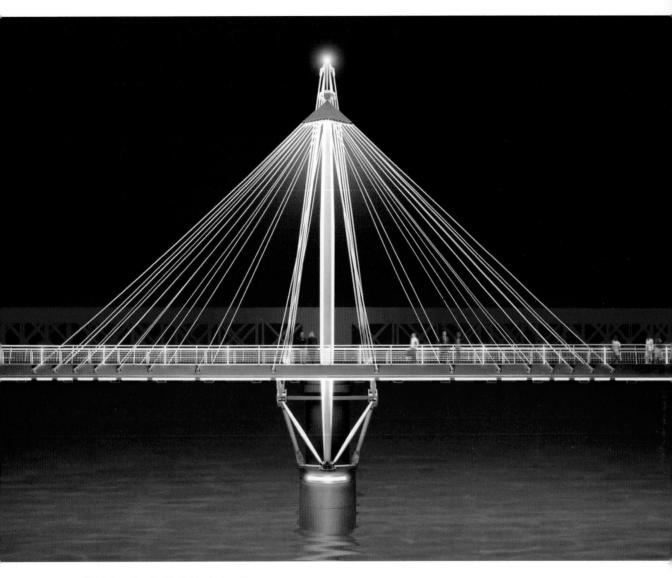

Night view showing the bridge's elevation

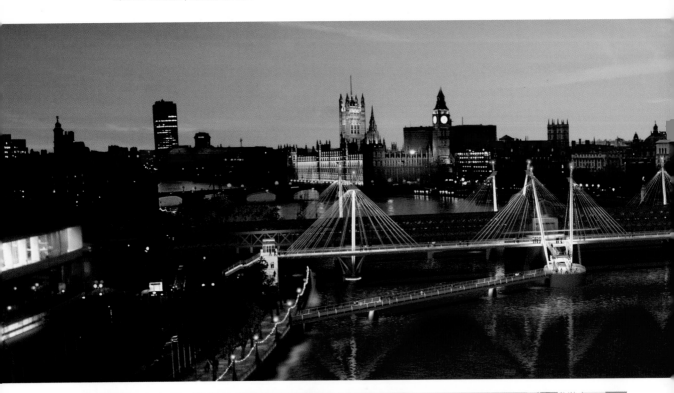

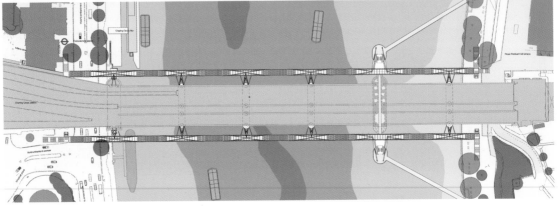

Top: Complete view of the bridge that unites the West End and the South Bank

Above: Plan of the proposal

Opposite: View of the bridge from the bank

connect the West End and Trafalgar Square with the South Bank, a cultural and leisure center.

The illumination project was carried out between 1997 and 1999, but, due to financial problems, the bridge was not finished until 2002. The proposal seeks to boldly illuminate the walkways while highlighting the views, thus creating a new landmark in London's night.

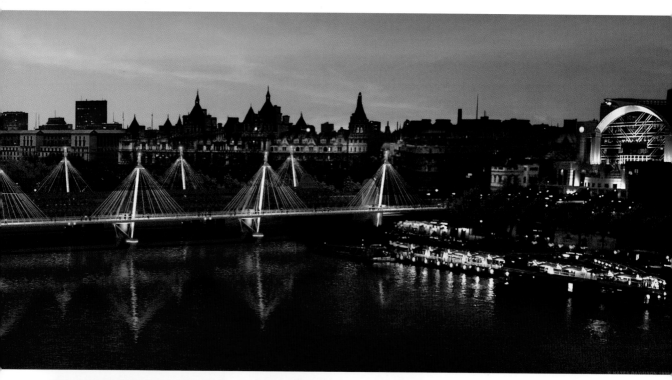

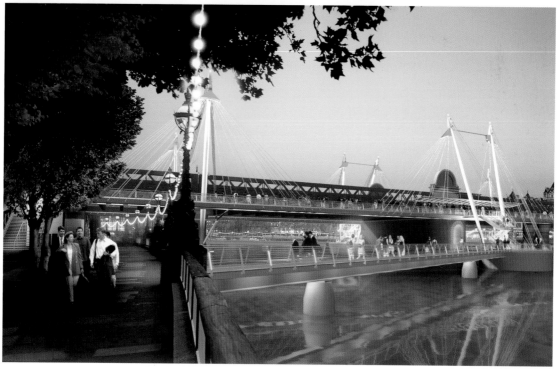

The gold of Saint Petersburg

Opera House Mariinsky II

DOMINIQUE PERRAULT

Saint Petersburg, Russia
Photographs: Dominique Perrault Architectes

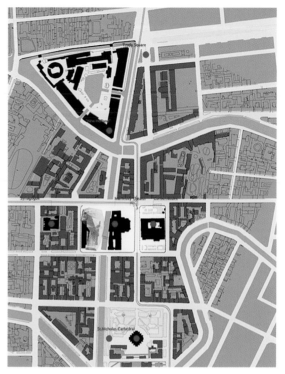

An international competition was held in 2003 for the new opera house in Saint Petersburg adjoining the historical Mariinsky Theater. The winning proposal includes a large opera hall with seating for 2,000 spectators, along with the necessary service installations, including dressing rooms, a scenery tower, rehearsal rooms, offices, and parking facilities.

In order to establish a connection with the city's traditional style, the design clads the new building in the same colors used in Saint Petersburg's golden domes. Between the enclosed surface and the interior volume of the opera house are public corridors where restaurants, stores, cafés, and other services are located. The interior

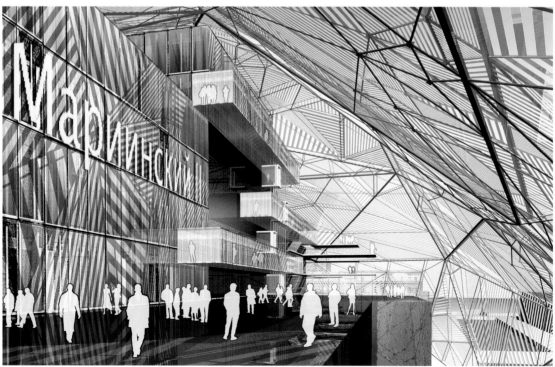

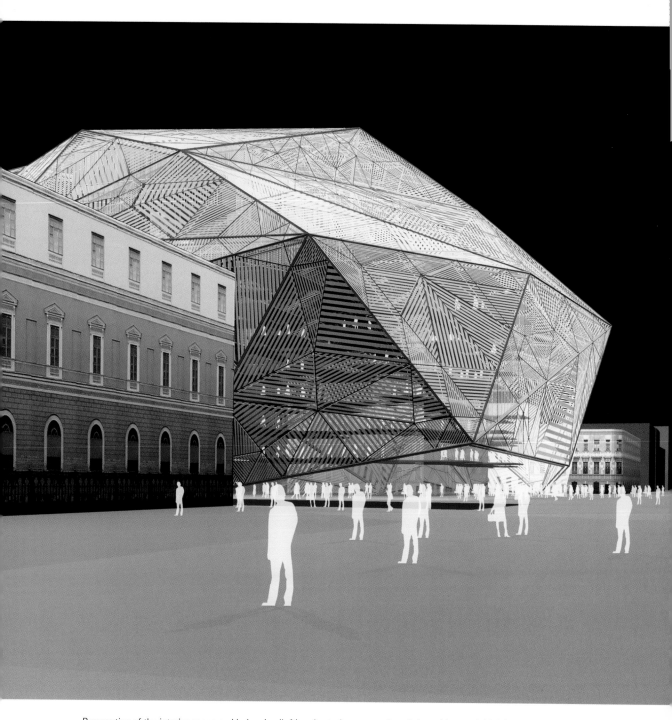

Perspective of the interior space and balconies (left) and exterior perspective of the golden mask (right)

Right: (top to bottom) Three perspectives of the
golden mask

Opposite: Elevations and sections of the building

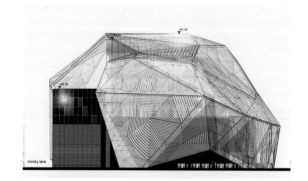

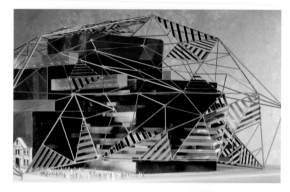

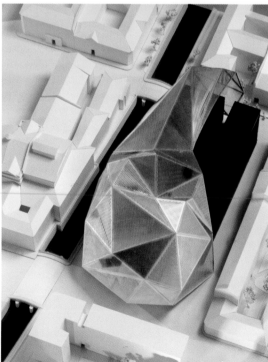

balconies give onto these corridors, visually connecting
the public areas with the theater's activities. Behind the
"golden mask" is the main opera hall, a unique dramatic
space in intense red and black. The surrounding service
spaces are arranged to maximize functionality. A tele-
scopic bridge over the Kryukov canal is planned that will
unite the new opera house to the historical Mariinsky
Theater by means of foyers shared by both buildings.

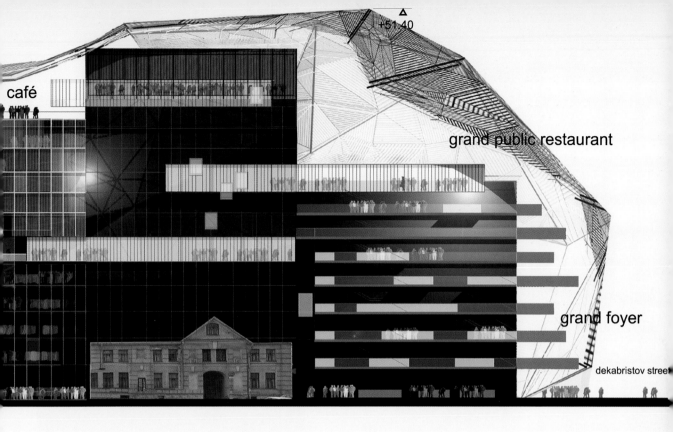

café

+51.40

grand public restaurant

grand foyer

dekabristov street

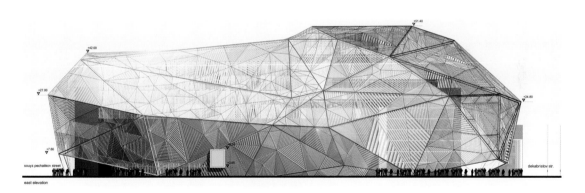

+51.40

+42.00

+27.00

+24.80

+7.60

souyz pechatikov street

dekabristov str.

east elevation

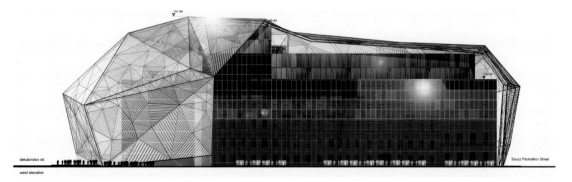

+51.40

dekabristov str.

Souyz Pechatikov Street

west elevation

The volcano in permanent exhibition

Shoji Ueda Museum of Photography

SHIN TAKAMATSU

Kishimoto-cho, Tottori, Japan
Photographs: Nacasa & Partners

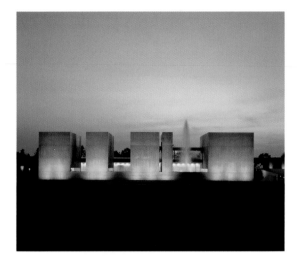

While Western architectural tradition resolves spaces either by use of strong geometrical elements or by a predominant, dynamic use of verticality, traditional Japanese architecture is characterized by a marked horizontality, irregularity, and non-geometrical spaces.

In this project, situated in front of the Daisen volcano and devoted to exhibiting the work of the photographer Shoji Ueda, Shin Takamatsu combines Western and traditional Japanese spatial options, providing an architectural logic derived from the natural environment in which the design is sited.

The museum presents a sequence of four volumes alternating with three spaces occupied only by sheets of water.

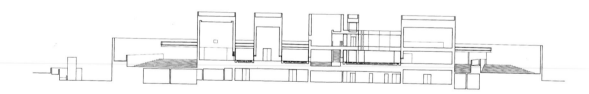

Above: Longitudinal section of the museum

Opposite top: Aerial view of the building, showing the four blocks alternating with four empty spaces, and the great curved wall that defines the building's limits

Opposite below: Façade facing Mount Daisen

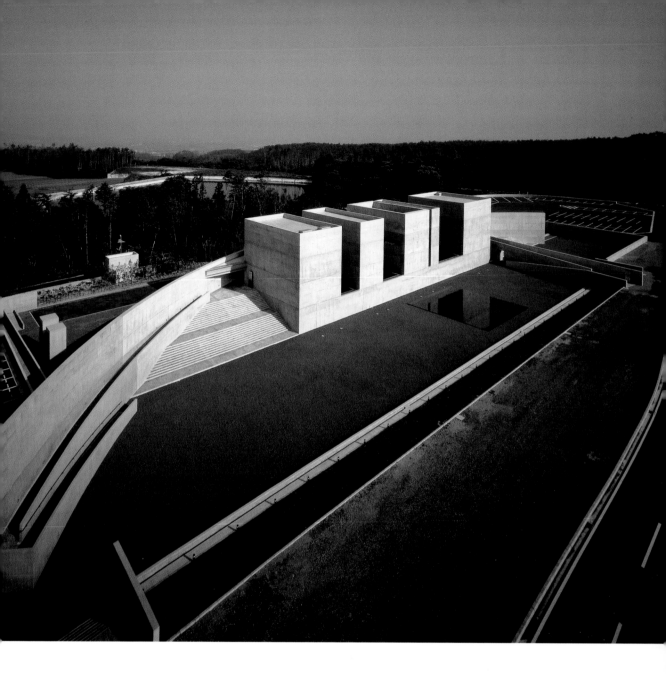

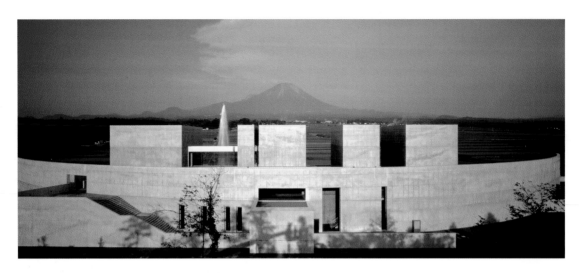

View of the façade facing away from Mount Daisen

The water reflects the landscape—with Mount Daisen and the volcano—in the manner of pure photography. A great curved wall contains the built-up space, which confronts Mount Daisen. Each of the blocks contains an exhibition area lit via vertical and horizontal incisions in the skin of the building; seen from inside, these incisions become framed pictures of the landscape outside.

Above: Lower, first, and second floors of the museum

Opposite: Aerial view of the museum, showing the use of concrete, gravel, and water

Opposite bottom: Façade facing away from Mount Daisen

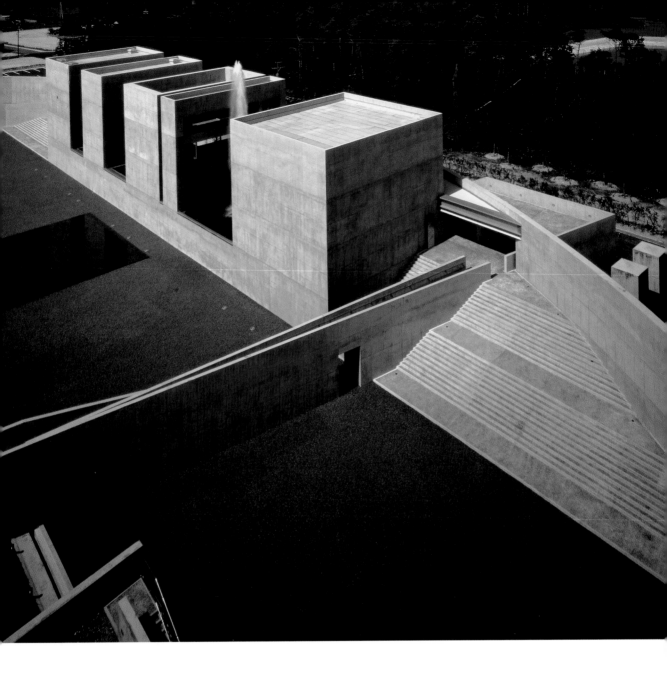

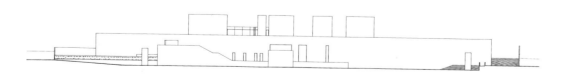

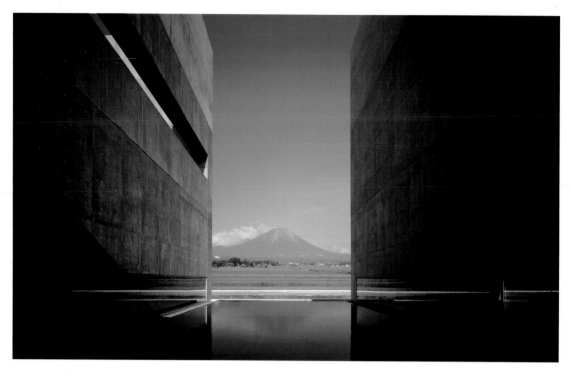

Above and below: Two images of the landscape framed by windows in the building

Opposite: Detail of one of the exhibition rooms, where photographs can be projected on ground level or exhibited on the walls above the windows

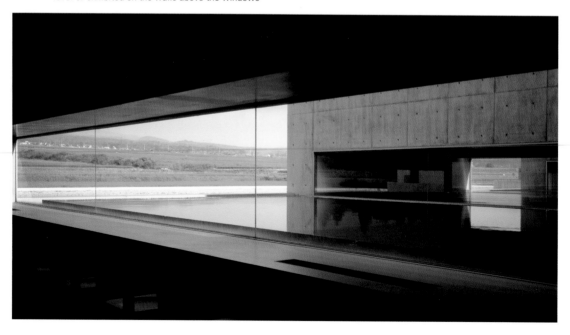

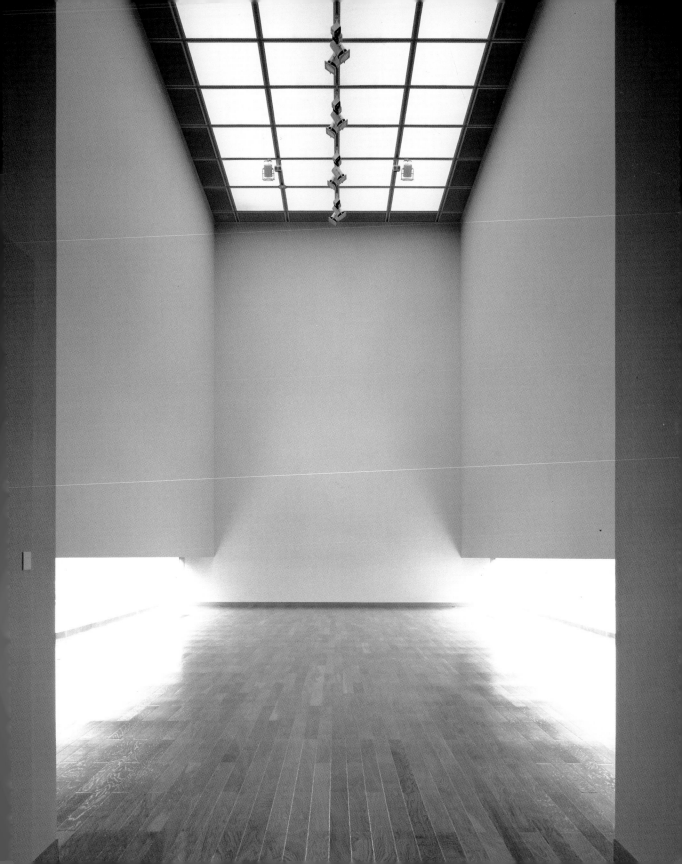

The smoothness of curves

Auditorium in Nagaoka

TOYO ITO

Nagaoka, Niigata, Japan
Photographs: Tomio Ohashi

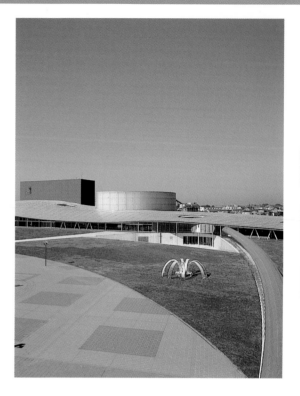

This project is situated on the outskirts of the Japanese city of Nagaoka, on the banks of the Shinano River with views of the Echigo Mountains. The building provides all-purpose rooms of a modest size that are very open to the public. There is a concert hall with a capacity for 700 people, a 450-seat theater, and studios of various sizes.

The building sits on an ample plot with a designed topography that organizes the parking areas in the west, while the public square in the south leads to a sloping lawn that functions as a prolongation of the roof. From the paths that follow the topography, one enters the building on the upper floor.

A tongue of earth dents the façade and sinks down, allowing light to enter the hall on the ground floor. The

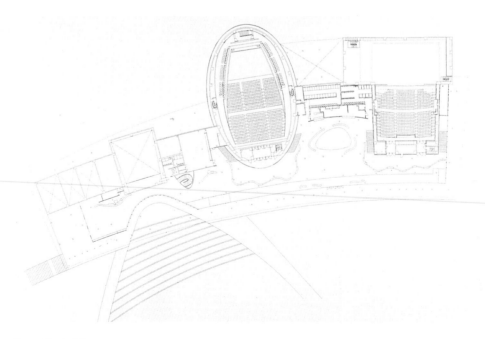

Floor of the building

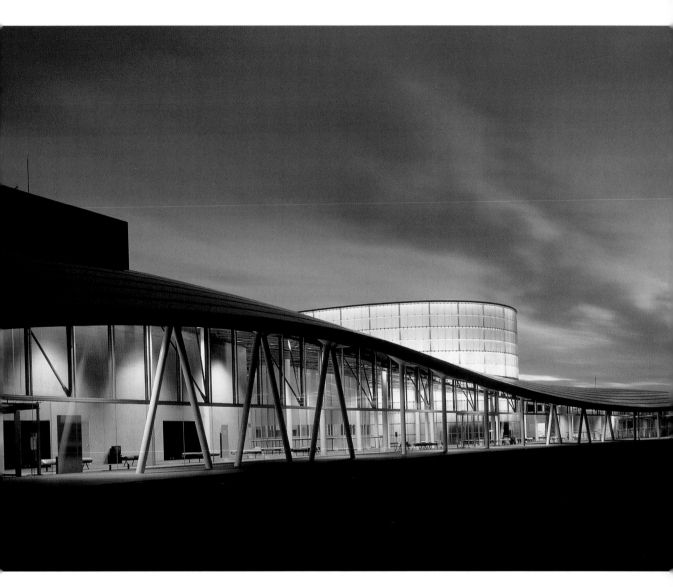

Night view of the building showing the effect of interior illumination on the architecture

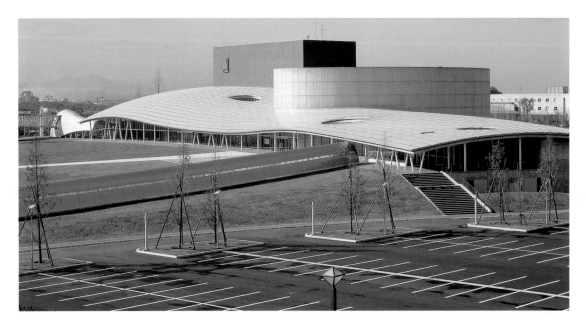

Western view of the building from the car park

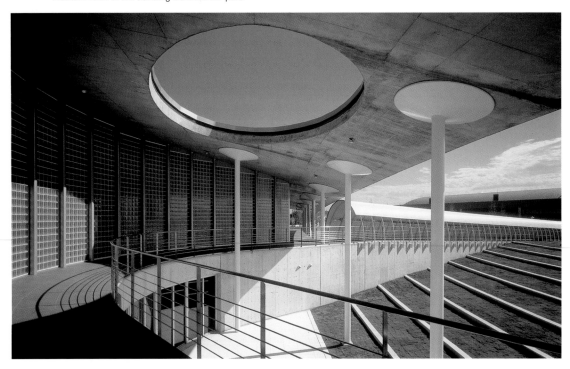

View of the corridor with exterior access and characteristic roof pillars

Opposite: Access staircase to the studios

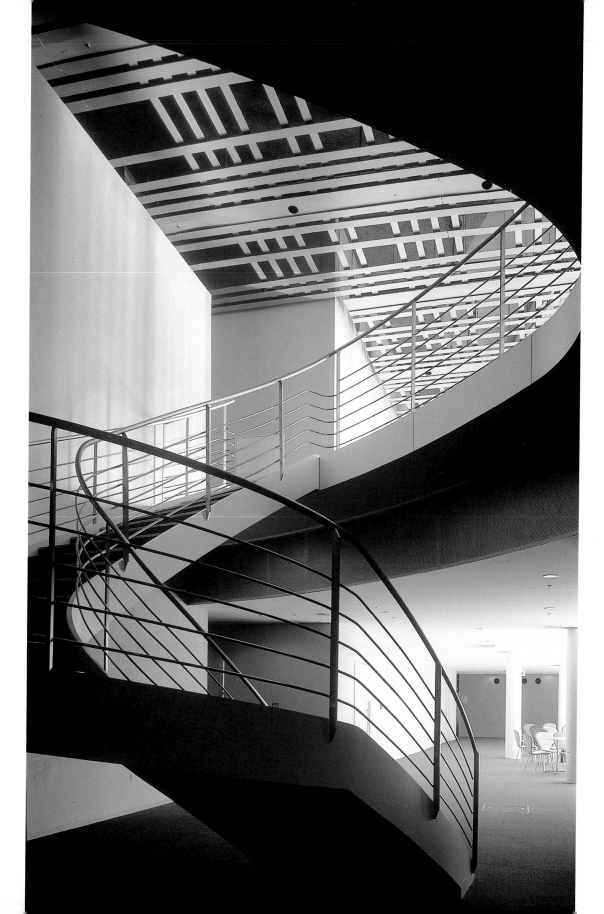

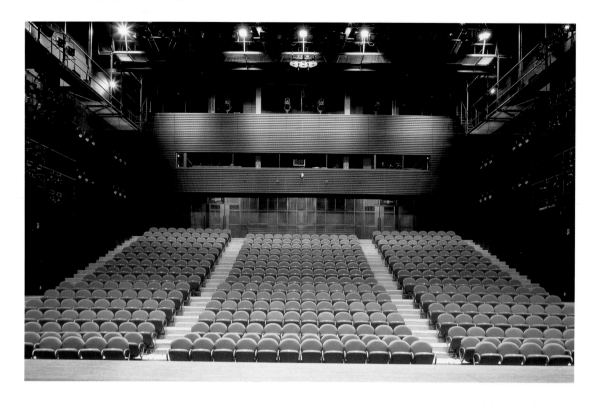

functional scheme follows the east-west longitudinal axis and situates the four main packages—theater, concert hall, studios, and administrative center—on the higher floor. A corridor with entrances to the different spaces widens as it comes into contact with them to serve as a foyer, landing, or cafeteria, for example. The roof curves with slabs of concrete that cover the entire building and that allow the large volumes of the theater and concert hall to protrude. Various oval voids in the roof let the light in at strategic points. The void between the two main rooms becomes a small glazed light well, creating dynamic inteplay with light according to the hour. The concert hall is covered with translucent polycarbonate panels that are illuminated from the interior converting the room into a recognizable symbol of the entire building.

On the ground floor, three functional packages are accommodated: the installations and other annexed services; services linked to the rooms illuminated through the ovoid light well; and a zone linked by a staircase with the higher floor where studios of various sizes are arranged around a hall that enjoys natural light.

Above: Interior of the theater and (right) cross section of the same

Opposite: Interior view of the hall

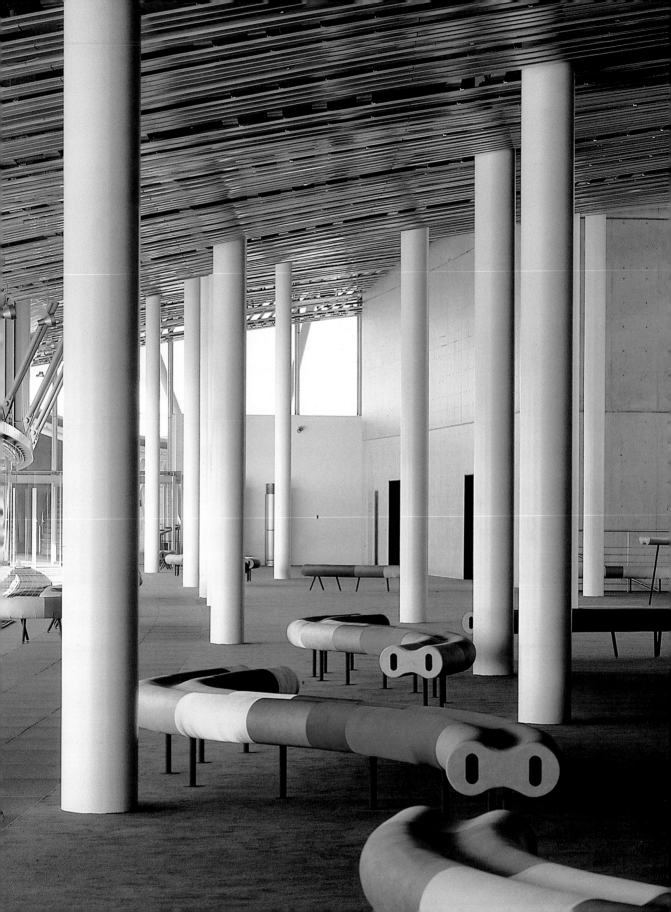

The eyelashes

Pointe à Pitre Airport

PAUL ANDREU

Guadalupe
Photographs: Paul Maurer

Architect Paul Andreu uses abstraction as a mode of exploration in creating a project in which the recurrent theme is light.

In this project, carried out one year before Terminal B at Bordeaux, the departure hall is a large space without pillars and with minor structures for services such as shops or bars. The perimeter is treated with vertical metal pillars, serving as brise-soleils, which permit the entry of light, framing the floor in a play of lights and shadows.

The enlargement of the airport opposite the existing runway is a response to the growth in air traffic as well as the nearby urban areas.

Formally, the terminal consists of a compact rectangular

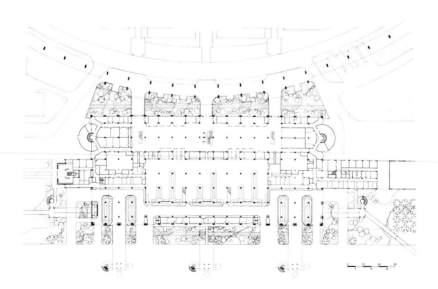

Ground-plan of the airport

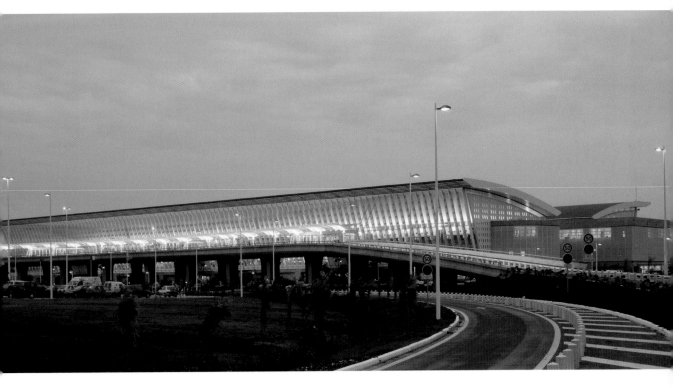

Above: View of the entrance to the terminal from the traffic access, which connects directly with the arrival and departure lounges
Below: View of the terminal showing the leaning façade and the bridge giving access to the aircraft

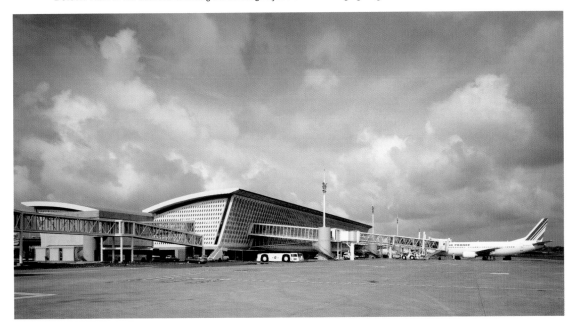

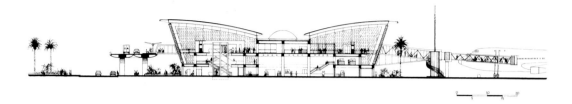

Top: Section of the design showing the two halls separated by a central spine

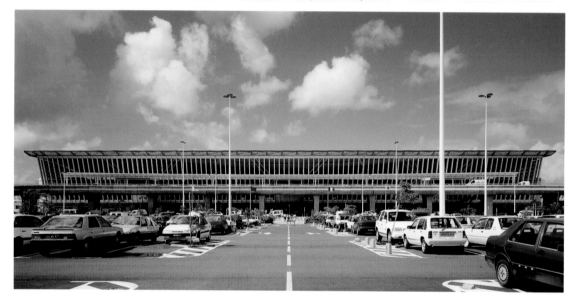

Above: View of the entrance façade from the adjacent parking lot

block, symmetrical in plan and in section. Functionally, it is divided into two levels of circulation: the arrival hall with pedestrian access from the parking lot; and, above, the departure lounge connected to a bridge giving access to the aircraft. An intermediate service level opens on to the ground floor. On the upper level, the curved roof generates two large lounges at each end of the longitudinal axes. Free from structural elements and installations, the lounges resemble floating plates, an idea reinforced by the use of indirect lighting. The service block runs alongside the building from end to end, separating the two passenger lounges like a spine that carries all the supply installations.

The façade contributes transparency to the complex. The north and south façades consist of an outward leaning glass sheet, 18 meters (59 feet) high, topped with the curved roof, which projects beyond the façades.

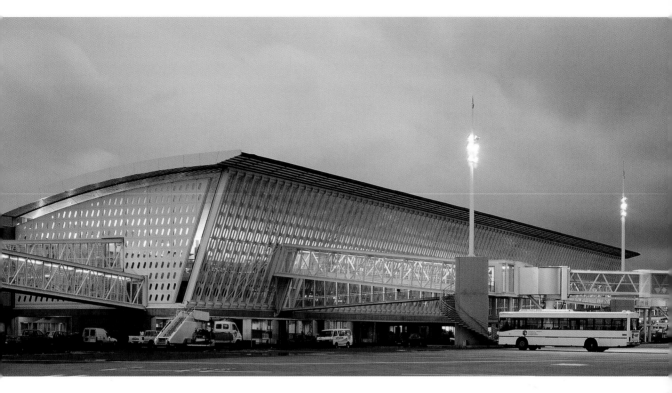

The airport lit up at night

Overall evening view of the terminal from the runway

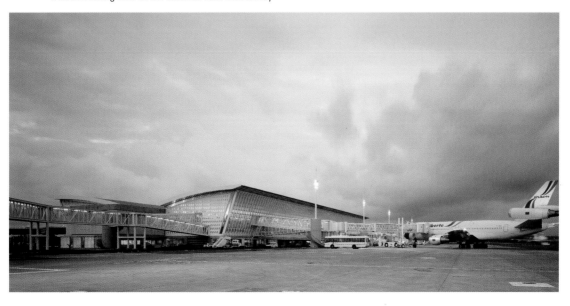

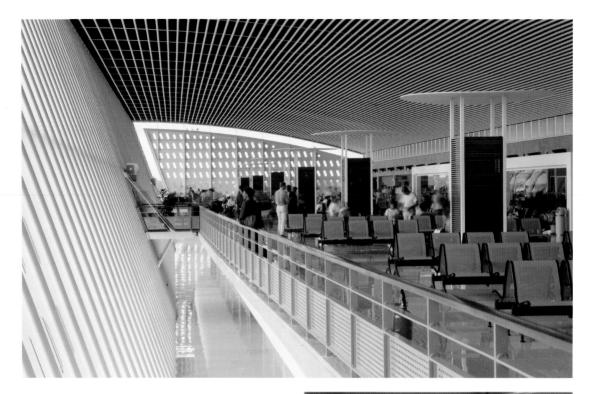

Above: First-floor lounge with the leaning façade and the building framework stopping short of it

Right: The interiors of the central axis along which the installations are located

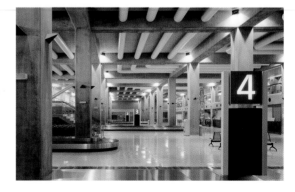

Opposite: Luminous effects of light passing through the perforated panels of the banisters and cast on to the floor of the terminal

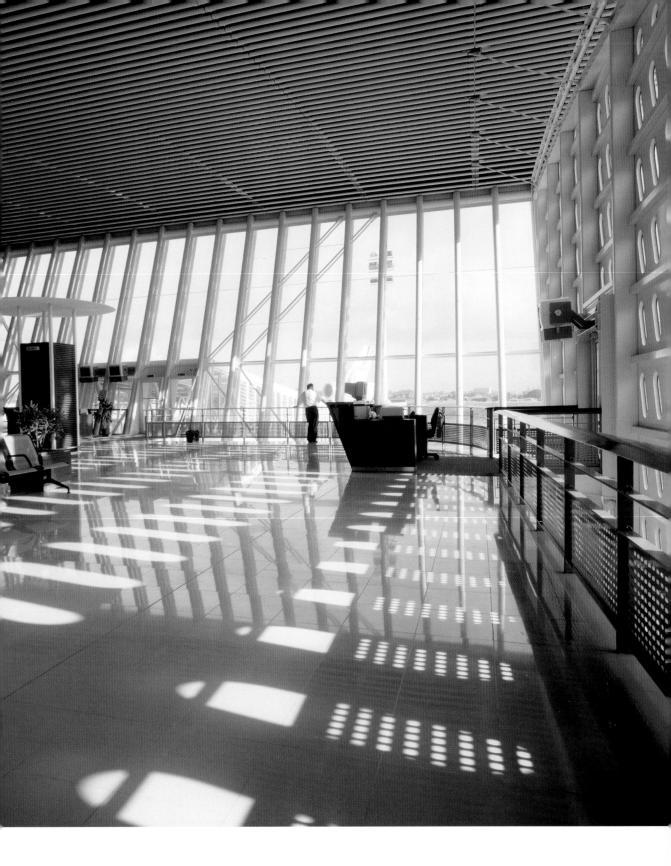

The biggest picture in the world

The Picture-Window House

SHIGERU BAN ARCHITECTS

Shizuoka, Japan

This house consists of a completely rectangular plan, which stands on a high hill of the Izu Peninsula, in a place "free from all distractions," as the architect describes it. One enters the house after climbing a hundred meters (328 feet) up the hill in a northward direction. The design of the house, and the materials and techniques employed to build it, permit the landscape to flow through it. Thus the shallow depth of the house together with the great horizontal, fully transparent window 20 meters (65 feet) wide on the ground floor, adds a transitional, roofed space to the landscape itself. From the interior, the landscape is turned into a picture of exceptional beauty.

Above: Roof story of the house

Opposite: The kitchen-dining-living area, showing spectacular views to both sides

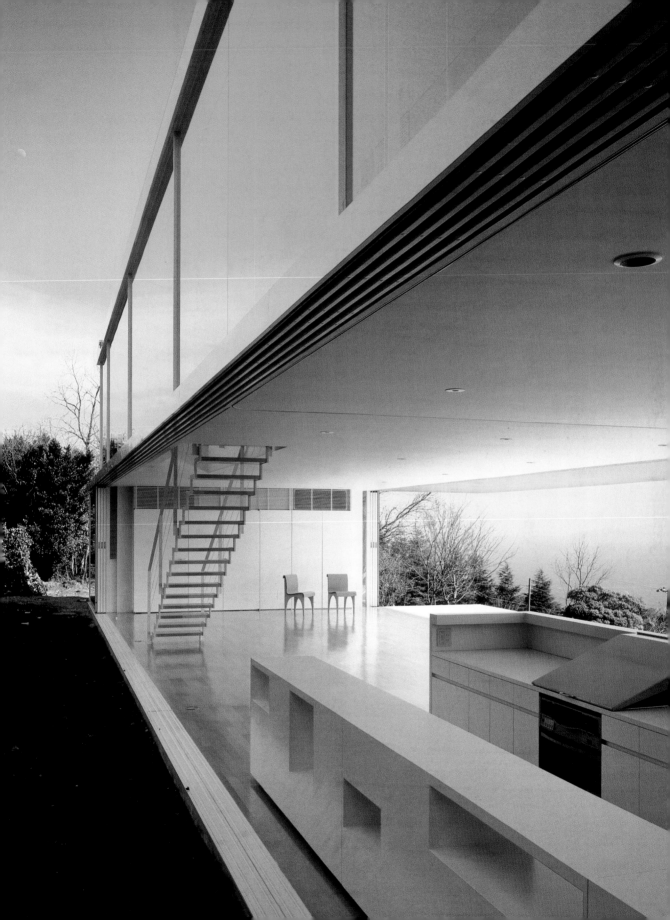

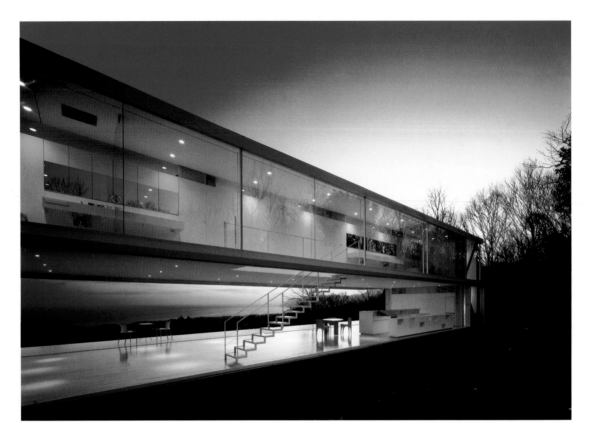

A covered space in the midst of nature

Below: Ground floor of the house

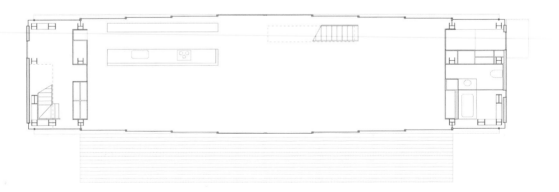

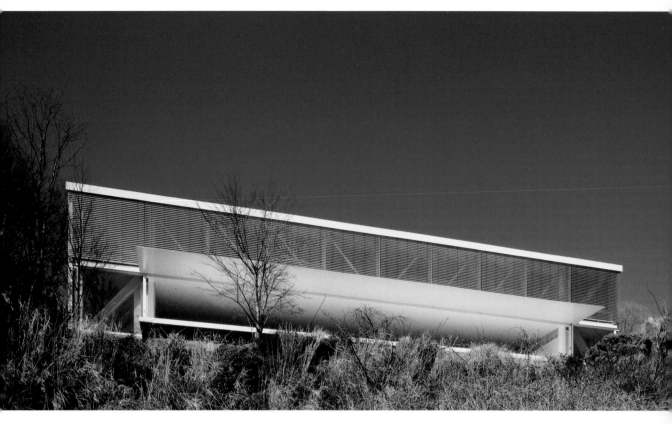

South façade facing the ocean, with the girder glimpsed behind the solar panels

Below: First floor of the house

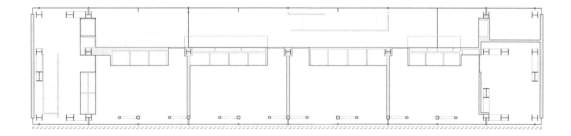

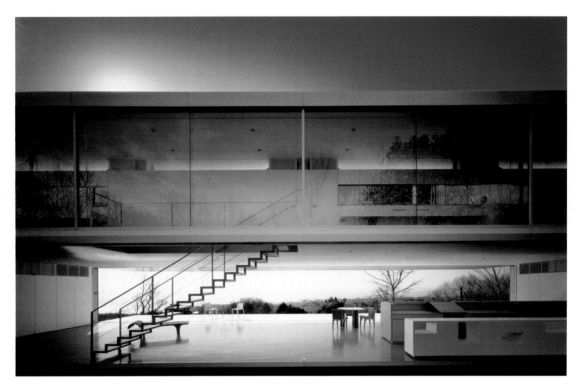

View of the house from the mountain

Functionally, the layout is distributed on two levels. On the ground floor is the entrance, made through a two-story-high space; the floor contains a small bathroom, a studio connected to the upper floor by a secondary staircase, and a single space combining the kitchen-dining-living area, linked to the upper floor by a light staircase that does not impede the views outside. On the first floor there are four bedrooms, a corridor-bathroom, and, at the ends, the dressing room and a studio. Structurally the house functions like a large porch, with two girders placed one on the south façade and clad with solar panels, and the other in the wall separating the bedrooms from the corridor-bathroom. This enables the north façade to be contructed entirely of glass. The girders rest on triangulated supports that rise from the ground to the upper floor. The prefabricated materials of which the house is built allow the architectural elements to be as light as possible, thus ensuring a lesser visual impact on the environment and a perfect integration of building and site.

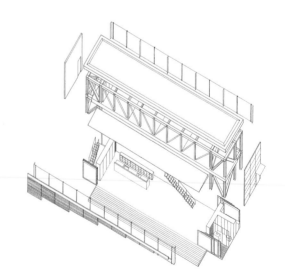

Above: Axonometry of the building

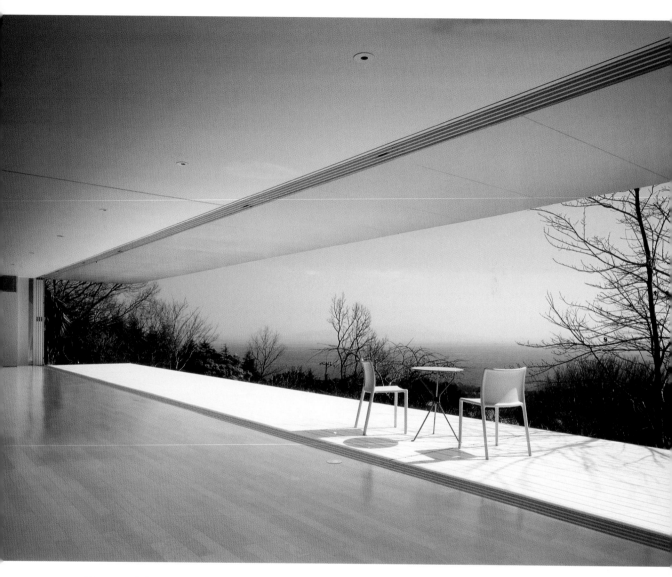

The great window

Nouvel as a tower in water

Torre Agbar

JEAN NOUVEL

Barcelona, Spain
Photographs: Jean Nouvel Architectes, Oscar García

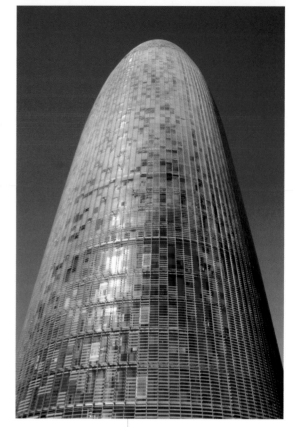

With its 145 meters (475 feet) of height and 30 floors, the new headquarters of Aigües de Barcelona (Barcelona's water company) has become the tallest skyscraper in the city. The building rises as a singular volume, in an apparently quiet city, like a geyser that seems to have perforated the ground, maintaining its fluid mass permanently under pressure. Its surface has a smooth continuous texture that vibrates and in places becomes transparent; its colored glass evokes water. In a formal sense, it suggests a certain similarity to the mysterious Catalan mountains at Montserrat or the Sagrada Familia by Gaudí.

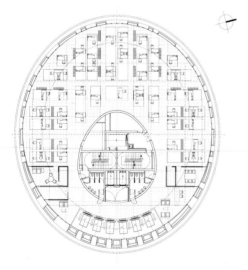

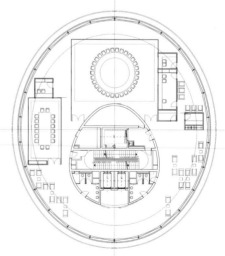

Above: Plans of the tower

Opposite: Perspective of the tower

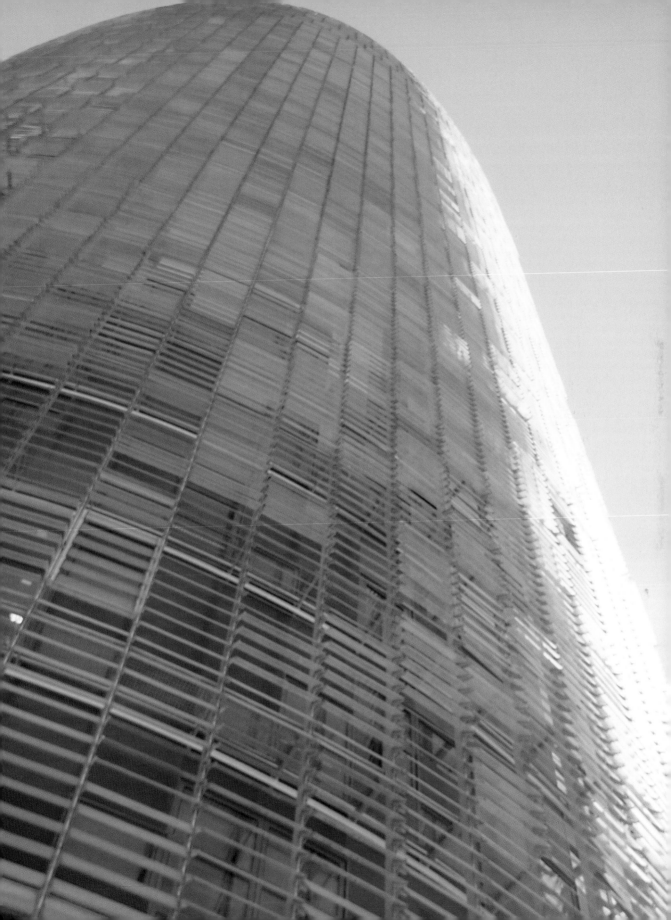

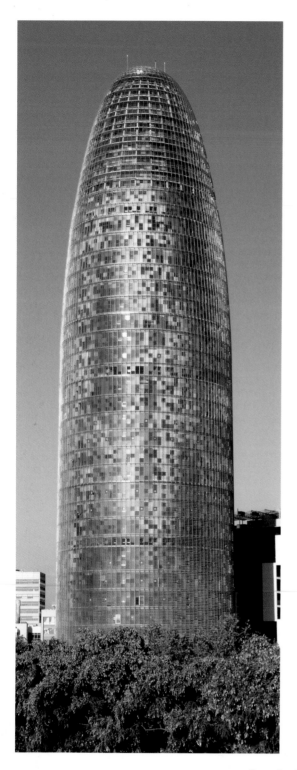

Left: Frontal view of the tower, with the park at its feet, and (bottom right) section of the same

Below: Plan of the tower's setting, with the park around it

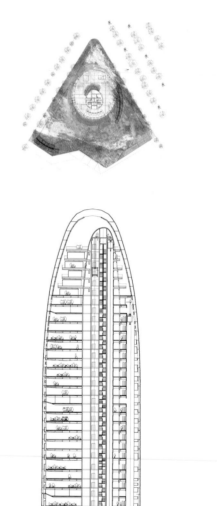

Opposite: Detail of the double layer of skin constituting the façade

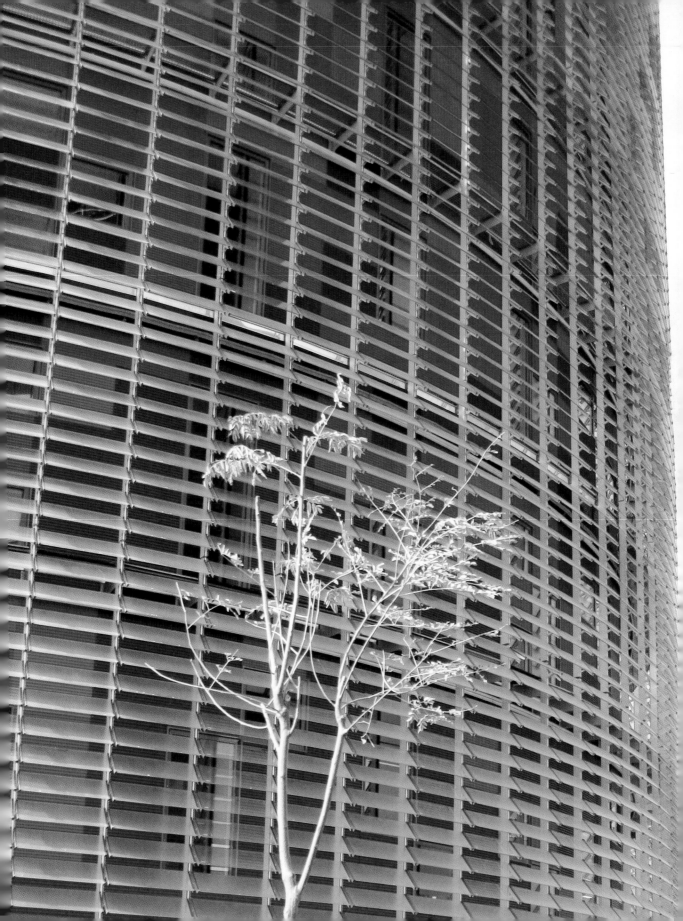

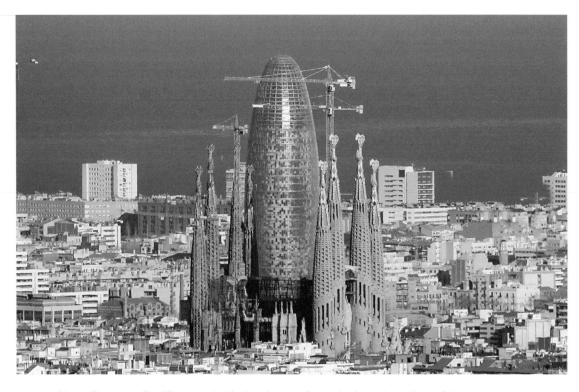

Above: The new profile of Barcelona. In this view, the tower is perceived as an integral part of the Sagrada Familia church.

The Barcelona skyline is now dominated by a new land-mark in its entrance to the Avenue Diagonal in Plaça de les Glòries. A sign visible from any place in the city, it displays its play on light, shade, color, and transparencies within its very own skin and geometry from a distance. This lumi-nous tower is composed of two superimposed cylinders covered with a glass skin that reflects light and creates a dynamic chromatic effect. Thousands of small windows in an asymmetric distribution resemble a mosaic of scales. Illuminated by a system of different colored lights at night, this luminous surface is the building's primary archi-tectural element.

Above: Distribution of the windows on the tower's surface

Opposite: Detail of the intersection, at ground-floor level, of the tower and the outside pergola

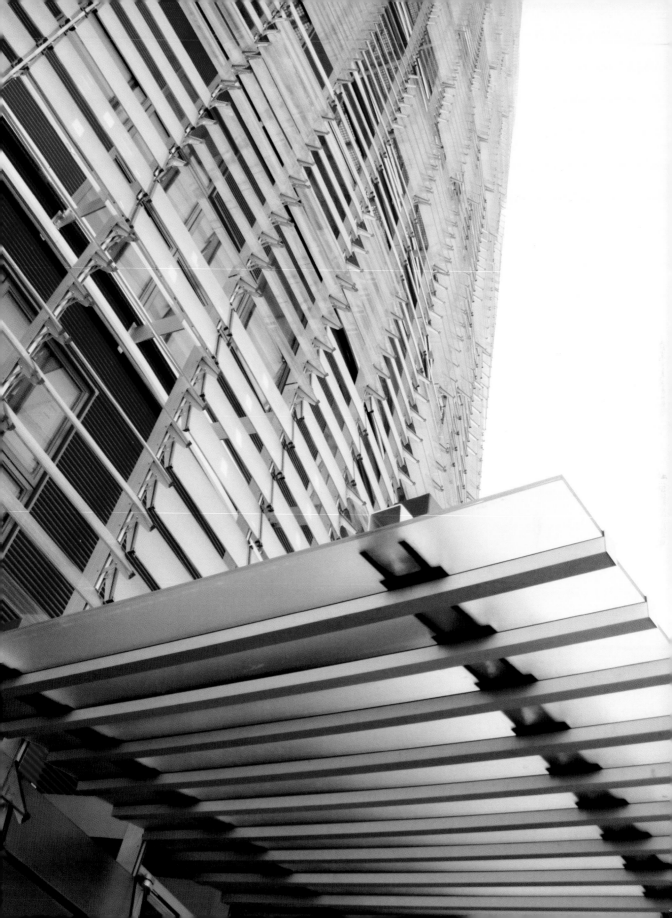

Top: Detail of the glass panes forming the exterior skin of the building

Above: View inside the tower, with its special windows illuminating the interior

Opposite: The attic with its triple dome

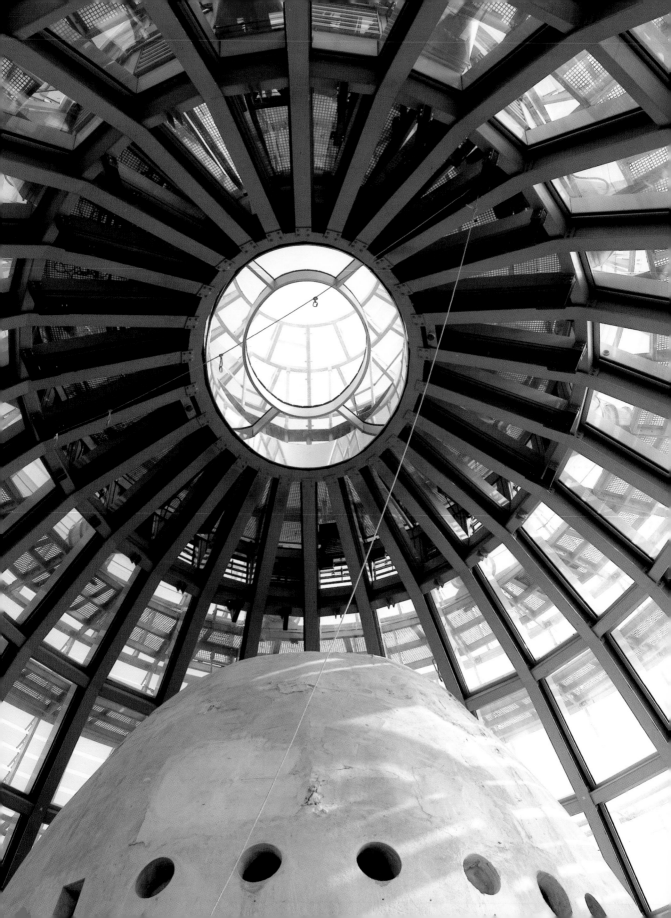

The Ottoman Empire in Japan

Kashiwasaki Turkish Village

KAJIMA DESIGN

Kashiwasaki, Japan
Photograph: Hiroshi Tsujitami

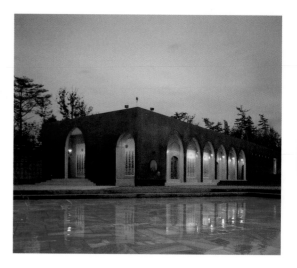

This project aims at reflecting the mental image of Ottoman culture that existed in Japan, rather than being a literal reproduction of fifteenth- and sixteenth-century architecture outside its proper context. In the words of its creators, the project "sets out to be a creation of that abstraction, the essence of a metaphor that enables the visitor to interpret his experience of the place in accordance with his individual memory, the images he has been learning throughout his life, his deductive knowledge, and his own fancy." The idea is to refer by means of built spaces to what is known only through photographs, going beyond the known conventions of pointed arches, tiles, or phrases from the Koran written on walls of the park.

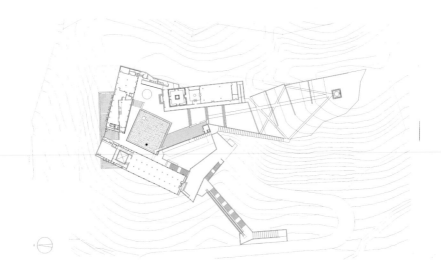

Above: Ground plan of the village

Opposite: View of the central atrium

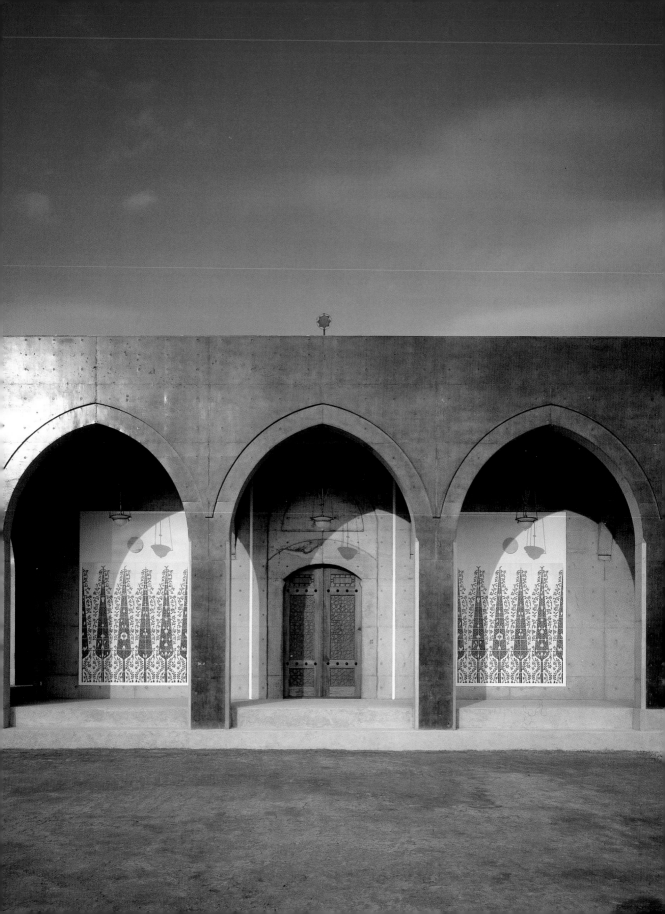

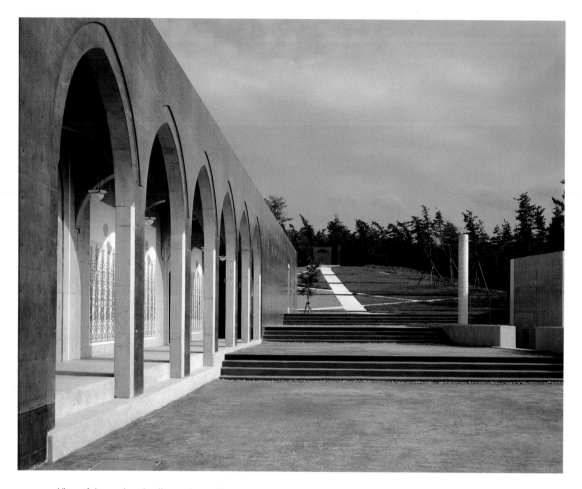

View of the gardens leading to the pavilion

Below: Detail of the gardens

Opposite: Entrance to the bazaar

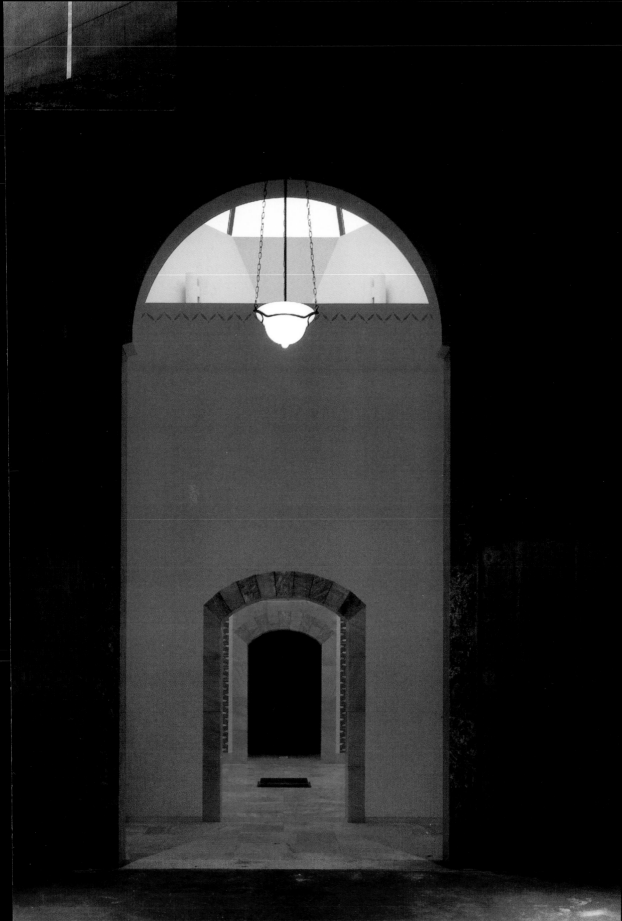

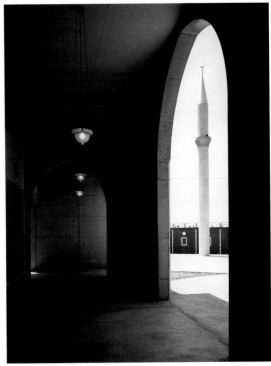

Different views (clockwise) of the bazaar, with Koranic inscriptions on the walls

Opposite: The porticoed space of the bazaar

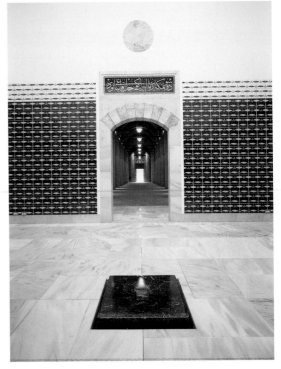

The buildings in the Turkish Village are linear, and each of them is in rotation with respect to the one before, inscribing a route that culminates in a completed circle. The central space is a closed, square area, dominated by the minaret, the only vertical element in the village.

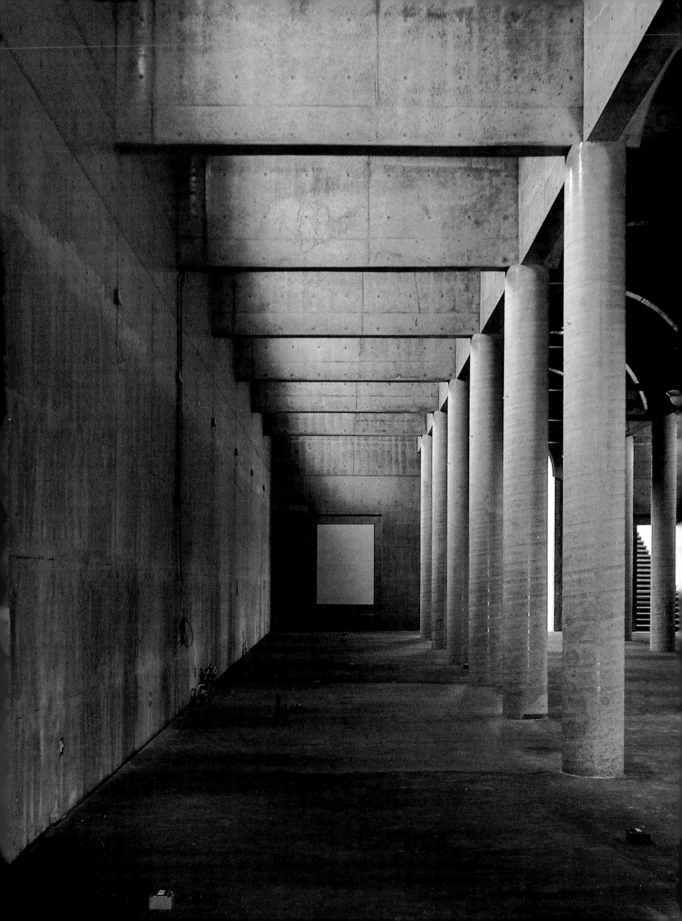

An organic household appliance

Living Tomorrow

BEN VAN BERKEL

Amsterdam South-Axis, Holland

This exhibition hall is proposed as an ideal model for the future, housing a pavilion for the exhibition of products and prototypes and two temporary exhibitions, "The house of the future," and "The office of the future"; these give the opportunity to travel in time, enjoying technological advances that will soon become part of our lives.

The building is presented as a great machine that is a product of the most advanced technology. Exhibiting an organic shape generated by the rotation of irregular curves around an axis, it is transformed into a continuous spatial mesh, with organic and almost anthropomorphic references. The way in is through the discontinuity of the fluid shapes. Inside, the curves are broken to reveal inde-pendent service spaces, such as the reception area, the staircase hall, and the access to elevators and the exhibition hall devoted to innovative products developed by brands such as HP, Microsoft, Telfort, Philips, or Unilever. The "green" building aims toward an ideal of eco-sustainability; characteristic of societies influenced by globalization; thus, the building includes solar panels, systems for collecting water and temperature control, and uses recyclable materials in its construction.

Above: Site plan of "Living Tomorrow"

Opposite: The building at evening

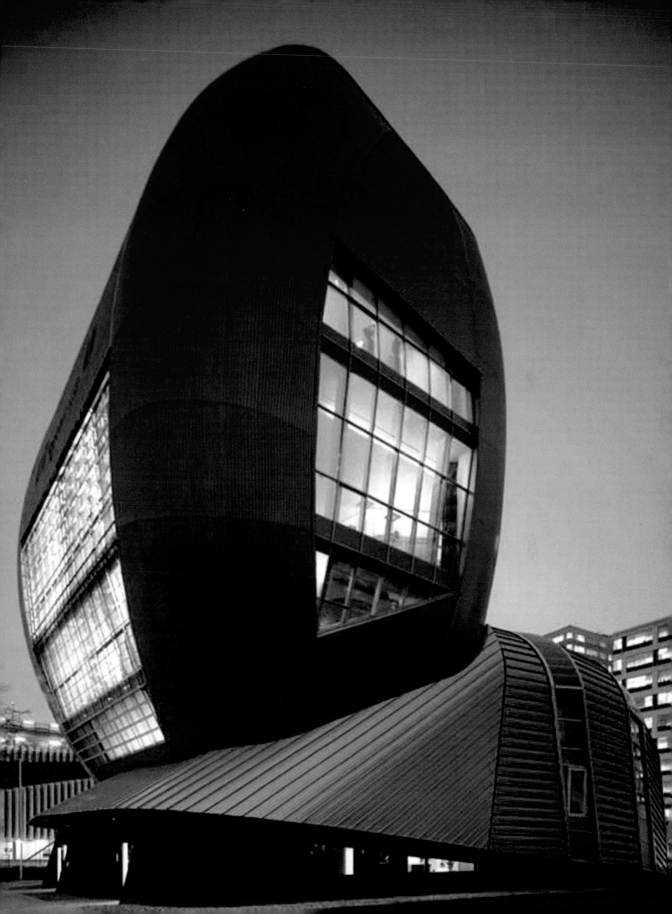

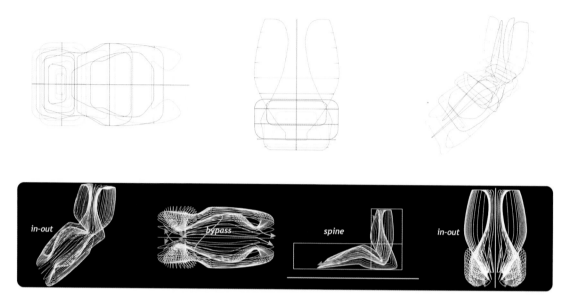

Top: Three-dimensional studies of the building

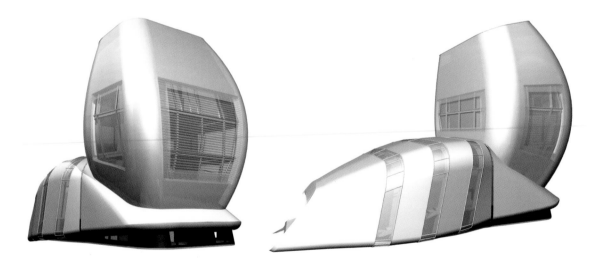

Above: Volumetric renderings of the building

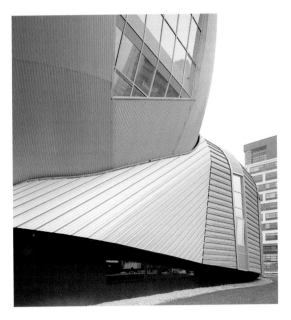

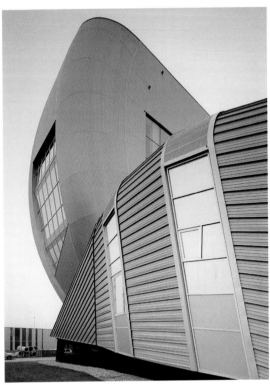

Top: (left and right) Two views of the pavilion showing its delicate curves

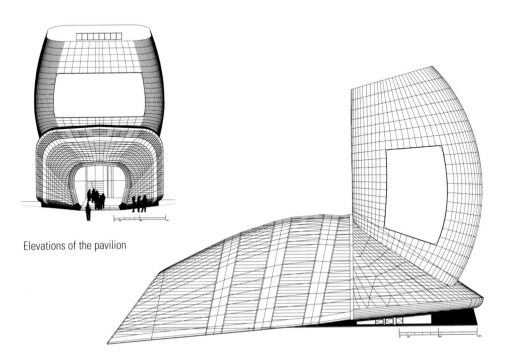

Elevations of the pavilion

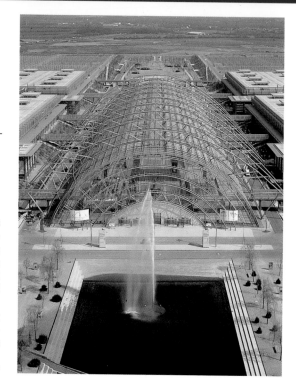

Leipzig goes to the fair

New Trade Fair

**VON GERKAN,
MARG & PARTNER**
Messealle 1, Leipzig, Germany
Photographs: Busam/Richter Architekturphoto

The long tradition of holding trade fairs at Leipzig is reflected in a proposal intended to reinvigorate the former Democratic Republic following reunification as a host city. Currently this trade fair has succeeded in becoming one of the most important meeting places and sites for commercial exchange between Eastern and Western Europe.

This project is situated on the northern outskirts of the city and is well connected to the city center and the airport. In addition to its traditional spaces, the fair includes spaces for holding conferences and meetings.

The solution proposed by Von Gerkan, Marg & Partner

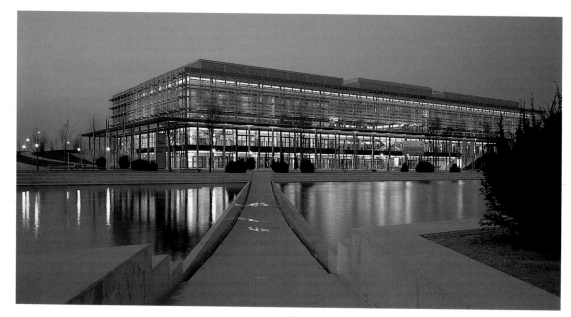

Above: View of the conference center overlooking an artificial lake

Opposite: East entrance to the hall

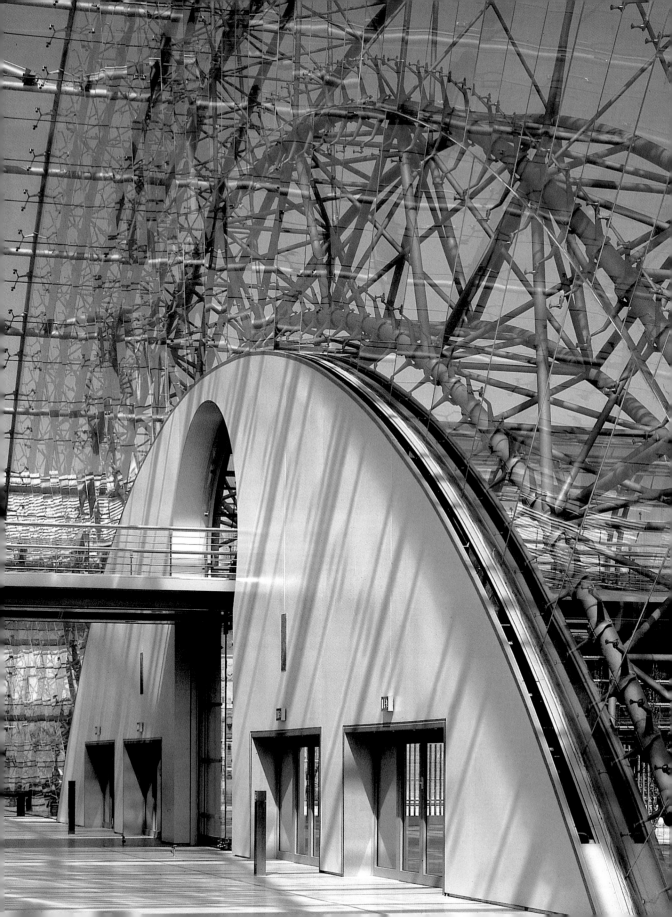

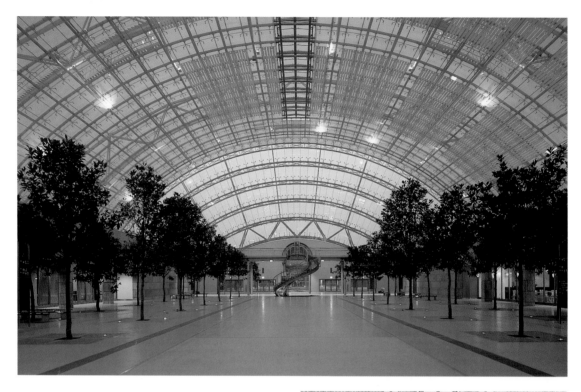

Above: Interior view of the hall

Opposite: View of the west entry to the fair

Opposite bottom: Cross section of the hall

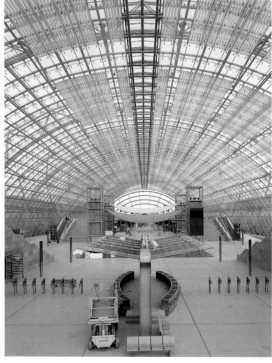

won the competition announced in 1991 that was restricted to a total of fourteen teams from around the world. In collaboration with the landscapers Wehber, Eppinger and Schmidtke, the architects argue for a dense urbanistic context in which a linear structure is articulated around a main exhibition hall and circulation is distributed on two different levels. While the level below ground is dedicated to the arrival and distribution of the visitors below the vaulted center, the higher level accommodates the exhibition and meeting spaces. The stair cases by which the galleries are accessed and some glazed walkways are finished in a stone texture.

The hall, of about 250 by 80 meters (820 by 262 feet) in dimensions, is the largest of its type ever constructed.

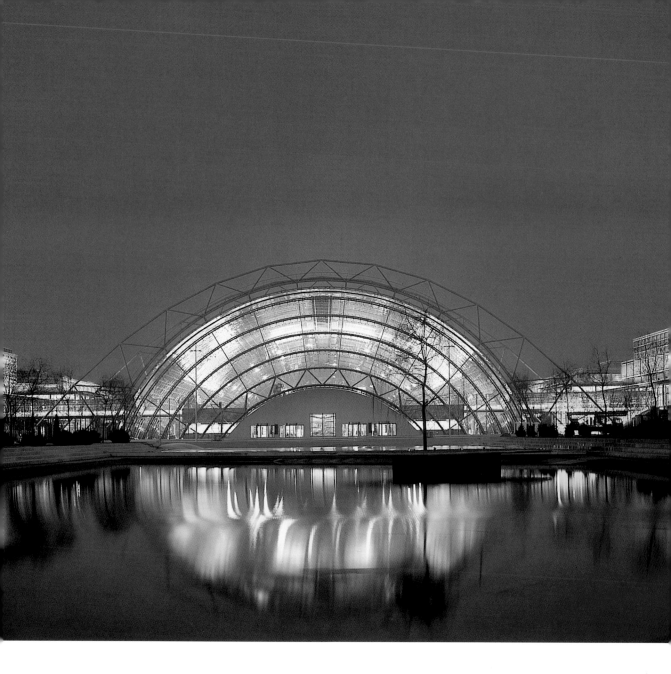

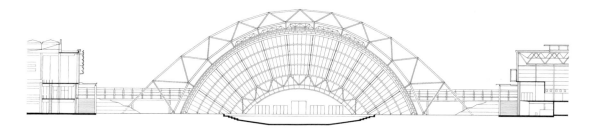

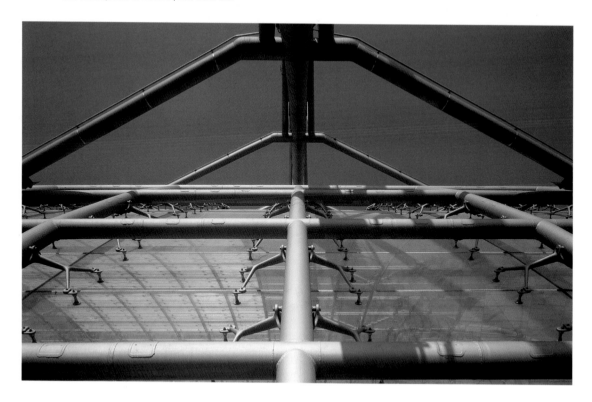

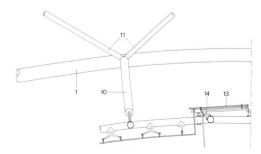

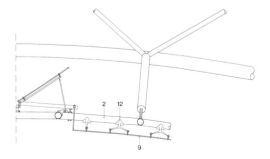

The glass is supported by an exterior parabolic mesh, which in turn is suspended from another metal structure. The glass plates are sealed with silicone making them clear and transparent. The structure has been completely organized around a 1.25-meter (4 foot) module so that it is more human in scale. The excess solar radiation is controlled partly by the exterior structure itself. In the more critical vaulted zone, protective ceramic plaques have been fitted. Other practical plaques run along the lower section and facilitate the natural ventilation of the central hall. In the administration and conference spaces, which connect to the main hall, glazed façades with an exterior protective coating of plaques are in place.

Above: Details showing anchorage of glass to the structure

Opposite: Detailed view of the entrance structure

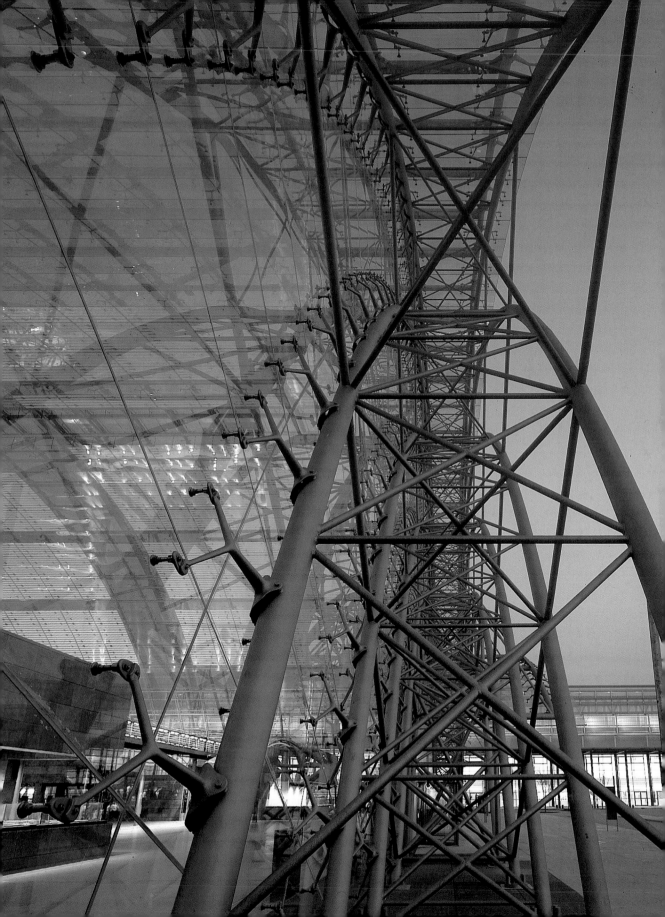

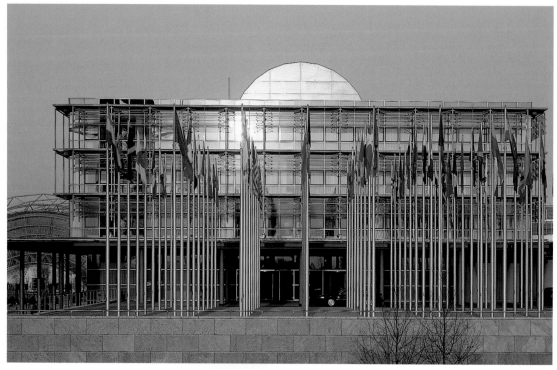

Above: Administration building with main hall in the background

Left: Corridor between the main hall and the conference center

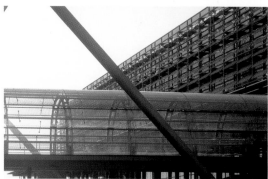

Below: Second and fourth floors of the administration building

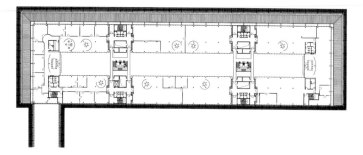

Opposite: Night view of the conference center building showing the façade with plaques

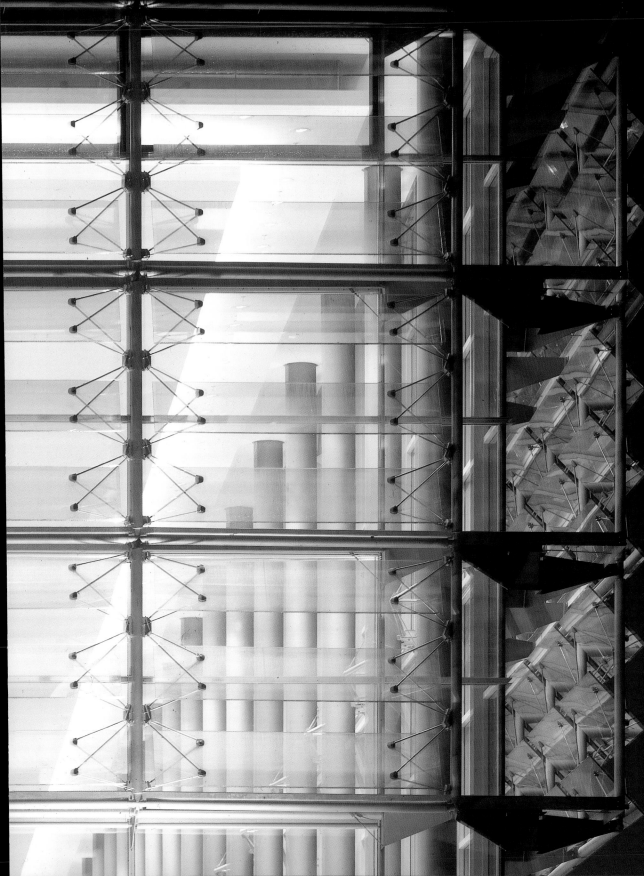

Opening Pandora's box

The Box

ERIC OWEN MOSS

Culver City, California, USA
Photographs: Tom Bonner

As in all of Eric Owen Moss's projects, which are difficult to understand without visiting them, The Box presents a series of geometric challenges that intend to create sensations rather than construct spaces. Concerned with how the senses perceive space, the architect experiments with a sequence of images that must be reconstructed by the spectator. In spite of their peculiar appearance, these spaces are constructed from very few materials and are highly finished. Their purity comes from their expressiveness, from their fluid forms that imply movement and are full of spatial enigmas.

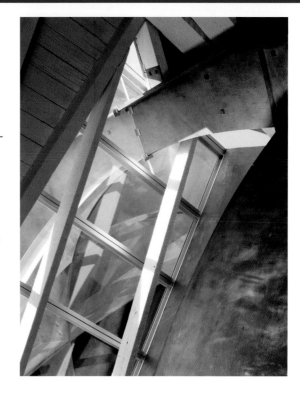

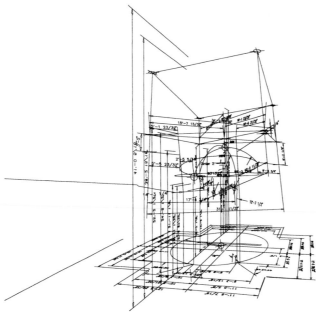

Above: Original sketch of the project

Opposite: Exterior perspective of "the box"

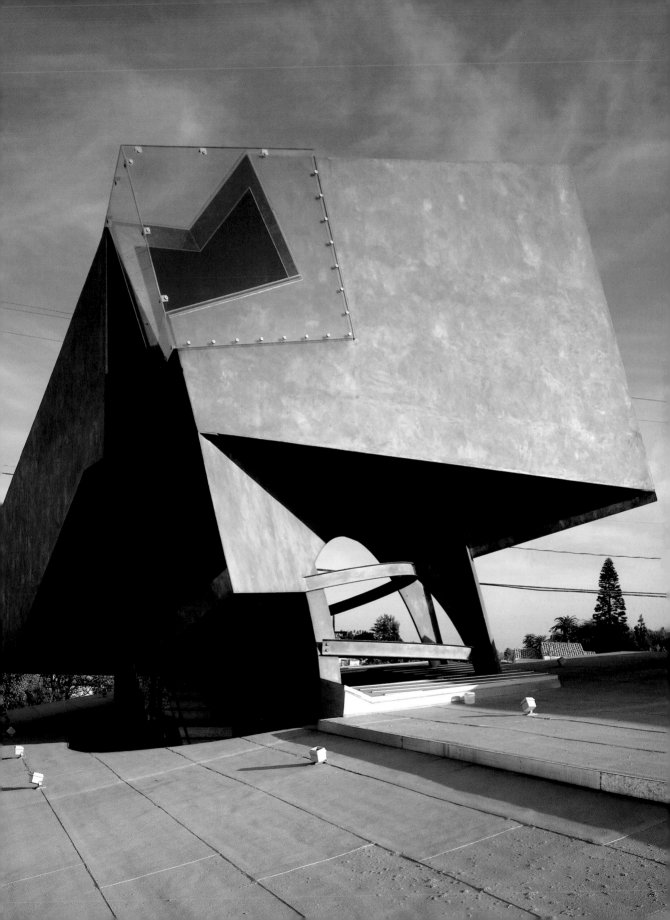

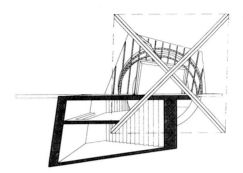

Right: Floor under the original wooden roof

Below: Detail of the glass corner

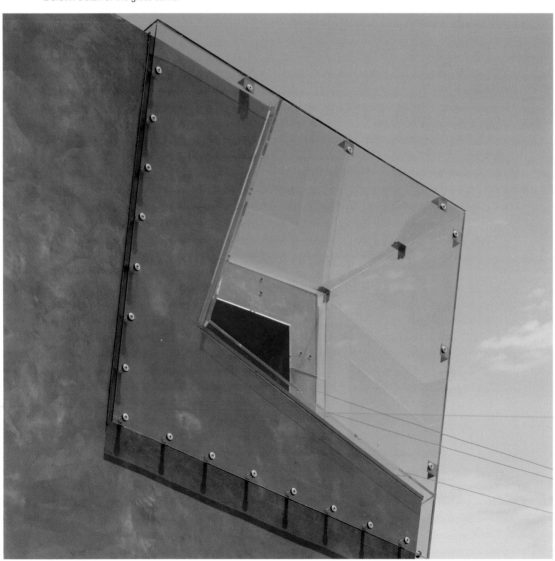

View of the box penetrating the original building

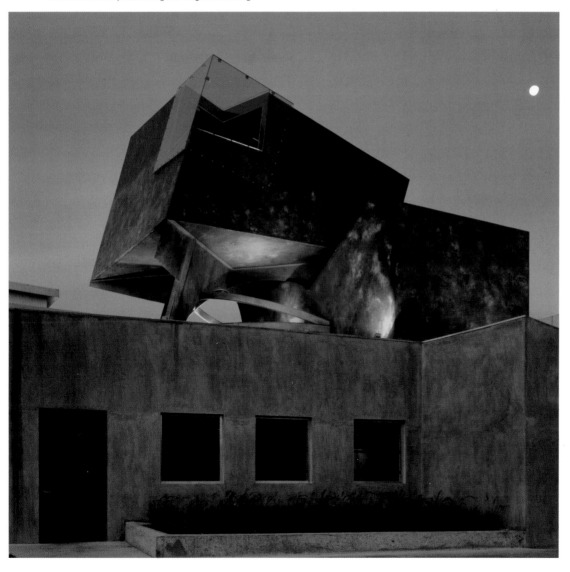

Right: Intersection of the reception cylinder with interior of the box

Below: Effect of the glass corner on the conference hall

Opposite: Staircase leading to the upper floor, with glass corner in the background

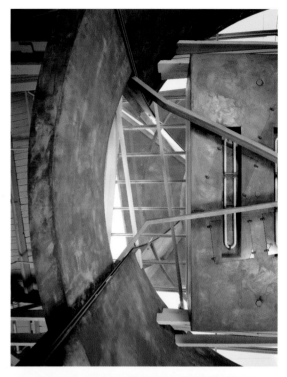

The project is situated in an old industrial building. The original roof has been refurbished. The floor plan is rectangular, as in the original, and the structure is based on wooden trusses with central pillar support. The size of "the box" is quite small and the functional design is laid out in three parts. First, there is a reception area that is almost cylindrical and that slices through the roof of the industrial building. In the back of this area is an exterior staircase that leads to the second level, supported by the existing structure and suspended over the cylinder. "The box" itself is a private space for conferences, superimposed on the exterior staircase with views of Century City to the west and Los Angeles to the east. The original box

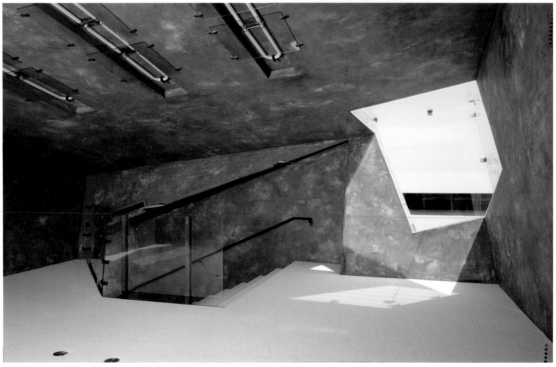

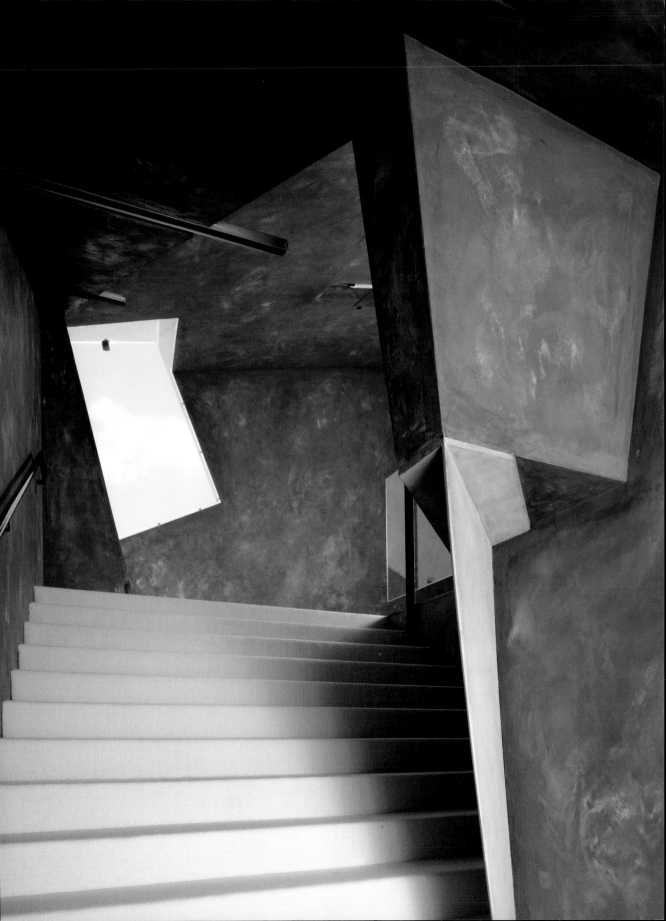

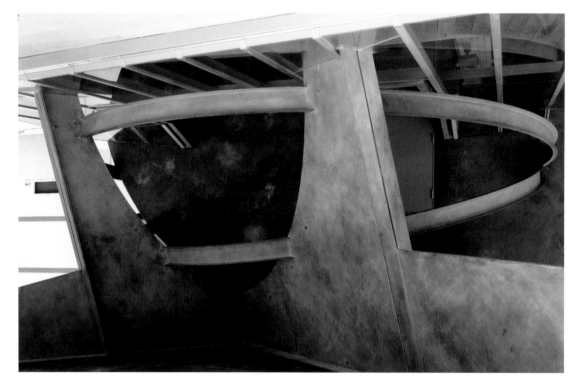

is subjected to geometric transformations, intersections of volumes, cuts in the wooden structure of the original industrial building, and conversion of architectural elements, all of which endows the work with an architectural complexity and inventiveness that becomes intelligible only once it has been visited. The author described the windows, situated in the two opposite corners of the conference room, as analogies to the box itself. As the windows occupy these corners, they cease to be flat elements and take on volume. The equivalence with which the materials have been treated, regardless of where they have been used (floors, ceilings, walls), suggests that "the box" has come from a sculptor's studio.

Above and opposite: Details showing intersection of the cylinder with the existing wooden structure

Opposite below: Floor plans of two levels of the building

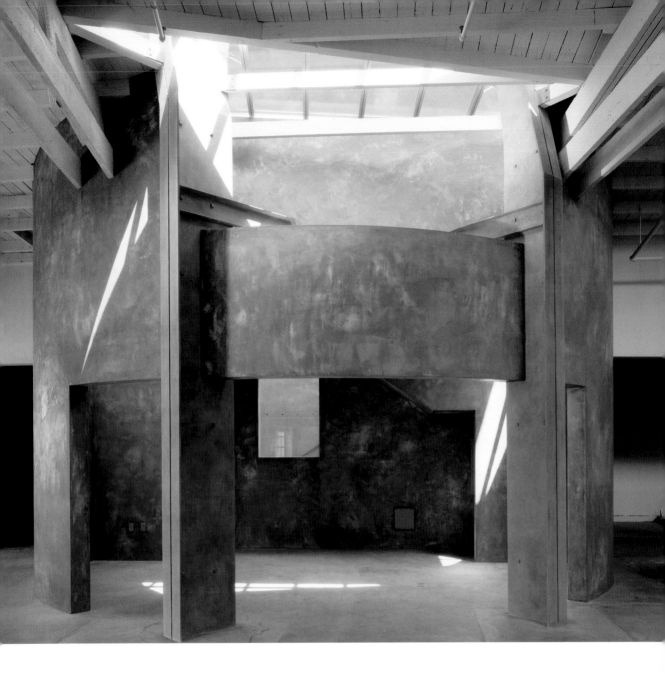

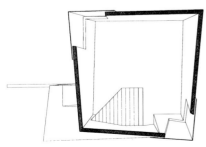
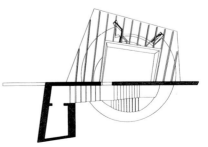

A luxury penthouse apartment

Republic Plaza

KISHO KUROKAWA

Singapore
Photographs: Musao Sudo, Shinkenchiku-sha

This building is situated on Raffles Place, where the OUB Center by Kenzo Tange is also found. The two buildings have equal floor area and both are the same height: They line up on a north-south axis of the square and are 280 meters (918 feet) high—the maximum permitted. The two buildings are products of new urban planning centered on the subway station and aimed to convert Raffles Place into a hub of development.

As in other skyscrapers, including the OUB, Republic Plaza is accompanied in its base by a smaller structure housing banks. The eastern part of the site is a parking area covered by a pergola. The pillars of the building form an exterior corridor that provides access to the interior. A hall on the ground floor surrounds a large elevator core that connects the tower with the lower building housing the banks. The core forms a square center in the tower that has been rotated 45 degrees. In the northeast part, there is another pergola and escalators which lead to the

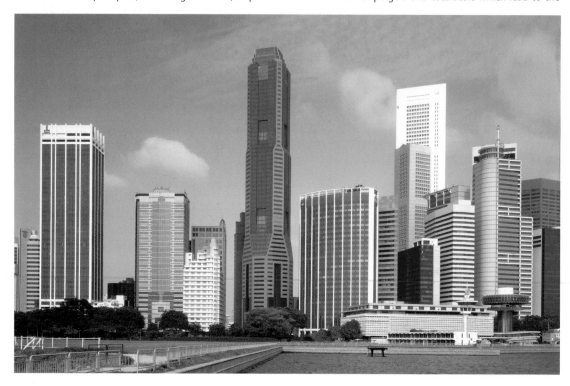

Above: View of Singapore with Republic Plaza and Kenxo Tange's OUB Center at the same height

Opposite: Panoramic view of the building from another skyscraper

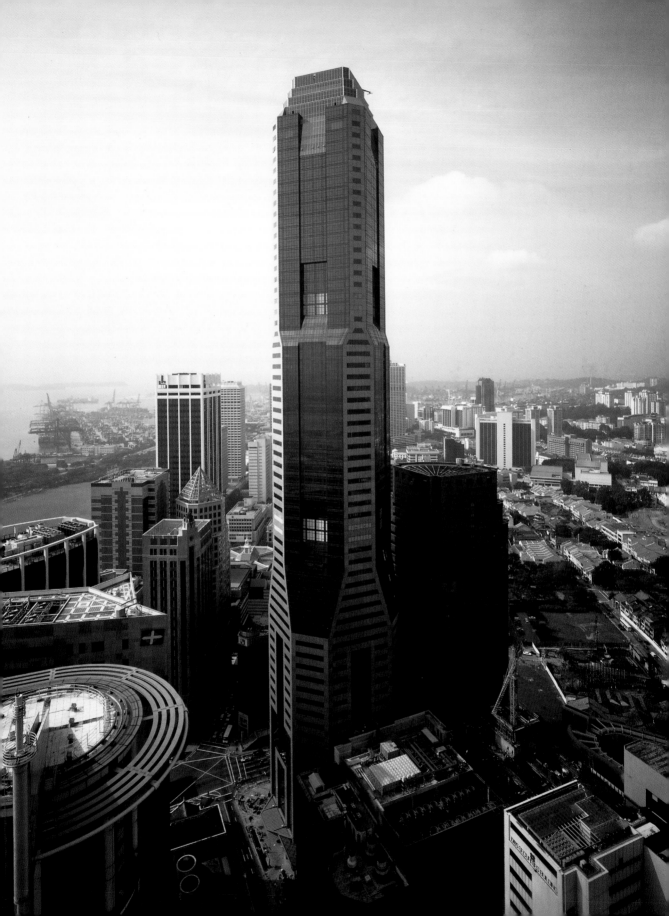

Top: Interior view of the hallway

underground part of the complex where the subway entrance can be found, as well as various leisure activities, such as shopping and restaurants. In turn, the perimeter is shaped like a square with its corners cut off to form an almost perfect octagon. The faces of the cardinal points are vertical to the summit. The diagonals entering take on greater magnitude as they rise, while others diminish in the style of a pyramid. Until the first fold, the diagonals form a base of granite and windows, which are then replaced by a curtain wall. The sixty-six-floor building is topped by the owner's penthouse, which is illuminated at night like a star and visible from all of Singapore.

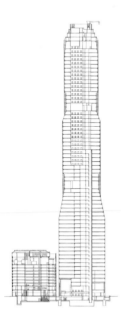

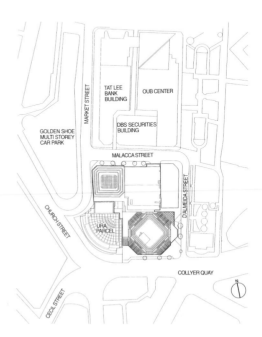

Left: Section of the building

Opposite: Detail of the façade

Right: Site plan

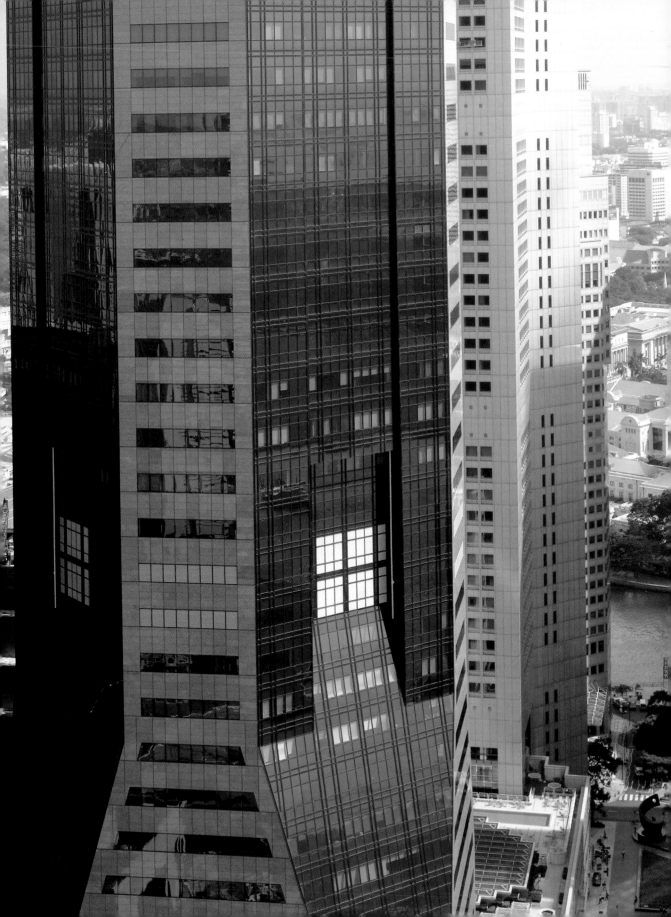

Facing the cliff

Student Hostel

PETER EBNER +
GÜNTER ECKERSTORFER

Salzburg, Austria

The rugged slopes of the Kapuziner mountain form the background to most of the buildings in Salzburg's city center, establishing a leitmotif for its architecture. Facing the mountain, the Student Hostel occupies a narrow fringe between the precipice and the old town, which has been molded by its contact with the mountain. Its design reveals how architectural forms can be an integral part of the topography and landscape.

The setting inverts the architectural characteristics of the place. Whereas buildings in the old town emphasize their presence by means of a plinth on which they rise, the Student Hostel, by contrast, stands on pillars that dematerialize its support on the ground. This creates an open

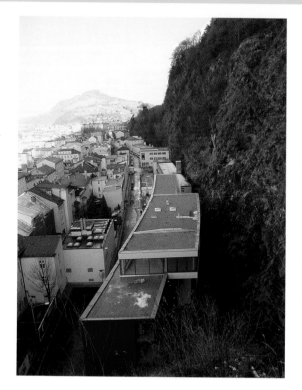

Above: Façade facing the precipice

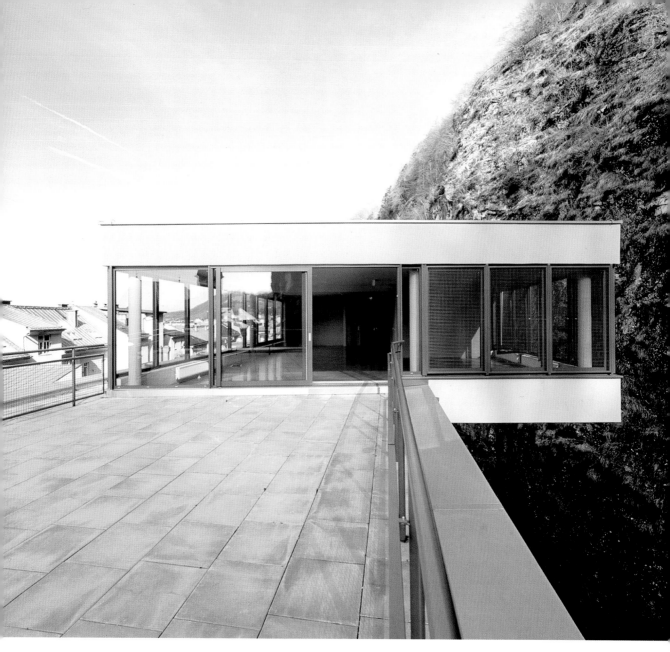

Entrance to the hostel

Above: The communications center, showing the glass opening in the façade

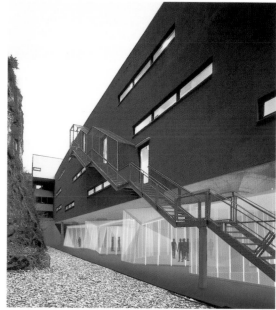

story consisting of various glass boxes, randomly distributed like rocks tumbling down a mountain. These modules contain shops frequented by tourists who visit the area. At one end is a space used weekly as a farmer's market.

The entrance to the hostel is through a tunnel, indicated by a vertical band of glass in the façade and home to the communications center offering spectacular views of the mountain. On the north façade, a homogeneous glass skin reflects the sequence of rooms in the hostel. The south façade, facing the mountain, is painted in cobalt blue in clear contrast to the mountain.

View of the south façade (top) and details of the staircase hall (bottom)

Opposite top: The south façade in relation to the cliff

Opposite bottom: bedroom story of the hostel

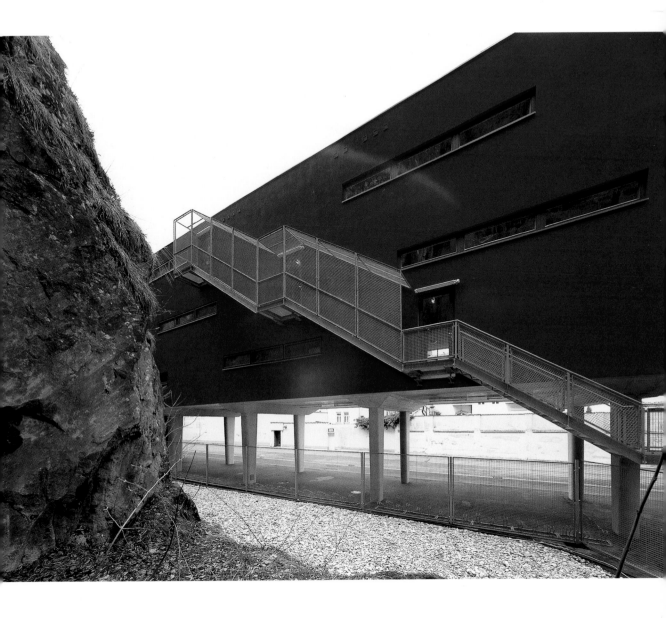

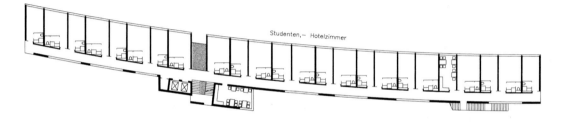

Studenten,– Hotelzimmer

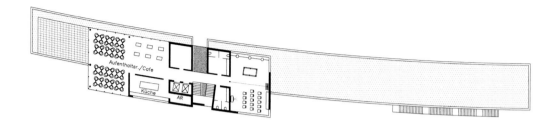

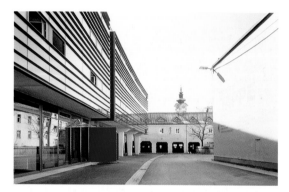

Above: Ground floor of the hostel housing different shops

Left: View of the entrance through the tunnel

Below (left and right): Details of the staircase

Opposite: Detail of the south façade facing the mountain

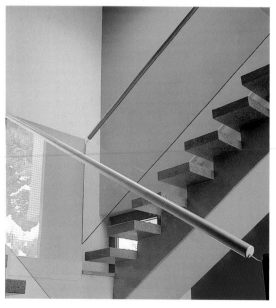

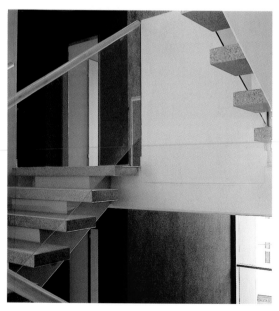

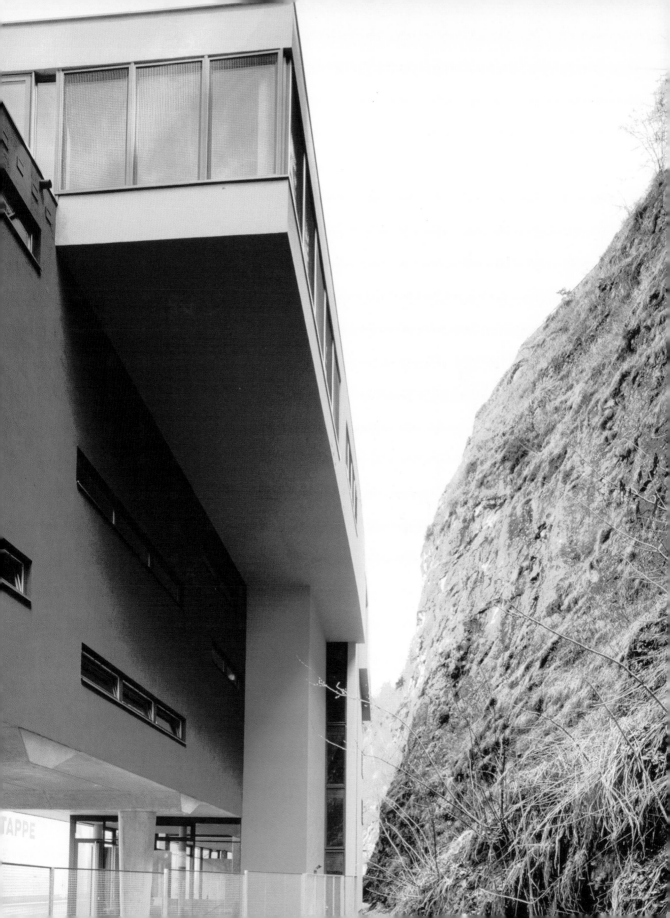

A project by Calatrava for his native Valencia

The Alameda subway station

SANTIAGO CALATRAVA

Valencia, Spain
Photographs: Paolo Rosselli

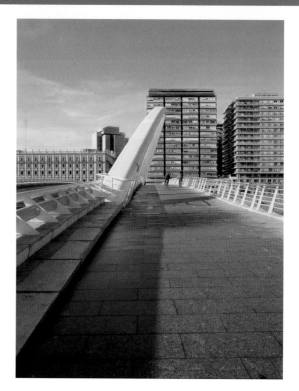

The project for reorganizing the dry bed of the Turia River envisages three independent elements in a single proposal: a bridge, a square, and a subway station, sited on different levels.

The station is located under the old riverbed, preserving contact with the exterior by means of a translucent roof that also serves as the floor of the square. The station structure is of prestressed concrete, and the skylights that provide it with lighting and ventilation define the perimeter of the square at night. The bridge platform is a structure in the form of an arch, made of a single piece of varnished steel, and spanning a void of 130 meters (426 feet) from one end to the other. The other arch, almost

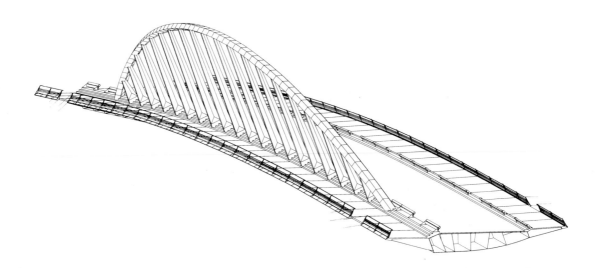

Above: Axonometry of the bridge

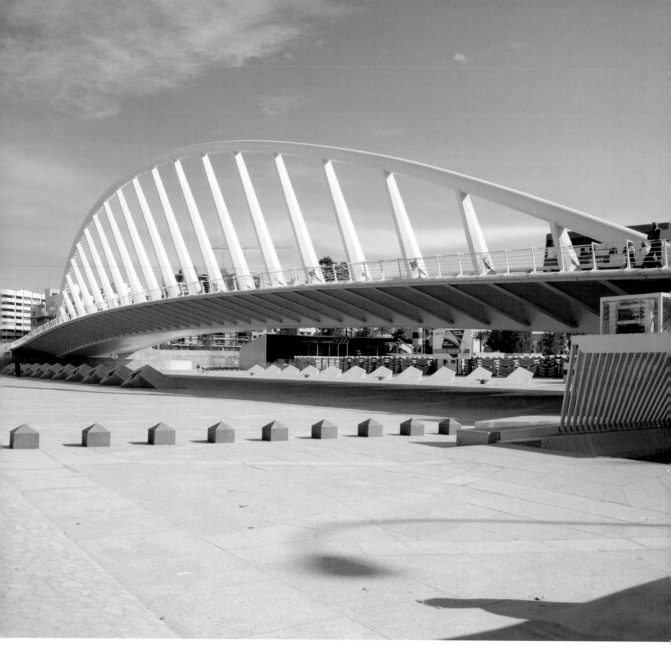

View of the bridge and the square

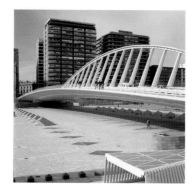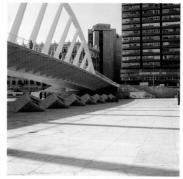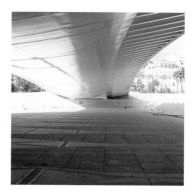

Top: Views of the bridge from different angles

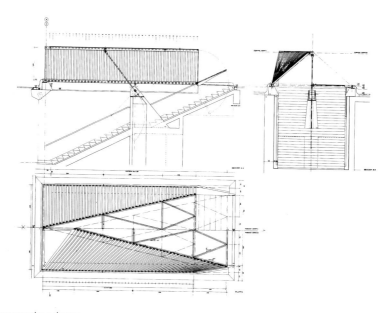

Above: Entrance to the subway

vertical, is a parabola 14 meters (45 feet) high with a 70-degree inclination from the horizontal. This arch springs from two pre-stressed concrete blocks and consists of tubes of different diameters joined together by triangular sections of sheet metal. As in all of Calatrava's works, every element in the design is conceived with structural, figurative, and expressive functions, which implicitly recall well-known organic forms.

Opposite top: Interior of the subway entrance

Opposite bottom: Cross-section of the station, square, and bridge

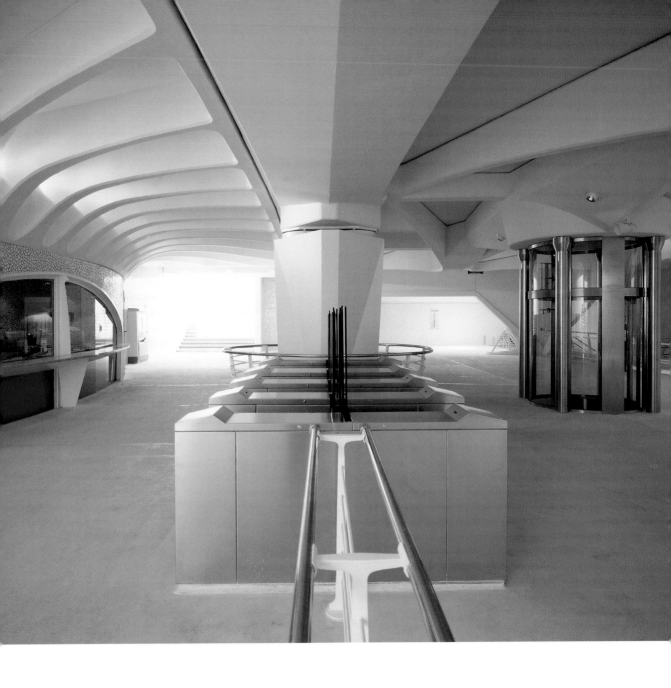

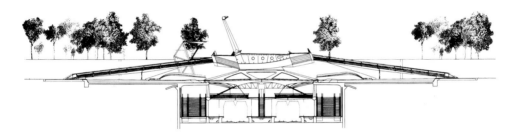

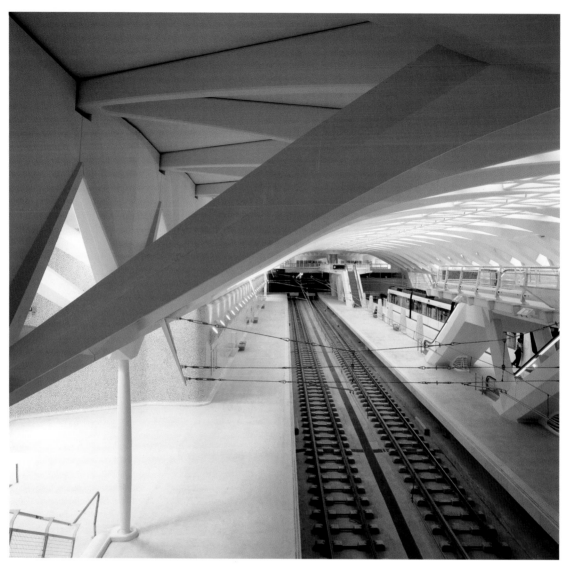

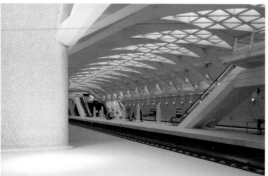

Above: Detail of the structure of the subway station beneath the bridge

Left: Subway platforms under the structure show its "ribs" and permit the passage of light between them.

Opposite: Interior view of the subway station from a platform

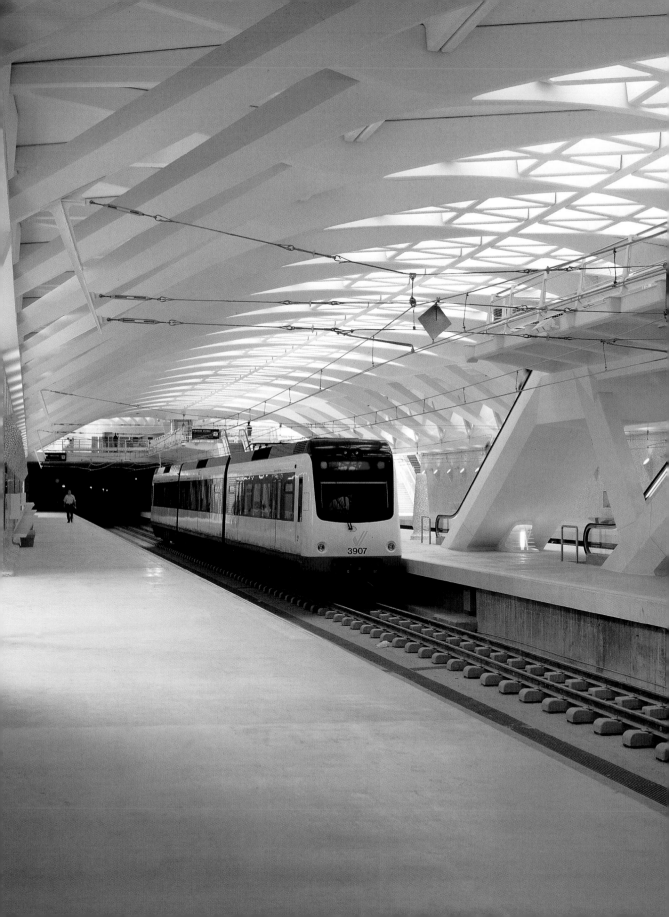

A greenhouse in the garden

Faculty of Law, Cambridge University

NORMAN FOSTER

Campus of Cambridge University, England
Photographs: Herman H. van Doorn

This was the winning project in the limited participation competition organized by Cambridge University in 1990 for the construction of its new Law Faculty and Institute of Criminology. On a relatively small site, Foster proposed two buildings in the shape of an "L" for construction in two phases to coincide with the university's requirements. It is situated on the Sidwick campus, in front of James Stirling's History Faculty. Since the preservation of existing vegetation was of fundamental importance, the proposal sought to maintain the buildings low in order to conserve the most significant trees. The buildings are finished in a wedge-shape and in between them is a garden occupied by an old maple tree.

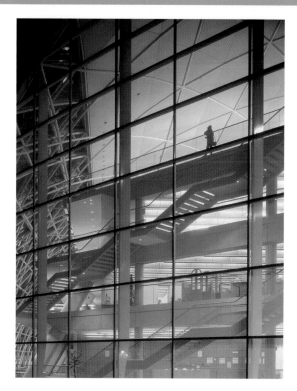

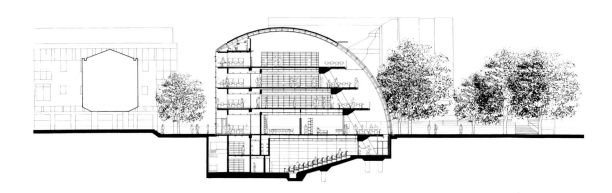

Above: Cross section of the Law Faculty building

Opposite: Detail of the wedge form on the west façade

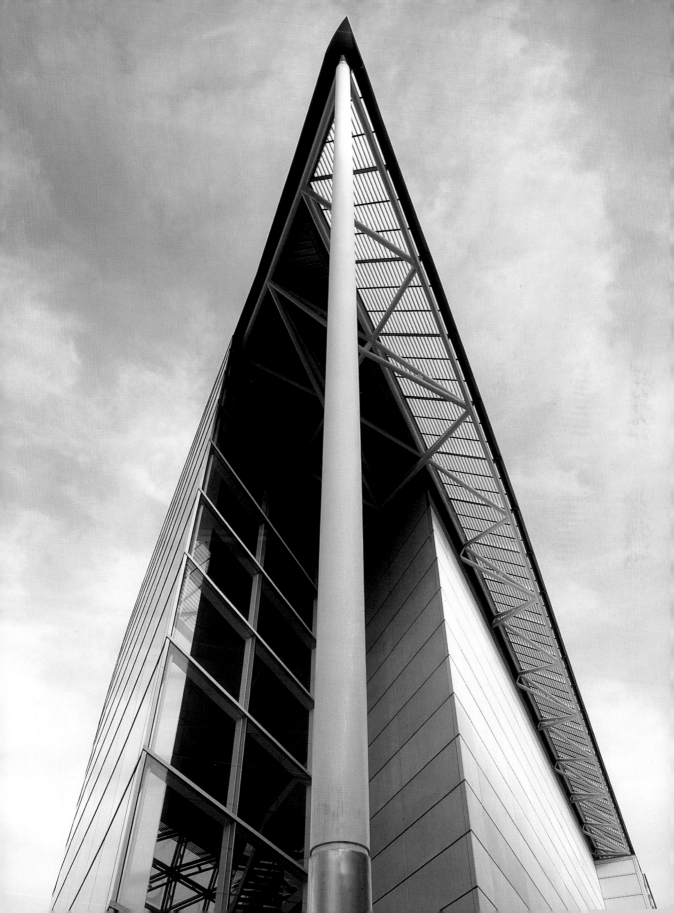

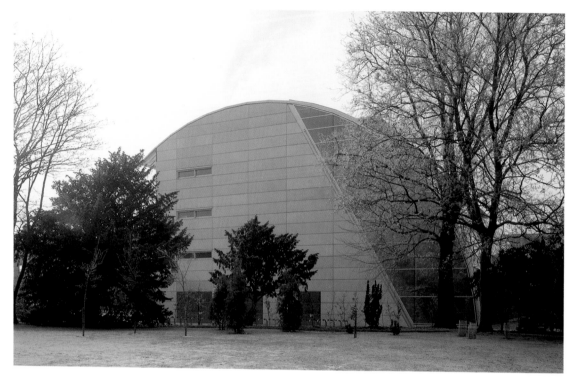

Above: East façade of the Law Faculty

Below: Detail of the south façade

Opposite: Exterior view of the building integrated into its landscape

The Law Faculty building's delicate siting on the plot contrasts with the expressiveness of its body, which has become a landmark on campus. The program includes five auditoriums, seminar rooms, meeting rooms, an administration area, and a large 9,000-square-meter (97,000-square-foot) library, situated on six floors of which two are underground. The all-purpose classrooms, administration area, and personal spaces are located on the ground floor. On the underground floors are three large auditoriums, a book-storage area, and meeting rooms for students. The other three floors contain the library. The entrance from the southeastern angle bites into the wedge-shaped volume, flowing into a full-height hall giving access to all floors, which are illuminated through the large hollow running through the students' meeting rooms.

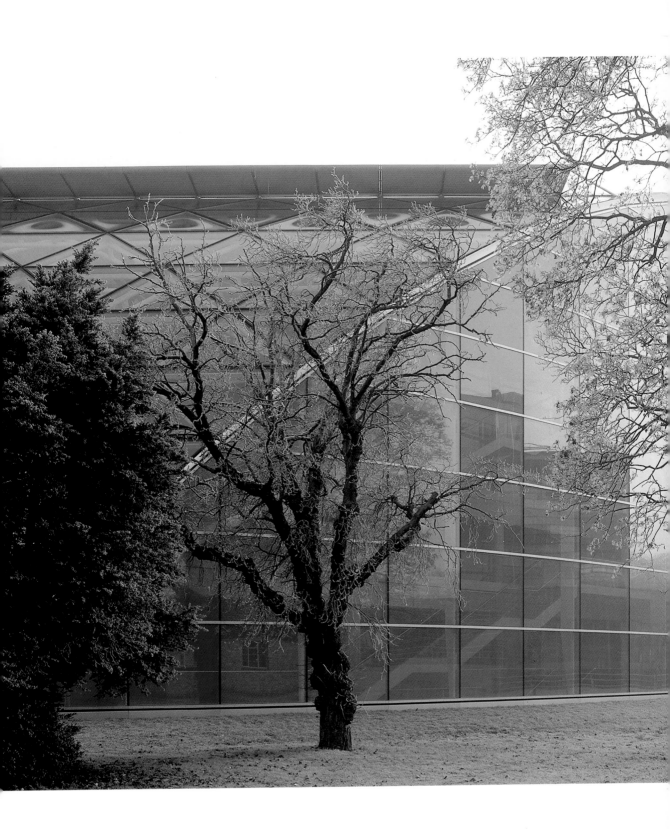

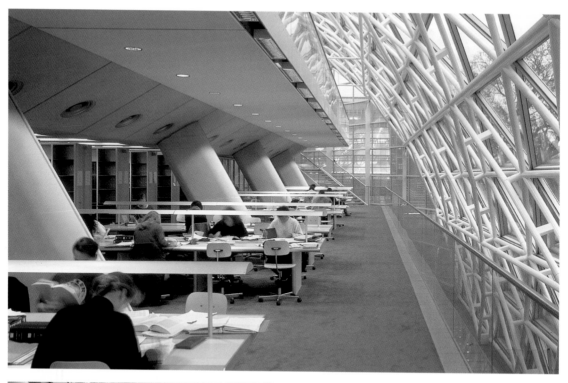

Above: Interior view of the library showing the relationship of the balconies to the façade

Below: Detail showing anchorage of the glass panels to the three-dimensional tubular structure supporting the façade

Opposite: Interior of full-height entrance hall

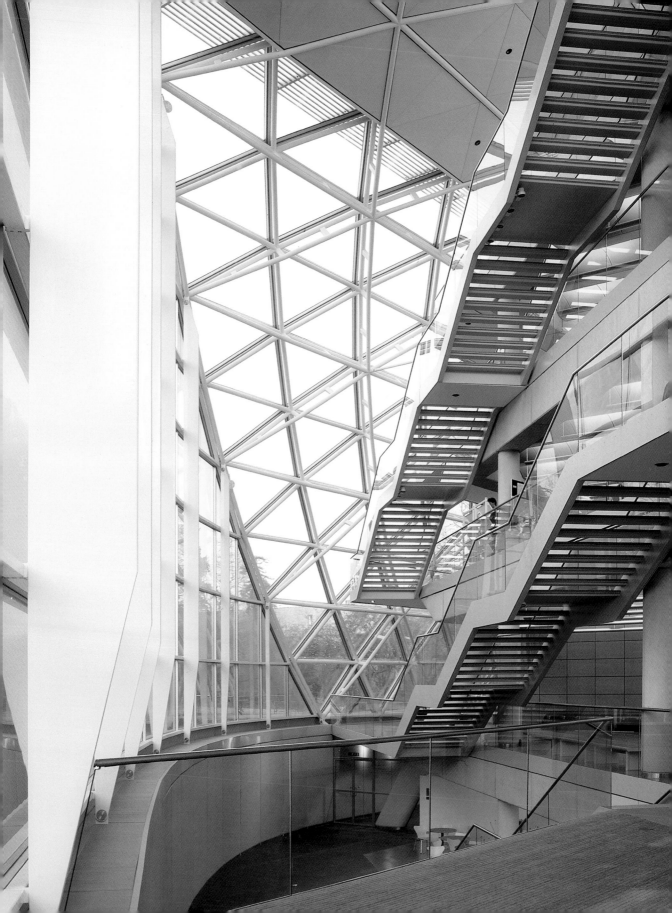

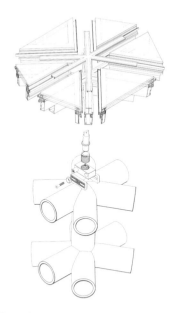

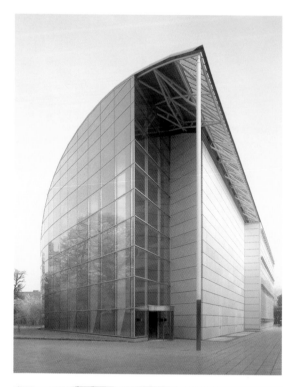

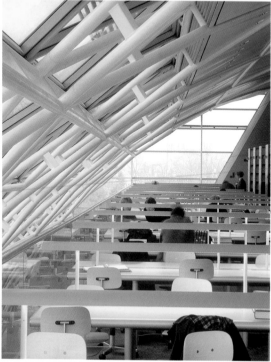

Above: Details showing the anchorage of the glass panels to the three-dimensional tubular structure that supports the façade

Top right: The entrance to the building where a "bite" has been taken out of the volume of the southeastern corner

Bottom right: Interior view of the library

Opposite: Views of the north (top) and south (bottom) façades

The services and administration offices are situated in the south façade; and views of the garden can be enjoyed through the curved glass surface of the north façade. The library levels form terraces that adapt to the façade without touching it.

Technically, the façade has been resolved through the use of panes of glass fixed with structural silicone; on the roof stainless steel panels are used to avoid excessive solar radiation. From a structural point of view, the floors are independent from the curved roof that uses a three-dimensional triangular mesh. The east façade doubles in a curved form that resolves the 45-degree cut in the cylindrical shape of the volume. The plane of the southern façade consists of glass with solar protection and natural Portland stone. The sealed glass panels on the curved façade are supported by industrial aluminum frames that reveal how the façade is constructed.

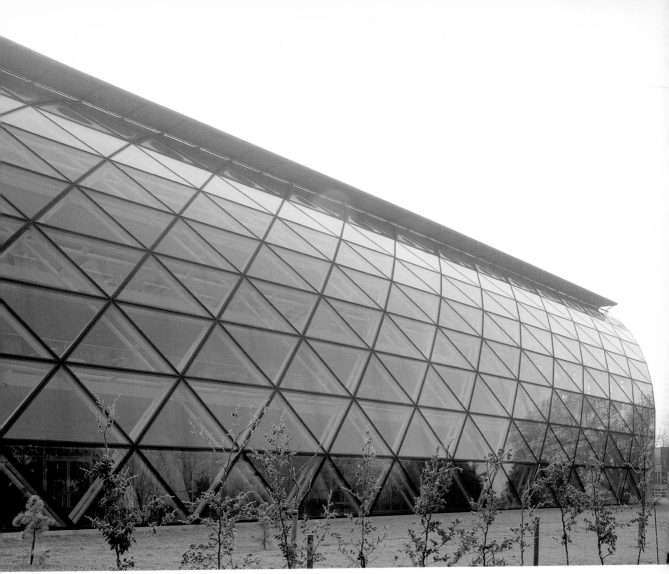

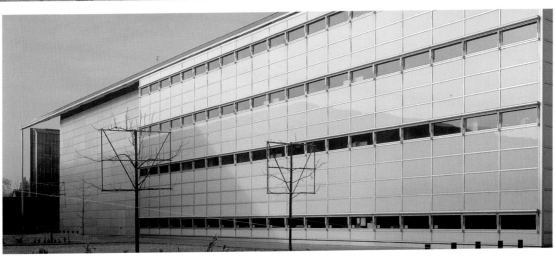

An architectural promenade

Chikatsu-Asuka Historical Museum

TADAO ANDO

Minami-kawachi, Osaka, Japan
Photographs: Shigeo Ogawa

Always seeking a solution with poetical and philosophical aims, the works of Tadao Ando are exceptionally coherent, reducing architecture to the essentials. Based on strong theoretical and intellectual foundations, his structures hark back to pure geometric forms and simple materials, in order to represent clear open spaces that capture the flux of light throughout the day and seasons. Despite the overriding coherent vision, Ando's works differ according to function: houses, small temples, and shrines evoke solemnity and mysticism, whereas large public works convey monumentality, as in this project.

This proposal retains a resemblance to the great monuments of prehistoric cultures, such as the pyramids and ziggurats. Located south of the Osaka region, this museum and memorial seek to commemorate and explore the *kofun* culture, centered in Chikatsu–Asuka, which played a significant role in early Japanese history. This region has one of the largest collections of burial mounds and cenotaphs, together with four imperial tombs. Responding to topography and function organically, the architect conceives the building as a stepped mountain from which panoramic views are afforded over the necropolis, while the building is enveloped in vegetation.

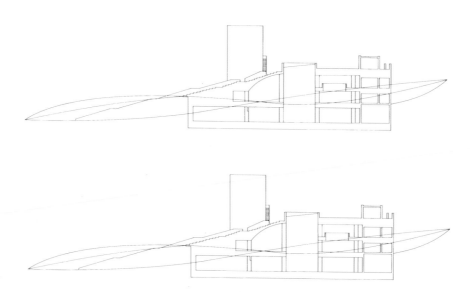

Above: Sections of the museum building

Opposite: Aerial view of the museum complex in its landscape

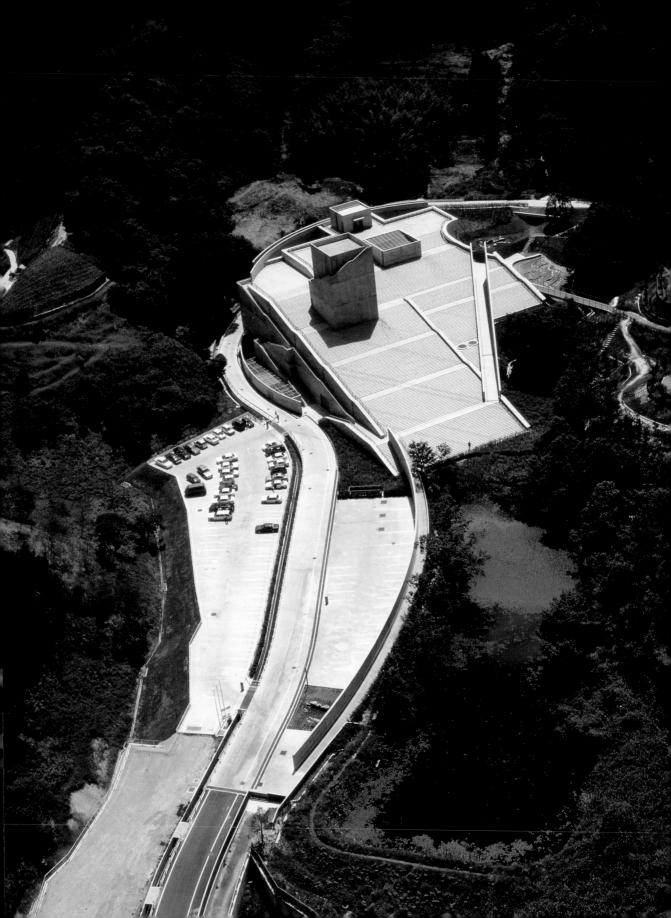

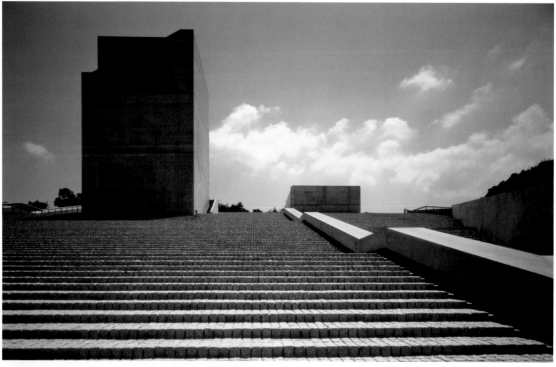

Top: The monumental staircase forms an approach in the manner of an architectural promenade.

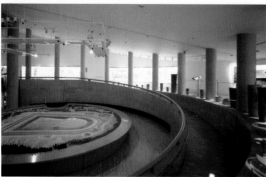

Above: The interior of the museum recalls ancient funerary temples.

Right: Axonometry of the building

Opposite: View of the access staircase leading directly to the museum's entrance

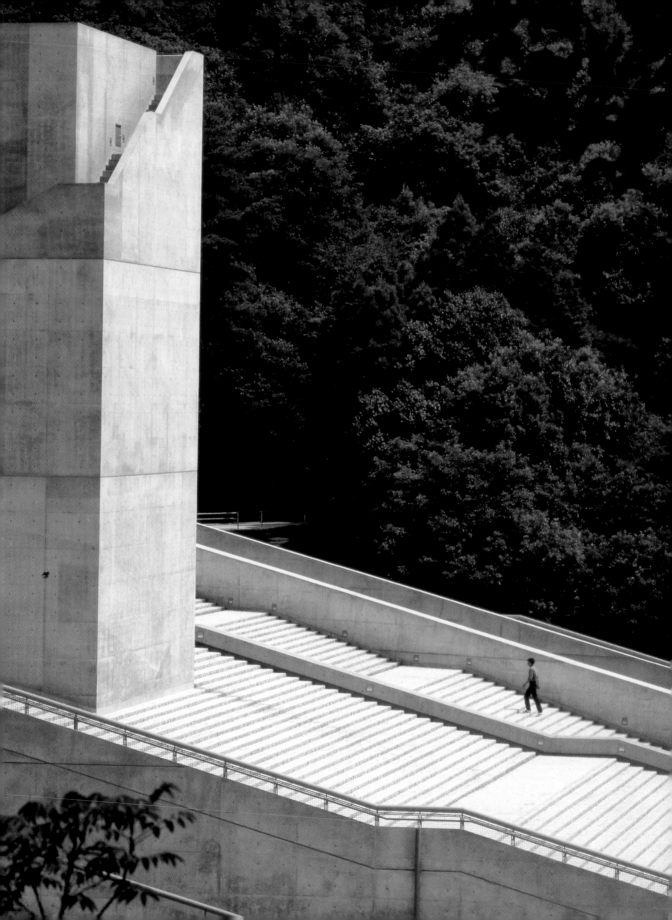

Russian dolls

Natural History Museum, Rotterdam

ERIK VAN EGERAAT

Rotterdam, Holland
Photographs: Christian Richters

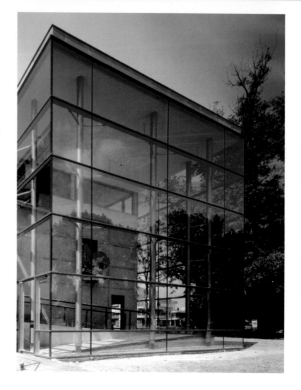

Since the death in 1924 of its last owner, the Dijkzigt villa has been the property of the Rotterdam city government, which wanted to refurbish and convert it into a cultural park. But it was not until 1985 that Erik van Egeraat took up the idea and an intense architectural activity began in the park. The old mansion housing the Natural History Museum—classified as a national monument—was built in 1851 by F. L. Metelaar. It had become too small, so the architect thought of refurbishing it to provide additional space, possibly constructing a complementary annex. The new configuration of the museum's space includes two stores, one in the attic and another in the basement.

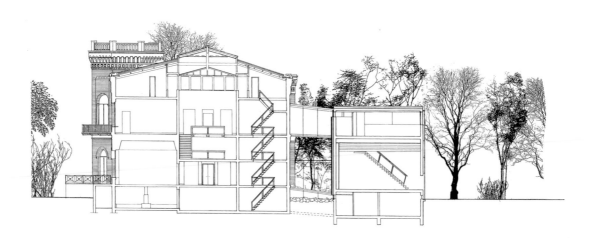

Above: Cross-section of the Dijkzigt villa, with the annex to the right

Opposite: Interior of the east façade of the annex

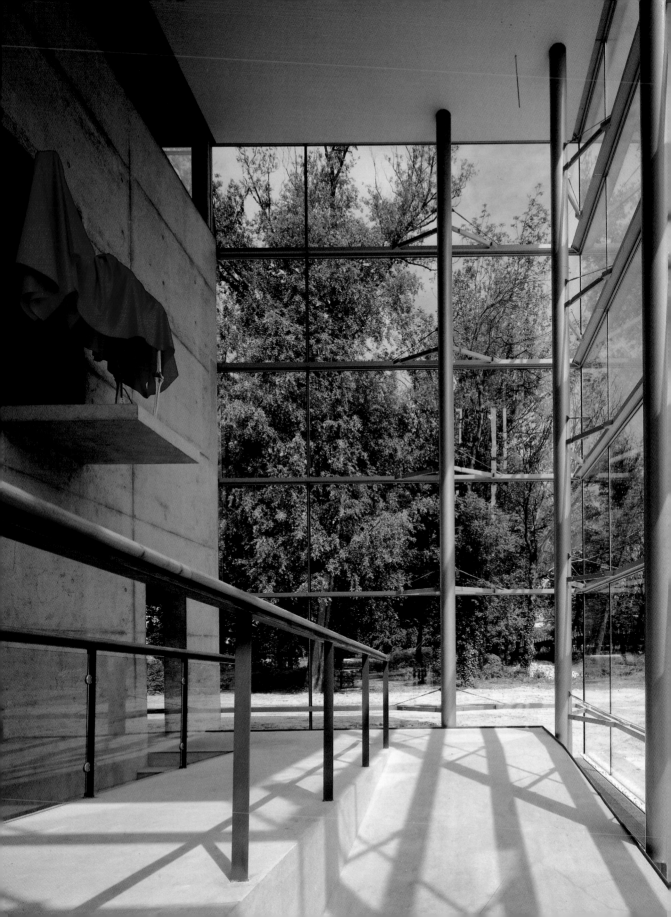

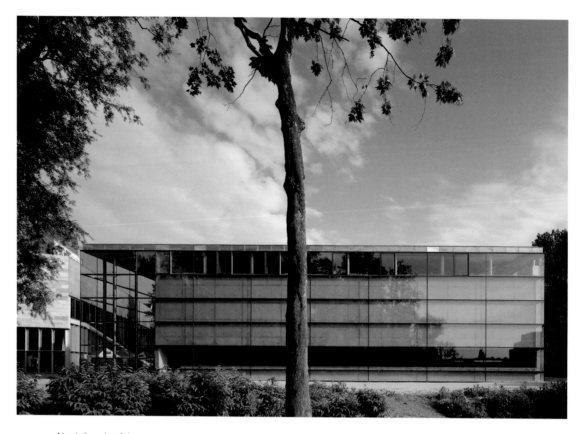

North façade of the annex

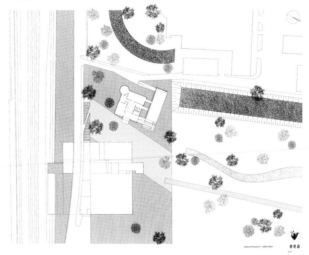

Above: Plan of the museum's setting within the cultural park

Opposite: View of the entrance hall of the new annex, showing the whale skeleton hanging in the air

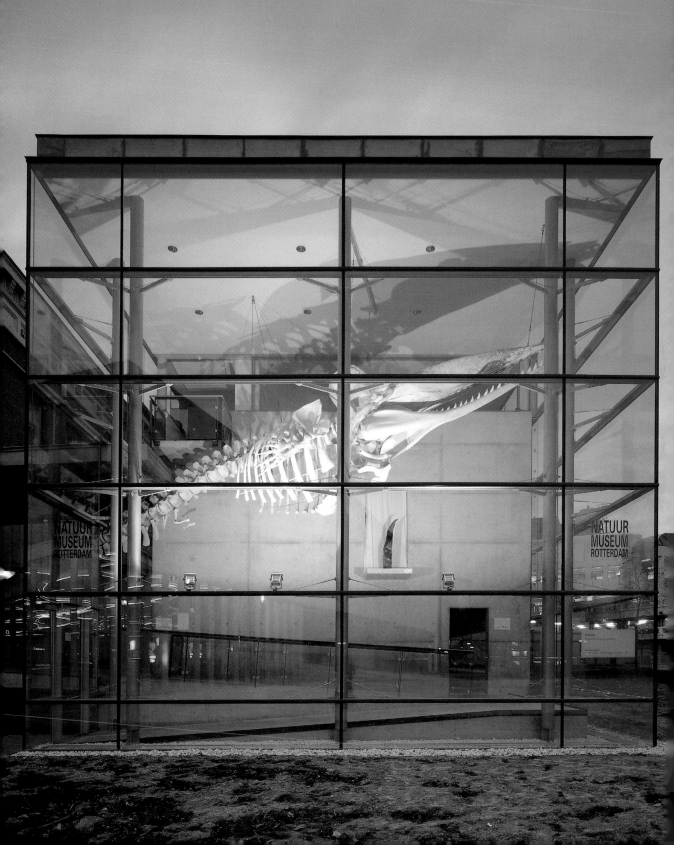

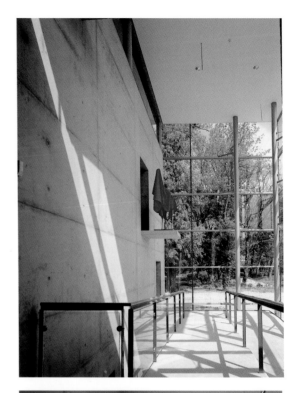

Above: Ground floor plan of the renovated museum

Above right: The ramp at the east end of the annex

Below right: Refurbished interior of an exhibition room in the Dijkzigt villa

Opposite: View of the interior of the concrete cube inside the annex

The new building contains a large hall for temporary exhibitions on the first floor, with offices and a library on the second floor. Thus, the two main levels are reserved entirely for exhibitions. The extension is connected to the original villa by a covered walkway leading from its entrance to the mansion. The materials, form, and technology contrast totally with those of the original museum.

The two buildings are separated by a long court, inspired by Japanese models. According to the architect, the façade has been designed to accommodate different layers of skin: concrete, which houses the exhibition space; glass, which functions like a membrane around the central cube; and brick, between the south and west façades, which prevents too much light from reaching the glass surface.

NOODUITGANG

Waves of glass

Terminal B at Bordeaux Airport

PAUL ANDRÉU

Bordeaux, France
Photographs: Paul Maurer

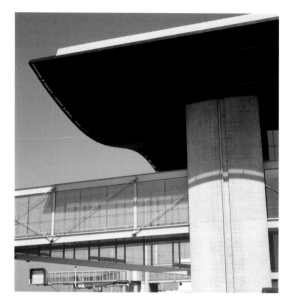

Like the classical architects, Andréu seeks conceptual clarity and beauty through simplicity. This project, relatively small, and intended only for the Paris traffic, illustrates this idea. The growth of users since the opening of Terminal A demanded that new premises be built, at right angles to the existing terminal and connected to them by a gallery of service rooms and shops. The architects were obliged to consider the new air-safety regulations, which did not allow the airport to be enlarged directly from the old terminal.

The project is divided into two levels, both architecturally and functionally. The arrival hall is located on the lower level, while the upper level is reserved for departures. The

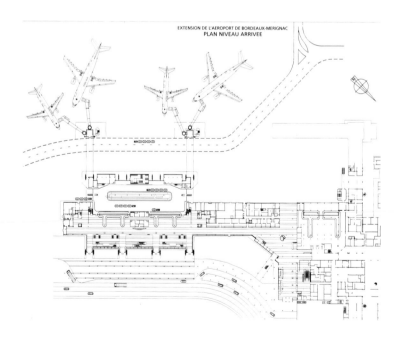

EXTENSION DE L'AEROPORT DE BORDEAUX-MERIGNAC
PLAN NIVEAU ARRIVEE

Above: Plan of ground floor of the new Terminal B

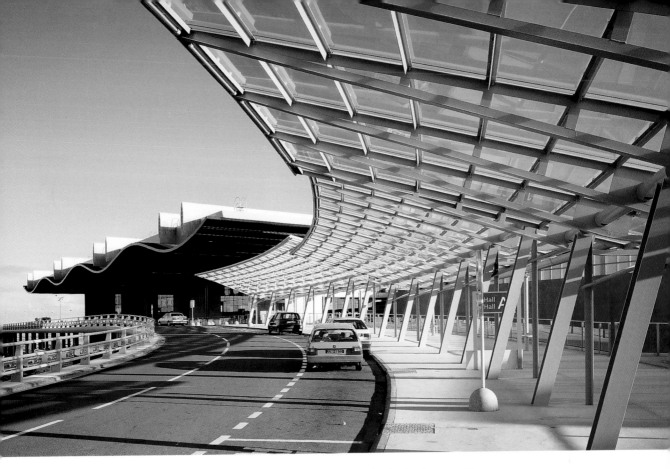

Above: View of the airport with the new Terminal B in the distance, showing its sinuous roofline
Below: Main façade of the terminal, showing the play of shadows, transparency, and reflections of the glass

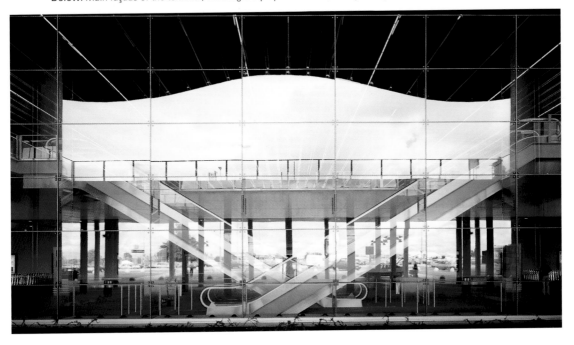

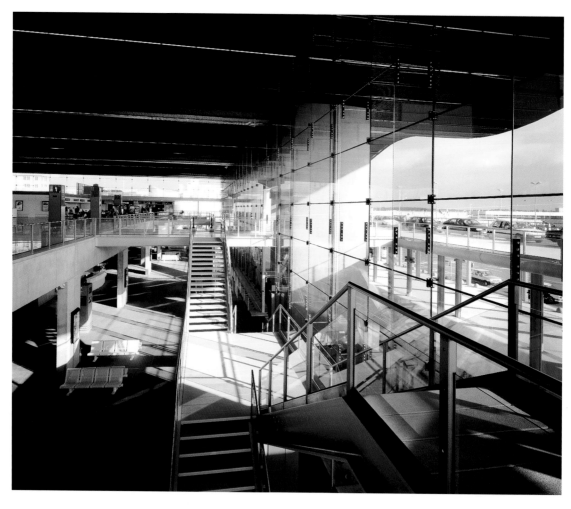

Image showing the entrance of natural light into the ground floor through the glass façade, as well as elements connecting the two floors

lower hall is conceived as a transitional area between the luggage area and the exit, containing no stopping places or architectural elements. The upper hall is 8 meters (26 feet) deep along the entire length of the façade, which faces the parking lot and the runways. The ends widen to 50 meters (164 feet); one of them connects Terminal A, while the other is ready for future enlargement. The two levels are connected at three points; and at the end are two identical blocks that house the rest rooms and other services. The rest of the hall remains empty, furnished only with benches. Under the sinuous roof of the building, the hall comprises an enormous open empty space bathed in natural light. The two façades are completely transparent glass planes, interrupted only by translucent horizontal bands that regulate the entry of direct sunshine.

Opposite: The (top) gallery connecting the two terminals; and (bottom) the façade of Terminal B, showing the access to the arrival hall

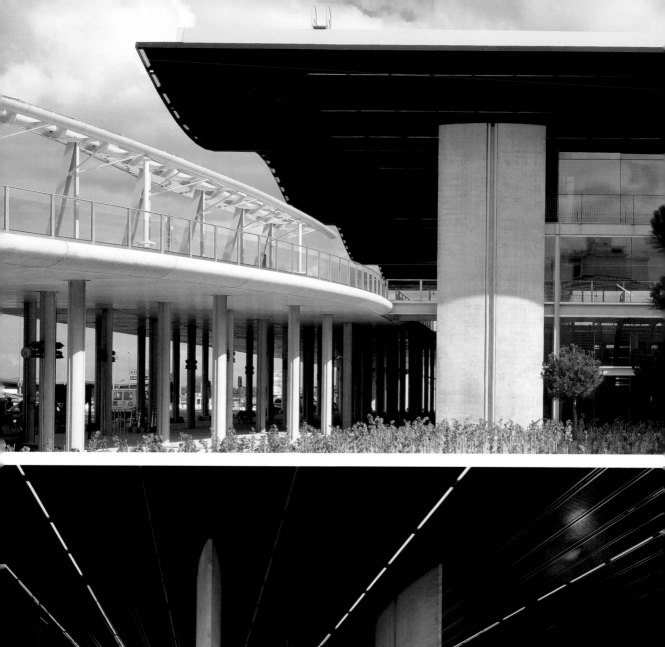
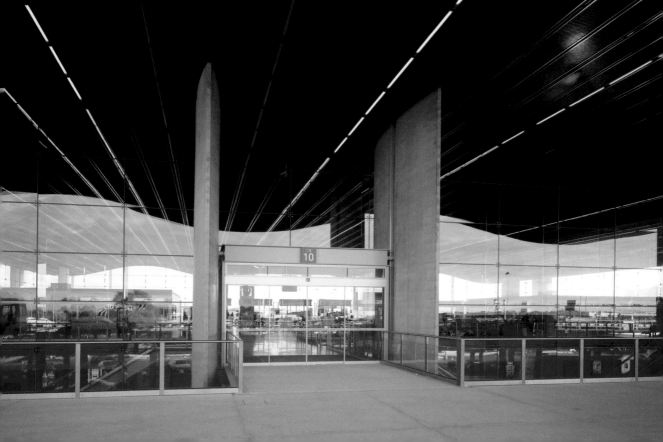

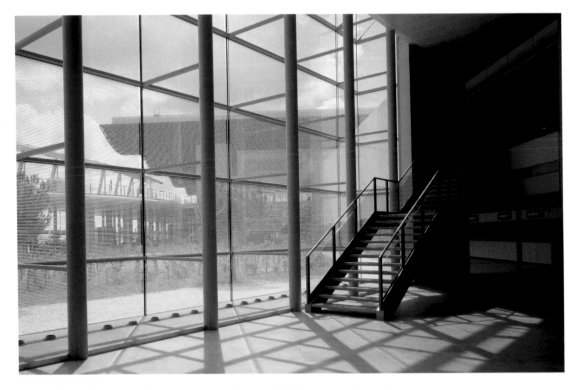

Detail of parts of the façade and support elements visible in the ground-floor hall

Interior of the luggage-claim area on the ground floor

Opposite: Access staircase from the lower-level arrival hall to the upper-level departure hall

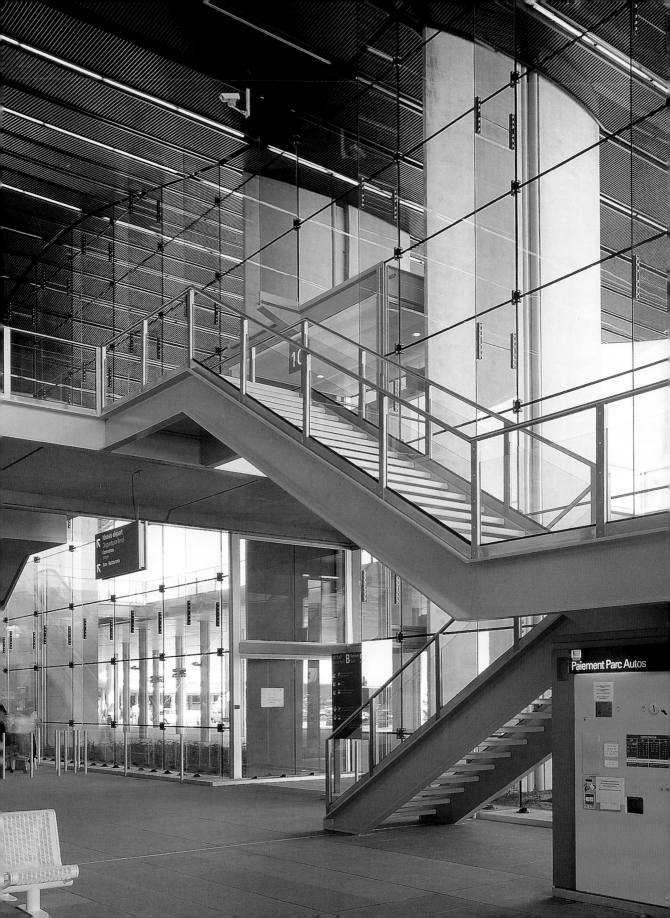

Manufactured patchwork in the pixel era

Seat of the Desert Park

EDUARDO ARROYO

Baracaldo, Spain

This park project is located in an empty space within the built-up urban municipality of Baracaldo. The irregularly shaped site stretches to the edges of the surrounding buildings. Like all the works of Eduardo Arroyo, the design emerges from an exhaustive analysis of the space's requirement. In response, the resulting proposal employs different materials—each with its particular hardness and texture of finish—to design the circulation, the landscape, and the visuals of the new park.

The proposal suggests dividing the site into a rectangular mesh of small plots of land that will be progressively filled with different materials selected to create a carpet woven on the town. The choice of materials is determined following an analysis of traffic patterns, exposure to sunlight, visuals, accessibility, perimetric uses, and wind, evaluating the effects of all elements on the various plots. The materials used are water, stone, asphalt, sand, grass, trees, steel, and wood. The interplay among them generates tensions that trace the pedestrian paths, the permeable areas, and the inaccessible ones. The result is a lively and dynamic public space that enhances the spatial context of the surrounding residential buildings.

Setting of the park in its urban context

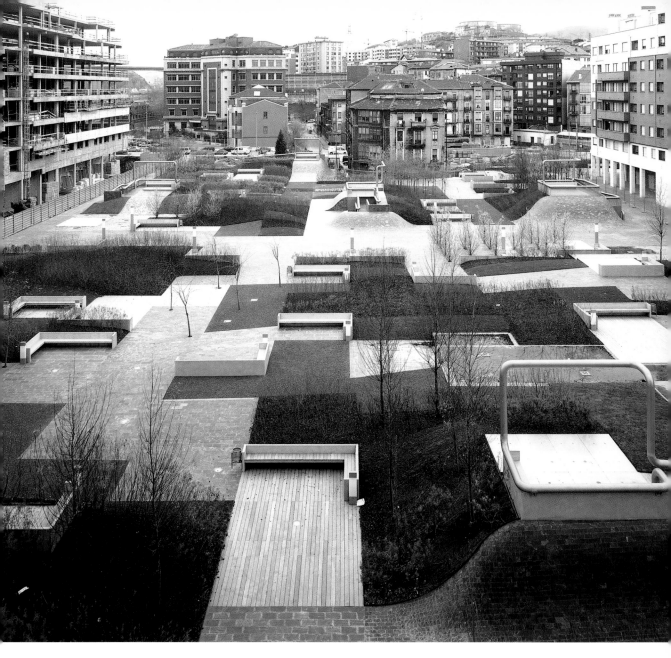

Different materials are used to create the diverse compartments of the tapestry.

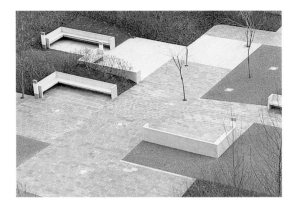

Repetition of the base modules revealing different textures and finishes

Detail showing a junction between different materials

Above: Sections of the park, showing its different profiles

Below: Scheme showing distribution of different materials in a patchwork of the park

Detail of the rest and relaxation areas showing the park's different ambiences

Miralles postmortem

Gas Natural SDG

ENRIC MIRALLES & BENEDETTA TAGLIABUE ARQUITECTS ASSOCIATES
Barcelona, Spain
Photographs: Gas Natural SDG

This office tower is designed to house the headquarters of Gas Natural. It is located in the new Diagonal Mar park, the work of the same architects, in which different urban networks flow together, with the sea and the city of Barcelona as a backdrop. To make the building compatible in height with its immediate urban surroundings, the building is developed vertically, and at the same time broken down into segments of smaller scale, forming a projection of 35 meters (115 feet). This large platform constitutes a great public space facing a diverse urban landscape—a speedway (the Ronda Litoral), the Diagonal Mar park, and La Barceloneta, the old fishermen's quarter of the city.

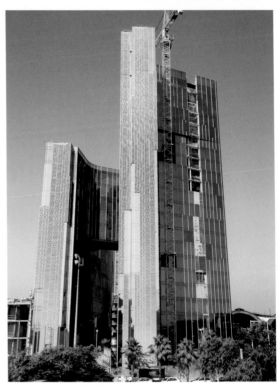

Above: Perspective of the main entrance to the tower, showing the permanent blue gas-fed flame that is the symbol of the company

Opposite: Exterior perspective of the tower, with its trademark fragmentation into distinct volumes

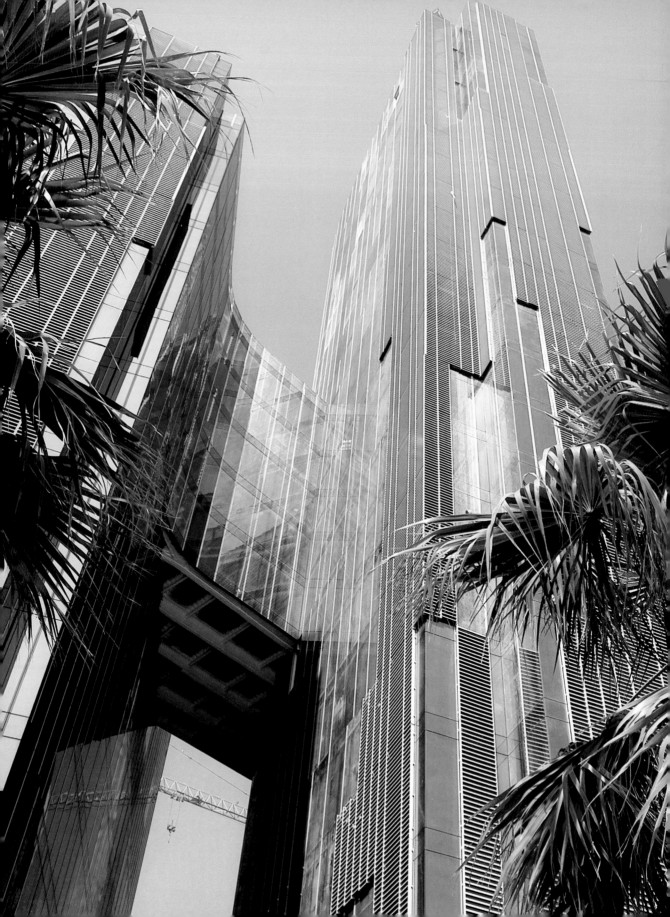

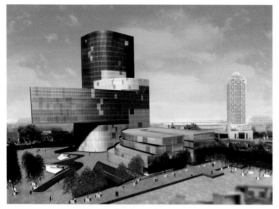

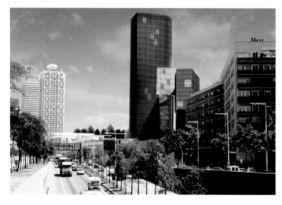

Different images of the complex under construction showing its immediate surroundings

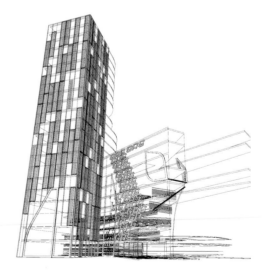

The building delves into the interplay of building, city, and person and converts an eminently vertical structure into a different, horizontal one. The main entrence of this private building is in a large space open to the public, where the old park and gasometers are a living witness to the history of the place. The building possesses twenty stories of offices, three for car parking, a 100-seat auditorium in the first basement, an exhibition room on the attic floor, a cafeteria on the ground floor, and an interior public passage that distributes the control areas and shops.

Above: Perspective of the project, showing its urban scale and the tower's pedestrian passage

Opposite: Detail of the façade under construction

View of the tower from a distance

Above: Perspective of the project, showing the more human scale of its façade

Opposite: Detail of the façade under construction

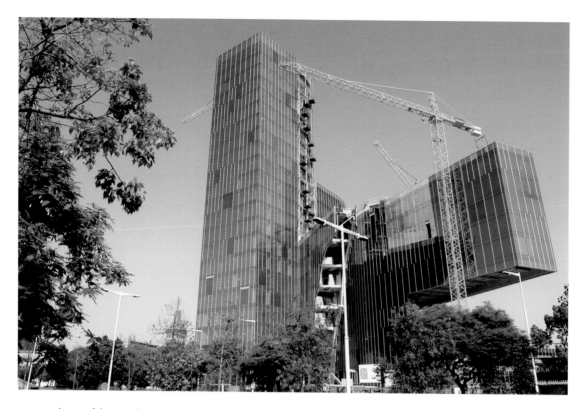

Image of the complex under construction, showing the large projection

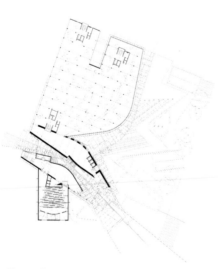

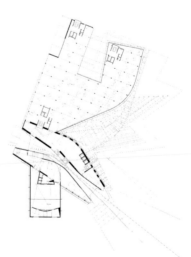

Above: First and second floors

Opposite: The building under construction

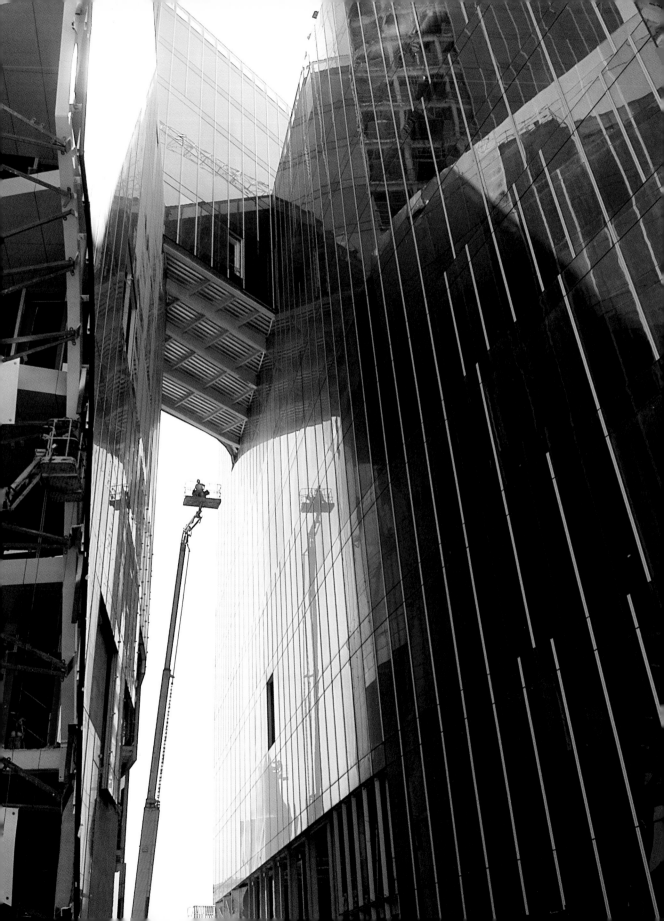

A view of Kobe

4 × 4 House

TADAO ANDO

Kobe coast, Hyogo, Japan
Photographs: Mitsuo Matsuoka

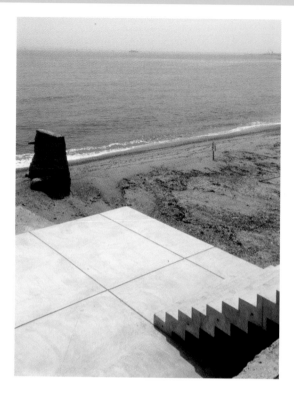

In 1995, a strong earthquake devastated the coast of Kobe. The epicenter was located on Awaji Island, where a number of Tadao Ando's projects are found, including his Temple of Water and the Yumebutai. The 4 x 4 house is set in complex surroundings on this Kobe coast, in an industrial context facing the Akashi Bridge—a symbol of Japanese civil engineering—as well as Awaji Island. The construction, entirely in steel reinforced concrete poured in situ, rises like a shelter in the bleakness of its landscape, but opens out onto spectacular views. Its dimensions (4-by-4-meter [13-by-13 feet] floors and four stories) are responsible for its name. Its vertical aspect has made it a landmark in the landscape, a lookout point onto

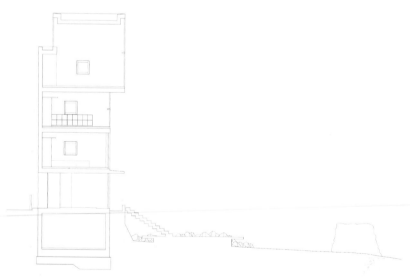

Above: A section of the house

Opposite: View of the house from the coast

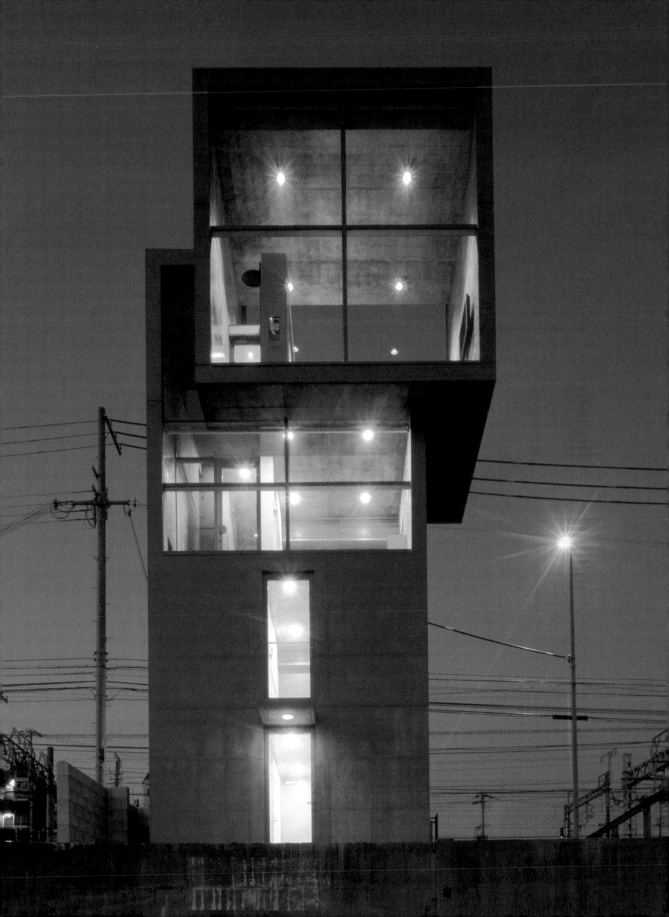

Above: Bird's-eye view of the house and its immediate surroundings

Below: Views of the interior

Opposite: Views from the interior

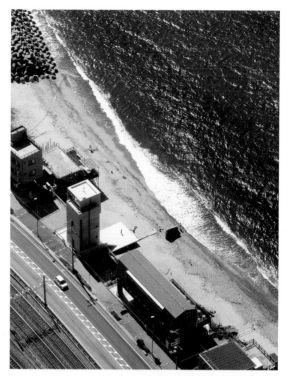

the Seto Inland Sea, the bridge, and the island.

On the top floor, the device of displacing the cube in two directions, south and east, is a simple formal gesture that gives great richness to the final composition. Due to the reduced surface area resulting from the dimensions chosen for the floor plan, the different functions are relegated to different levels that are connected by a staircase running from top to bottom of the house. On the ground floor, there is a washroom and bathroom. On the first floor, we find the bedroom. The studio is on the second floor, and the kitchen-living-dining area on the top. The two lower floors gain privacy by closing onto themselves, while the upper levels open up generously to the views of the coastline. There are now existing plans to extend the house as if it were "architecture that penetrates the water at high sea."

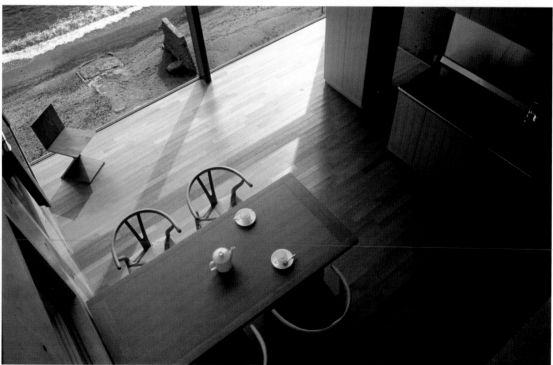

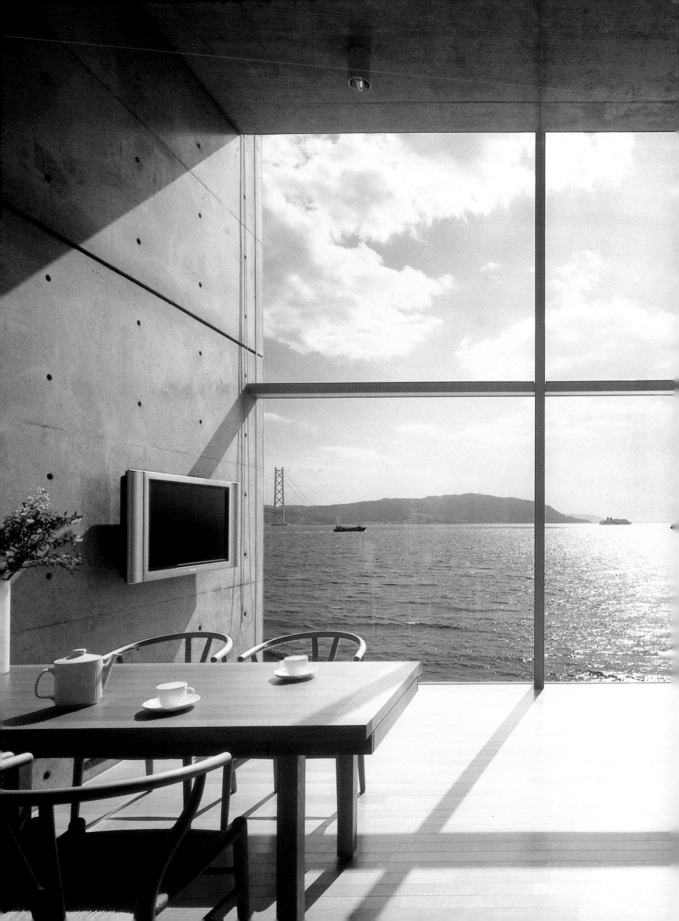

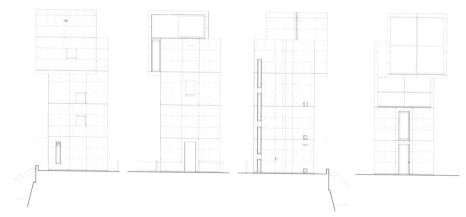

Façades of the house

Above: View of the house in its industrial setting

Opposite: Side view of the house from the coast

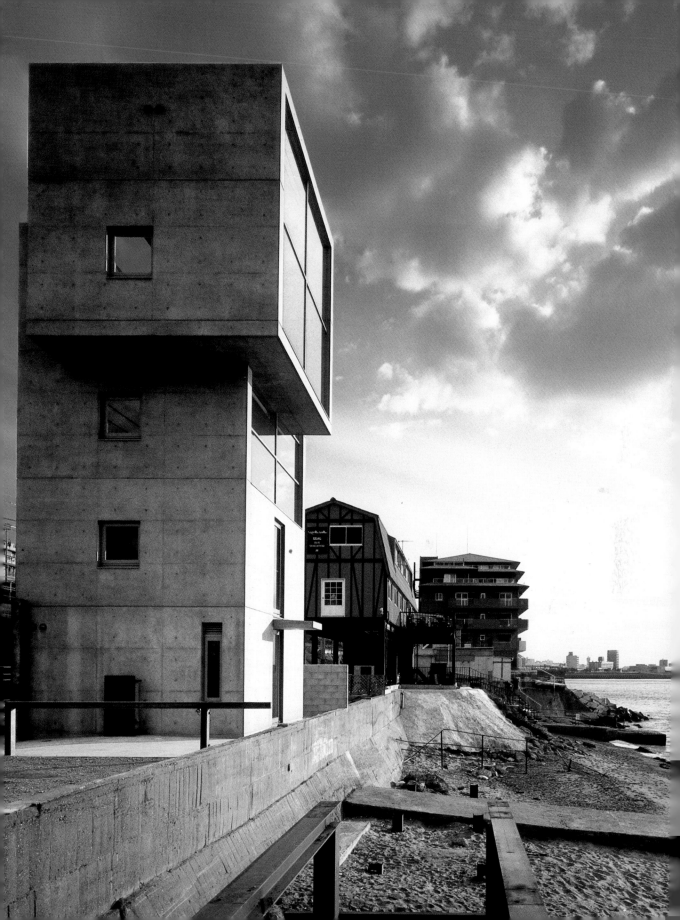

Right: View of the house facing the sea and bridge

Below: Composition for the façade in front of the railroad tracks

Opposite: View of the bridge from the interior of the house

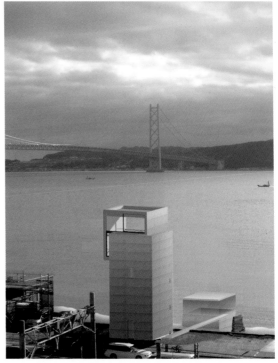

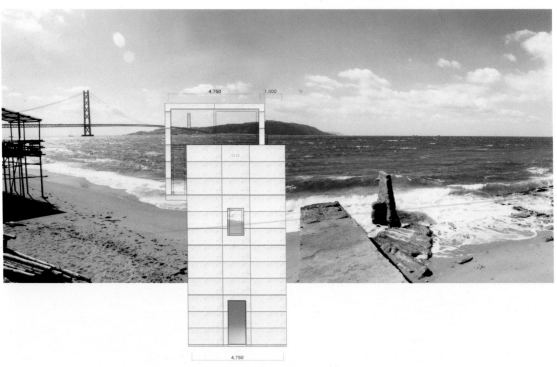

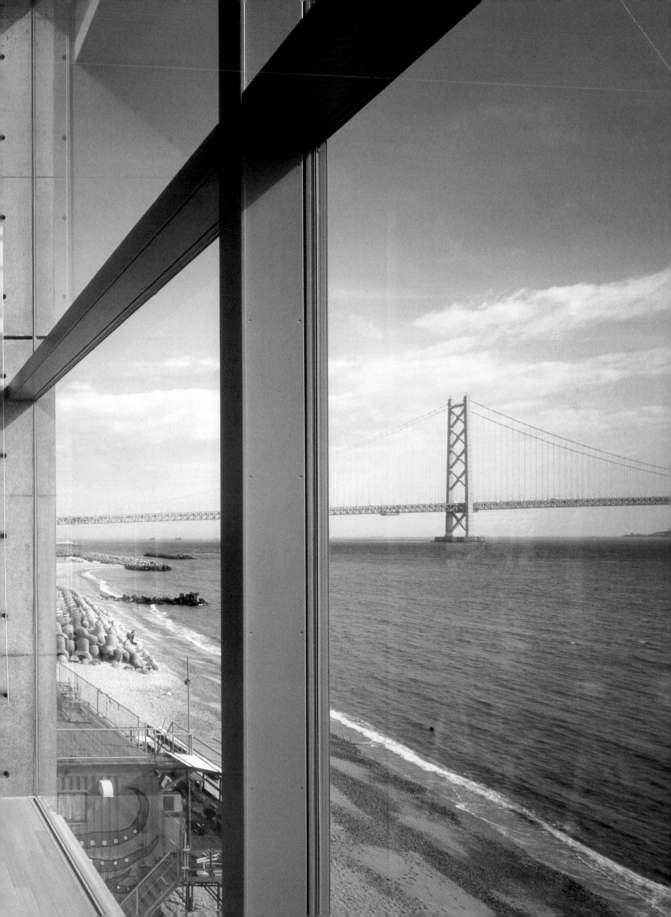

An Indian encampment in Colorado

Denver Airport

CURTIS W. FENTRESS

Denver, Colorado
Photographs: Timothy Hursley, Nick Merrick

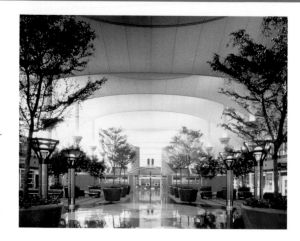

The airport is often one's first impression of a city, the way into it. And yet many airports are so similar in construction in different parts of the world. Though they are among the few building types that show a strong link to the landscape around them, capable of being seen from the air from a truly long distance. Denver Airport exploits that integration of structure and site by adapting to its surroundings, especially in regard to size. Early sketches interpret the pointed peaks of the Colorado mountains in a poetic image of welcome to the city of Denver.

Eschewing unnecessary devices, the project tends toward the utmost simplicity: an elongated central space, with a large lobby arranged on different levels according to func-

Opposite: The airport's roof of stretched canvas uses one of the oldest techniques known to humanity for shelter from the weather.

Opposite below: Longitudinal elevation of the airport, showing basements and canvas roof

Below: View of traffic access to the terminal

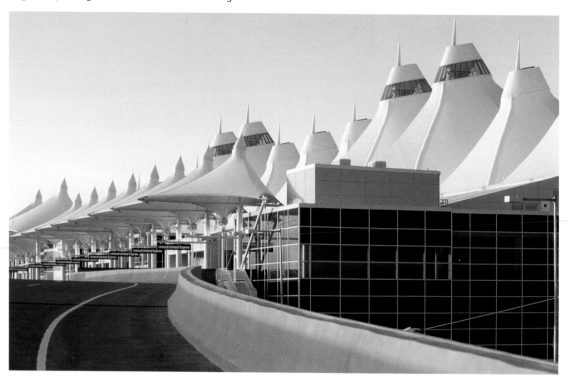

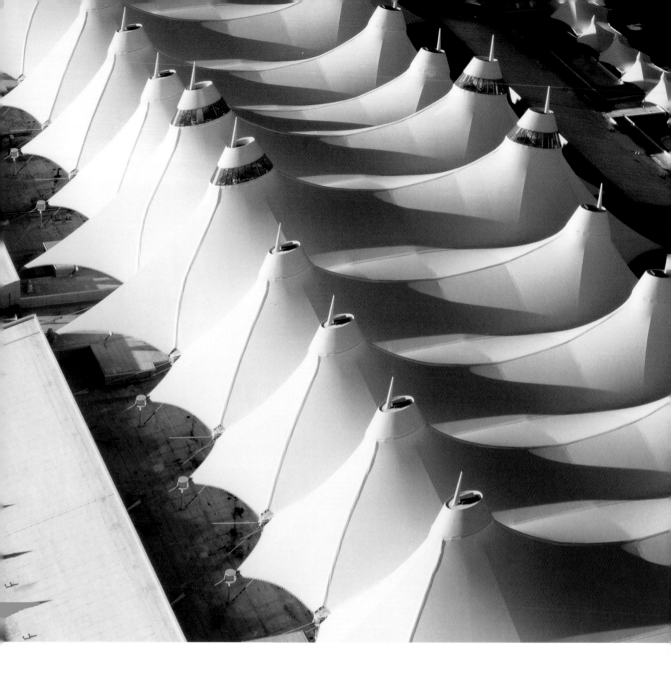

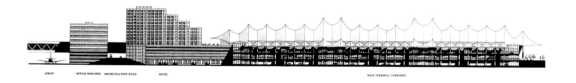

APRON OFFICE BUILDING RECIRCULATION ROAD HOTEL MAIN TERMINAL CURBSIDES

WEST ELEVATION

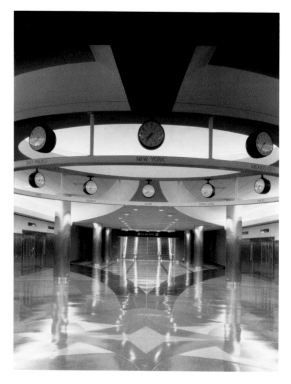

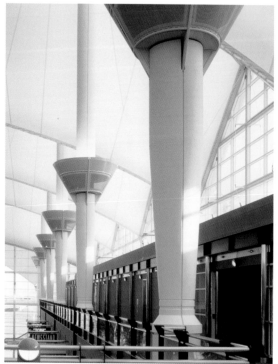

Above: Two different images of the lobby

Right: Daytime and night views of the airport and its integration into landscape

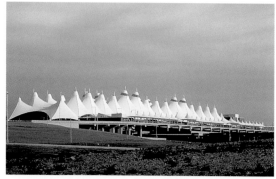

tion. On either side, three blocks of several stories are devoted to parking. The spaces between the blocks, reaching the lobby, connect the different levels of the terminal. The roof of the central lobby is an enormous canvas tent held up by two rows of pillars and tightly stretched. Direct access from the outside is gained through two roadways for traffic at the upper level, flanking the lobby above the parking levels. Along each of the two roadways is an entrance porch, also covered in canvas. The image of the airport is thus defined by its two aspects: a large basement of three or four stories with a compact concrete form, and an open space covered with canvas. Throughout the day, the basement remains shaded; and the white canvas roof remains the focus of attention of the entire project.

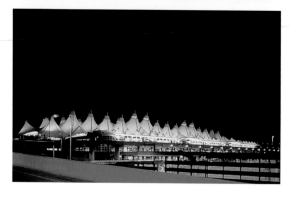

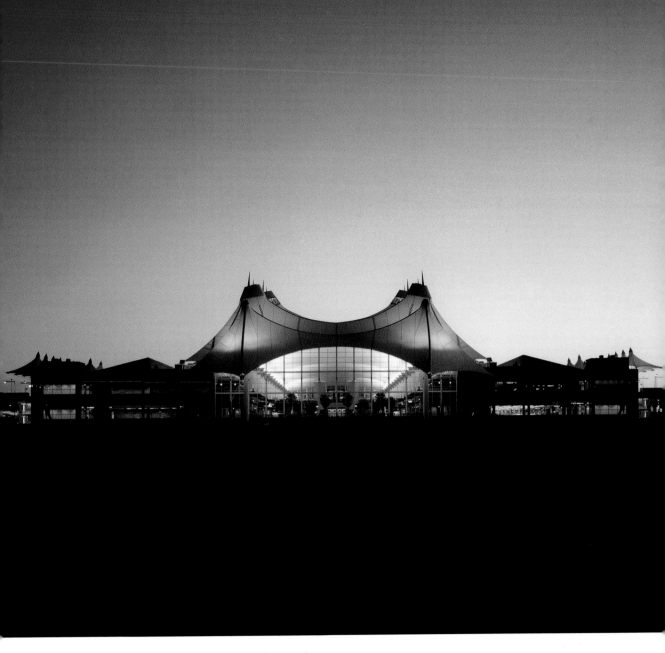

Above: Exterior view of the large central lobby at evening
Below: Transverse elevation of the airport

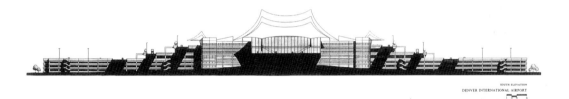

SOUTH ELEVATION
DENVER INTERNATIONAL AIRPORT

In a village of the Mesa

Mesa Public Library

ANTOINE PREDOCK

Los Alamos, New Mexico
Photographs: Timothy Hursley

This project is situated in the Jemez mountains of Los Alamos in an area of pine forest, green meadows, and spectacular rock formations. The place has been of special historic and cultural interest since ancient times. It has seen Native American settlements used to graze animals, 19th-century farms established by the government, as well as the site of the Manhattan Project during the Second World War. The design explores sculptural abstraction without overlooking its integration into nature and the landscape.

The body of the library fills two floors and follows a curve that permits attractive views to the north to be enjoyed. A large wedge of stone cuts the building in two,

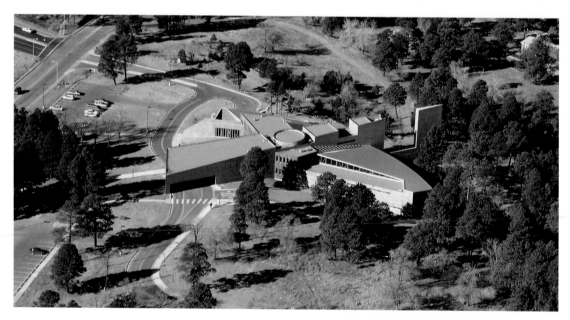

Above: Bird's-eye view of the library

Opposite: Frontal view of the dividing wedge

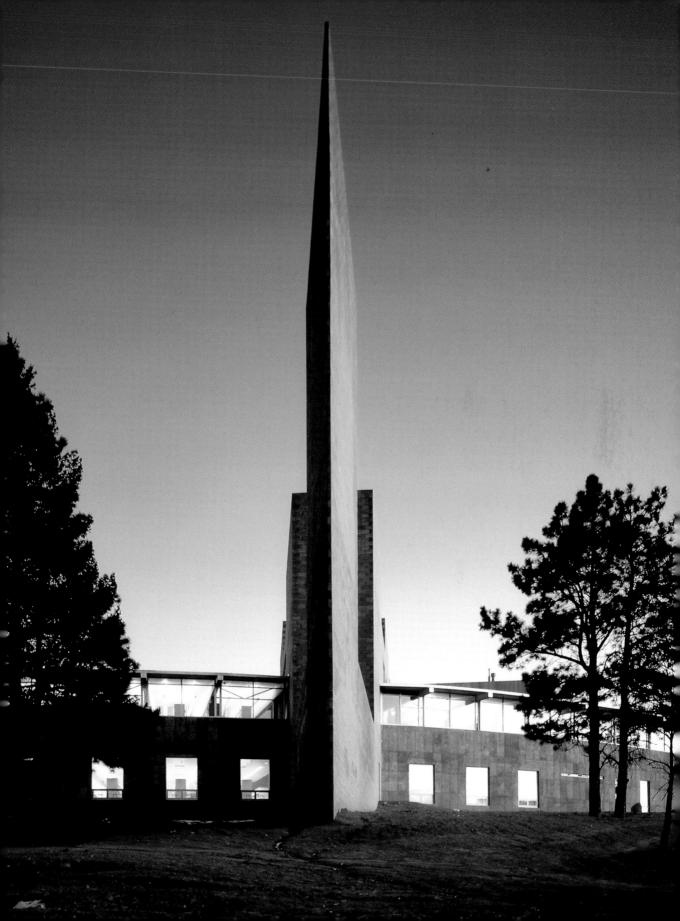

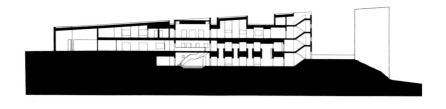

0 5 20 40

Top: Section of the wedge

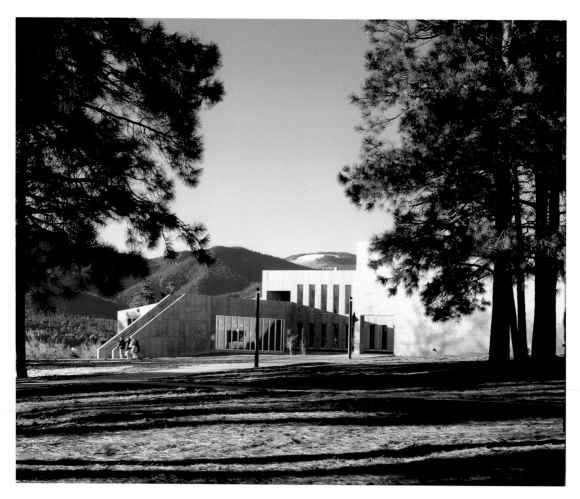

Above: Exterior view of the access

Opposite: Interior view of the skylight and shelves

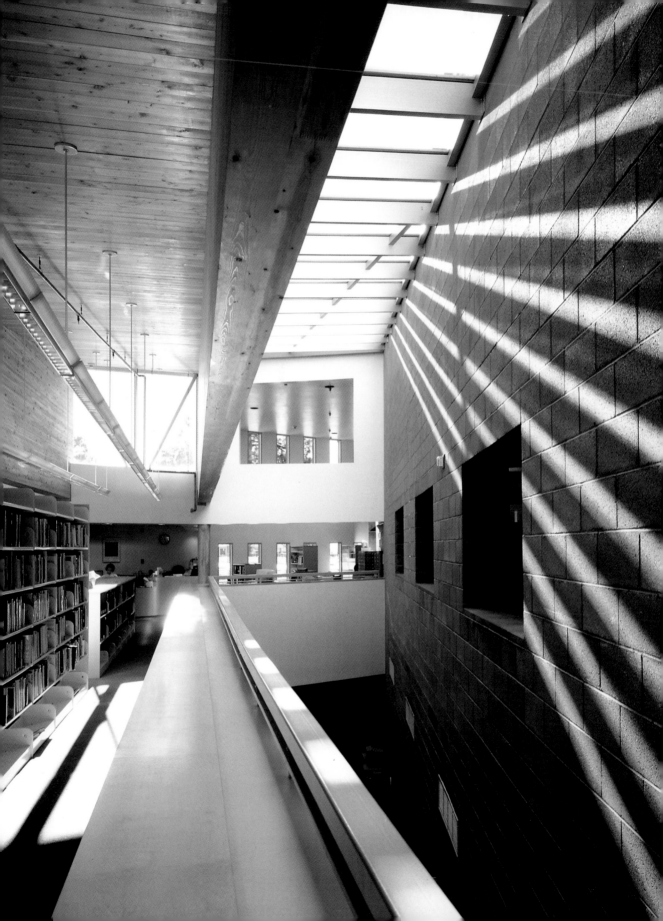

bringing to mind the nearby rocks of Turfa. Here, we find a large courtyard that forms the real access to the building. One arrives by the path leading to the large entrance that offers protection from the rain and snow typical of the cold winters in Los Alamos. In the access body, we find the lobbies, staircases, meeting rooms, and areas for reading in private. The curved volume forms a space exclusively dedicated to bookshelves. The main characteristic of this library, in contrast to others, is that it does away with everything else to take the reader directly to the shelves in front of the window. A skylight oriented to the south allows sunlight to illuminate the shelves; and the continuous window on the northern façade permits the visitor to enjoy the views of Pajarito Mountain. The use of material—concrete—is based on Predock's intent to create an organic unity between the building and the primitive constructions of its surroundings.

Below: View of the double-height lobby

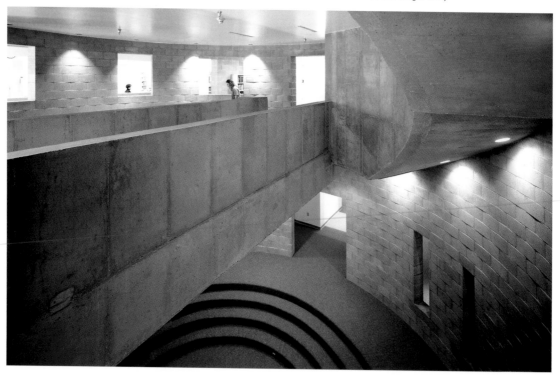

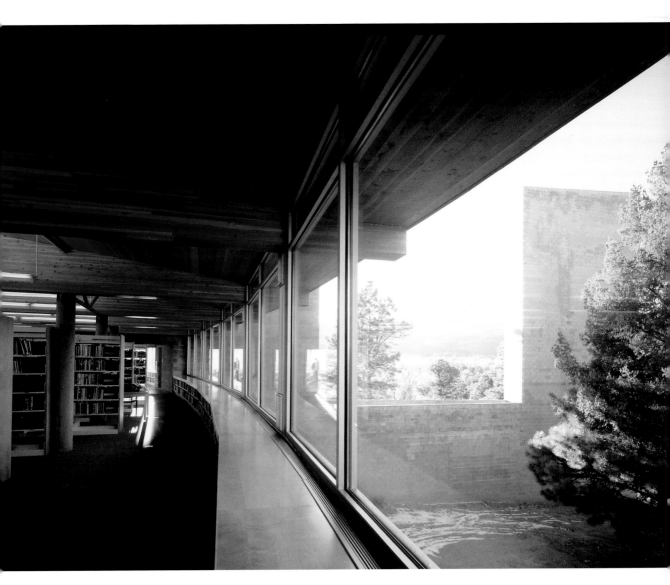

View of the continuous window to the north with tables and bookshelves

The Cave

Itäkeskus Swimming Pools

**HYVÄMÄKI-KARHUNEN
PARKKINEN**
Helsinki, Finland
Photographs: Voitto Niemelä, Jussi Tiainen

Historically, architecture in Finland has preserved a balanced dialogue with the landscape, making use of local skills and materials. That closeness has subsequently been incorporated and purified by different currents in modern architecture. The project described here belongs to the period preceding the breakup of the Soviet Union, when in view of a possible nuclear crisis, Finland undertook the construction of a series of covered public spaces. In Helsinki this idea also responded to the need for public swimming pools and baths in the eastern district of the city center. The Cave emerges as a magic landscape inside a mountain. As in a cavern, its ceilings reveal a rough white surface, recalling cloudy Scandinavian days.

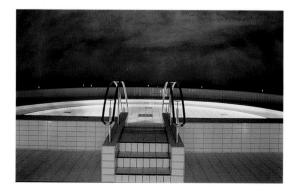

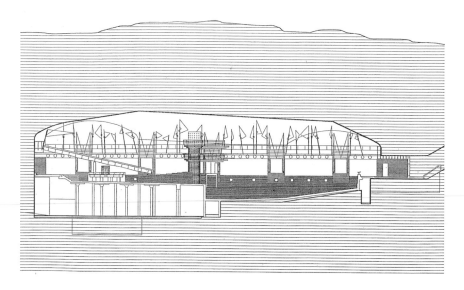

Above: Section of the completely underground leisure park

Opposite: Interior view of the swimming pool, showing the irregular treatment of the ceiling

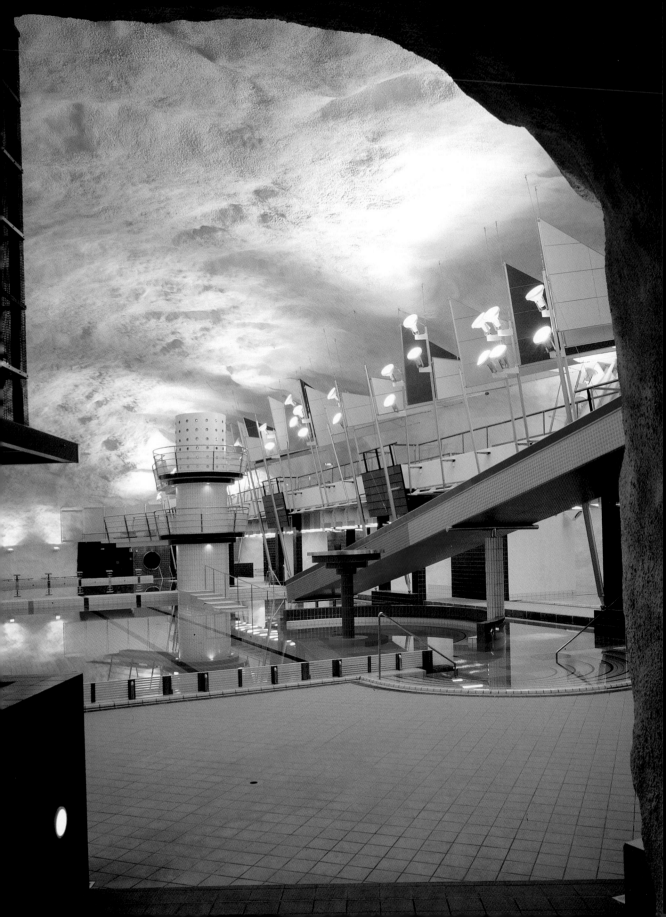

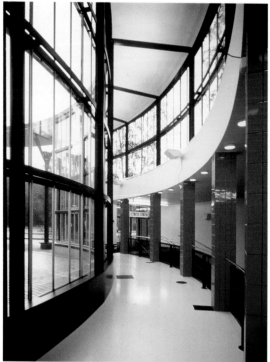

Left: Parking area at the foot of the mountain

Right: Interior view of the entrance, at street level

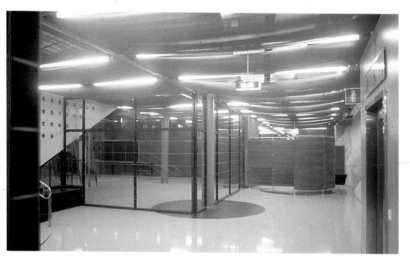

Above: The use of color and light endows surfaces with a rich variety of textures and shadows.

Opposite: The trampolines, slides, and walkways take on the status of landmarks in the enclosed space between the dome of the mountain and the swimming pool.

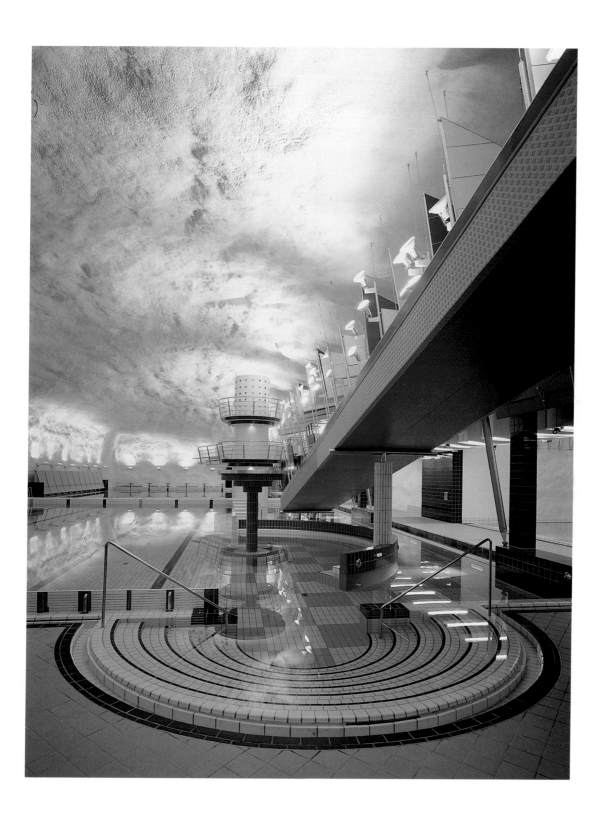

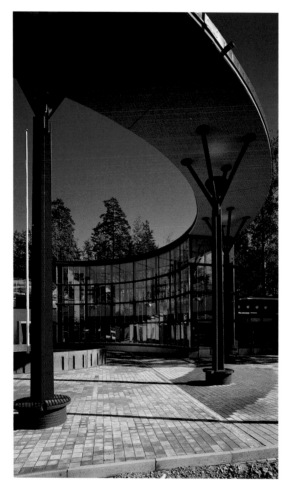

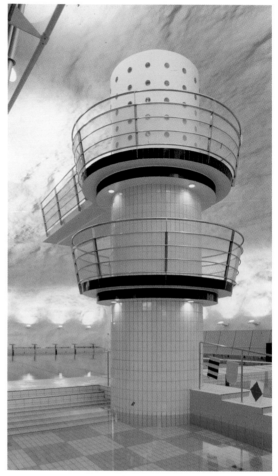

Left: The entrance emerges in the midst of a forest within the mountain. The rest of the building is buried underground.

Bottom left and right: Views of the interior

Right: Detail of the diving tower

Opposite: Given the lack of views to the outside, the interior evokes a landscape crammed with features.

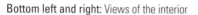

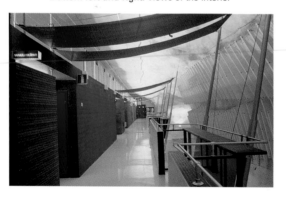

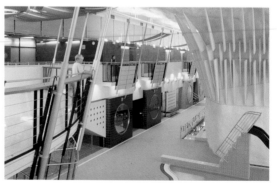

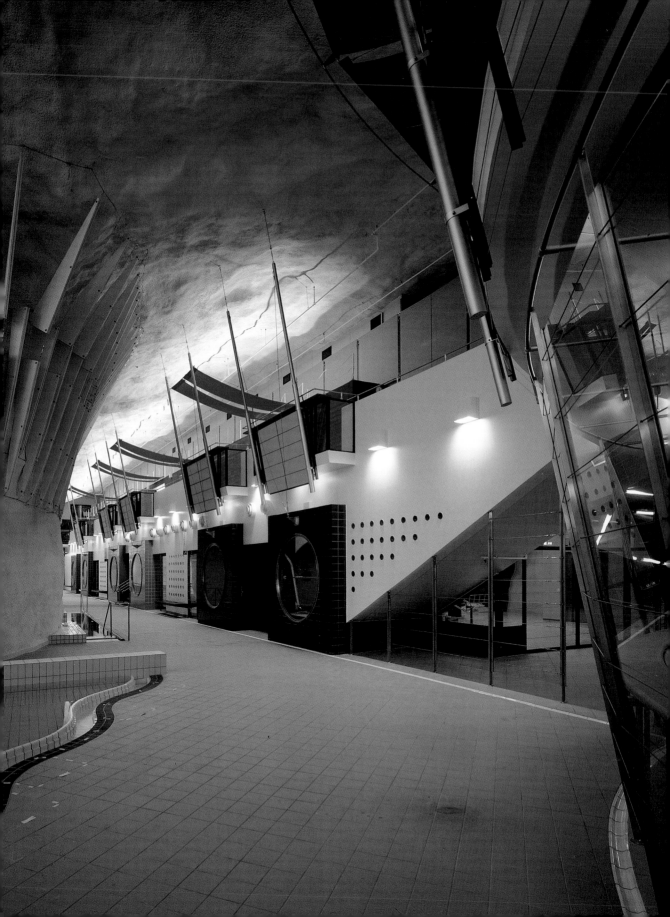

A pagoda in the museum

Museum of Modern Art and Wakayama Prefectural Museum

KISHO KUROKAWA

Wakayama, Japan
Photographs: Tomio Oshashi

Modern Japanese architecture has its origins in the International Style from 1950 onward, attaining a surprising expressiveness and formal intensity by integrating elements of traditional architecture. *Wakonyosai* follows that tendency, employing Western technology to contruct large complexes housing a great variety of activities on a larger scale than conventional buildings.

The Metabolist group, to which Kurokawa belongs, uses modern technology and residential design to express its particular vision of a society in continual evolution as well as to transform vital and technological processes. Recently, its views on the standardization of industrial society have centered on identity.

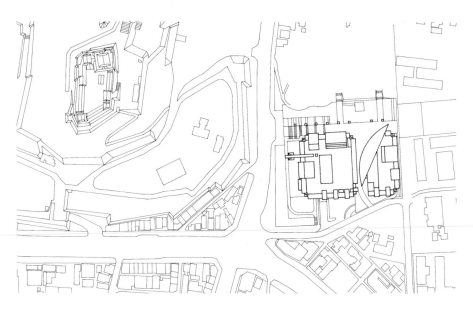

Above: Plan of the museum's site

Opposite: Image of the museum façade on the entrance side at night

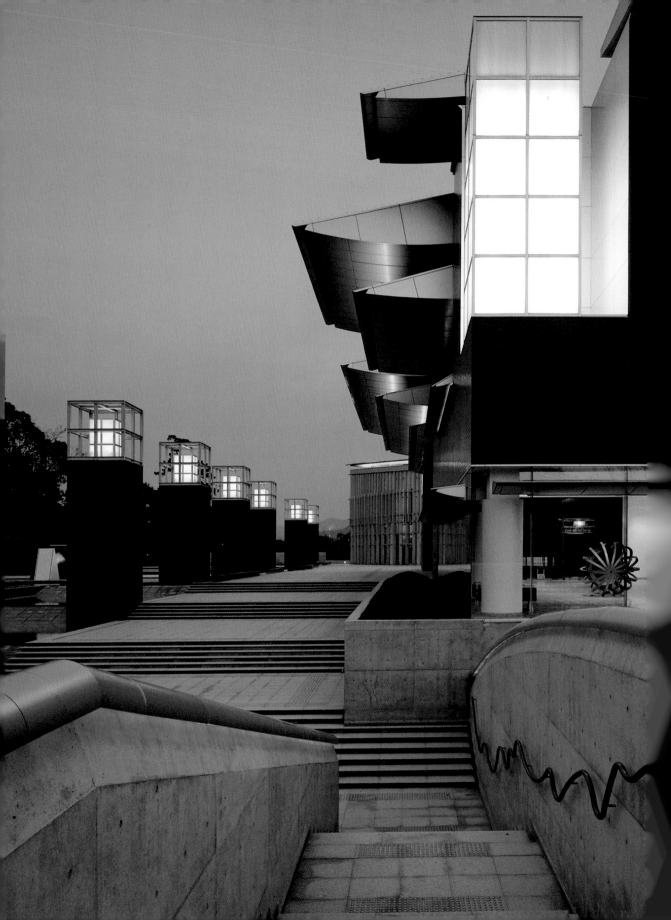

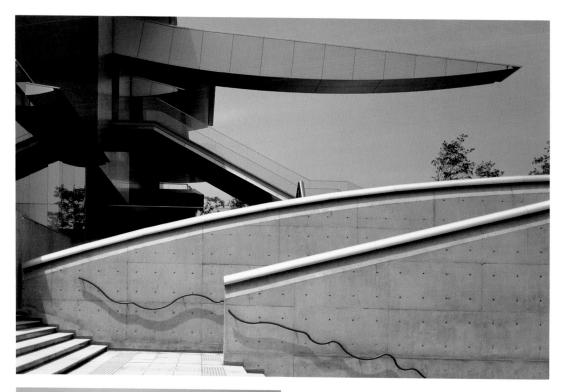

Above: Stairs leading to the main entrance, adorned with curves recalling the eaves of traditional Japanese architecture

Left: Detail of lamps

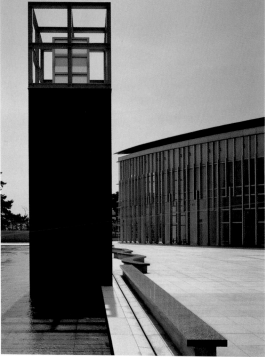

Opposite top: Vew of the complex at night

Opposite bottom: Cross-section showing the basement shared by the two museums

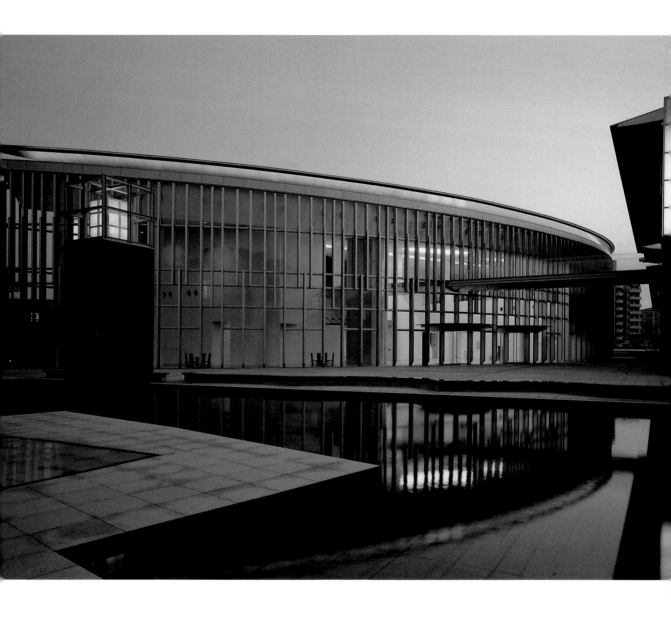

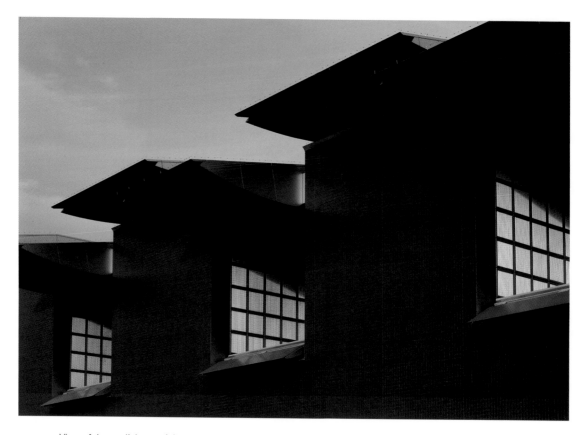

View of the top lights at night

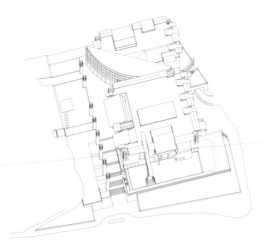

Above: Axonometry of the two-museum complex

Opposite: Entrance to the Museum of Modern Art, the larger of the museums

The museum is situated in gardens surrounding the Wakayama castle, a specimen of the architecture developed in the sixteenth and seventeenth centuries and restored after bombing in the Second World War. The project comprises two buildings, the larger of which exhibits international works of modern art in permanent and temporary exhibitions. The Wakayama Prefectural Museum, the smaller building, exhibits works of local and regional interest. The formal vocabulary of the design follows the dictates of *wakonyosai* and the Metabolist group, offering an abstract reinterpretation of traditional Japanese architecture through the use of modern materials that permit greater structural adventure. At the same

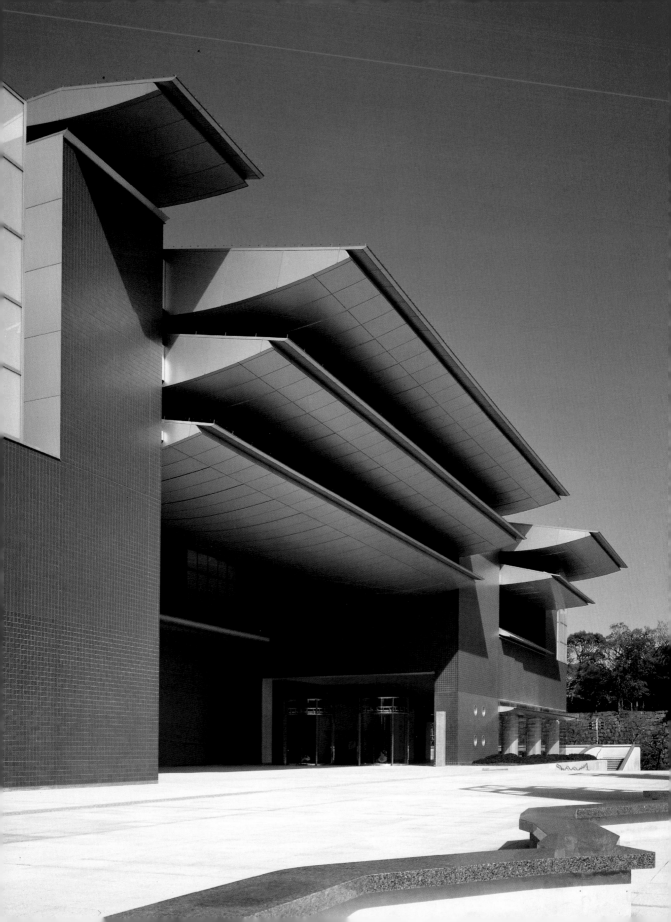

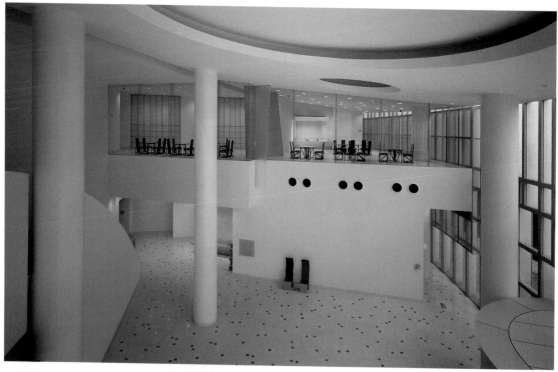

View of the main lobby and an exhibition room of the Museum of Modern Art.

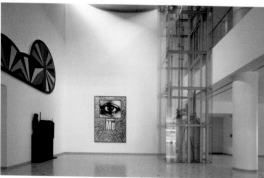

time, the architecture introduces the traditional *engawa* philosophy to create a space of transition and relation between indoors and outdoors. Between the two buildings is an empty space, which in the Japanese tradition expresses the essence of existence. Both the art museum and the regional museum employ a design of simple geometrical forms, where the simplicity and continuity of the ground floor is enriched by the façade, an irregular plan with insertions and projections that give it greater expressiveness.

Above: Plan of the basement level

Opposite: Detail of the roof eaves recalling traditional Japanese forms

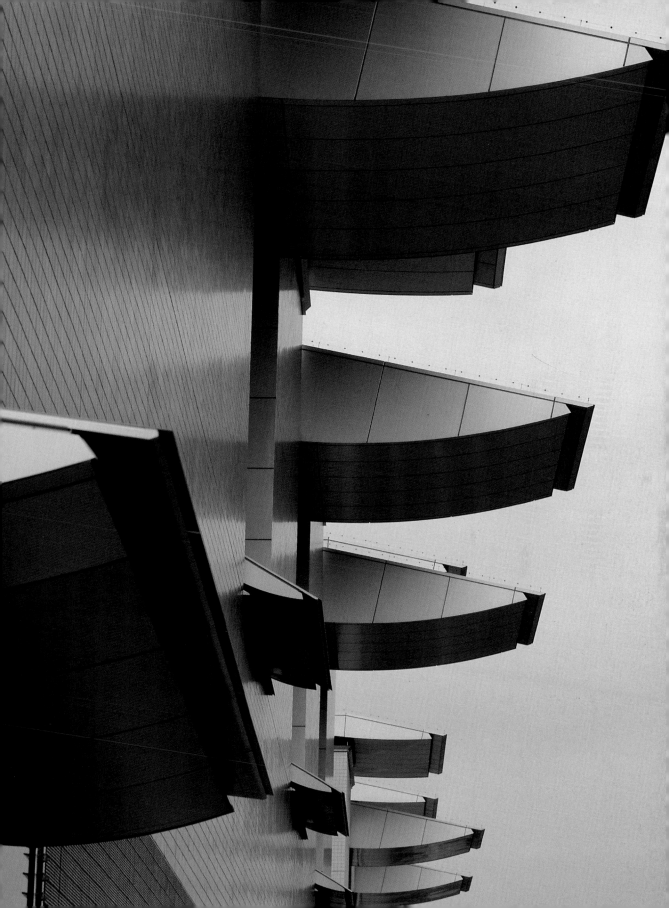

Where Is It?

Chichu Art Museum

TADAO ANDO ARCHITECT & ASSOCIATES

Naoshima, Kagawa, Japan

The Chichu Art Museum stands on the island of Naoshima—where Ando has built many projects since 1988—on a hill with remains of a salt mine, and 600 meters (1,968 feet) from the island's Museum of Contemporary Art. The Chichu museum contains a permanent collection of works by Claude Monet and the contemporary artists Walter de Maria and James Turrell, who collaborated with the museum's director in the design of the galleries. The design concept springs from the idea of burying the building underground to preserve the characteristics of the landscape facing the Seto Sea.

The building is arranged into gallery and entrance wings, respectively triangular and square, with voids in their

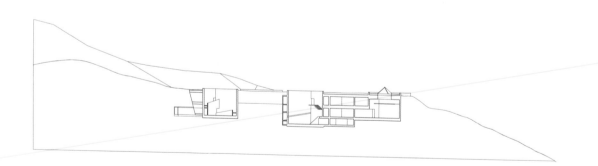

Above: Section of the museum complex

Opposite: Interior view of the museum

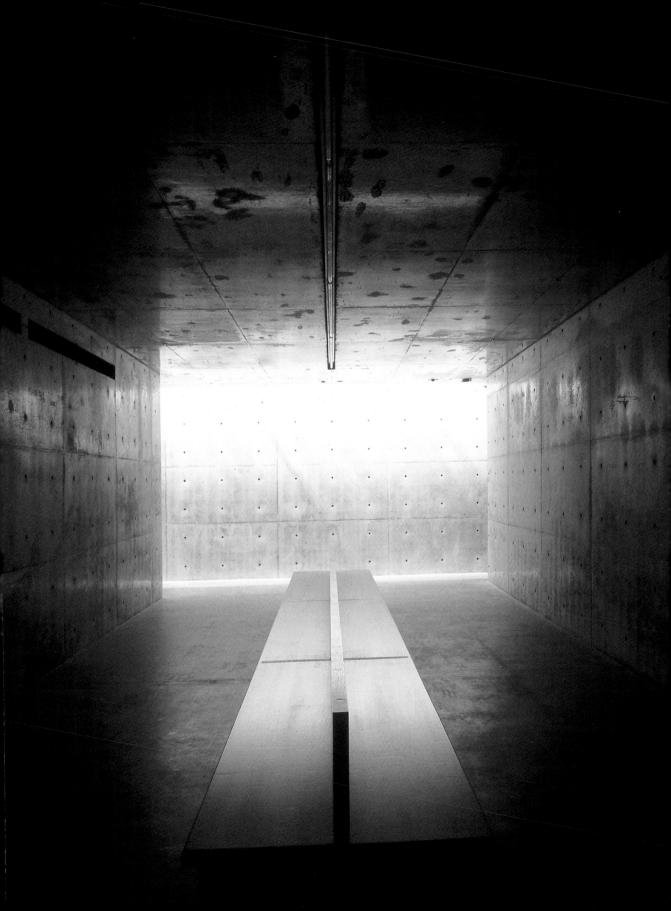

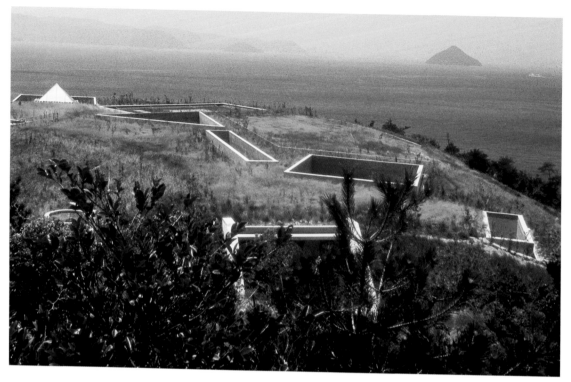

View of the hill, which is the roof of the building, with
Seto Sea in the background

centers. The two wings are joined by a doorway through a
passage closed to the side. On the summit of the hill are a
series of dispersed geometrical forms, which constitute
the only element integrating the buried building with its
landscape. Functioning as a roof, these forms provide light
and ventilation to the spaces situated on the first floor.

Above: Section of the site

Opposite: View of one of the inner courtyards

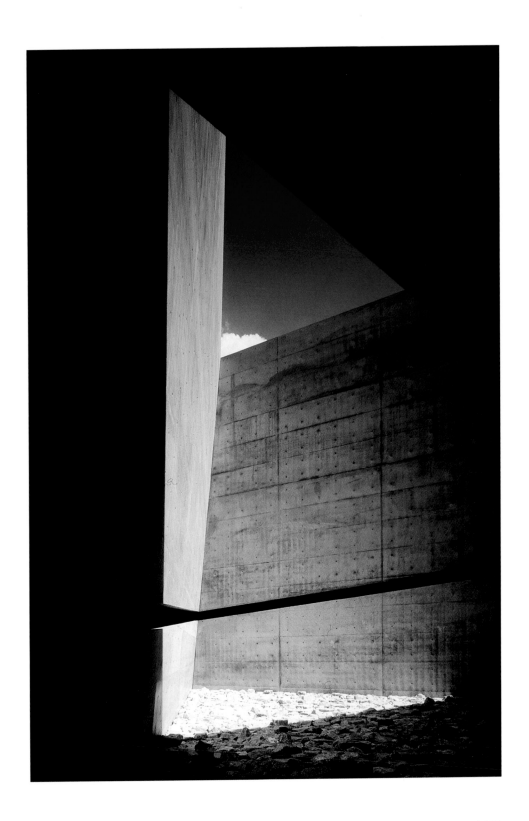

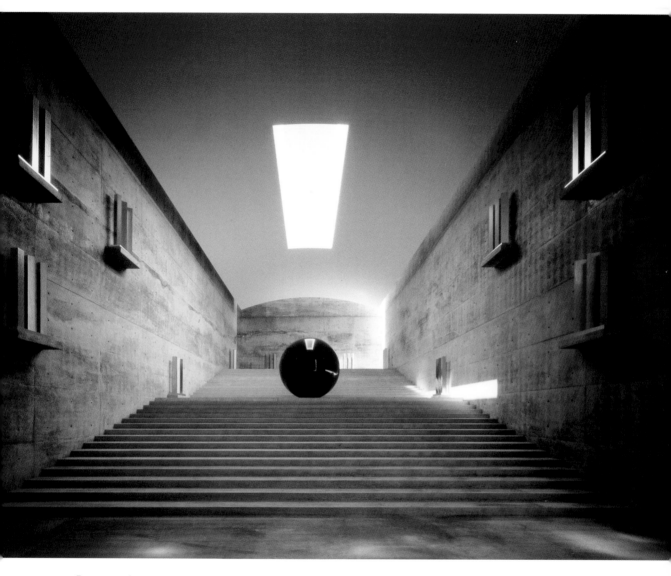

Entrance to the museum

Opposite top: Initial sketch of the setting

Opposite below: Axonometry of the museum

The function begins

Le Sémaphore

CHRISTIAN DREVET

Roussillon, France
Photographs: Eric Saillet

Constructed on the outskirts of the city of Roussillon within an area of reasonably heterogeneous structures, the building includes multipurpose theater installations that are used for functions, concerts, parties, and banquets. The motorway that cuts through the new residential zone abuts the building and brings new infrastructures into the resolution of the project.

Three architectural forms are especially significant: the luminous mast, the metal screen, and the parallelepiped. The mast anchors the building to its site, establishes a visual reference that is identified from the motorway, and introduces itself into the collective memory. The metal screen protects the east façade from the sun, defines the

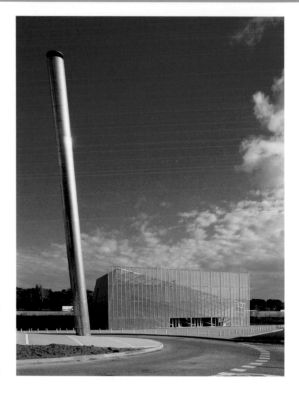

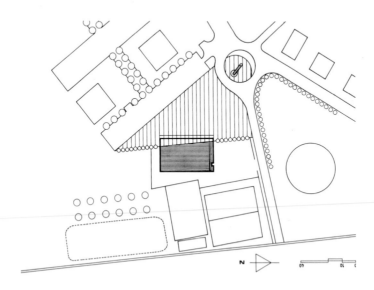

Above: Site plan of the building

Opposite: View of the building at night

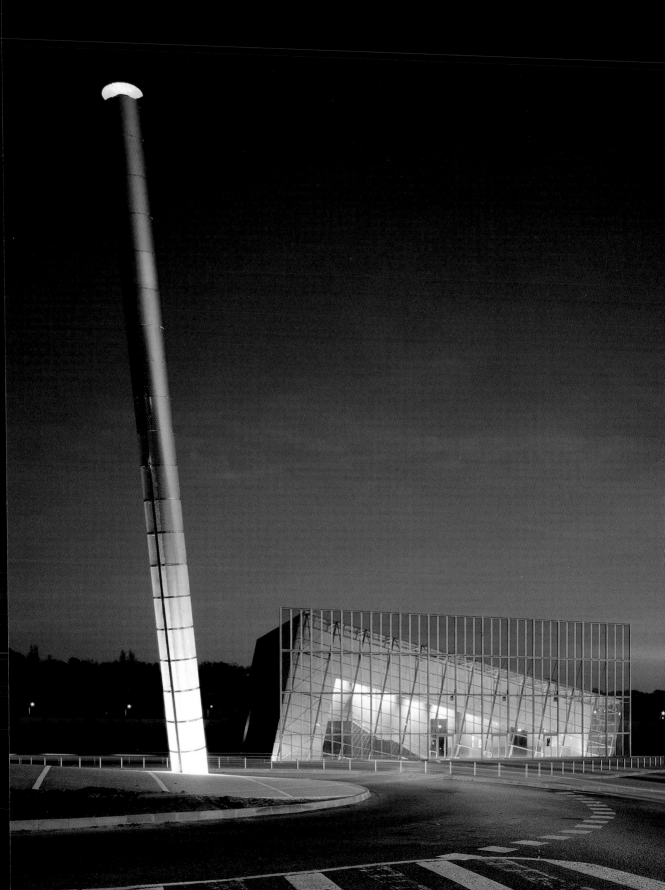

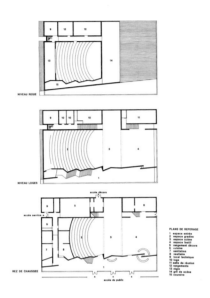

Floor plans of the building

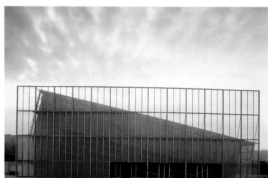

Above and top: Details of the façade

entrance, and creates a backdrop for the view from the approach road. Finally, as a mysterious volume dropping over the motorway, the partially buried parallelepiped accommodates the theatrical program and uses the inclined roof to distribute the different interior functions according to the spaces required. Behind the metal screen are a second skin of glass and behind that, a double wall forming a curtain. Each successive layer of skin is perceived as a different scenic plane and, according to the light, offers sensations and optical illusions. The architect's design of the interior was influenced by criteria for establishing good acoustics. At night, illumination of the building makes it possible to see the interior events from outside.

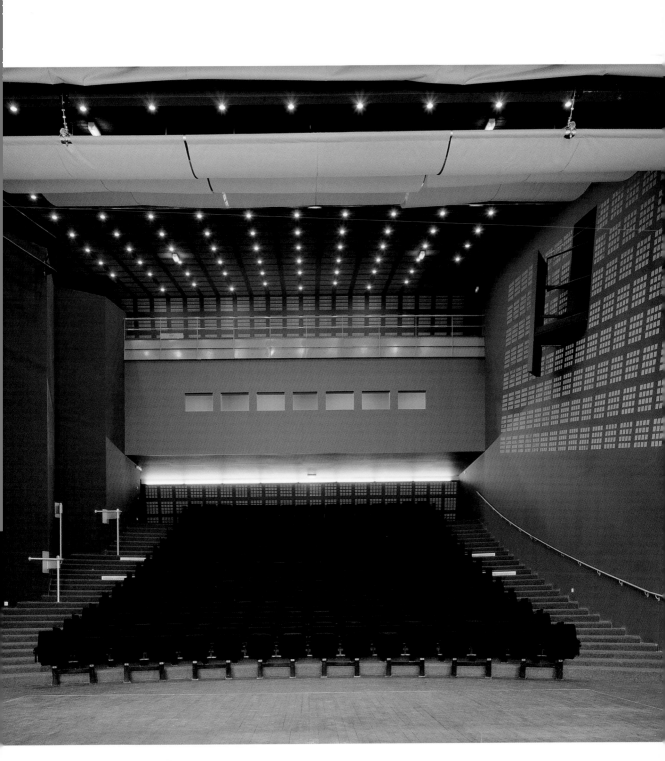

Interior view of the hall

Right and below: Details of the façade

Opposite: Details of the metal screen on the main façade

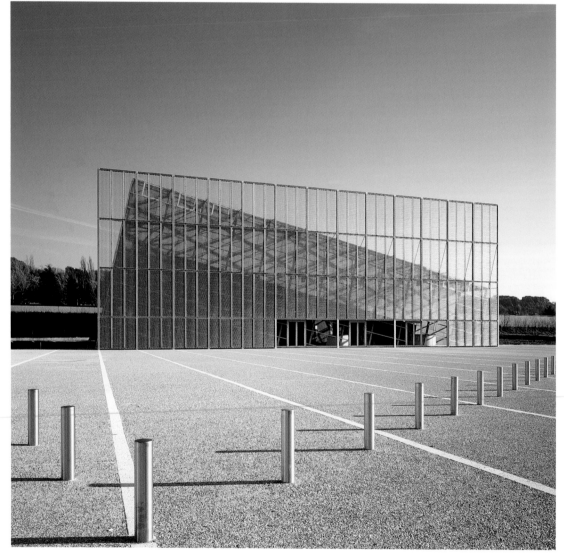

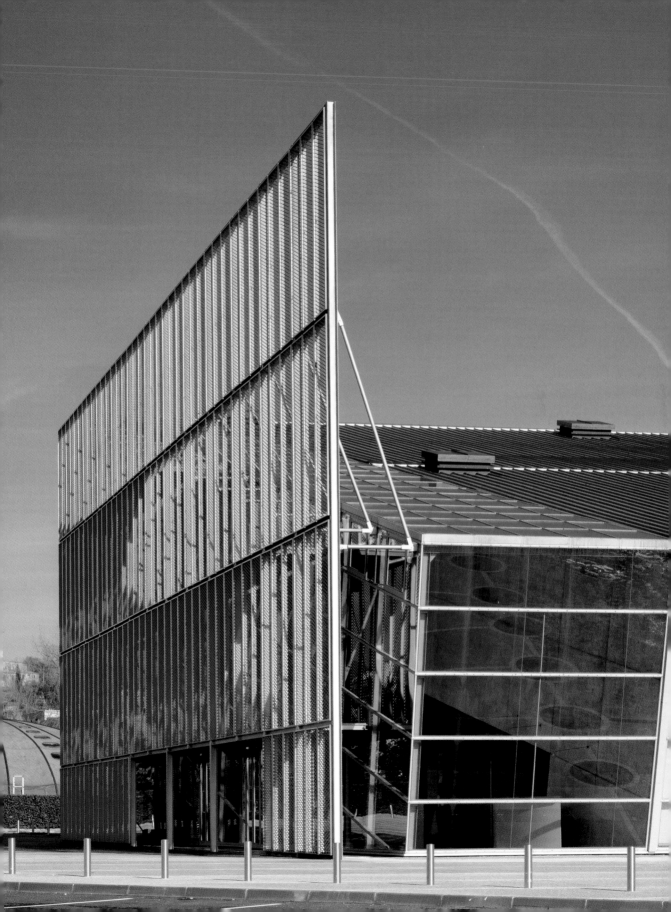

Top right: Detail of support for the metal screen

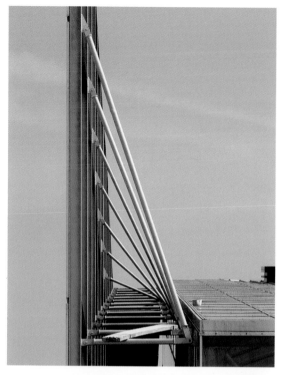

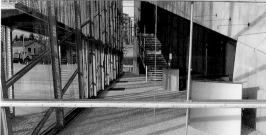

Bottom right: Detail of the space between the two first skins

Opposite: View revealing the space between the two first skins

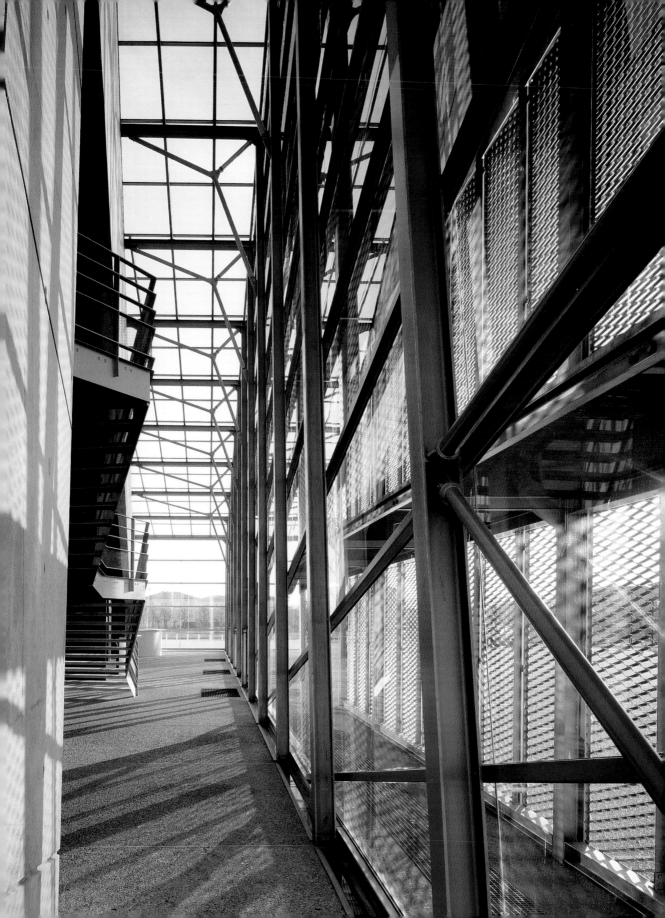

A plan from Perrault for Vienna

Urban Planning Donau City

DOMINIQUE PERRAULT

Vienna, Austria
Photographs: Dominique Perrault Architectes

The urban planning for Donau City in Vienna, along the Danube River, won an international competition in 2002. The proposal conceived of a program of offices, residences, hotels, retail and cultural buildings, restaurants, and parking facilities in a built area of 750,000 square meters (8,100,000 square feet) on a 160,000-square-meter (1,700,000-square-foot) plot. The proposal explores the construction of a new futuristic district crowned by skyscrapers that transform the Viennese skyline and modernize the international image of the city. The project also entails the construction of an enormous terrace that would form a base for the new horizontal line of skyscrapers, thus enlarging the horizontal surface area as well as the vertical. The intent is to make possible a physical contact with the water and thus bring urban life closer to nature.

Below: Night view of the district

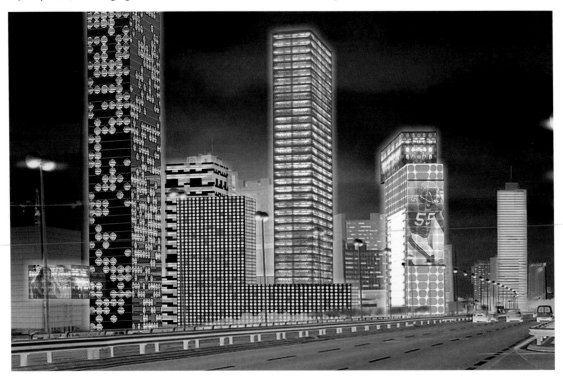

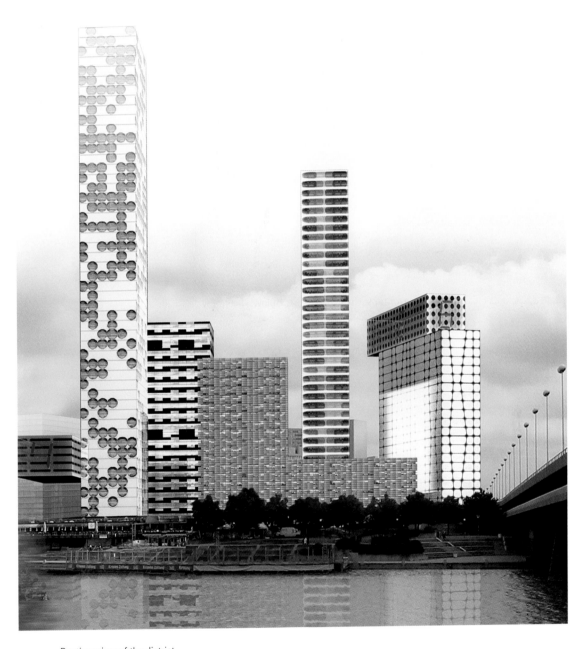

Daytime view of the district

Below: Bird's eye view of the district

Opposite: Night view of the proposed new district

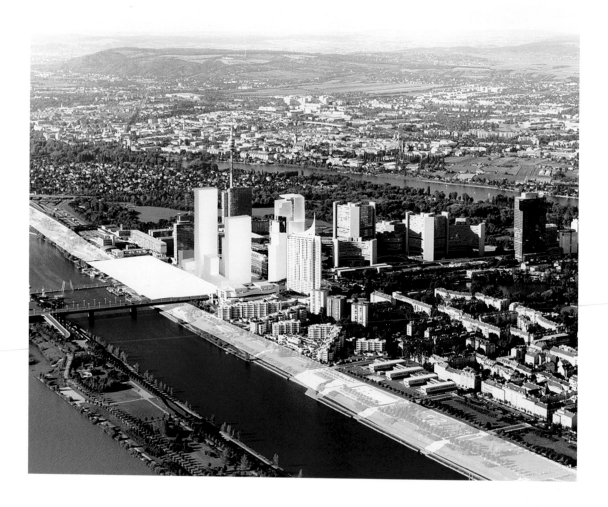

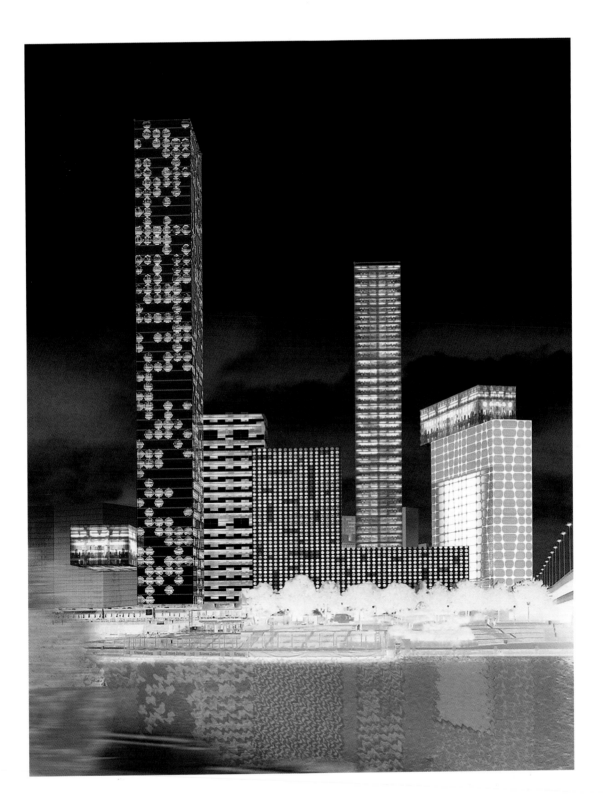

El tirachinas (The slingshot)

La Barqueta Bridge

JUAN ARENAS, MARCOS PANTALEÓN ING. AUXIDESA
Seville, Spain
Photographs: Fernando Alda + Archivo fotográfico de Expo 92

Since rivers flow through cities and towns, they create the need for numerous urban routes to accommodate them, including bridges that often become symbols of the places in which they are built. The city of Seville is traversed by the Guadalquivir River, and the city's activities are highly dependent on the construction of bridges to span the river. La Barqueta, which was originally conceived as a simple footbridge, serves as the link between the city's historic center and the island of La Cartuja—the site of the 1992 Universal Exhibition known as Expo 92; the bridge is thus the point of access to that site.

Its simplicity of construction is the bridge's outstanding

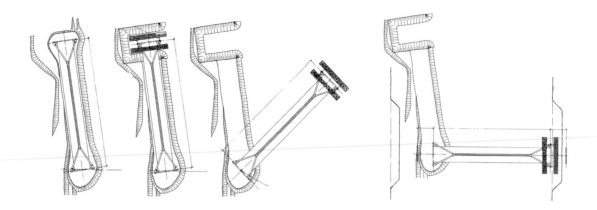

Sketch (above left) of the phases involved in unloading the bridge and (above right) rotation for setting it up *in situ*.

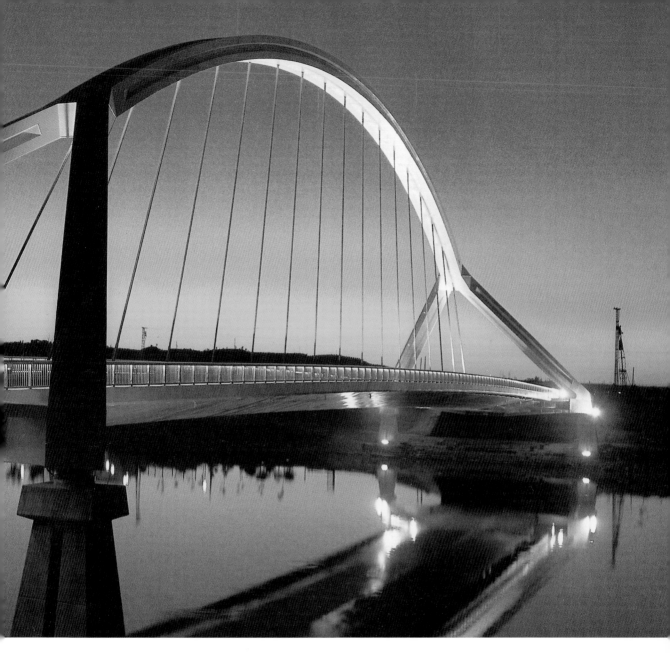

View of the bridge from the riverbank at evening, revealing spread of the arch toward the ground, and the single line of tensors in its center

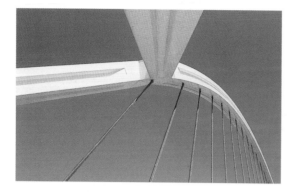

Top left: Detail showing attachment of tensors to the metal arch
Below: Detail showing bridge on riverbank

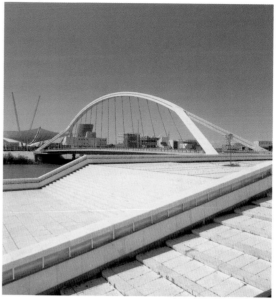

Top right: View of the entire bridge from a riverbank

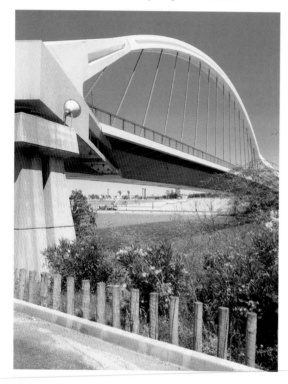

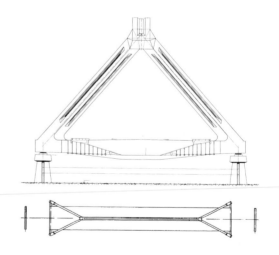

characteristic, defined by an arched metal structure and tensors emerging from its central segment, preventing all visual interference. At its edges, the arch divides into two arms that rest on support pillars, stabilizing the entire structure transversely despite the slenderness of the arch's section—180 centimeters wide; 270 centimeters high (70 inches by 106 inches). This structural decision is exploited formally to frame the points of access to the bridge, permitting vehicles to cross it.

Above: Plan and elevation of the bridge, showing the two support arms

Opposite: Detail showing anchorage of the tensors in the bridge's causeway

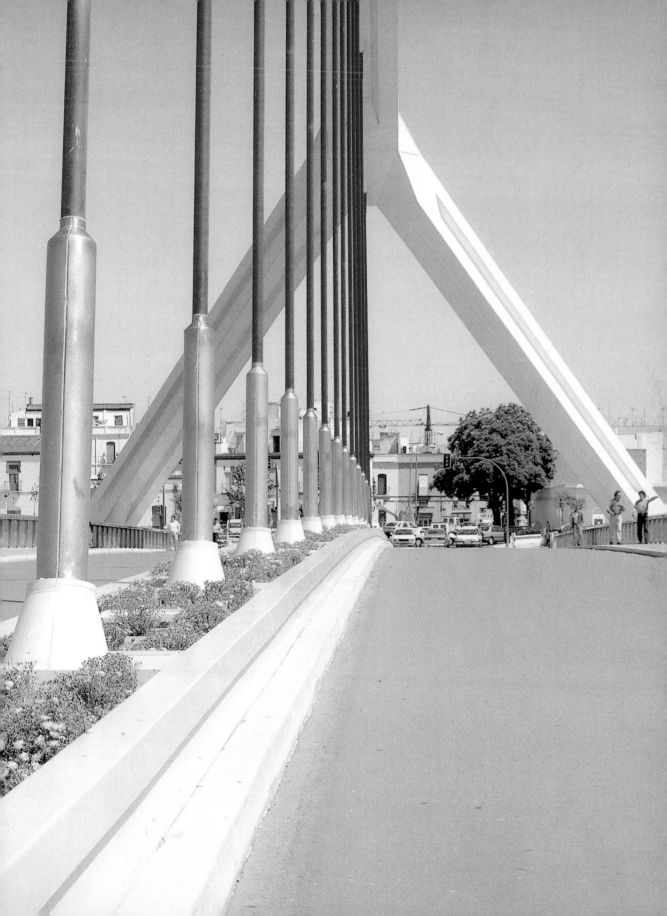

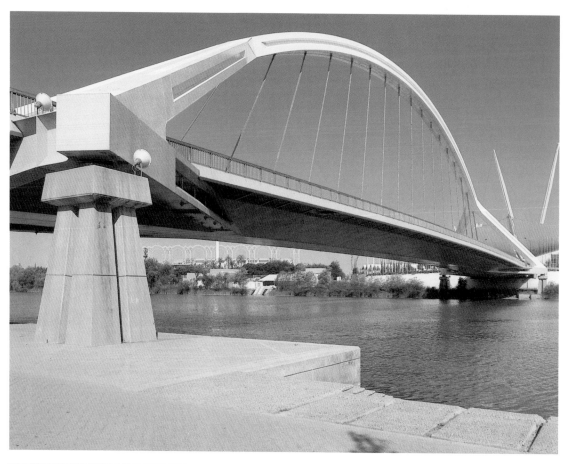

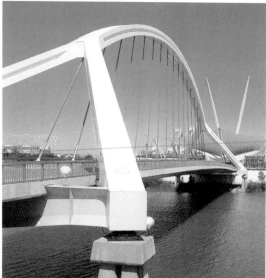

Above: View of the entire bridge at water level, from one of the riverbanks

Left: View of the bridge from the causeway; with the Expo 92 complex in the background

Opposite: Detail of bridge's support pillar on the riverbank showing the metal structure that undergirds the two arms of the bridge

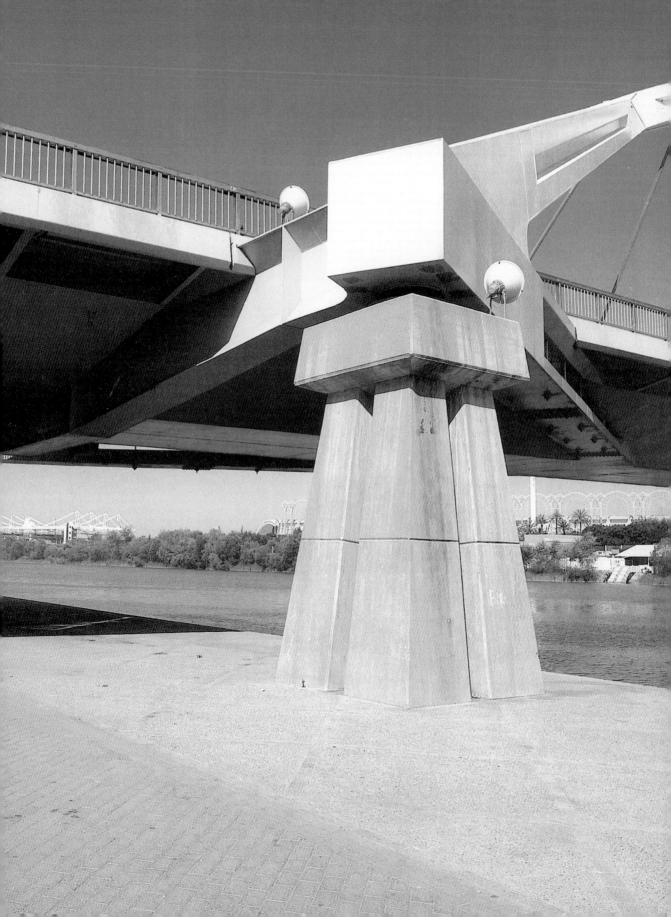

The colors of a toothpick and a ribbon in the wind

The Höfðabakkabrú and Kringlumyrar Bridges

STUDIO GRANDA

Reykjavik, Iceland
Photographs: Sigurgeir Sigurjónsson

Höfðabakkabrú Bridge is part of the communications network of Reykjavik. The use of a reasonably formal language manages to simplify the structural complexity of this project, which addresses the functional criteria of vehical transport with engineering logic. The structure is in pretensioned concrete and formed by a platform supported over pillars. Three central ribs absorb the vibrations of the vehicular traffic. The main preoccupation of the authors was to reduce the impact of the size of the structure—1,850 square meters, with a span of 37 meters and a width of 36 to 60 meters (20,000 square feet, spanning 120 feet by 118 to 197 feet)—in context. In contrast to the integration of the bridge in its topography and the use of

Opposite top: The colors of the pillars stand out against the darkness of the tunnel.

Opposite bottom: Aerial view of the junction

Below: Site plan of Höfðabakkabrú Bridge

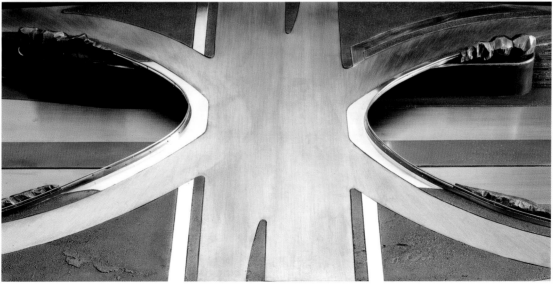

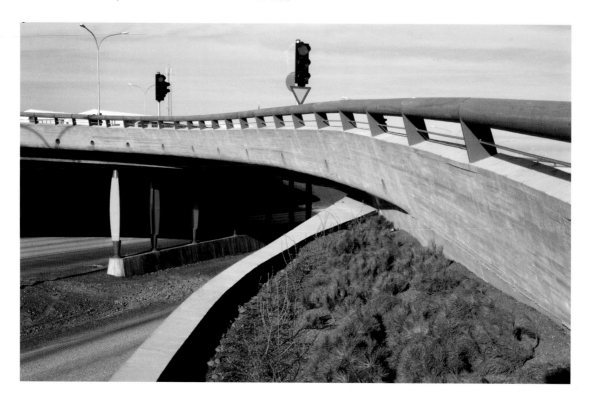

View of Höfðabakkabrú Bridge from a roadway

native vegetation, black artificial stone has been used to cover the walls, providing a background for the moving cars. In the same way, the central metallic pillars are painted in vivid colors that do not go unnoticed in the dark tunnel.

Also in Reykjavik, the Kringlumyrar Bridge serves to unite two zones of the city separated by the incursion of a highway. The bridge has been constructed so as to create a new recreational space for pedestrians and cyclists. The project deals with the highway by situating a green zone between two of the exits. The outline of the bridge twists and turns like a ribbon in the wind, an image that is accentuated by the metal screen on its northern edge that manages to reduce the impact on pedestrians of both traffic and strong winds.

Above: Site plan of Kringlumyrar Bridge

Opposite: Two images that reveal the winding line of the bridge over the highway

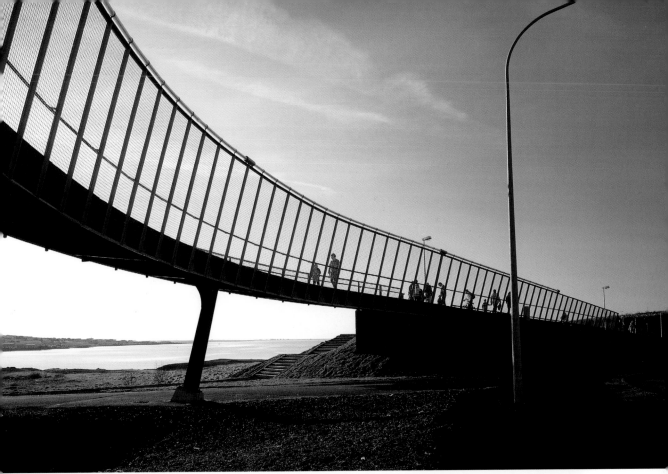

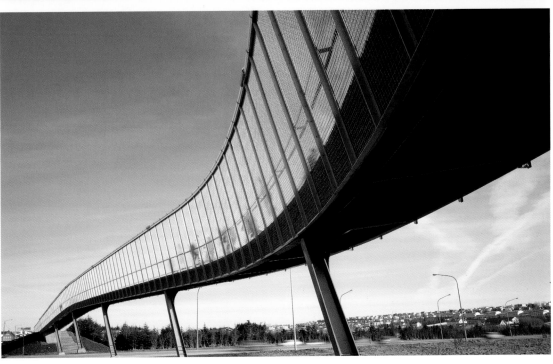

Hannover's new forest

Expo 2000 Hannover

VOLKWIN MARG ARQ.; JÖRG SCHLAICH ING., ARCHITECKTEN VON GERKAN, MARG & PARTNER; SCHLAICH BERGERMANN & PARTNER
Hannover, Germany
Photographs: Jürgen Schmidt

Ever since the appearance of Joseph Paxton and Charles Fox's Crystal Palace, international fairs have become a medium for communicating aspects of industrial progress as well as cultural and ideological meeting places of countries from all over the world. In the organization of Hannover 2000, more than 150 different countries were invited to present their points of view on the theme of "Man, Nature, and Technology" to some 18 million visitors. At the same time, thematic pavilions, cultural events, and shows were organized to run during the five months of the fair.

The rules of the announced competition to construct bridges within the fair precincts proposed projects for four bridges. The winning project, by Volkwin Marg and Jörg Schlaich, sought to frame the entrances—always in the open air—by planting a forest of luminous masts set in line as if they were a guard of honor flanking visitors as they passed through the precinct. The structure of the decks on the bridges was resolved by fixing a metal mesh to these masts.

Opposite: Daytime view showing the line of masts greeting visitors

Below: Site plans for the four constructed bridges

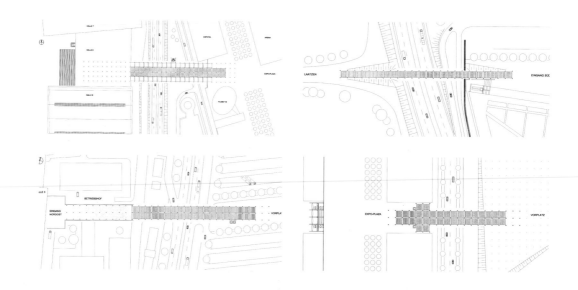

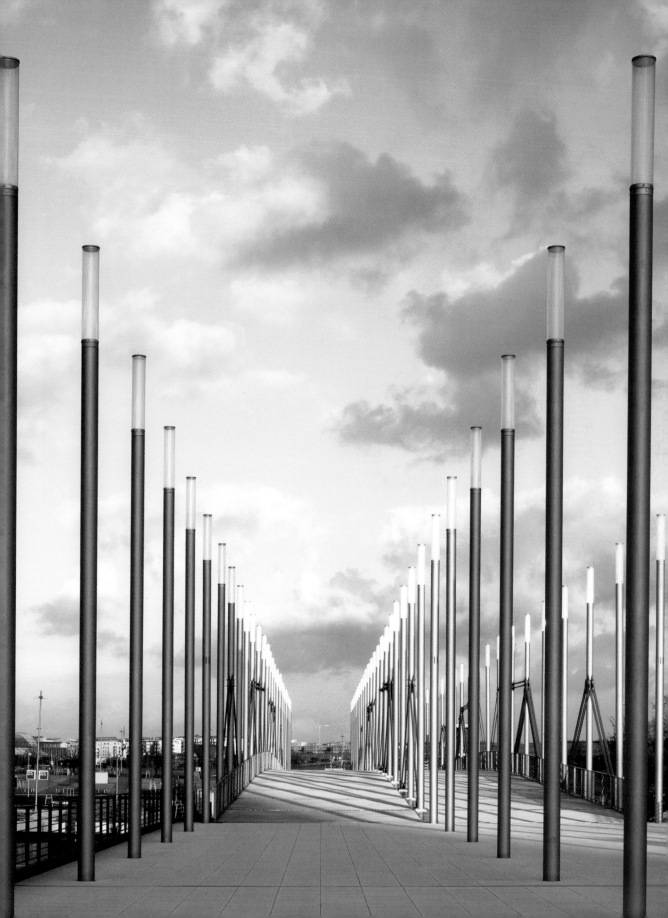

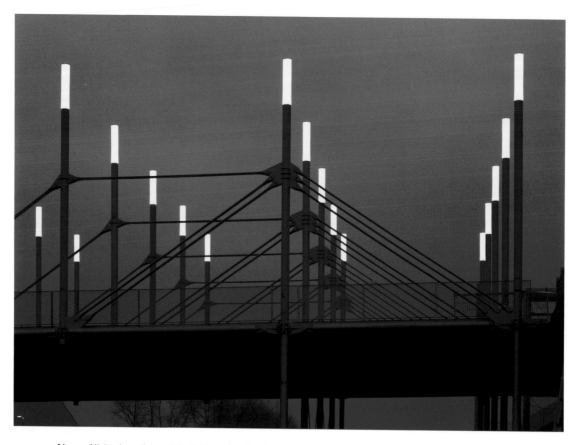

Above: Night view of one of the bridges showing the masts as lampposts

Below: Layout of the four bridges in the fair ground

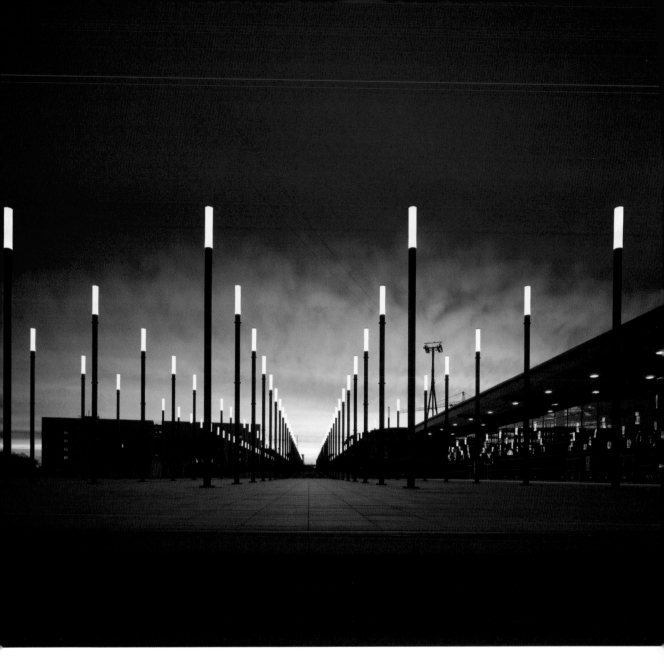

Above: The forest of masts at nightfall

Below: Elevation of one of the bridges

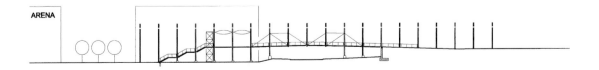

ARENA

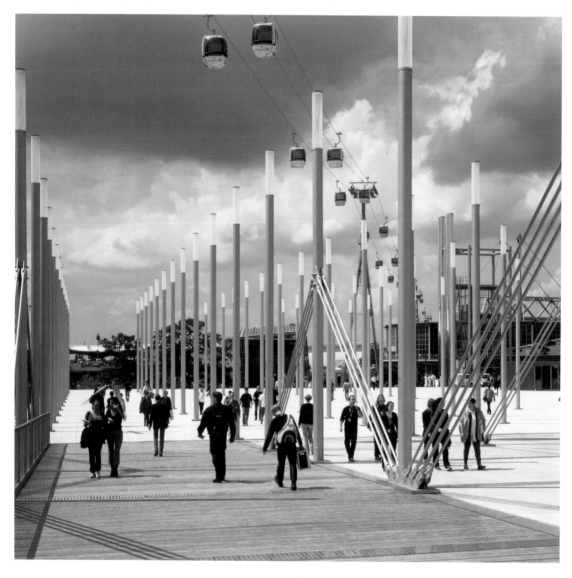

Above: Image showing the scale of the forest of masts

Opposite: Detail showing anchorage of the bridge cables

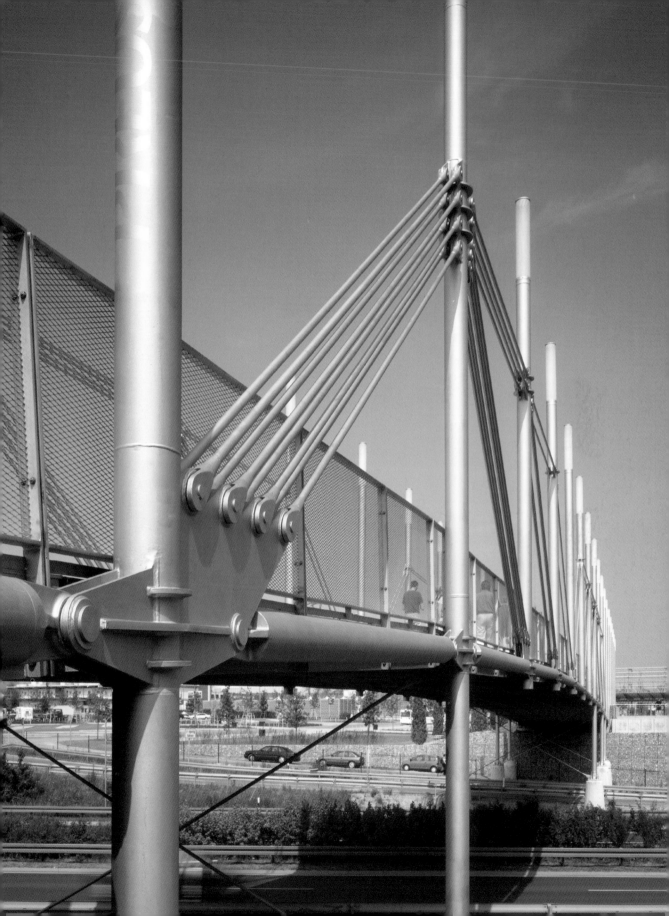

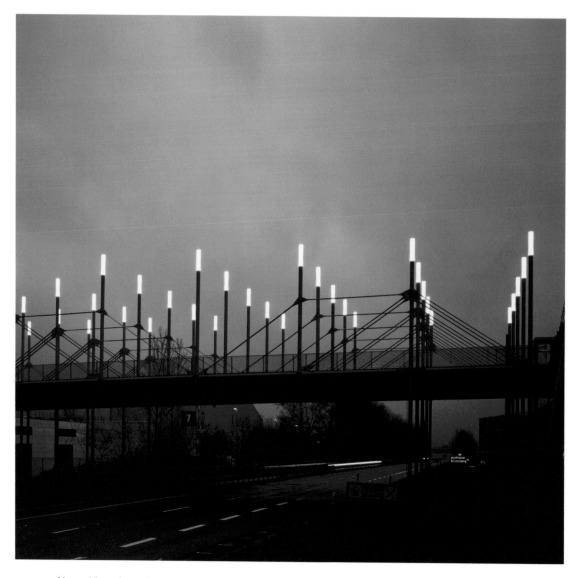

Above: View of one of the bridges at night

Opposite: An access to one of the bridges at night

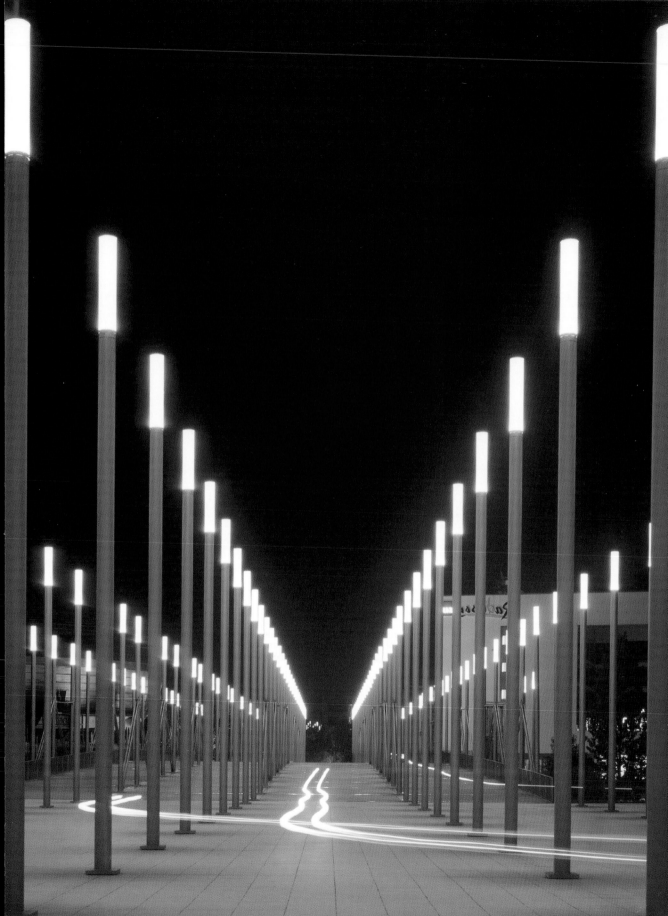

The new Bank of America, the new Charlotte

Bank of America

CÉSAR PELLI
Charlotte, North Carolina, USA
Photographs: Timothy Hursley,
César Pelli Associates

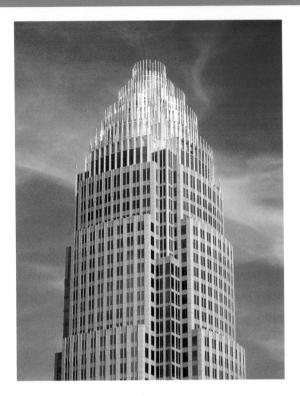

As well as being the corporate headquarters of the Bank of America, this building concentrates a great diversity of services in its base. Situated in the economic, historic, and geographical center of the city of Charlotte, its construction sought economic viability as well as the possibility of revitalizing the urban center of the city culturally and economically. The architect fulfilled his assignment and the building has become an icon for the city.

With the Bank of America tower as the principal attraction, a large public complex was created. The ground floor—occupying the entire block—accommodates a series of public uses. These include a hotel, two theaters, two landscaped plazas, and Founders Hall, a commercial and

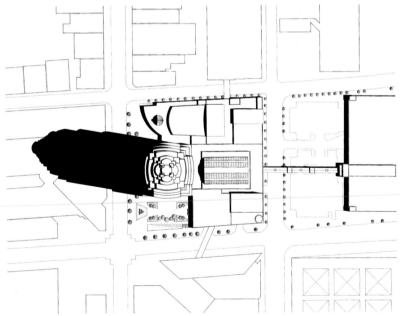

Above: Floor plan of the complex

Opposite: Perspective of the complex

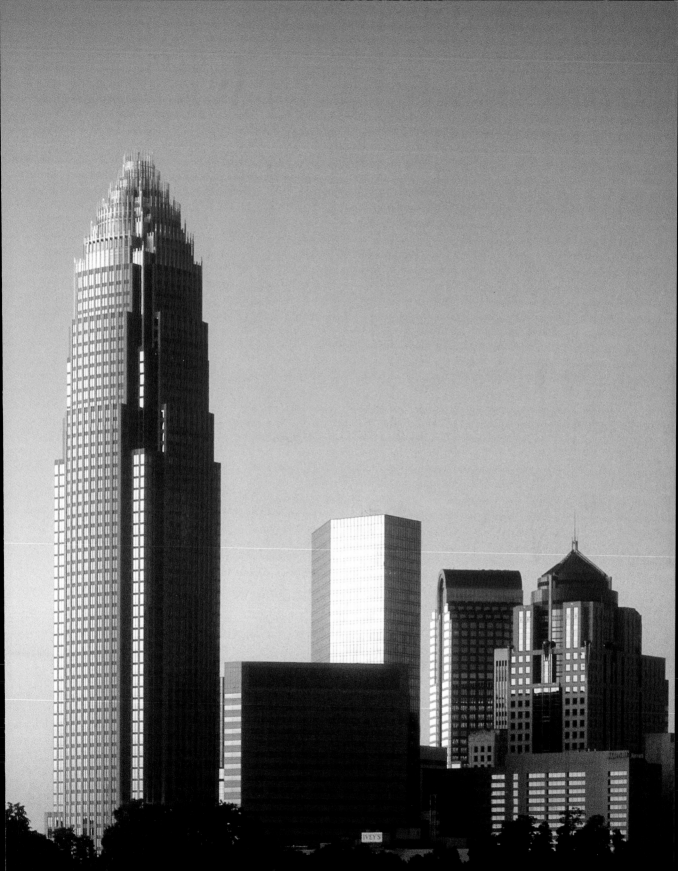

Above: View of the access area

Below: The new skyline of Charlotte

Opposite: Night view of the complex

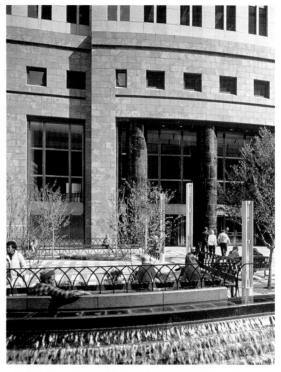

civic center, situated in the center of the tower. The public space is organized around a large atrium under a rectangular skylight that leads to retail premises, spaces for the North Carolina Performing Arts Center, and the pedestrian entrances to the main tower. A walkway that crosses the street is linked to the public parking lot on the next block. The same device is also employed to connect the interior of the complex with the surrounding street. A landscaped area provides a side entrance, which is resolved in classical volumes with curved floor plans. The solidity of the base of the tower, in dark granite, is lightened by the use of a large square grid in beige granite and hollows for the windows on the higher floors. The building is crowned with aluminum bars that reflect the sun as well as nocturnal illumination.

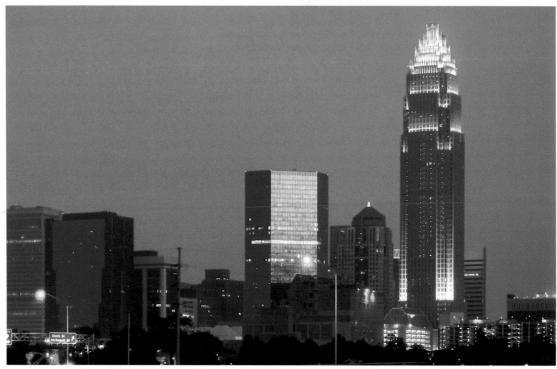

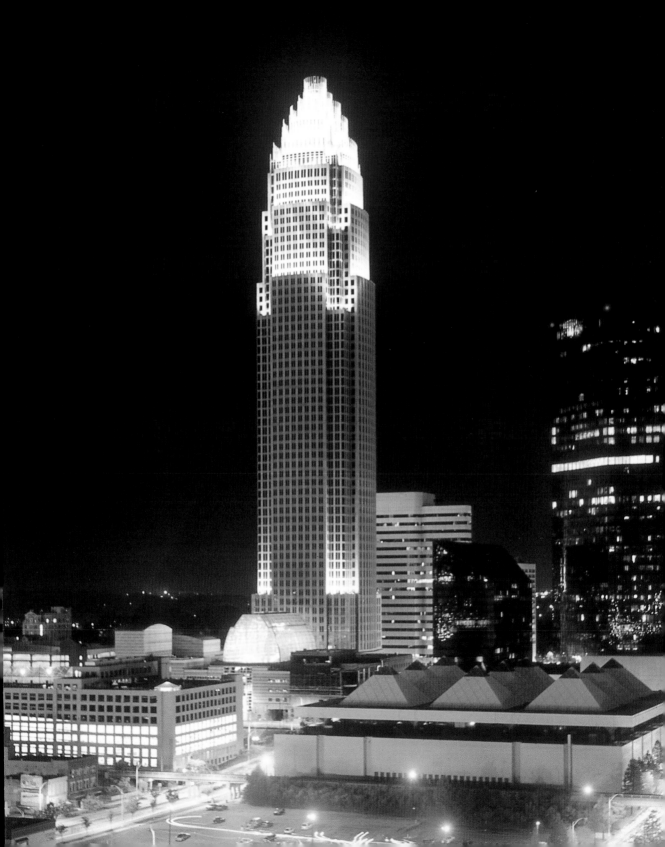

A lively forest

Stansted, Stuttgart, and Cologne:
The Airport as Forest

**VON GERKAN + MARG,
NORMAN FOSTER, MURPHY/JAHN**
United Kingdom and Germany
Photographs: Andrew Ward, Richard Davies, Richard Bryant/Arcaid

Following the latest trends in airport construction, the airports at Stansted, England, and Stuttgart and Cologne, in Germany, are using organic shapes to create structures that evoke forests. This appreciation for biomorphic forms, a cyclical phenomenon in the history of architecture, is reflected in a number of current airport proposals—for example, Kansai (using wave shapes), Lyon-Saint-Exupéry (birds), and Denver (mountains).

The concept of a pillar represented as a tree reappears in architecture, from the classical temple to the works of Gaudí and Victor Horta's wrought-iron work. In the metal forests of Stansted, Stuttgart, and Cologne, the pillars are trunks that fork out in a system of branches to the roof where the dense "foliation" filters the light, permitting only a few rays to penetrate. This design concept is symbolic of the technological era seeking its roots in nature.

Above: A tree in the interior of the airport

Above right: The forest adapts to current conditions

Opposite: Detail of an organic pillar

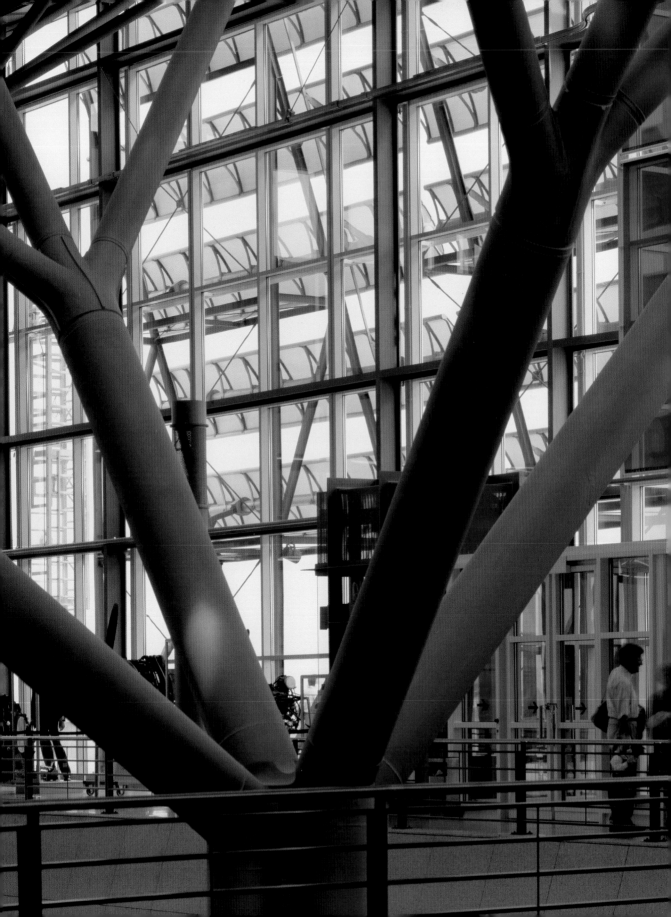

Above and below: Various details of the skylights penetrating the roof

Opposite top: Detail of the pillar abutting the roof

Opposite bottom: Scale model of the complex

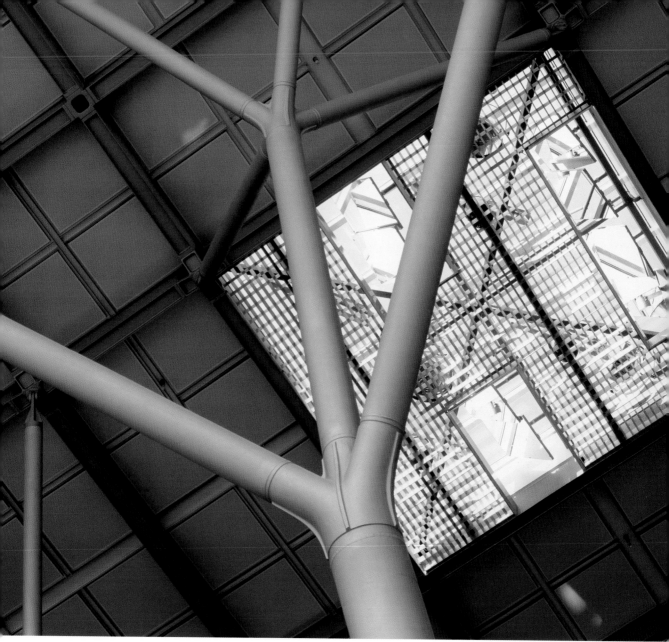

Crossing the Straits

Ohnaruto Bridge

HONSHU-SHIKOKU BRIDGE AUTHORITY
Honshu-Shikoku, Japan
Photographs: Honshu-Shikoku Bridge Authority

This bridge forms part of the complex system of interconnecting bridges that link the principal islands of Japan—Honshu, Shikoku, Kiushu, and Hokkaido. It connects Shikoku Island with the larger island of Honshu. Under construction from 1976 to 1985, it was the first bridge constructed along the Kobe Naruto route to the region south of the Akashi Straits.

A three-span, two-hinged, truss-stiffened suspension bridge with an overall length of 1,629 meters (5,344 feet) and a central span of 876 meters (2,874 feet), the bridge unites the Shikoku Islands with the small Awaji Island across the Naruto Straits. At its end, the bridge gives way to a road connection to the Akashi Kaikyo Bridge, which finally connects with Honshu Island. Studies of the horizontal forces impacting the structure were critical during the development of the project, given the seismic conditions and winds that are typical of the area.

Opposite top: Aerial view of the bridge suspended over the Naruto Straits

Opposite bottom: Elevation of the bridge

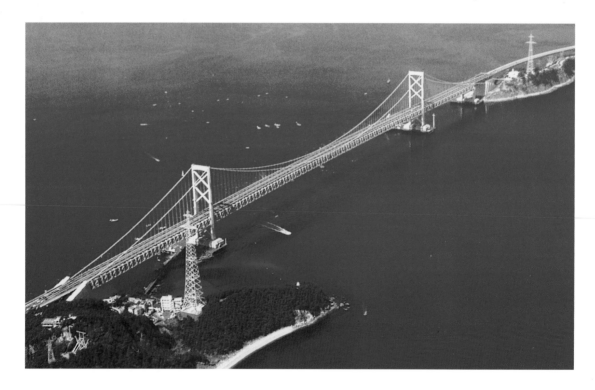

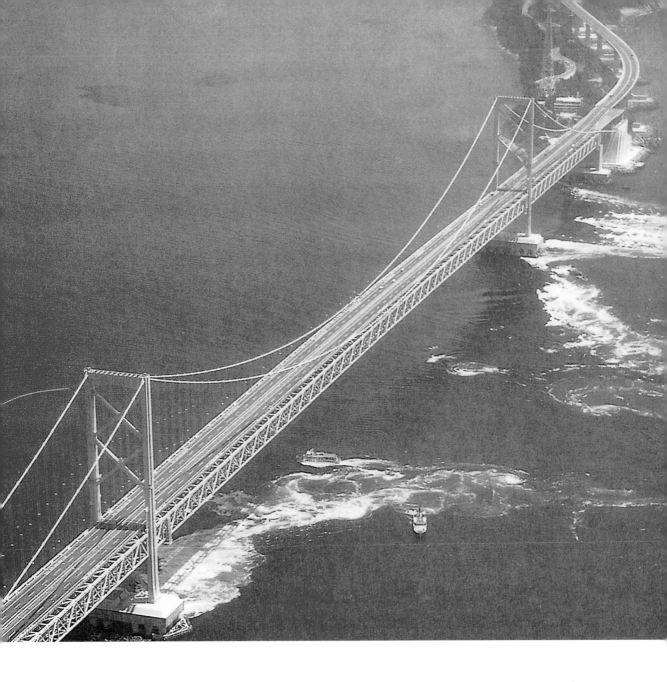

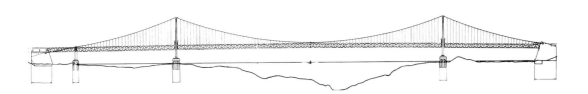

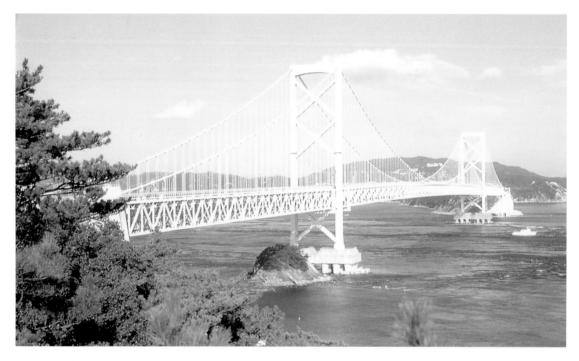

Above: View of the bridge on its arrival to one of the islands **Below:** Aerial view of the bridge over the straits

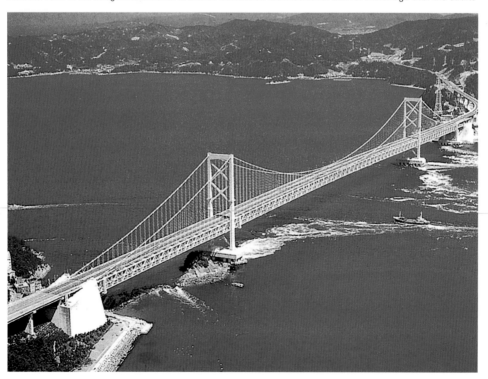

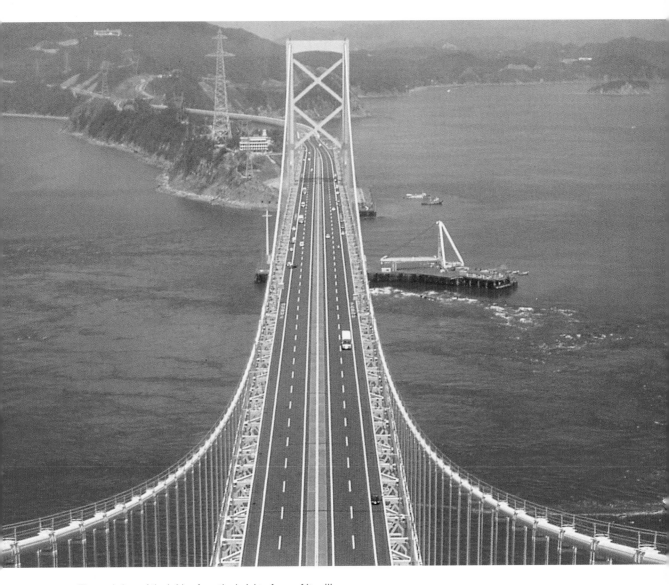

Elevated view of the bridge from the height of one of its pillars

Taking off

Lyon-Saint Exupéry TGV Station

SANTIAGO CALATRAVA

Lyon, France
Photographs: Ralph Richter/Architekturphoto

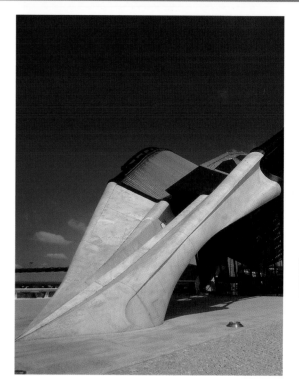

Calatrava's architecture constantly explores the intrinsic forces of structure and is often based on anatomical-sculptural associations present in animal skeletons or trees. Situated in the north of Lyon, this station is the first in Europe to link an airport with a railway network. Having won the competition, Calatrava understood that the authorities wished to create a building emblematic of contemporary changes in communications just as they aimed to reinterpret the last century's engineering.

From the point of view of composition, Calatrava's project expresses symmetry and duality. The station is configured in the form of a cross. Forked pillars support the roof of white concrete beams. The tracks have been

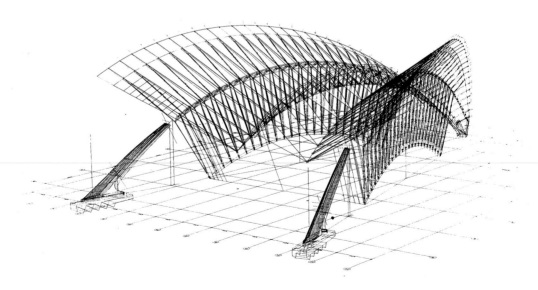

Above: Perspective of the triangular roof of the hall

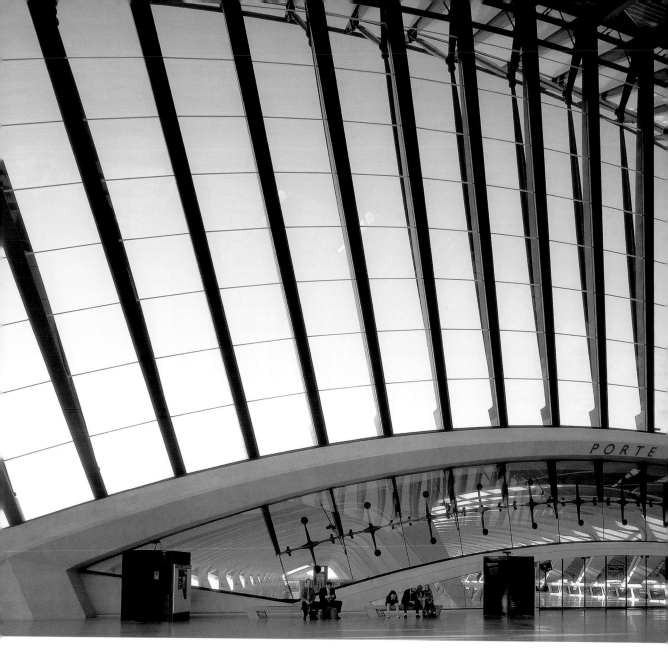

Interior view of the entrance hall

Right: Details showing the forked pillars (top) and the glass skylights (bottom)

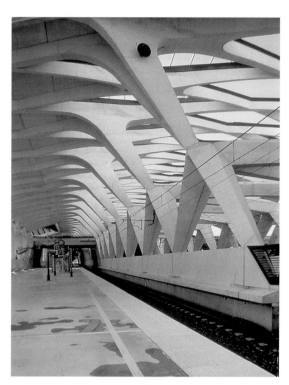

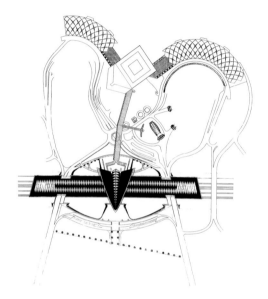

Above: Site plan of the project

Opposite: Exterior views of the entrance hall

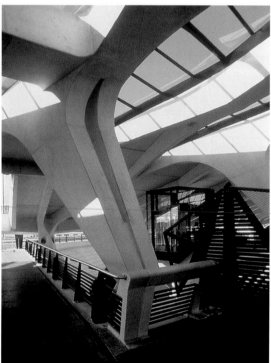

excavated in the ground, and the roof is just higher than the access. The overall impression given is of a tunnel prodigiously illuminated by natural light. Transversely, this roof is crossed by a large triangular hall that connects the principal entrance with the bus and taxi terminals and the pedestrian walkway taking passengers to the airport. The platform in the lobby modulates the change in elevations between the access and height of the walkway by means of an escalator. The roof is the most significant architectural element of the project. It contains two metal arches that rest on the vertices of the triangle defining the north and south façades as well as a movable glass and steel structure that is used to venti-

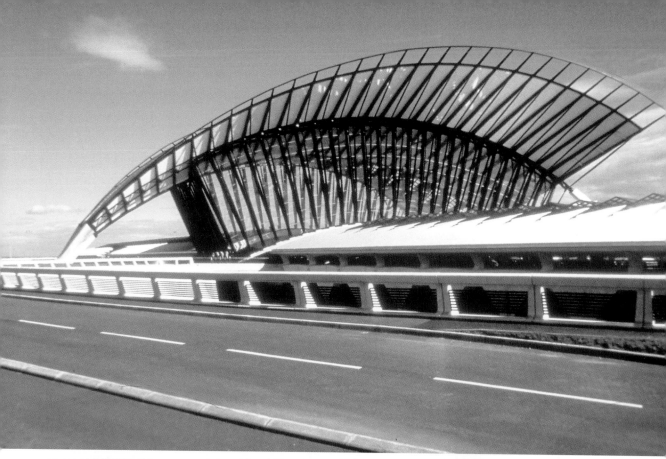

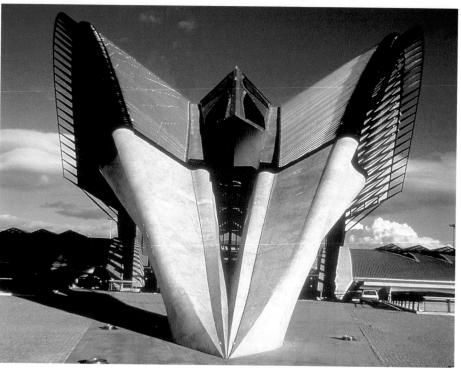

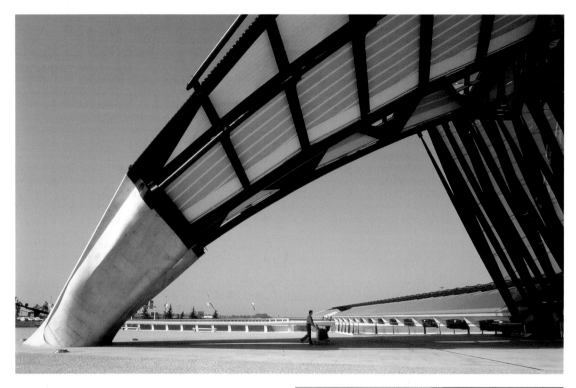

Above: Detail of the support of the roof of the hall

Below right: View of the interior of the same

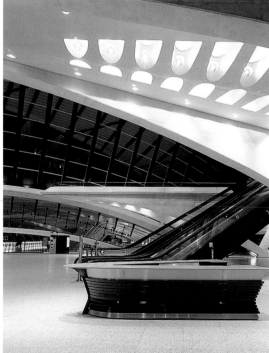

late the lobby. All of the station's services are located on the east side between the pedestrian walkway and the hall: offices, ticket offices, restaurants, the police. Finally, two perimetric projections in the two arches give the impression that the roof has flaps or wings, and that it is about to take off.

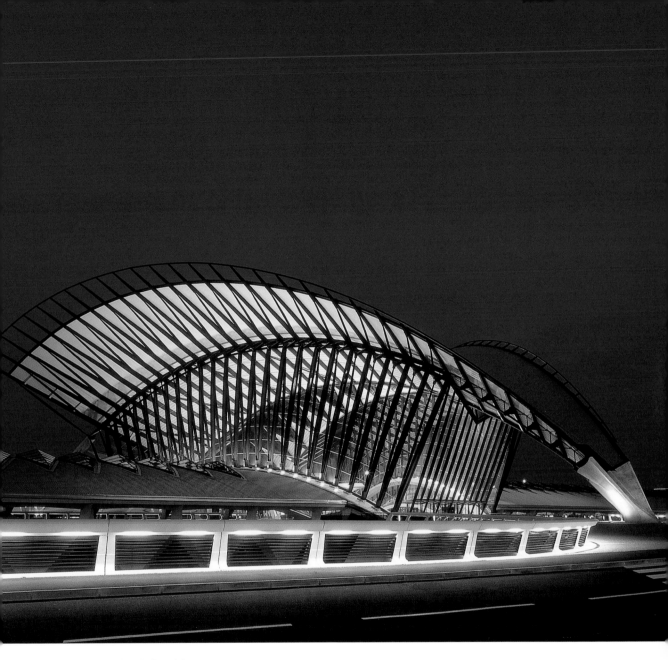

Skeleton of the hall at night

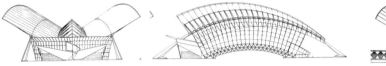
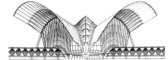

Top: Elevations of the entrance hall seen from the platform area

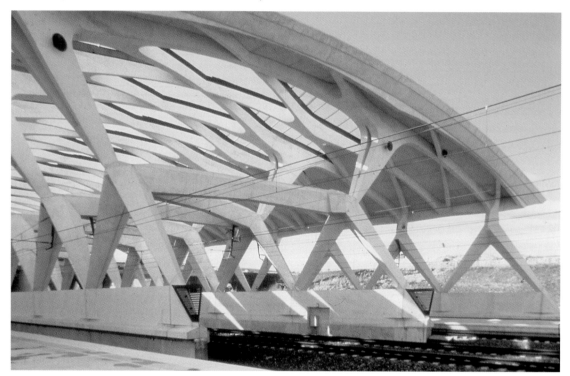

Above: View from the area of the tracks

Opposite: Details showing the ribs and their intersection with the concrete pillars

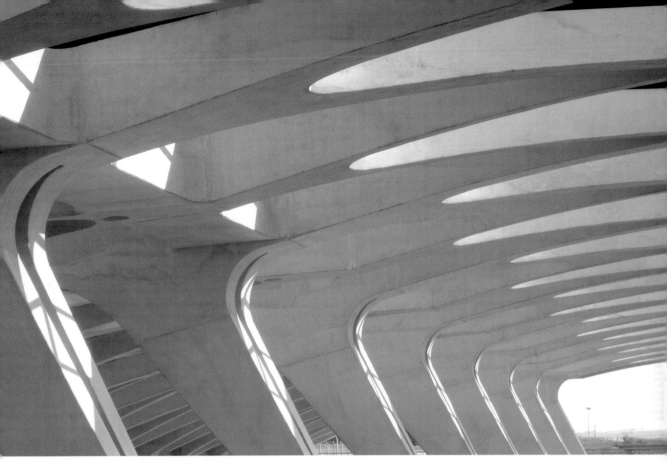

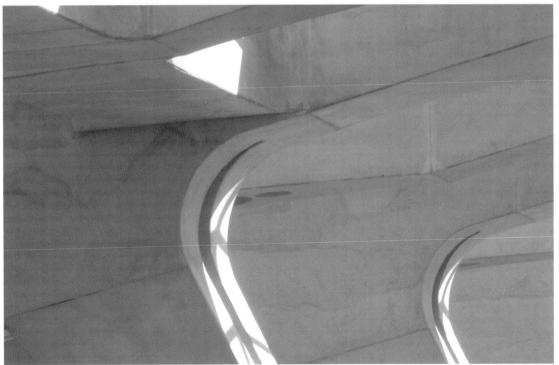

The new Dutch order

Schoonhoven

WINKA DUBBELDAM

Schoonhoven, Holland

The Dutch government's determination to protect the green heart of the center of the country has had direct consequences for outlying towns and districts. So much so that the town council of Schoonhoven, aware that the town could not go on growing indefinitely, opted for reclassifying the area of the old town and endowing a forgotten zone, currently used as a parking lot, with specific function.

The solution tackles the need to re-establish the original structure of streets and canals in this section, to reconnect it with the city center, and thus intensify the densities, flows, and uses of the area. The strategy aims to redefine the urban infrastructure by broadening and transforming

Below: Analytical diagram of the town

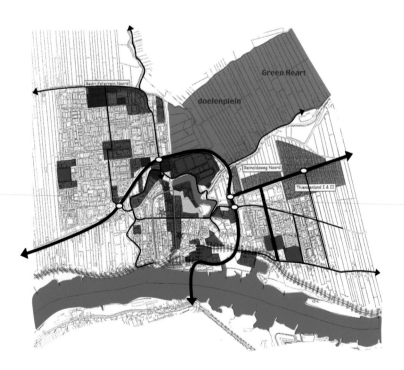

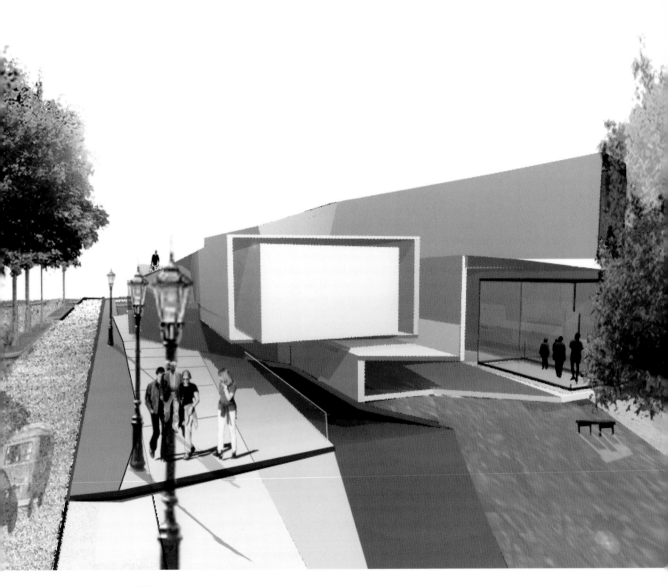

Exterior view of the museum

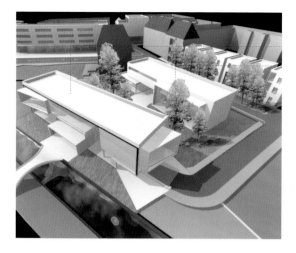

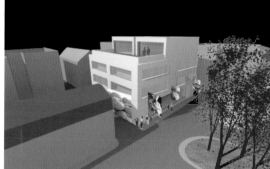

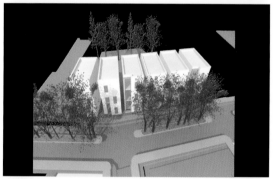

Above: Points of access to the urban renewal area

Top right: Conversion of the parking lot

Middle right: New promotion of single-family houses

Below right: Variety in the new residential units

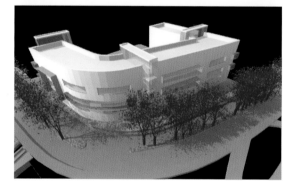

main arteries into tree-lined streets with shops and restaurants. The parking lot has been divided into three built-up areas with different functions: a new museum, situated at one end, to strengthen the cultural connection between the district and the town; a few schools grouped in the center and adjoining the park; and a residential zone that incorporates a green area with direct access to the park and the commercial districts surrounding the museum, which links the new urban structure with the low density of the old town.

Below: Cross-section of the renewal area

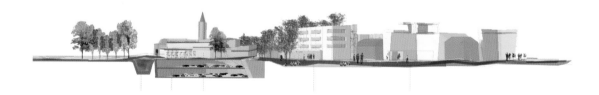

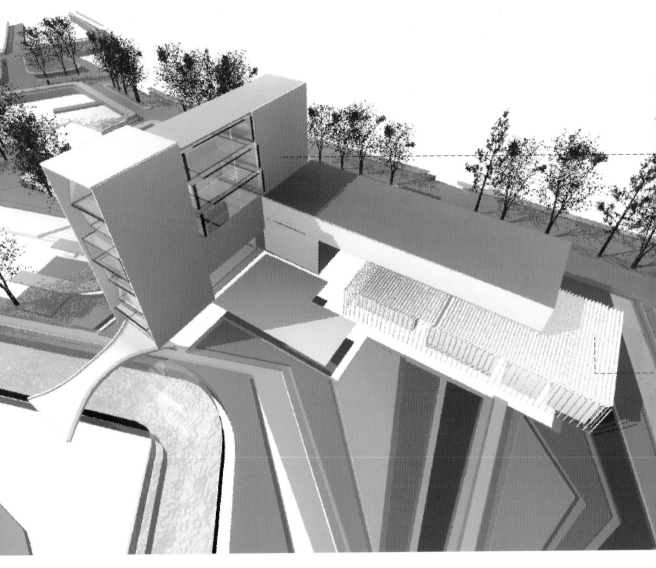

Top: View of the access points to the new district, crossing the canal

Below: Cross-section of the urban-renewal area

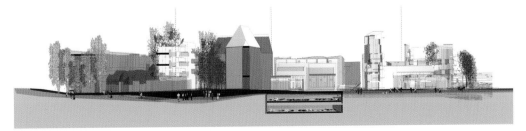

A palace of gold and crimson

Palace of the Arts in Lille

JEAN MARC IBOS & MYRTO VITART

Lille, France
Photographs: Georges Fessy, Hervé Abbadie

The donation by the Musée des Invalides in Paris to the Palace of the Arts in Lille of models of neighboring towns and fortresses led to a rethinking of the building, which after a century of administrative control, had lost its original character. The terms of the competition envisaged the creation of new spaces for exhibiting the models; construction of a new space for temporary exhibitions, an auditorium, a library, and educational workshops; the reorganization of the museum's conservation services; and the possibility of restructuring the permanent exhibitions. Some 5,000 square meters (53,820 square feet) of space were to be added to the 17,000 square meters (183,000 square feet).

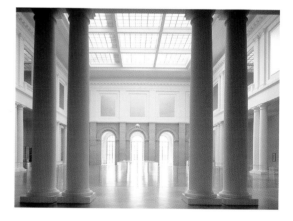

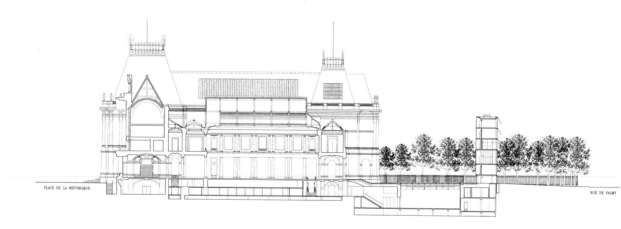

PLACE DE LA REPUBLIQUE

RUE DE VALMY

Above: Longitudinal section of the project

Opposite: Detailed view of the glass screen façade from the space devoted to temporary exhibitions

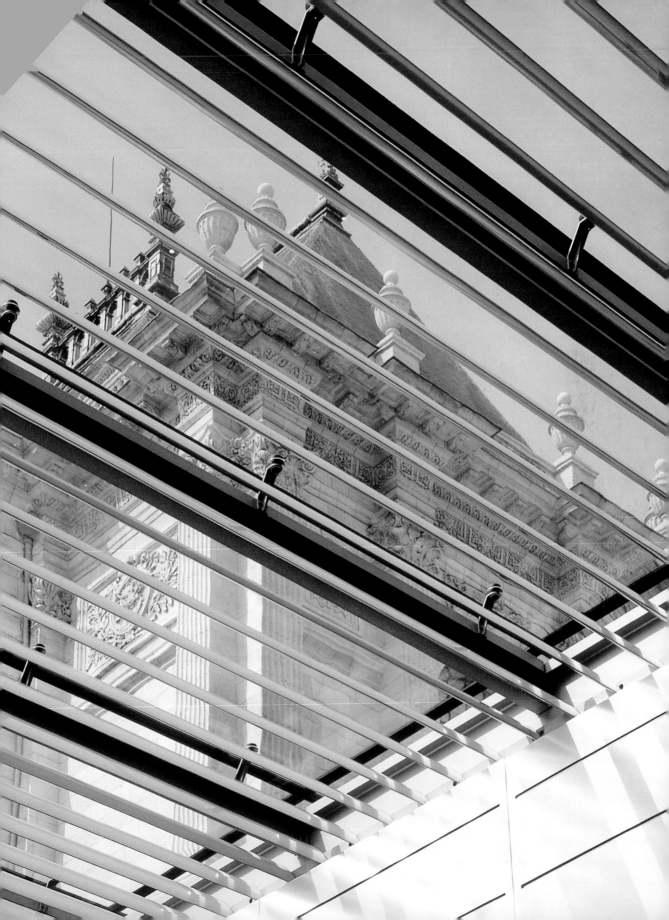

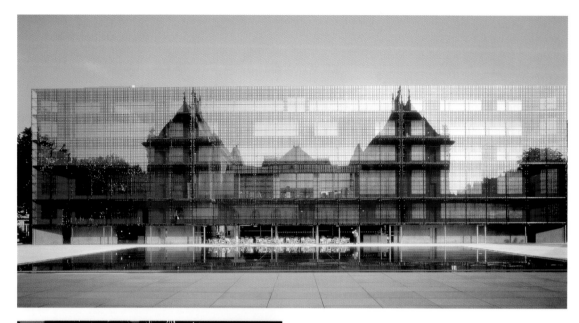

Top: View from the Palace of the Arts in Lille toward the new extension, a screen building

Left: Red, the insignia color of the entire project, cuts across the sculpture garden

Above: Site plan showing the structural function of the palace atrium between the Place de la République and the glazed square facing rue Valvy

Opposite: Detail showing reflection of the palace on the north façade of the screen building. The superimposition of glass on the chromium-plated backing panels of gold on red is achieved via the shadow silhouette projected by the palace.

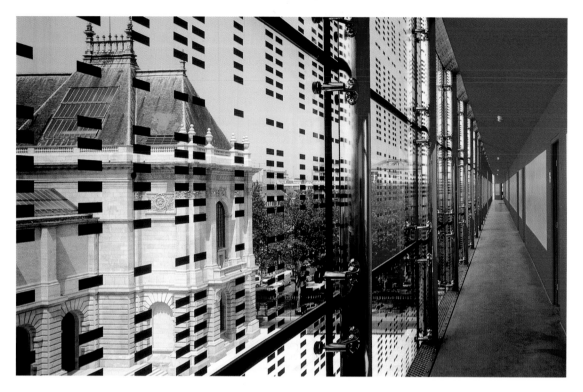

Top: Detail showing treatment of the north façade viewed from the corridor of the screen building

The palace, dating from 1895, is a reduced version of a more ambitious project to create something like the Louvre. Ibos and Vitart, winners of the competition, opted for the strategy of recovering the project's original intention, freeing the existing building of later additions, reinforcing the visual correspondences, transforming the atrium into a civic meeting place, and locating a cafeteria-restaurant on the ground floor.

The museum space is arranged in a circle around a three-level-high courtyard, alternating the more neutral spaces with others having stronger content. The space devoted to the models was gained by excavating the ground of the atrium in order to provide a fitting size for the works exhibited, some of which are more than 150 square meters (1,615 square feet). But the leading part in the play of perspectives and reflections is performed by the new extension, a screen building that occupies an adjacent site, as well as by the false pond, also made of glass, that serves as a retractable roof of the new space for temporary exhibitions, located between the old and new buildings. The screen façade, having a depth of only 6 meters (20 feet), is formed by a plane of reflecting dotted glass that projects an impressionist image of the Palace of Arts. Behind it, chromium-plated planes of gold on a red background contribute their brilliant color to the reflected image.

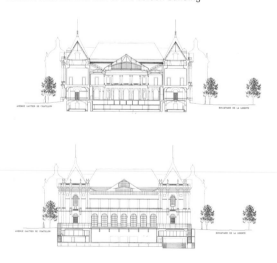

Above: Cross sections of the project

Opposite: Lamps made by Gaetano Pesce framing the south gallery of the palace

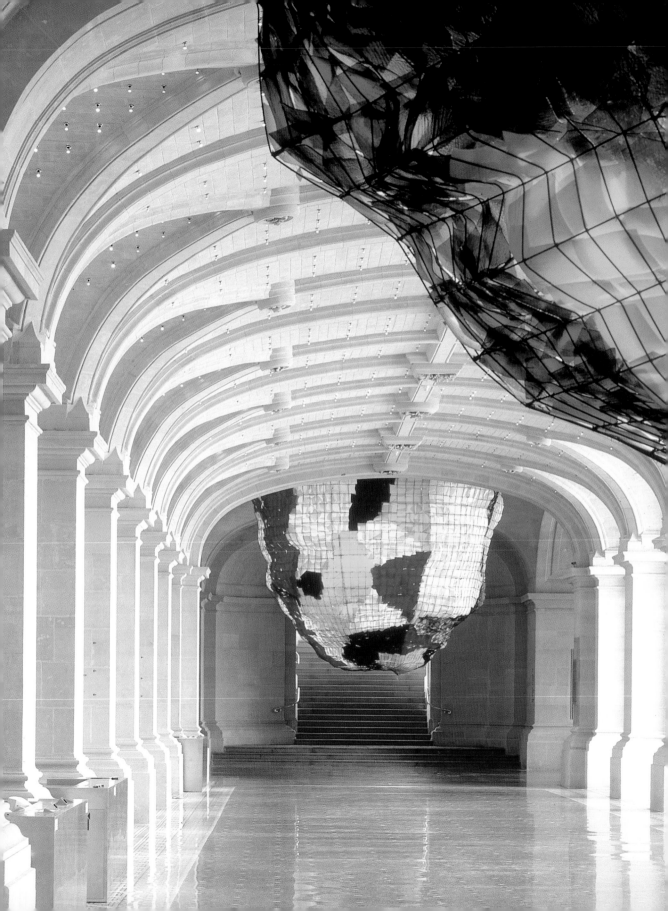

Network of volumes

Faculty of Economics

MECANOO

Utrecht, Holland
Photographs: Moisés Puente

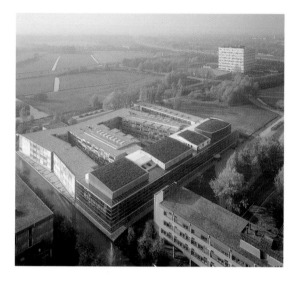

As in North Africa, the urban development of the "Casbah" area of the Uithof campus, in Utrecht, is characterized by its compactness, low height, and introspection toward inner courtyards. Similarly, the 23,500 square meters (253,000 square feet) of the design are arranged around three courtyards and on only three levels. The concept was to create a building that would meet educational requirements and provide spaces for interaction.

On the north entrance-side are communal services such as meeting halls, multimedia library, and cafeteria-restaurant, enveloped in a glass skin with an independent structure. The different faculties and administration are on the perimeter, while the central wing, grouped around the

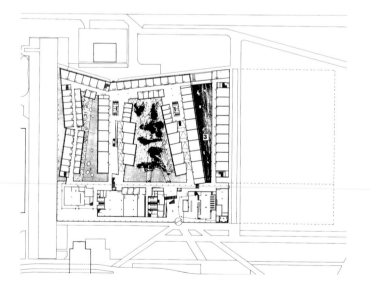

Above: Plan of the setting

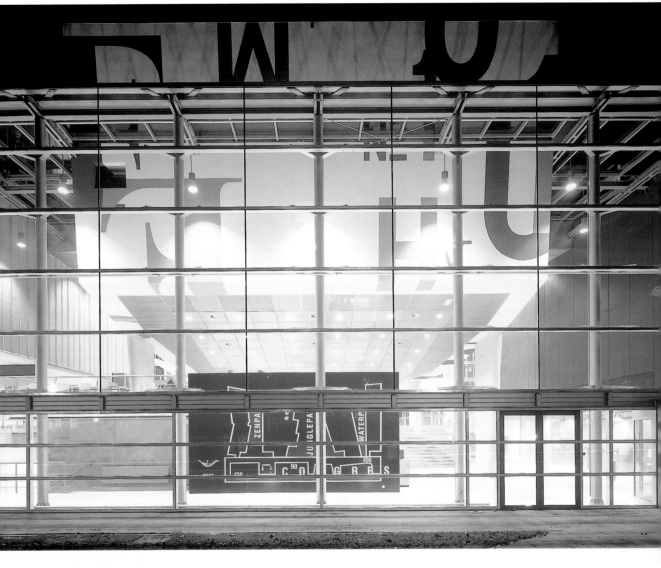

View of the main entrance

Below: Longitudinal section of the glass prism housing classrooms

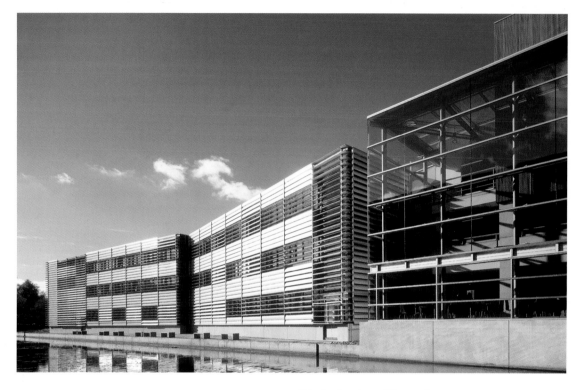

Exterior view toward the canal

main courtyard, is devoted to classrooms. In the north wing, the tour de force of the project, the four boxes that enclose the rooms intersect a glazed roof. The great glass prism allows the four volumes to be seen. The shapeless lobby creates a series of corners where different activities can be carried out on different levels. The two central wings containing classrooms unfold into spectacular ramps that span the width of the corridor from side to side, giving access to each classroom. Top-lit staircases communicate with all levels.

Each of the inner courtyards evokes a characteristic ambience and contributes its own personality to its section of the complex: the Zen courtyard, with its gravel and large rocks; the water courtyard looking onto a landscape of fields and canals; and the central court, like a bamboo jungle, with its greater traffic and dynamism. The materials used for the façade of each courtyard are also different: lattices of cedar wood and panels of okumen in the Zen court; glass and planks of metal grating for the central court; and aluminum plates for the water court, a cladding also used on the exterior. This whole mesh of volumes, different materials, heights, and activities generates a series of rich spaces with the power to promote relationships among the students, who are as much a part of academic life as the curriculum.

Above: Construction detail of the glass envelope

Opposite: View of the Zen courtyard from the building interior

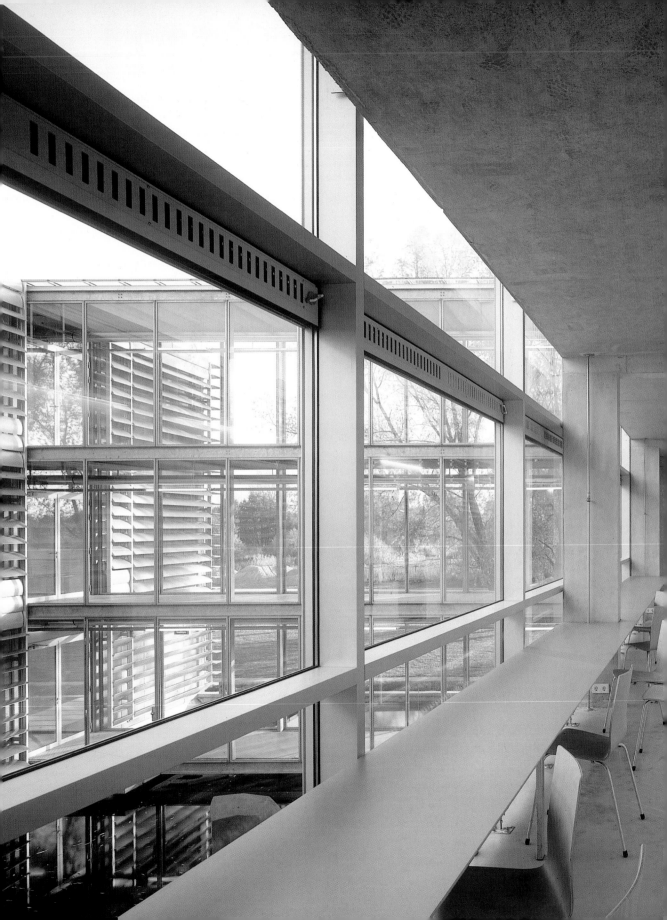

A glass pavilion in the landscape

Museum-O

KAZUYO SEJIMA & RYUE NISHIZAWA/SANAA

Nagano Prefecture, Iida, Japan

This project is located on a plateau alongside the Scribal house, declared a national monument, and flanking the rear walls of Shiroyama castle, which dates from the Muromachi period. This outstanding setting highlights the important relation between the museum and its site, including the museum building itself as an exhibition item among the group of historic buildings present in the landscape.

The museum seeks to harmonize with the landscape and therefore rises slightly from the ground, permitting a spatial continuity of the landscape below it and avoiding the traffic at the castle's rear walls. This allows the most important documents to be stored on the main floor, pro-

tecting them from the damp. Glass plays a very important part in this project—depending on the spectator's point of view—changing from opaque to completely transparent so as to frame the Scribal house within a window. The texture of the material, with clearly marked vertical lines, creates different impressions when observed from different distances, becoming more opaque when seen close up and more transparent from a distance. The volumetrics of the work meet one of the principal concerns of the SANAA team—to enable activities to take place in a sequence of different rooms without establishing a hierarchy of spaces. This would facilitate the building's adaptions to new functions as future needs arise.

Below: View of the building showing different treatments of glass in its façade

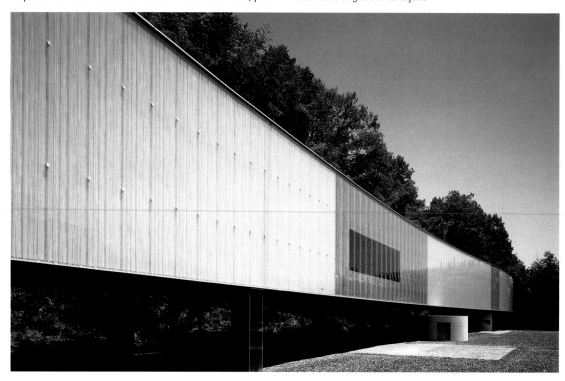

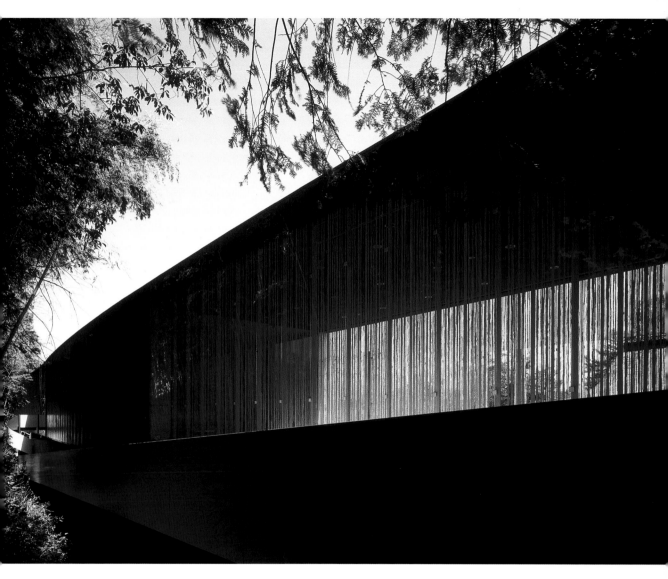

Above: Detail of the rear section of the museum, nearly touching the vegetation; note the building's transparency despite stripes in the façade glass

Below: Elevation of the building above ground level

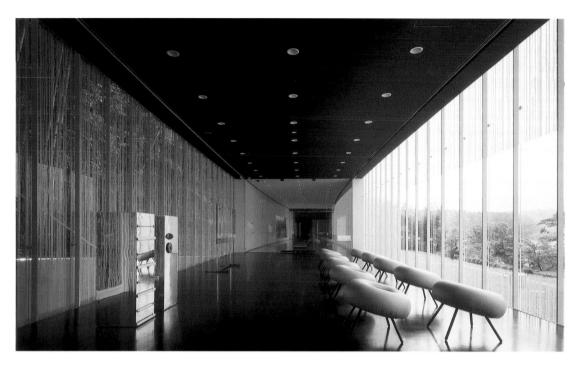

Above: View of the entrance hall revealing the permanent exhibitions in the distance. The texture of the glass walls varies in transparency, framing views of the Scribal house (below), together with Isuki-no-Sato further down. Depending on light and atmospheric conditions, the glass takes on different aspects.

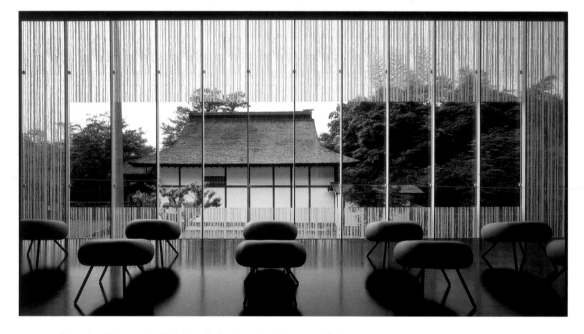

Opposite: Close-up detail of the main façade, where it appears almost opaque

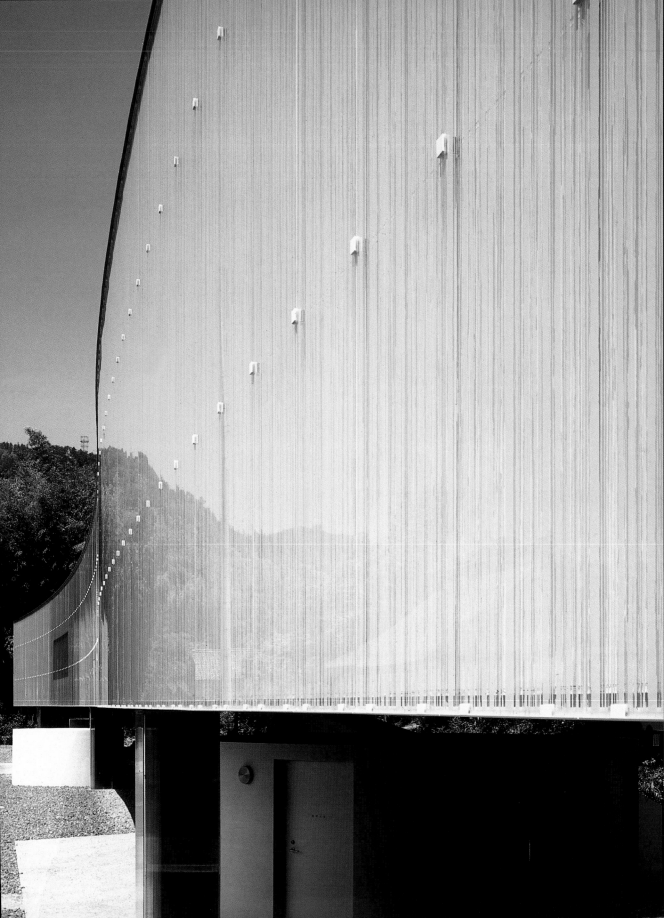

A sculpture at the doors of the Tate Modern

Millennium Bridge

FOSTER AND PARTNERS, SIR ANTHONY CARO, OVE ARUP & PARTNERS, K. SHUTLEWORTH, A. BOW, C. RAMSDEN, J. SALERO, ARQ.
London, England
Photographs: Foster and Partners + Denis Gilbert + Grant Smith / VIEW

The proposal by sculptor Anthony Caro, engineer Ove Arup, and architect Norman Foster won the international competition held for the construction of the Millennium Bridge. The project consists of a delicate span reflecting the dialectics between art, architecture, and engineering. It is a symbol of the revitalization of both banks of the river, with the Tate Modern and the Globe Theatre at the south end, and St. Paul's Cathedral in the northern zone. With a length of 325 meters (1,066 feet), the bridge is the first pedestrian crossing over the Thames River at the center of London in more than a century. From its beginnings, the bridge intended to be an urban space from which to admire the city. However, since the construction of the

Tate Modern, it has become one of the most vibrant sites on the Thames, and it is free of vehicular traffic.

The proposal follows a modular philosophy, repeating modules in order to facilitate construction and simplify maintenance. The use of cables gives it lightweight structure. The aluminum deck, four meters (13 feet) wide, is flanked by stainless steel balustrades and supported by cables that descend on both sides just halfway across the bridge's span to allow continuous views of the city to be enjoyed.

Below: The bridge on its arrival to St. Paul's
Opposite: The bridge as seen from the water

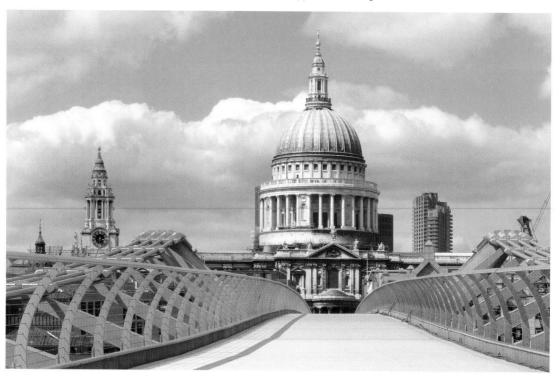

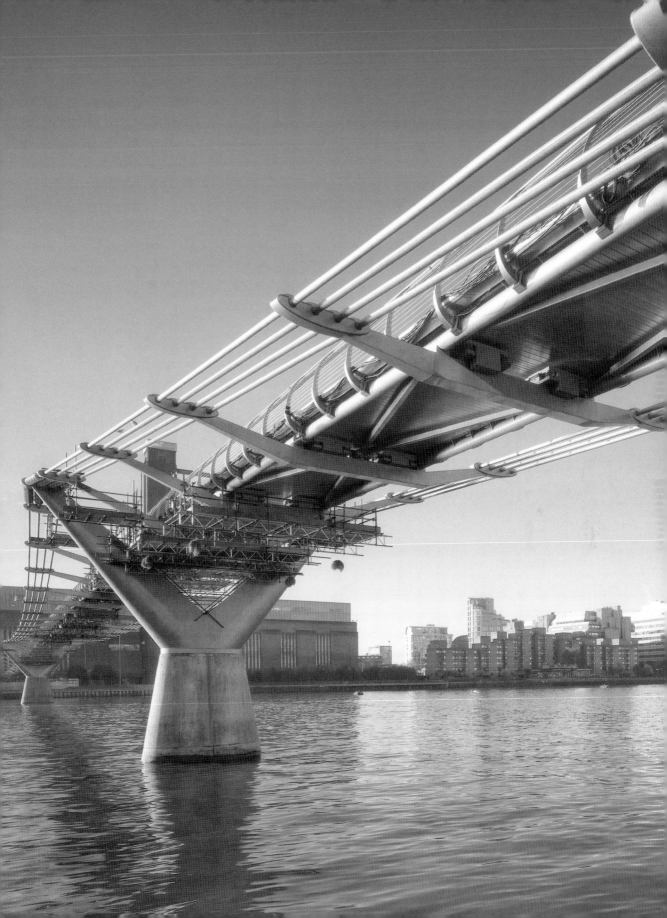

Panoramic view of the bridge spanning the Thames River with the city in the background

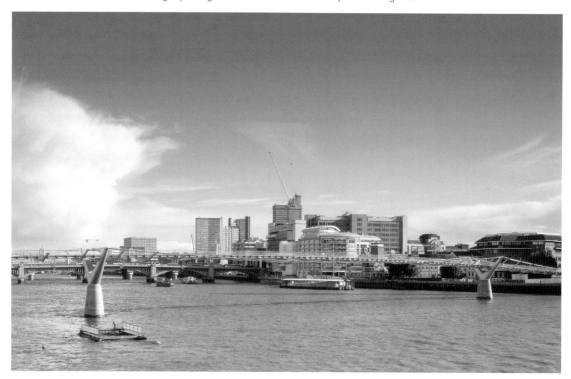

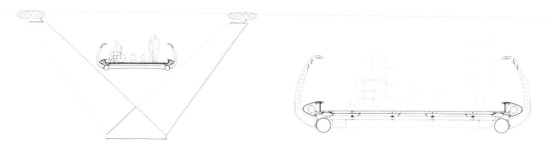

Above: Section of the bridge at one of its supports (right) detail of the pedestrian deck

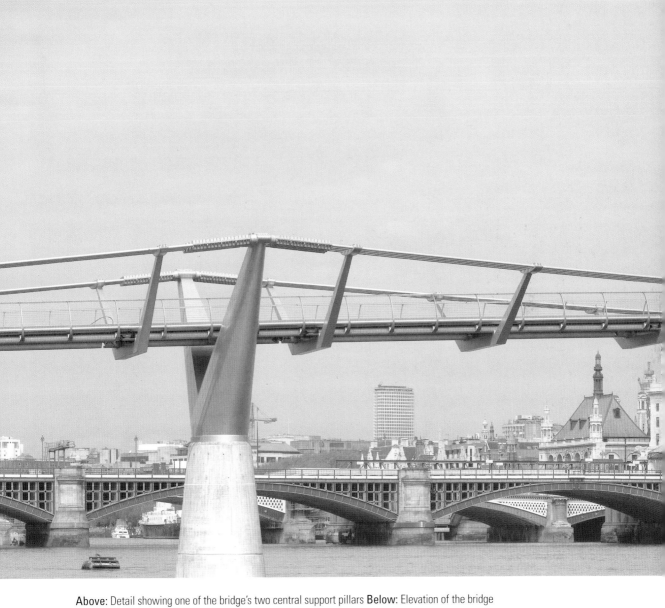

Above: Detail showing one of the bridge's two central support pillars **Below:** Elevation of the bridge

Discovering the other riverbank

Vasco da Gama bridge

GATELL, LOSUPONTE, CONCEPCIÓN, NOVAPONTE, FREYSSINET
Lisbon, Portugal
Photographs: Freyssinet

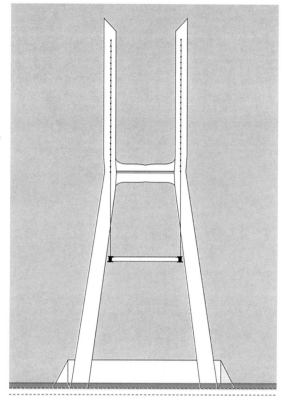

Desiring to create an alternative to the route provided by the 25th April Bridge, a competition was announced for the construction of a new bridge to be inaugurated at the Universal Exhibition of Lisbon in 1998. This bridge forms part of a large-scale network including roadways, bridges, and accesses that establish a six-lane span connecting the two riverbanks and communicates the metropolitan areas of greater Lisbon.

The 17.2-kilometer (10.6-mile) suspension bridge—the longest in Europe—rests on pillars and one of its spans is anchored to two towers to provide navigation channels for seagoing vessels through three points (the North, Samora, and Barcas). The bridge is located near the Universal Exhibition of 1998 and named after Vasco da Gama to commemorate the 500th anniversary of his arrival in India. The dominant building material is concrete, which imparts its particular color to the bridge with the exception of the mixed deck of the suspended viaduct. The visual impact of this new structure makes it an iconic reference over the Tagus River.

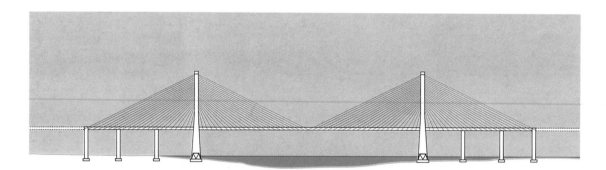

Above: Elevation of the bridge

Opposite: Aerial view of the bridge with the city of Lisbon in the background

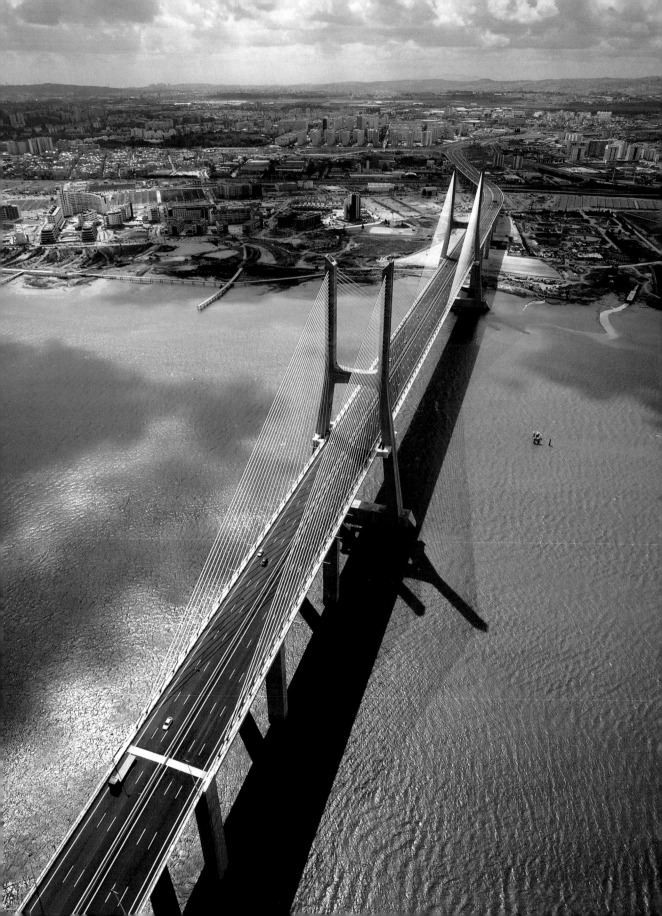

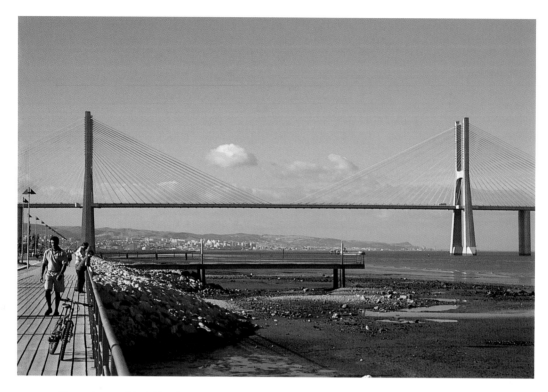

Above: Image of the bridge from one of the riverbanks

Below: Different views of the bridge from the same distance

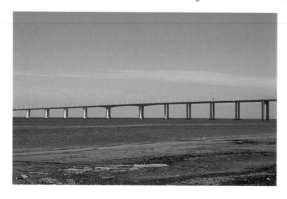 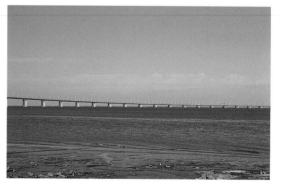

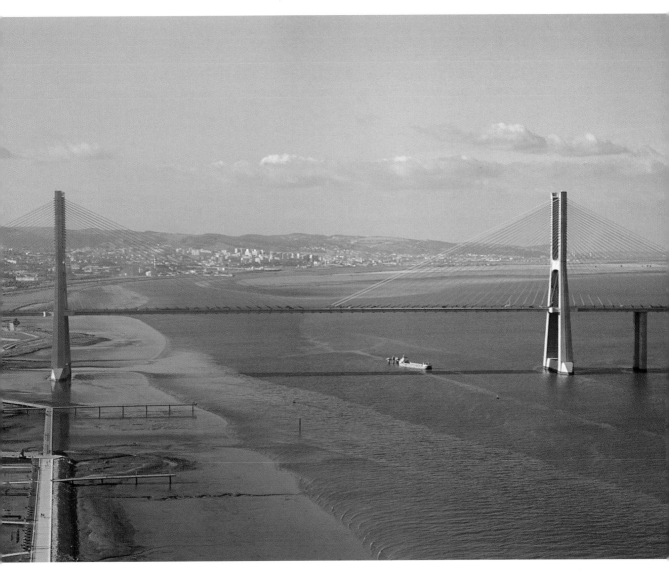

Above: Panoramic image of the central span of the bridge

Left: View of the bridge emphasizing its length

An oriental patio

Garden of the Louis-Jeantet Foundation

DOMINO ARCHITECTS

Geneva, Switzerland
Photographs: Jean-Michel Landecy

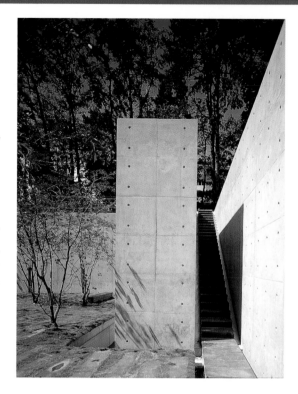

This was the winning proposal of the competition announced in 1993 by the Louis-Jeantet Foundation for its headquarters in Geneva. The program included the refurbishing of an Italian neo-Renaissance villa and a house by Louis Jeantet, with a garden adapted to the gradient between both buildings. The team of Domino Architectes (Jean-Michel Landecy, Jean-Marc Anzézui, and Nicolas Deville), along with the landscape architects of the TER team (Henri Bava, Michel Hoëssler, and Olivier Philippe) resolved the relationship of scale between the villa, conceived as a large esplanade in front, and the small area designated for the project. Other problems involved the distance, setting, and relationship between the two buildings.

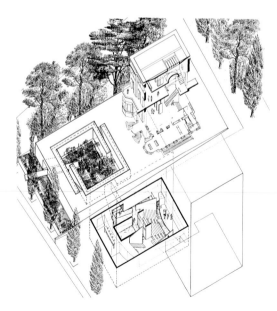

Above: Perspective of the neo-Renaissance villa

Opposite: Detail of the patio interior showing the elements that constitute it

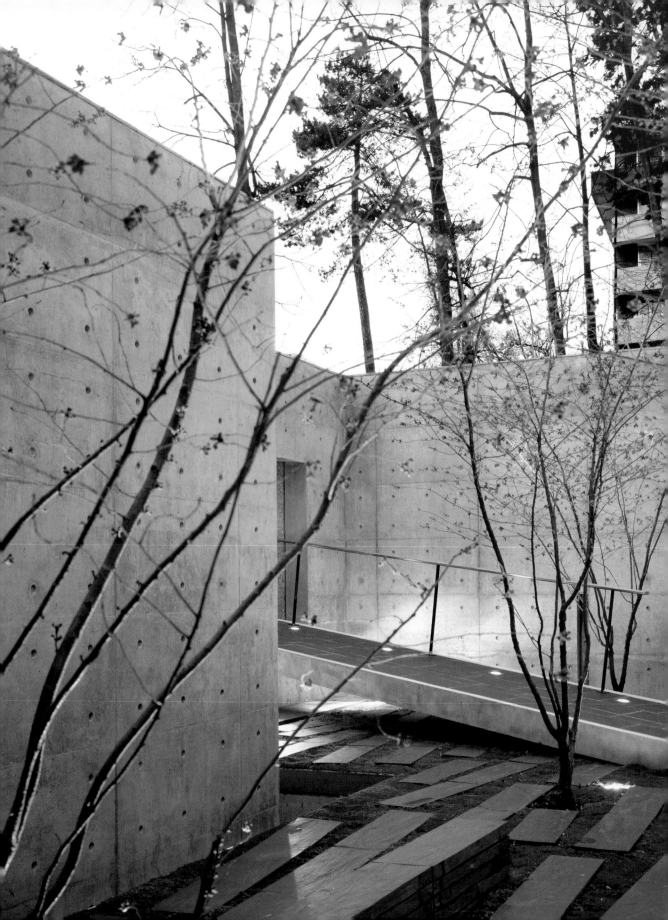

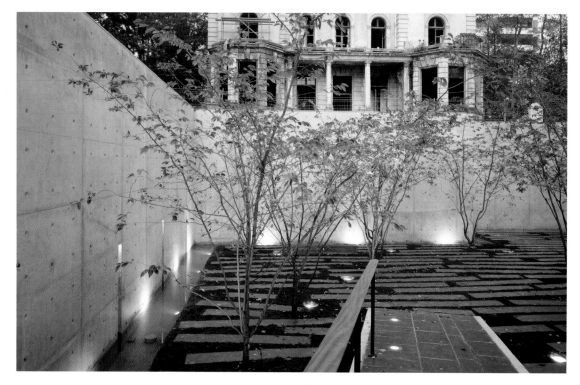

Above: Interior view of the patio illuminated at night

Right: A water channel separates the moss green carpet from dark stone of the natural concrete walls.

Opposite above: View of the patio from the ground floor

Opposite below: Longitudinal section of proposal for the foundation

The proposal sought to optimize the garden space and to divide it into two levels: a horizontal platform that would occupy most of the plot, at the villa's ground floor level; and a lower level that perforates the higher platform, becoming a patio that gives access to the villa and the auditorium. The higher platform is a square of concrete surrounded by trees.

This reconfiguartion led to the creation of a podium that isolates the villa from the traffic in the street. The sunk-in patio resolves the separation between the buildings and the street. The new patio uses natural elements such as water, vegetation, sounds, light, and shade to welcome the visitor. The material used for the walls is natural concrete, on which the marks and textures left by the shuttering can be seen. The concrete wall forms a background against the colors of the garden.

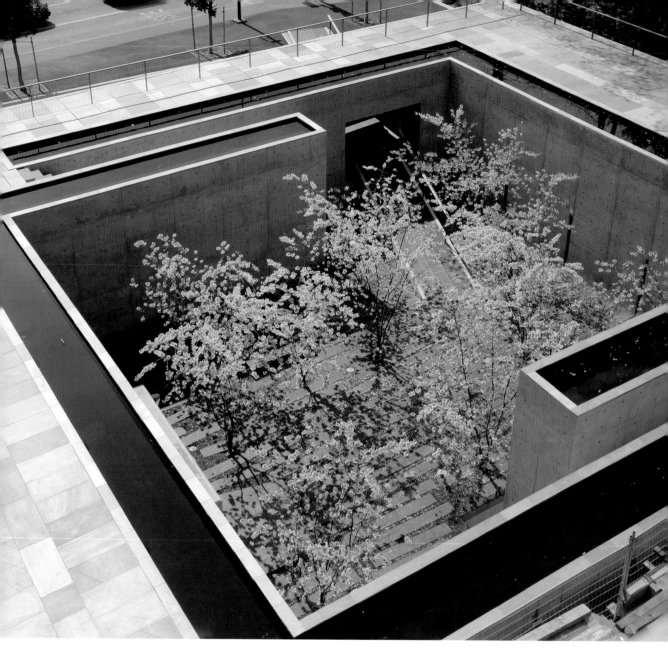

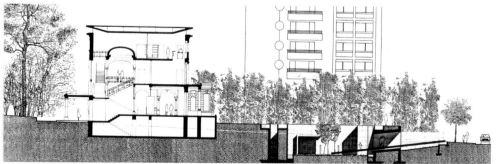

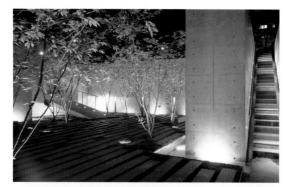

Left and below: The illumination emphasizes the contrast between the natural and artificial by highlighting the geometry of the complex

Opposite: Detail of the staircase that slides down the gap between two concrete walls

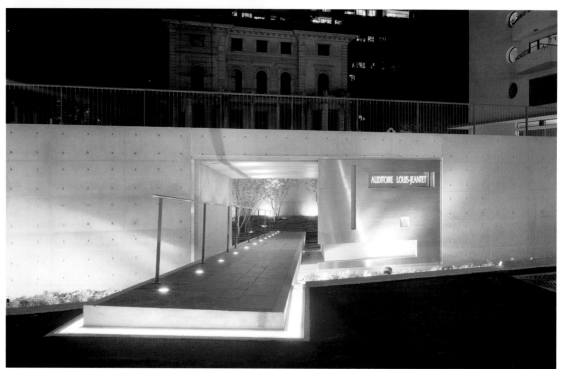

Above: Initial sketches showing the relationship between buildings and landscape

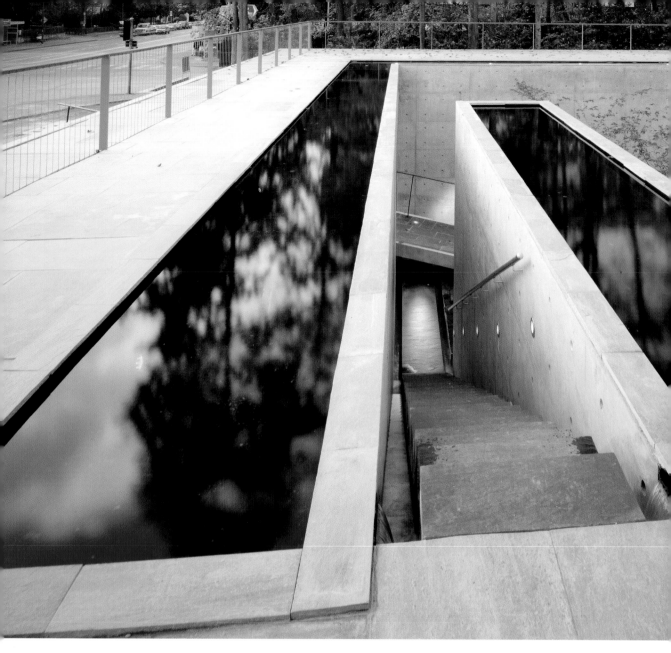

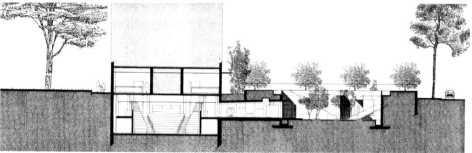

Above: Cross section of the proposal

Hollows in the skin

Faculty of Journalism

IGNACIO VICENS, JOSÉ ANTONIO RAMOS
Pamplona, Spain
Photographs: Eugeni Pons

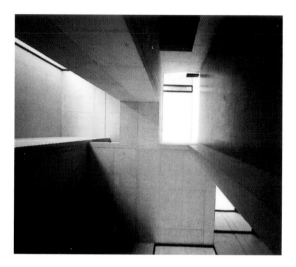

The Faculty of Journalism is located in the heart of the campus of the University of Navarre, near the library and the faculties of Law and Economics. Its central site demanded that a central square be included in the design of the building. The faculty also needed to be able to house students of other disciplines in its lecture halls.

The building shows a balance between blocks constituting its volume and the spaces that bring light into the inner mass. The design follows a double strategy. The first was to divide the different functional areas into different blocks. The second endows each space with the necessary light to conduct activities, which includes the use of openings and courtyards. The architects chose a homogeneous

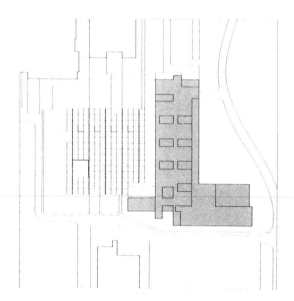

Above: Site plan for the faculty building

Opposite: The skin of perforated concrete

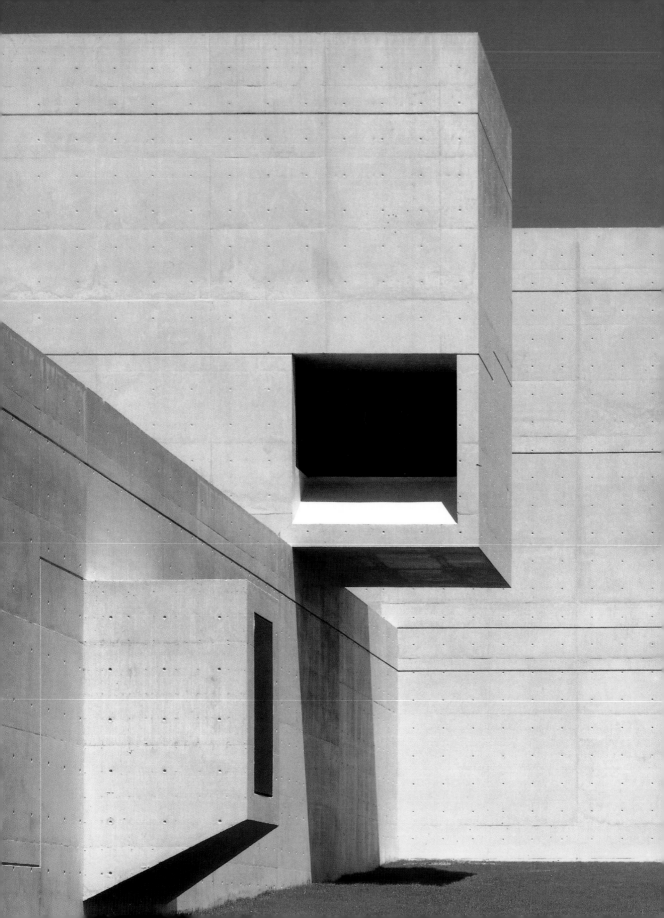

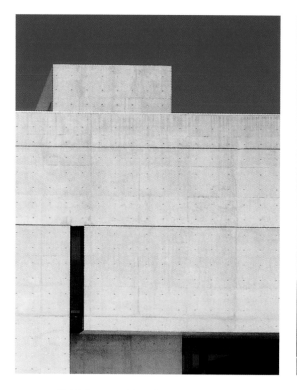

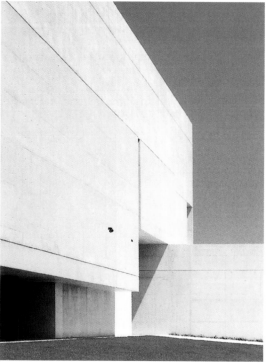

concrete finish for every block, inserting openings and perforations directly in the material, thus dematerializing even the carpentry itself. In fact, the building appears to be made of a single material. The layout includes practical and theoretical workshops, radio and television studios, seminar rooms, an audiovisual library, offices, and a cafeteria. In the words of the architects, the building facilitates conduct of the university's activities: research, transmission of knowledge, and communal living. For these, the main space of the faculty building is the atrium, reaching various heights, it leads to the lecture halls and constitutes the largest social space of the complex.

Details of the incisions for windows

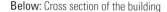
Below: Cross section of the building

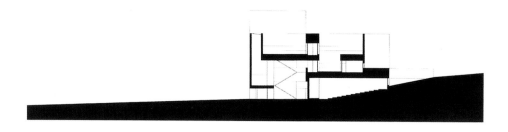

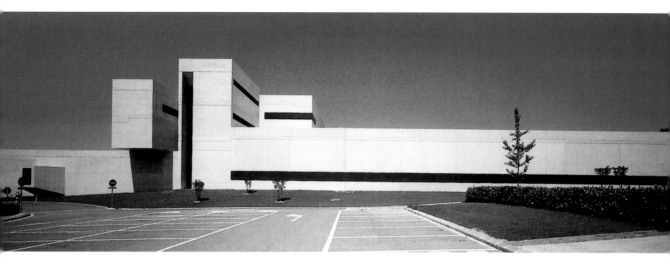

Above: Rear façade of the building

Below: Façade onto the square

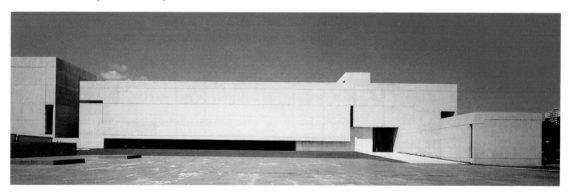

Below: Longitudinal section of the building

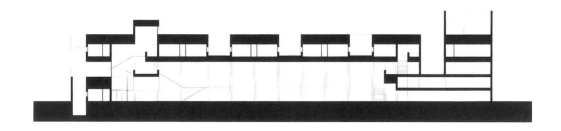

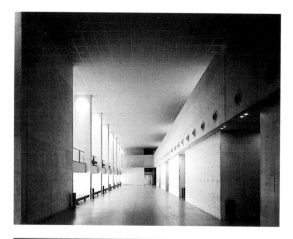

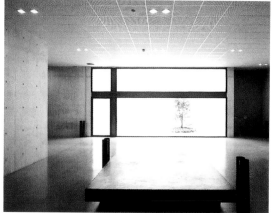

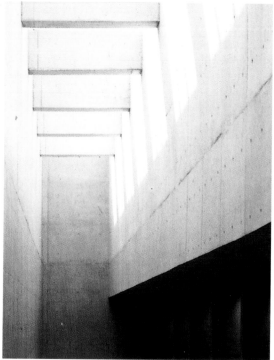

Top left: Detail of the central atrium, the main social space

Above: All the walls, even inside, are concrete

Below left: Detail showing illumination of the main atrium

Above: First and (right) second floors of the faculty building

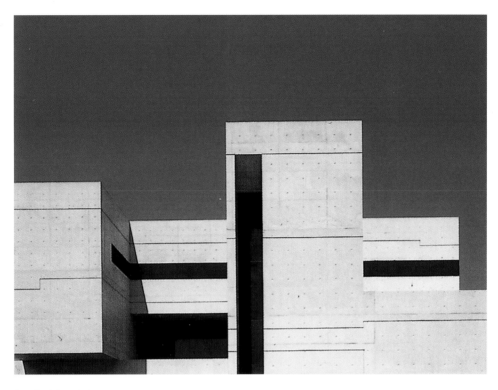

Detail of the windows

Interior of the auditorium

West façade

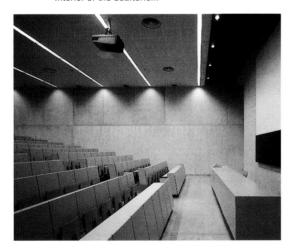

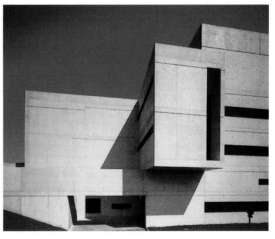

Theater in a bottle

Matsumoto Performing Arts Center

TOYO ITO & ASSOCIATES, ARCHITECTS

Matsumoto, Nagano, Japan

Situated in the town of Matsumoto, in the prefecture of Nagano, this performing arts center is located in the center of town, adjacent to the old theater. The project was the winner among ten teams of architects in the competition held for its construction. It consists of two different-sized lobbies to be used for different functions. The main auditorium has a capacity of 1,800 seats, enough to house opera performances in the Saito Kinen festival, which takes place every summer. The smaller auditorium has a 240-seat capacity, a space much more appropriate for local shows and small presentations. Also included are rehearsal rooms and multi-use studios.

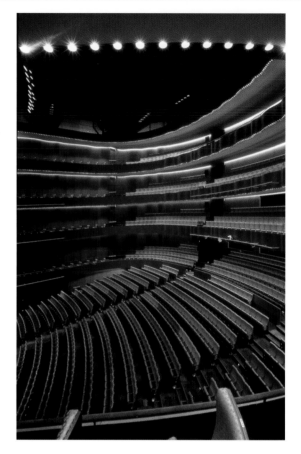

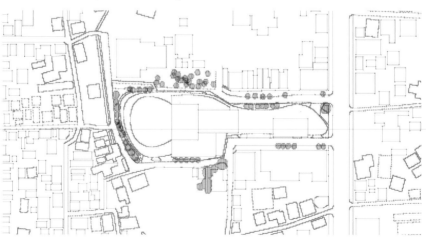

Above: Site plan of the complex site

Opposite: Interior view of the theater

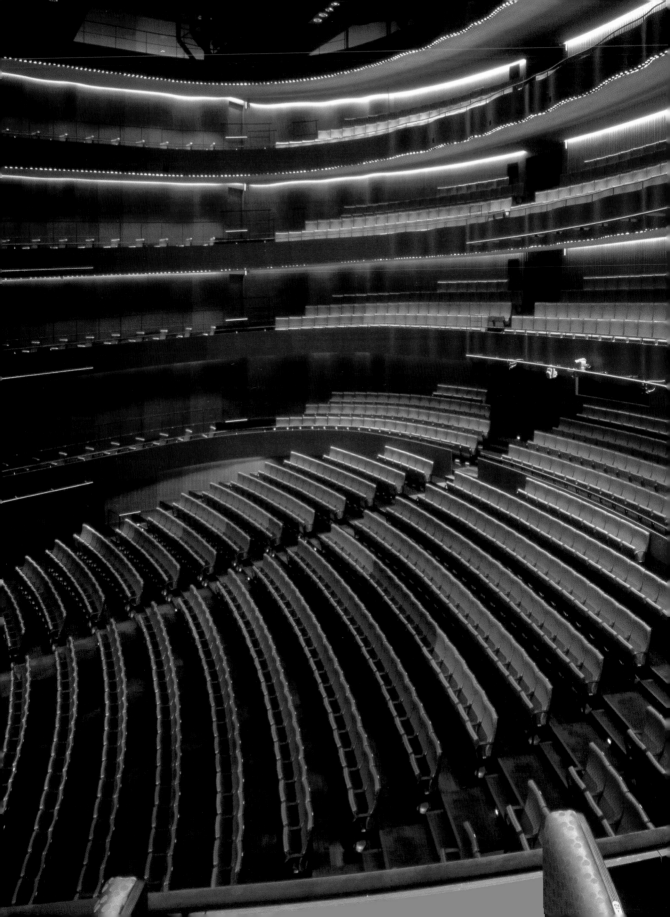

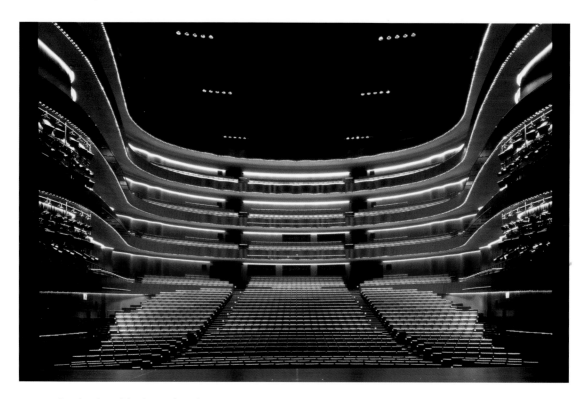

Interior view of the theater from the stage

Opposite above: View of the stage from seating

Opposite below: Entrance façade of the theater

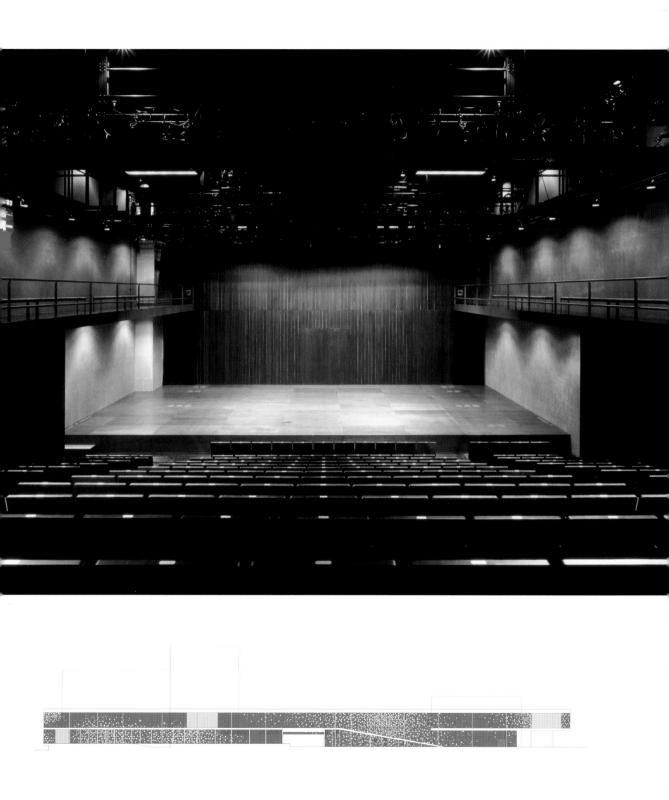

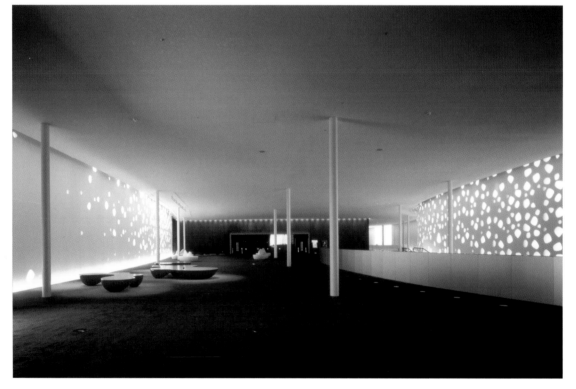

The main challenge was to house all these functions in a space with the unusual shape of a bottle. The depth of the site, together with the diagonal street running alongside it, required the main auditorium to be located in the southern part of the site, with the seating and access doors to the south, so as to avoid having a main and back façade to the building. Entry to the theater is by escalators, which reach the north section of the lobby and the small auditorium. Between the main auditorium and the small one is a lobby in which one can relax. Since the surroundings did not offer pleasing views, a predominantly opaque wall was selected, with glass panels—randomly distributed—providing gentle lighting to the interior.

Top: Longitudinal section of the theater

Above: Interior of the lobby, showing the effect of lighting on the walls

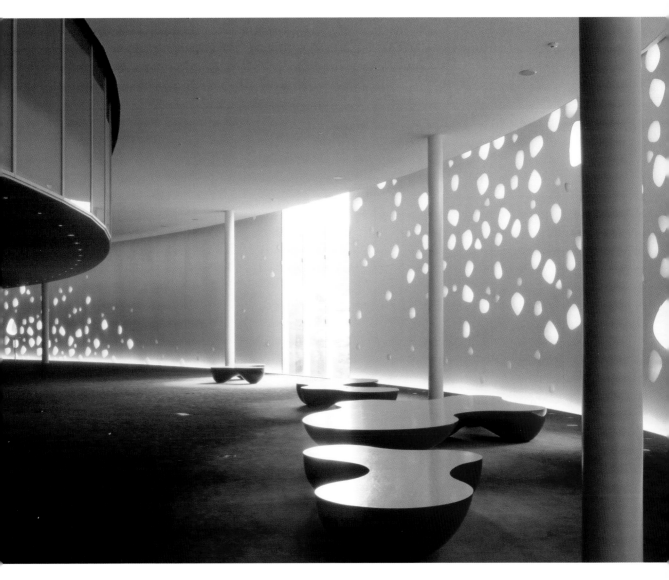

Detail of interior of the lobby showing the glass panels that light the interior

The matchbox
Kirishima Art Gallery

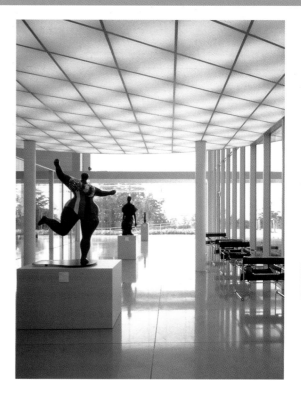

KUNIHIKO HAYAKAWA

Aira-gun Kagoshima, Japan

The strategy of this project pursues two objectives: to site the building in an appropriate environment and to make use of innovative solutions for organizing its internal functions. In fact, the building is set down in the landscape with an apparent indifference, seeking the best orientation and concentrating its architectural program in a compact construction of two stories. The building contains a metal structure and light elements in the continuous skin enveloping the façades and roof. Inside, an open ground plan facilitates freedom of movement and perception, establishing a continuous and direct relation between spectators and art, for there is no mediating spatial hierarchy to intervene. Instead, a source of illumination in the roof highlights the immediate artistic experience, which involves the visitor and the art object.

Above: Floor plan of lower gallery

Opposite: Perpendicular view of the glazed side of the gallery, at evening, and plan of the upper floor

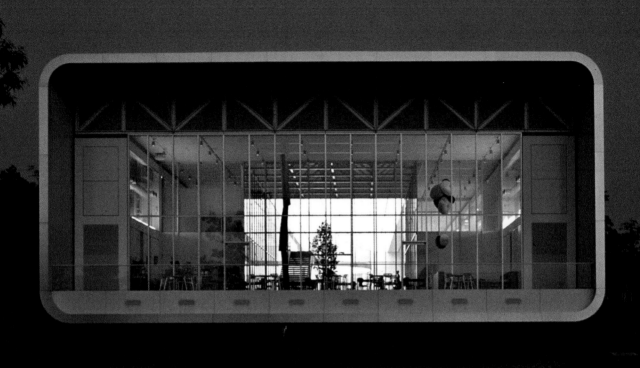

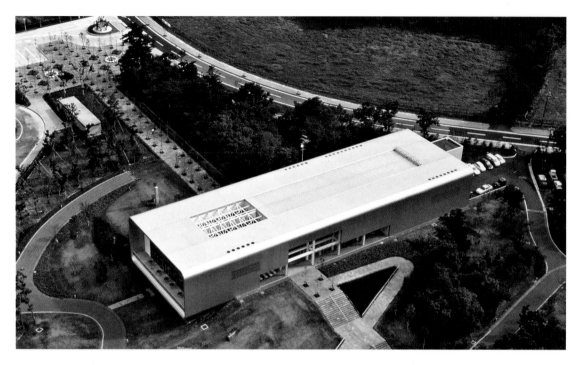

Top: Aerial view of the building, showing its relation to the landscape

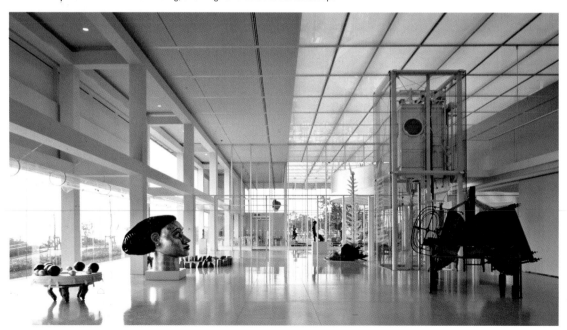

Above: Interior of the gallery

Opposite: Access to the building

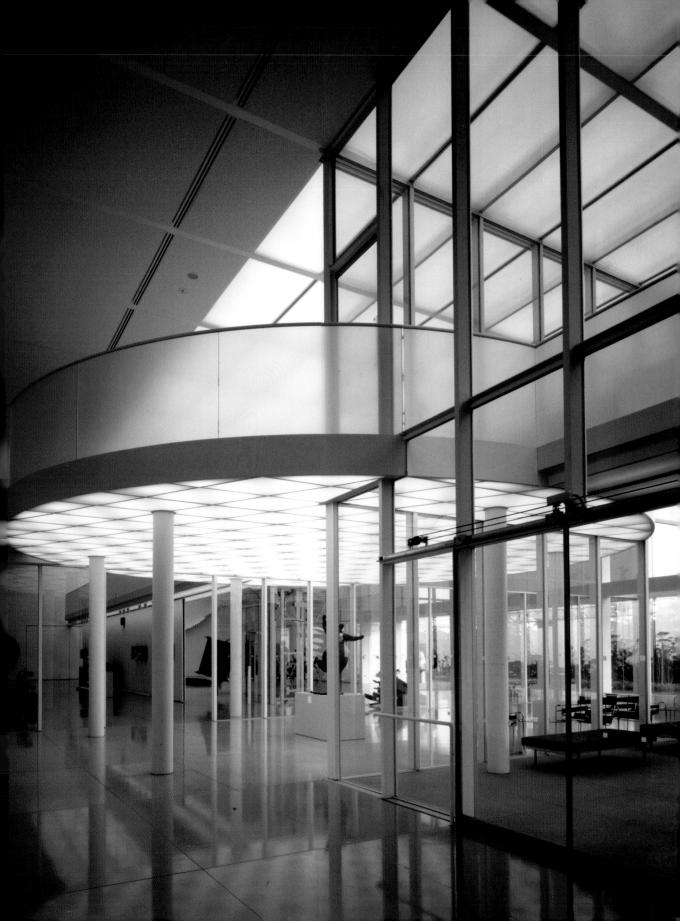

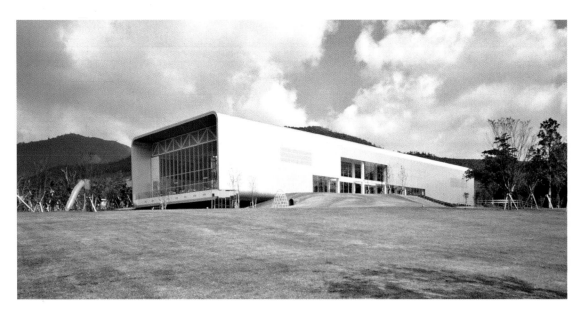

Top: View of the building from the outside

Right: Perspectives showing the sequence of layers constituting the building envelope

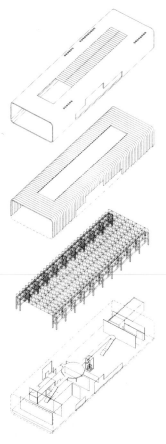

Opposite: The transparent roof illuminates the building's interior

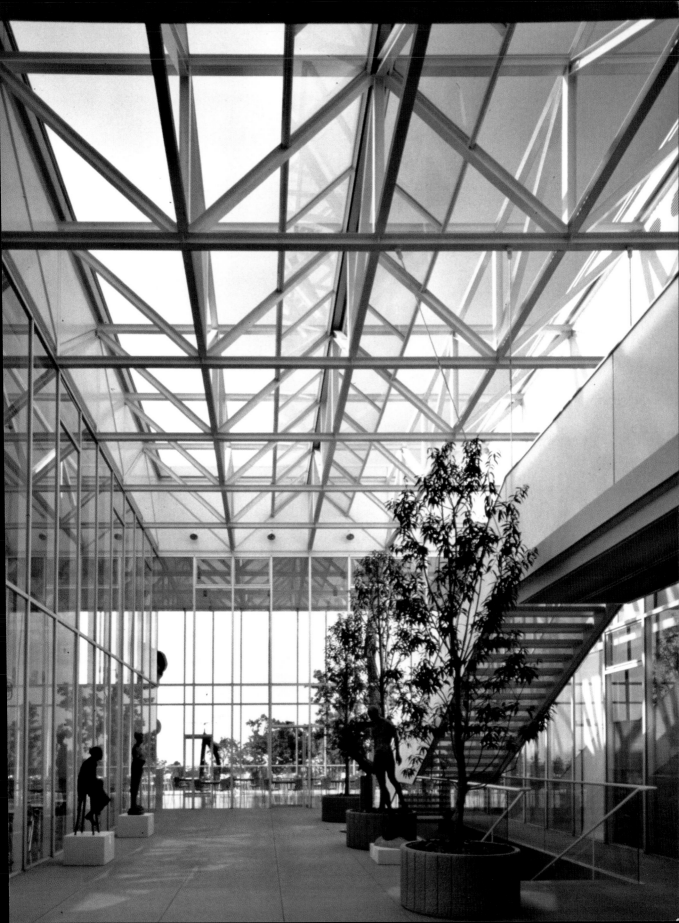

Fireflies

Subway in Bilbao

NORMAN FOSTER

Bilbao, Spain
Photographs: Luís Sans

Captivated by the industrial structures of Bilbao and the nearby presence of the river estuary as a border between the old and new parts of the city, Foster approaches the project by asserting the city's historic heritage and by using structures typical of engineering, but with the fine and meticulous finish that characterizes Foster's works. The project sees the tunnel as a place of extreme beauty inside the earth, and promotes its organic form through the lighting. The treatment is in only three materials: panels of prefabricated concrete, stainless steel, and glass, keeping within a single colorway. The search for simplicity and reduction to the minimum of small-scale elements help the user to gain an overall image of the work.

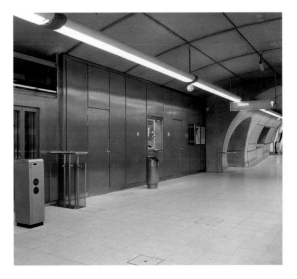

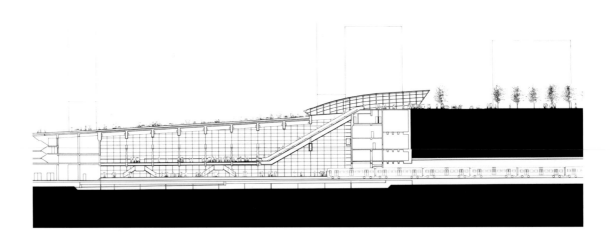

Above: Longitudinal section of the Sarriko station, one of the most heavily-used on the line

Opposite: Night view of an entrance to the subway

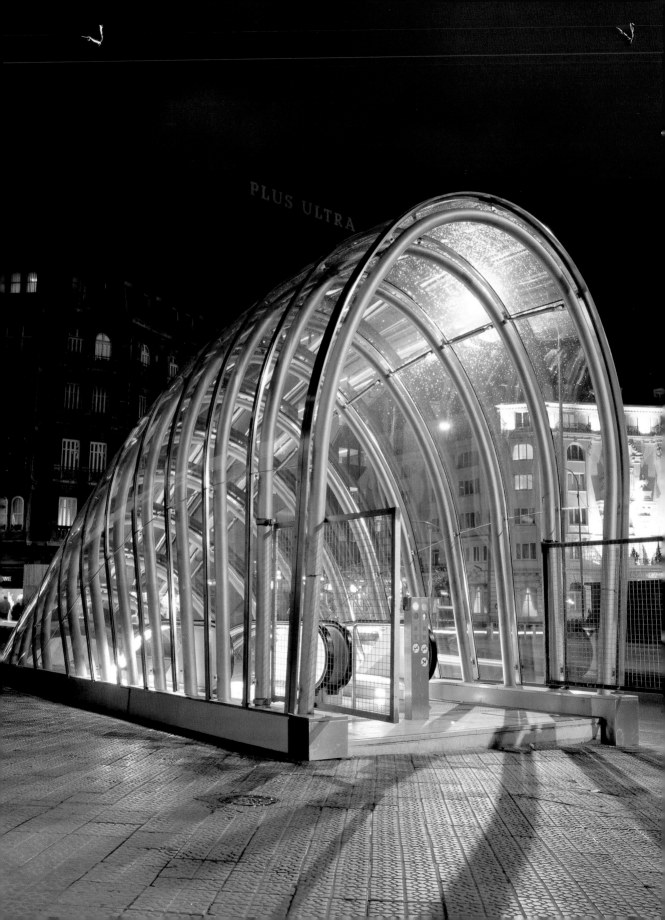

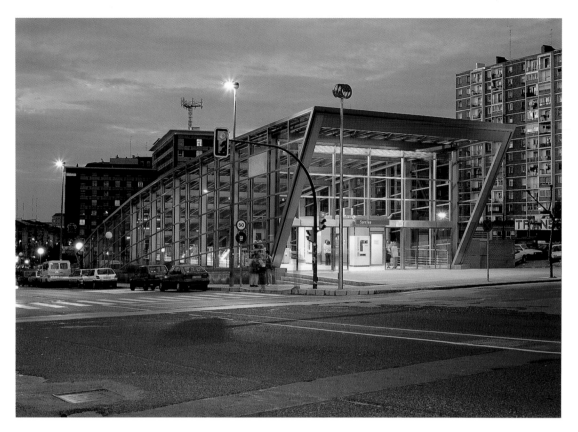

Top: Entrance to Sarriko station

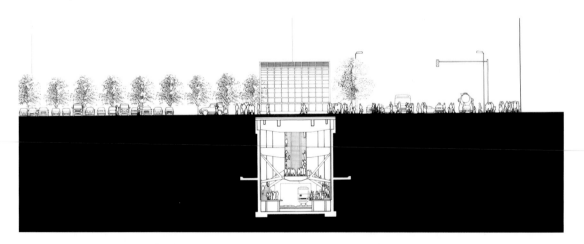

Above: Cross section of the same station

Opposite: Tunnels may convey poetry intrinsically. According to Foster, trying to change their appearance is a mistake.

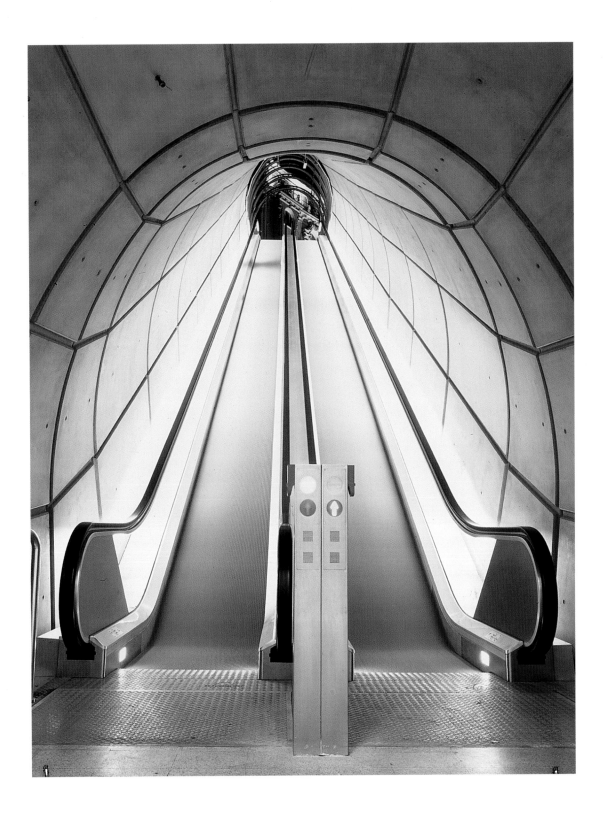

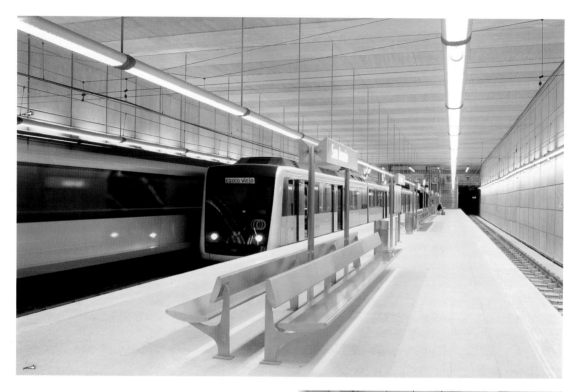

Above: Details of the subway interior, treated with only two materials and a single color—light gray

Opposite: View of one of the platforms

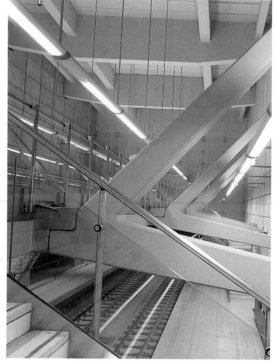

The entrance canopies at the mouths of the subway, made of glass and a stainless-steel structure, take on the symbolism of the whole project, turning into enormous lamps that light up the city at night. The first stage of the project's execution concentrated on the elimination of level crossings, the remodeling of some already existing stations, cleaning up the rivers, and recovery of the banks of the estuary and of the passages under the river. The most significant work is the stretch between Elorrieta and the old town. In the future, the HI line will solve the problem of connecting other densely populated districts.

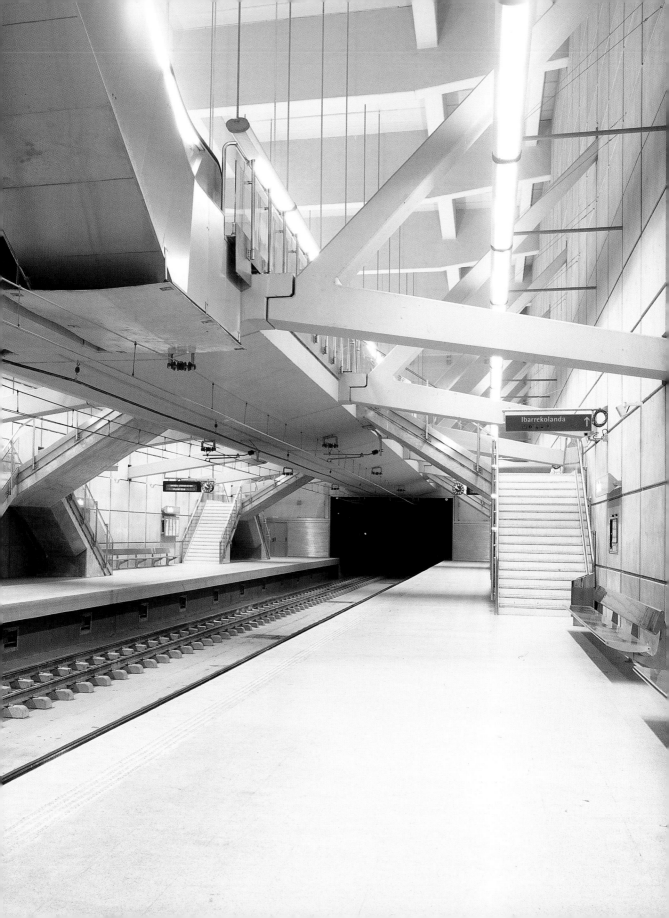

A hangar in Hamburg

Hamburg Airport

VON GERKAN + MARG
Hamburg
Photographs: Klaus Frahm,
Heiner Leiska, G. Grimmenstein

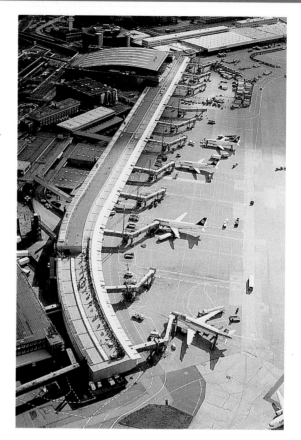

Meinhard von Gerkan often establishes recurrent design elements in his projects for airports, such as the dialogue between the basement-like concrete structure and the large, light sloping roofs of the lounges, together with the visual metaphors produced by the latter, representing a wood or, for example, the wings of a plane. In this case, as specified by the rules of the competition established in 1986, it was necessary to keep the airport functioning during its expansion.

The new blocks establish structural intervals, which suggest an urban arrangement, but without determining their future development. The new terminal is a spacious hall with natural lighting, covered by a great curved roof that also shelters shops, a restaurant, and levels for visitors.

Above: Façade of the airport, from the runways

Opposite above: The airport lounge, showing its light roof and the triangulated girders supporting it

Opposite below: Façade of the airport

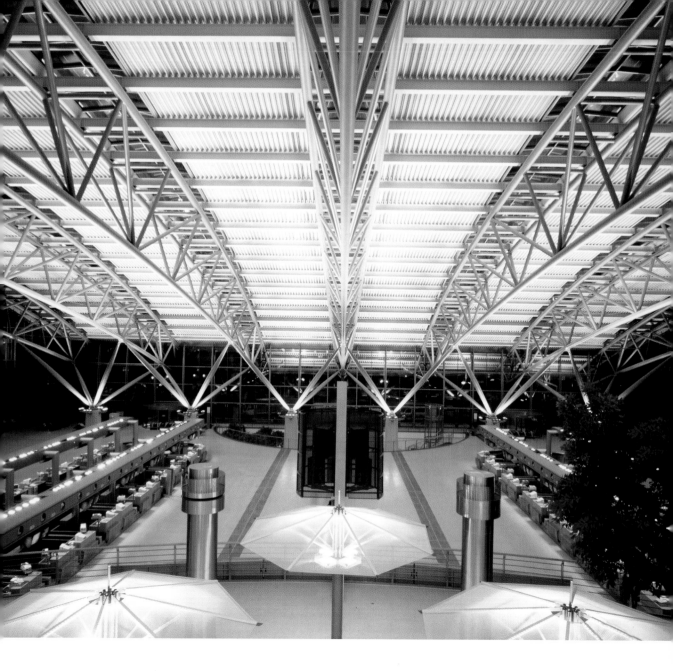

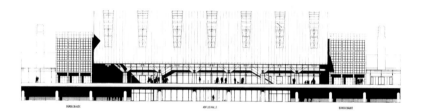

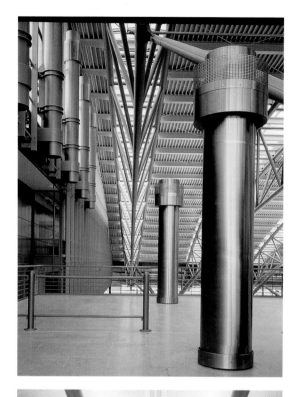

Below: Scheme of the different levels of the airport

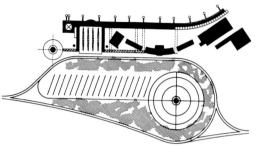

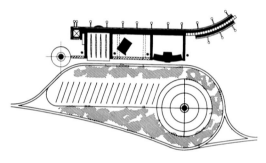

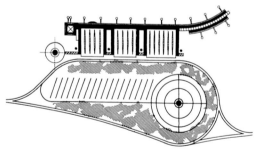

Left: The careful finishes of the structure, staircases, ventilation tubes, and conveyor belt contribute a purity of form through the use of industrial elements

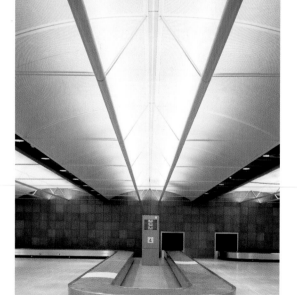

Opposite: View of the lounge showing the diagonal supports of the roof girders

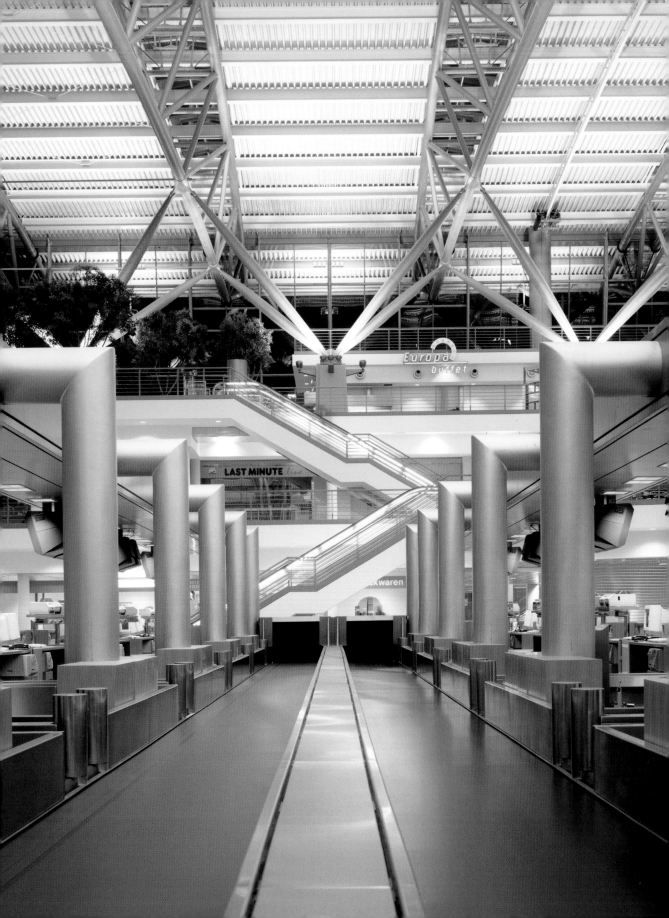

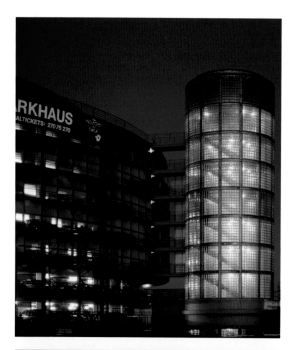

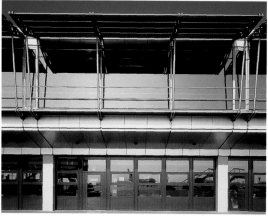

Left (top and bottom): The staircases and the circular ramps are among the most recurrent and suggestive themes in von Gerkan's work.

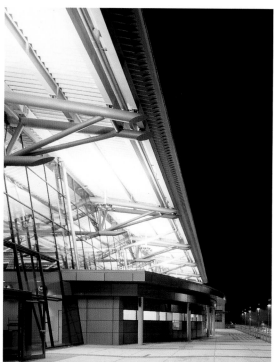

The roof's shape echoes that of an airplane's wings, establishing a deliberate contrast with the monolithic blocks flanking the hall. The roof covers an area of 75 by 101 meters (246 by 331 feet) by means of seven triangulated girders springing from two pairs of diagonal supports. The effect of the wind is countered by the use of diagonally placed supports. The construction of the roof is light and economical, in spite of its 62-meter (203-feet) span. A large semicircular opening in the floor contains the escalators and panoramic elevators, which are among the main attractions of Hamburg Airport.

Above: One of the key issues in developing the design involved integrating the existing main corridor and the embarkation functions. The arrivals hall is situated on the ground floor for better access to the exterior, while the departure lounge is on the first floor.

Opposite: Details of the circular nucleus of staircases and ramps connecting to the parking structure previously built by von Gerkan

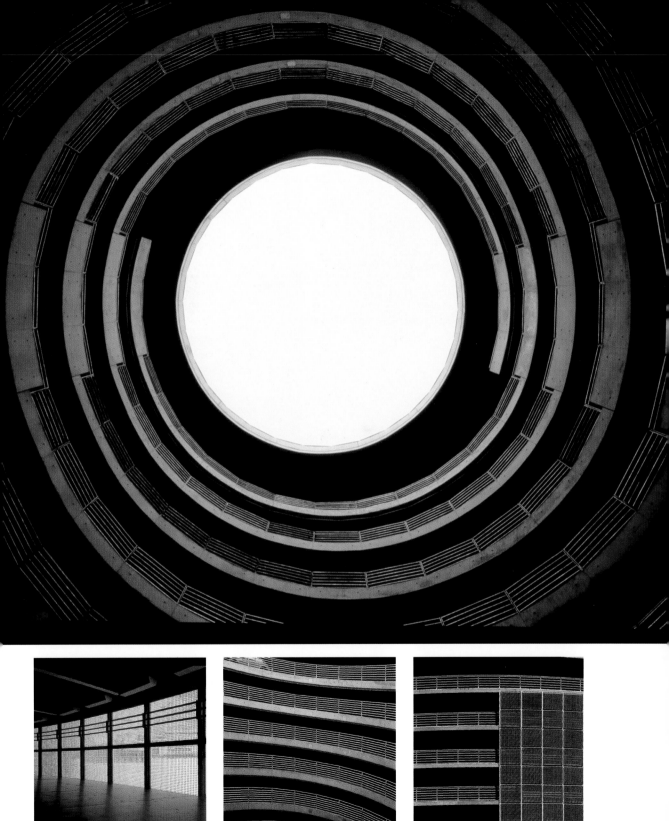

An interchange for Lille

Triangle des Gares Euralille

JEAN NOUVEL

Lille, France
Photographs: Philippe Ruault, Ralph Richter

This building is situated within the context of the Euralille project, the large European complex dedicated to the flow of people and multiple activities. The building consists of a retail center crowned by a line of five office towers to the south and bounded by a line of apartments and a hotel to the west. The complex is situated at the intersection of Lille-Flanders Station, the new TGV station, and the avenue Le Corbusier. It also includes a supermarket, student accommodations, various leisure and cultural projects, and a school—in short, an amalgam of activities and functions in an environment of human interaction and flux.

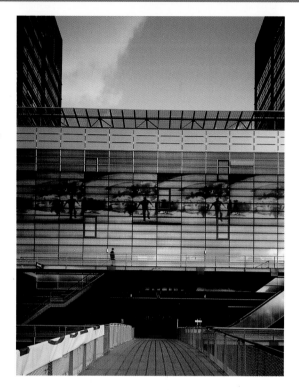

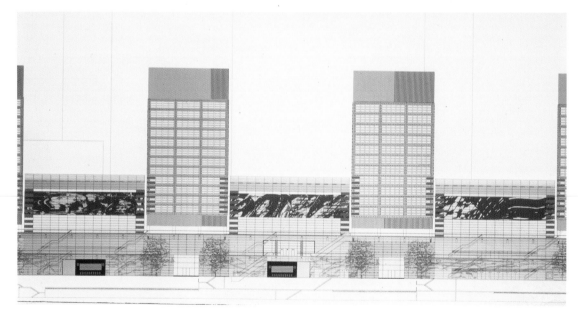

Above: Elevation of the project

Opposite: Reflections and transparencies on the windowpanes

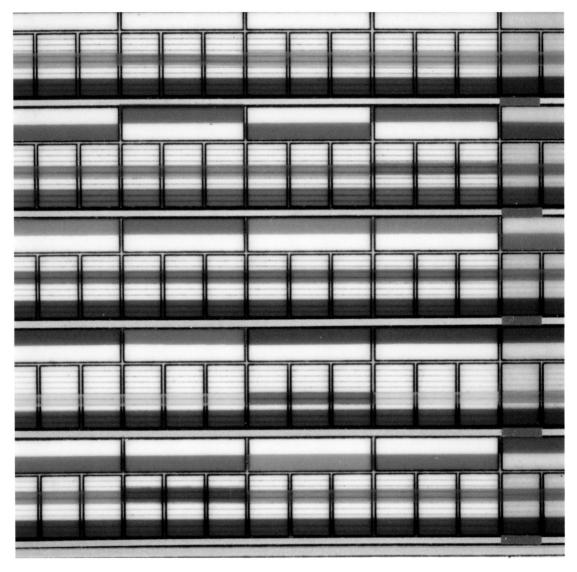

Above: Study of the façades

Opposite: Exterior perspective of the towers

Opposite below: Section of the building

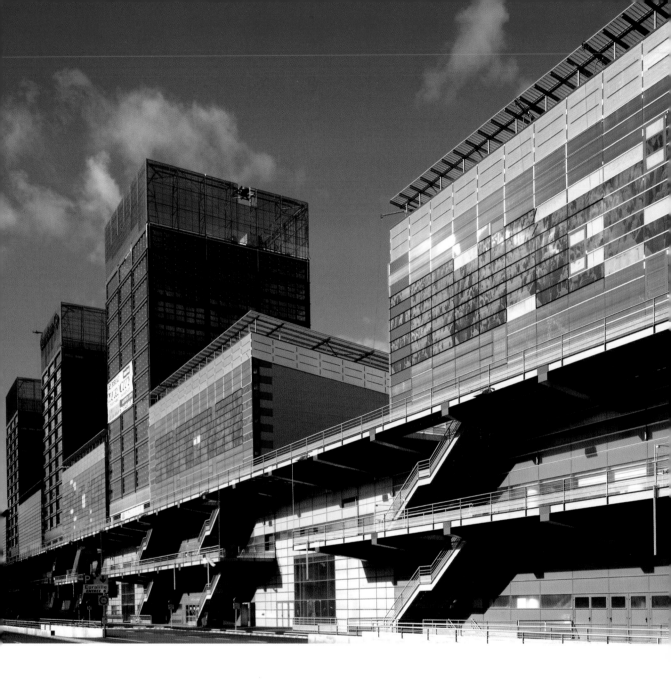

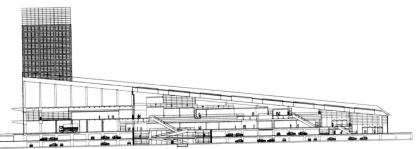

Above: Detail of an exterior staircase

Right: Reflections and transparencies on the windowpanes

Opposite: Images and colors on the façades

The retail center is situated on the lower two floors below the pitched roof. The lowest level accommodates the apartments and hotel. The highest is occupied by the restaurants, which enjoy impressive views. The hotel, student accommodations, offices, and other functions occupy the five towers. The spaces between the towers house the cultural and educational spaces. The simplicity of the project's basic forms are complemented by a variety of intricate architectural elements, for example, the treatment of materials, colors, textures, and images. However, the different parts of the complex are integrated into a whole by means of the rational use of materials that implicitly project a certain identity. For example, the lacquered gray aluminum façade, which is considered optimal for advertisements, logos, reflective paints, and intense red illumination, is an element present in airports, televisions, and computer screens, among other technology, and signifies the modern world.

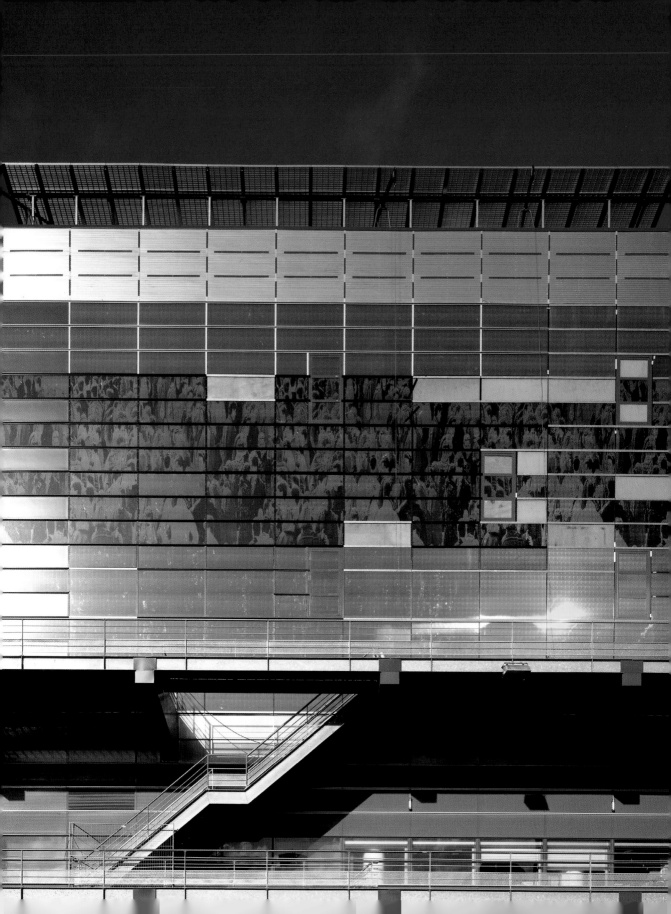

Life in an ellipse

Kaze-no-Oka Crematorium

FUMIHIKO MAKI & ASSOCIATES

Nakatsu, Japan
Photographs: Nácasa & Partners Inc.

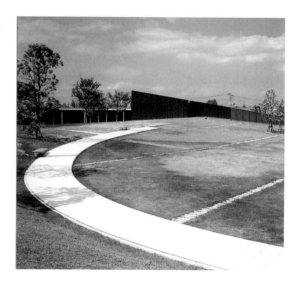

This project stands in a setting of outstanding beauty on the outskirts of Nakatsu, Japan. From the beginning it was a collaboration between the architect Maki and a team of landscape architects, who set out to integrate the building completely into its landscape.

The crematorium constitutes one floor consisting of three principal parts: the inclined block of the chapel; a blind inclined wall containing the functional areas of the crematorium; and a porch making a transition between those two elements. Inside, the layout follows a strict functional order, although treatment of the elements gives the complex the status of a landscape experience. By contrast, the green areas of the park take on a distinct

Above: Ground floor of the crematorium

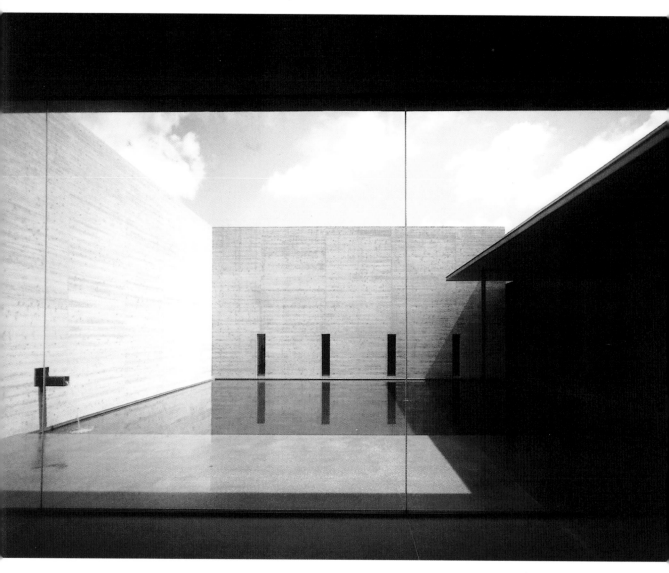

The interior of the building conceived as a landscape through the use of the elements of water, light, sky, and wind

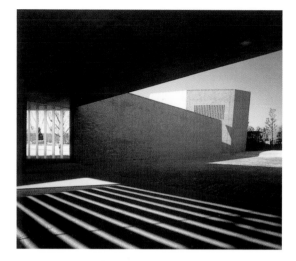

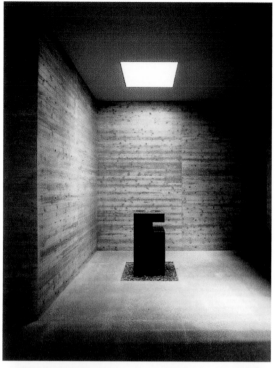

Above: Without a direct reference, the spiritual importance of the landscape recalls the crematorium of Asplund.

Right (top and bottom): The austerity of the interiors is a call to asceticism.

Opposite (top and bottom): The building is perceived as an object placed in the landscape and in organic unity with it.

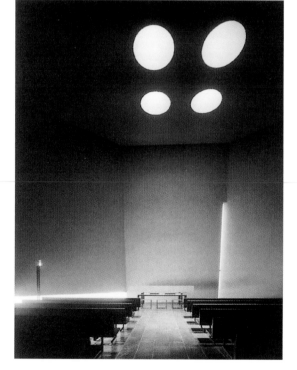

architectural note because of their geometrical treatment, which culminates in the central ellipse of the garden.

The crematorium incorporates old tombs discovered in the place before work was begun, and the design makes use both of architectural and landscape methods in order to create a proposal successfully combining both disciplines. Thus the solution displays a skillful use of changes in paving, of trees as isolating elements, and of rigid geometrical-topographical meshes, at the same time that it achieves an ideal of vertical movement that is present everywhere—for example, in the openings and changes of level outdoors. But the true heart of the project is based on the spectator's horizontal vision, with the design at every moment is perceived as a façade.

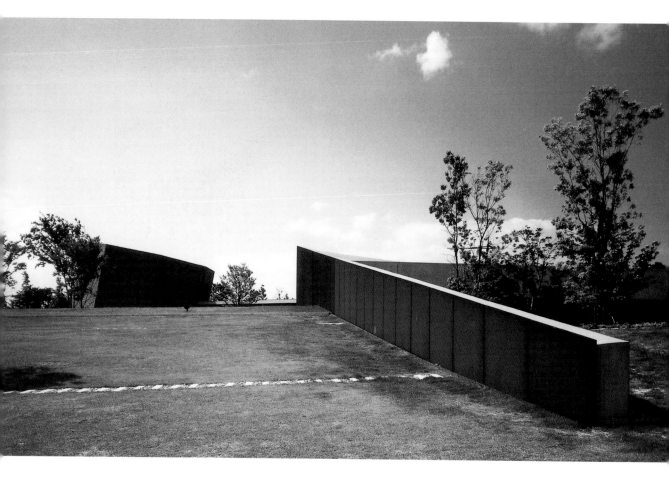

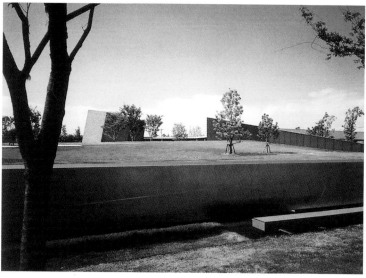

Vees

Funeral parlor in León

BAAS ARQUITECTES—JORDI BADIA/JOSEP VAL

Leon, Spain

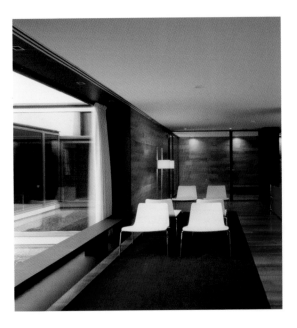

This building adopts a solution of minimum visual impact, buried entirely in the ground with a roof displaying a sheet of water on its surface, which serves as a mirror to the town. Its continuity is interrupted by the appearance of irregular volumes that reach to the sky in search of natural light for the building interior. The water façade is also punctuated by courtyard voids, which function to provide additional light. Access to the building is conceived as a subtle approach integrated into the green area that advances into the basement. A slope of ivies and birches appears to probe into the entrance through the window created for their contemplation.

Above: Site plan of the building

Opposite: Detail of lanterns on the water's surface

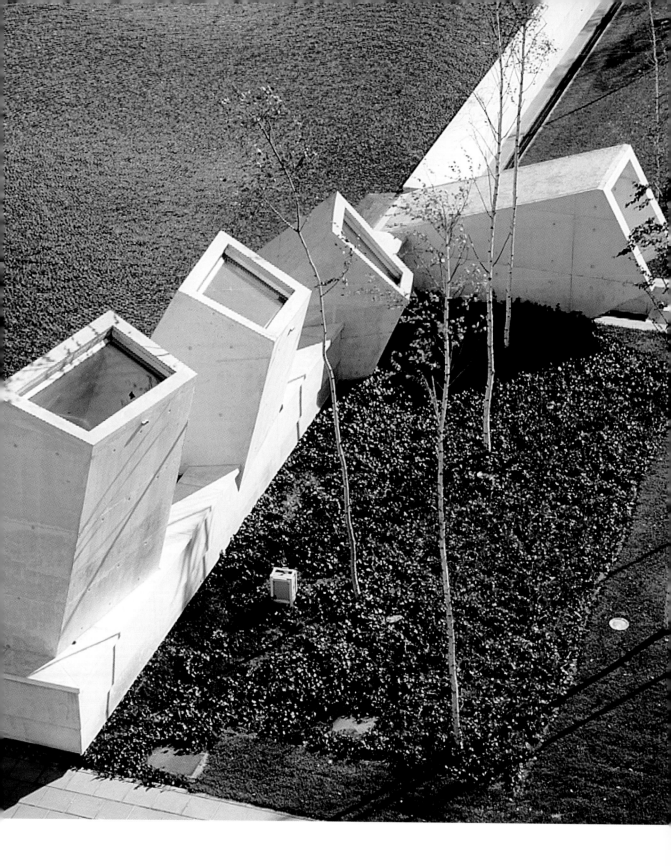

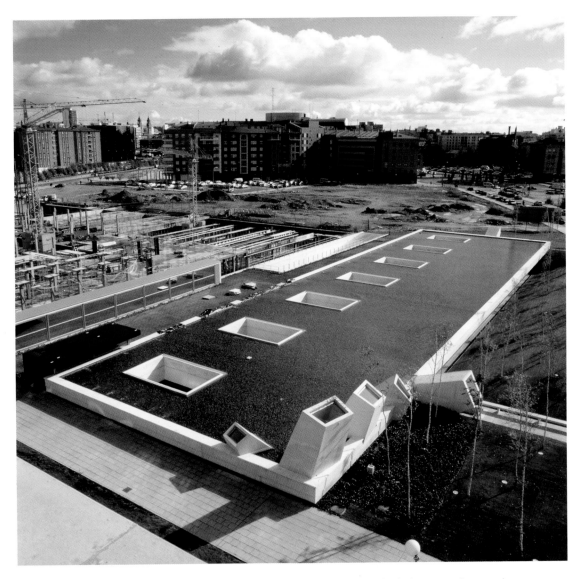

Above: Aerial view of the building, showing its single façade: the roof, displaying its lanterns and courtyards

Opposite (top and bottom): Different images of the water façade integrated into its outdoor context, as an element of the townscape

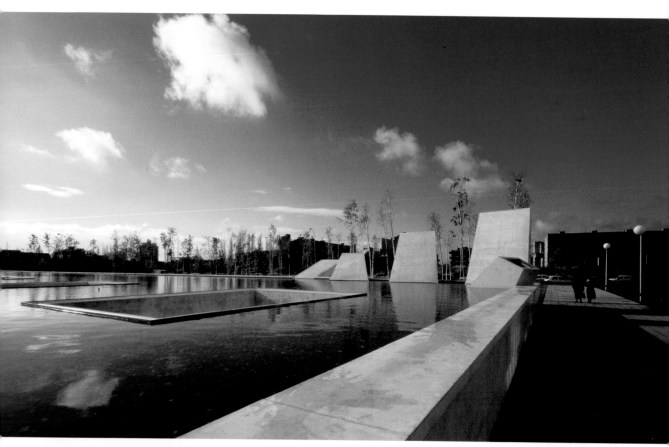

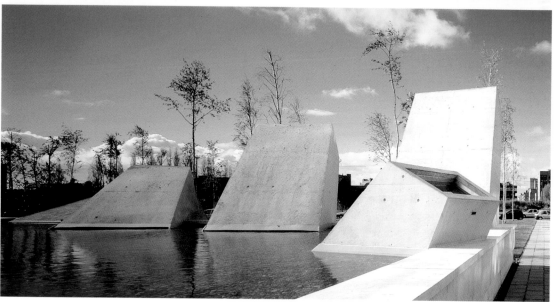

Below: The uninhibited display of the V-shaped pillars reveals the weight they carry.

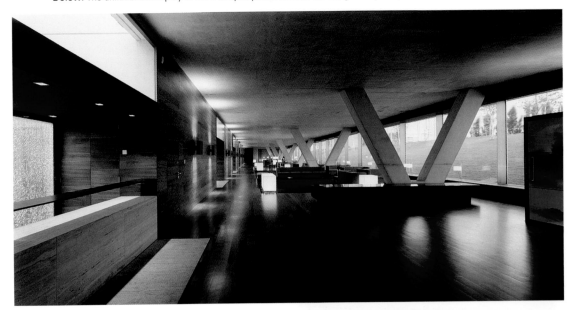

Right: The interior of the building, showing the use of different materials and lighting

Opposite: Detail of one of the work areas

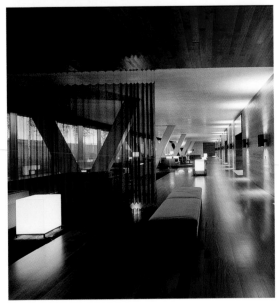

Inside, a play of lights and shadows is cast on the surfaces and furniture, which follows the purity of line of the whole complex. The use of colored concrete for the interior seeks the tone of the local stone; in the interior, the floor consists of sheets of iroko wood, contributing the warmth conveyed by that material, and extending to the walls that serve as partitions between the vigil rooms and lobby. Black is used in different places as an expression of mourning. A notable feature is the use of V-shaped pillars, carrying the roof with its sheet of water above. In counterpoint to the fluidity of the indoor spaces and their relation with the landscape outside, the work spaces are enclosed; here functionalism dominates and superfluous elements are excluded.

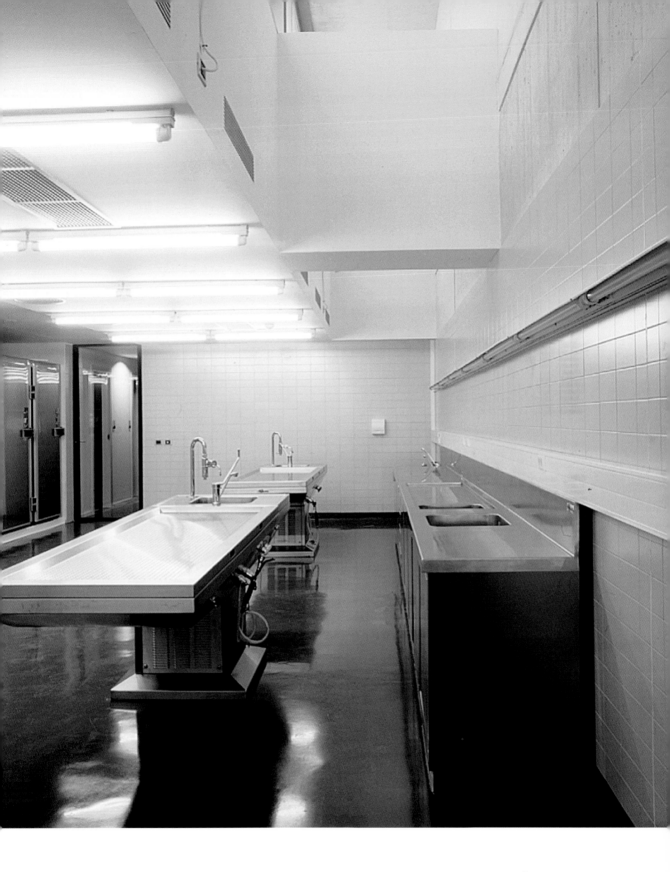

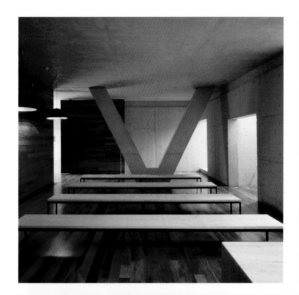

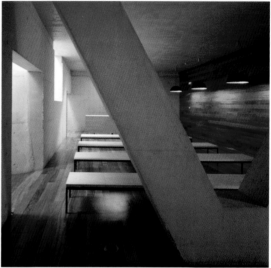

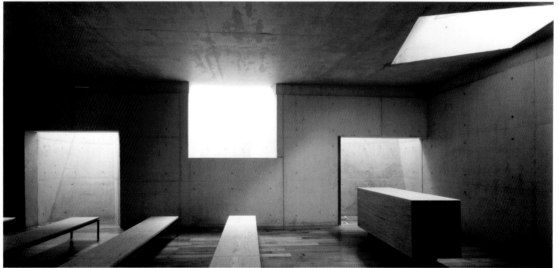

Above (left and right): Details of the inner areas lit by the architectural lanterns

Opposite: Detail of the lanterns of colored reinforced concrete that bring light into the building

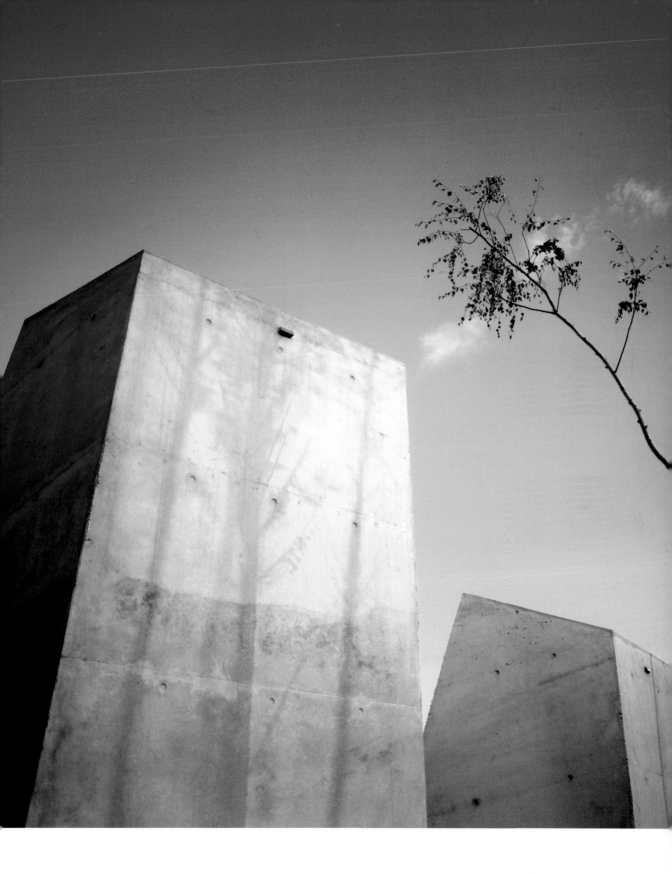

The window of the soul

Funeral parlor in Terrassa

BAAS ARQUITECTES— JORDI BADIA

Barcelona, Spain

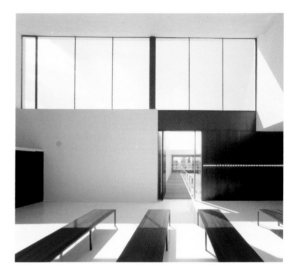

Designed to house both ceremonial and spiritual rites, the principal characteristic of this complex is conceptual clarity. Compositionally, a white volume occupies the space, cantilevered over the gentle slope of the terrain, which is exploited to provide a half-basement below the main story of the building where the administrative premises are located. This story functions independently of the rest of the plan, opening onto a side courtyard and entered by direct access from the street using an outside staircase.

The plan of the rest of the building is divided into three areas grouped into separate modules: places of vigil, the chapel, and the cafeteria, linked around a courtyard in which water is a symbolic element.

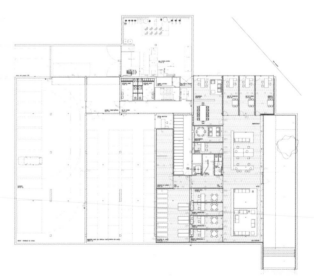

Above: Plan of the ground floor, housing administrative and private functions independent of the rest of the building

Opposite: Exterior view of the complex showing the independent accesses of the two levels

Opposite below: Schematic section of the building showing its relation to the topography

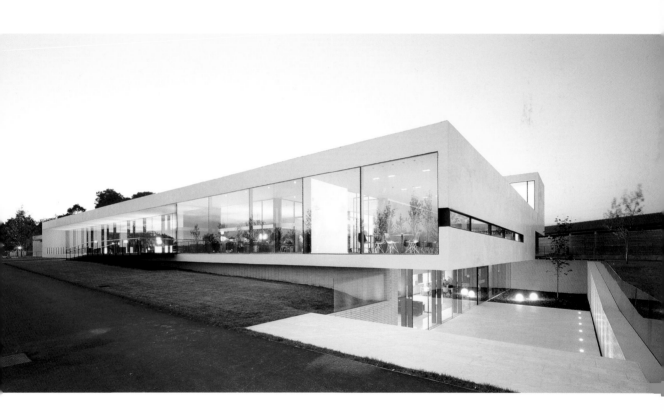

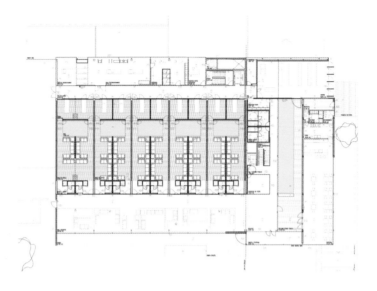

Top: First floor, containing the public spaces, distributed around a courtyard with its sheet of water

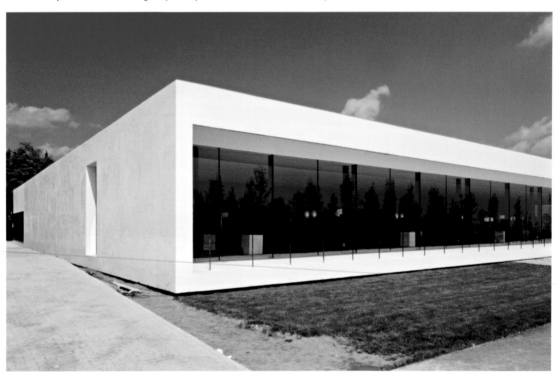

Above: Exterior view showing the building's delicate setting on its site

Opposite: Different exterior views of the complex

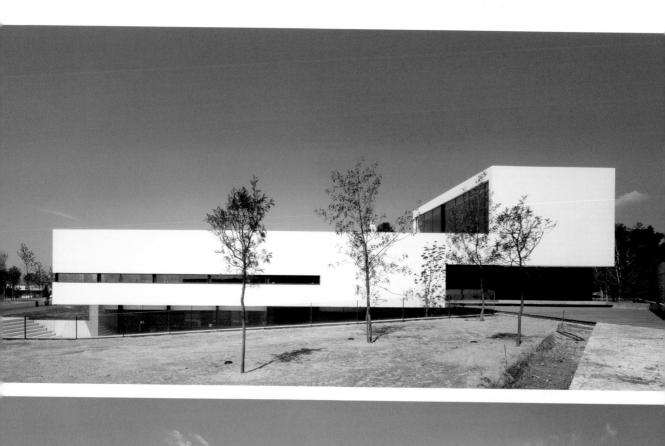

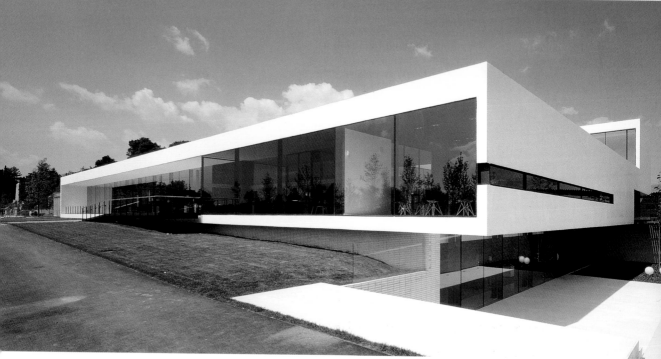

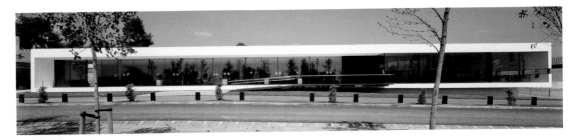

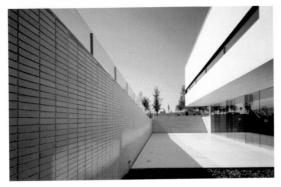

Above: Entrance façade of the building

Left: The upper story cantilevers over the courtyard, lighting the ground floor

The design seeks to integrate natural features and the simple forms of the architecture within a distinctive space, where circumstances make emotions play an essential part. The building breaks through its enclosed form with a porch open to the landscape on the main façade, framed by the outline of the horizontal reference volume. The building is flooded with light through its façades and inner courtyards that give life to the visiting rooms, arranged in architectural sequence leading from the entrance lobby: a ramp following the main façade, the porch, and a large doorway. From the lobby one can see the courtyard with its sheet of water, which dominates and interconnects the entire building. The chapel is placed symbolically on the second story, with an independent entrance via a pedestrian path that finally leads to a space for introspective reflection, peace, calm, and faith, welcoming visitors by means of the light and sky.

Opposite: Two views of the courtyard showing the sheet of water and gravel background

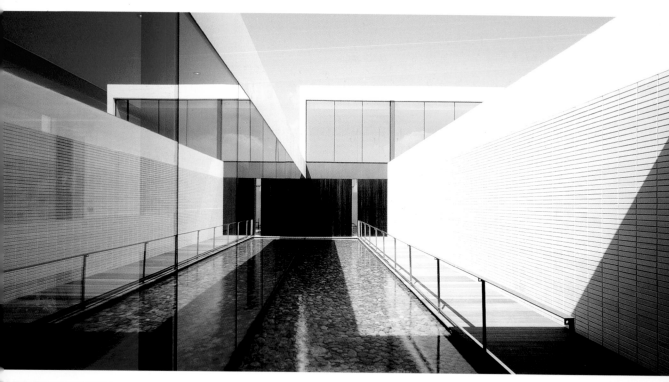

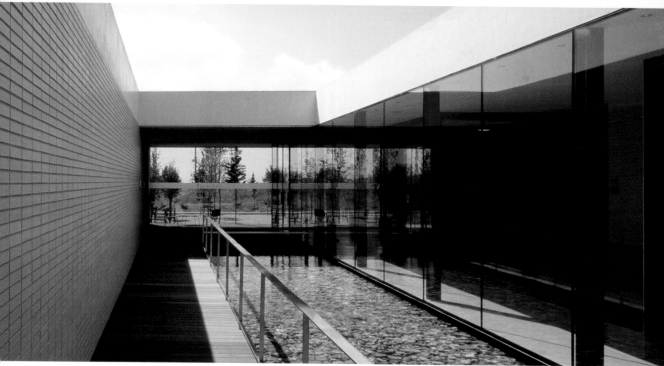

Vienna in transparencies

Wien Twin Tower

MASSIMILIANO FUKSAS
Vienna, Austria
Photographs: Drexel, K. Furudate,
Angelo Kaunat, Rupert Steiner

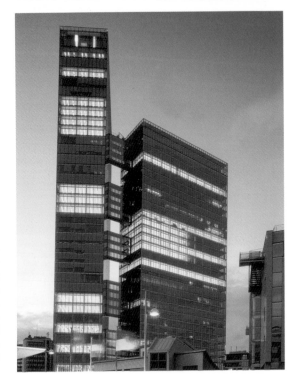

This project was intended to create a new urban zone on the margins of Vienna, a city of significant aesthetic substance where architecture has played an essential role throughout the most important periods of European history. The contemporary architectural debate was in the hands of the Coop Himmelbau studio, among others. Vienna is a conservative city, but prepared to innovate; and Massimiliano Fuksas was selected for the commission. The plot designated for the commission did not form part of the fabric of the city, so it was decided to construct a new area that could serve as an urban model and enrich the Viennese skyline as well.

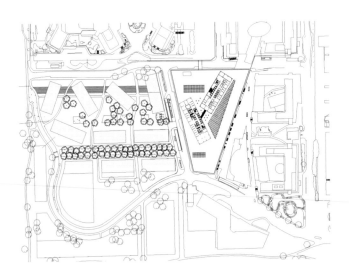

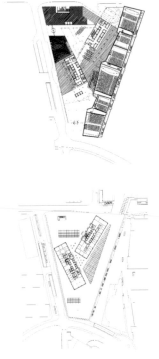

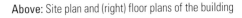

Above: Site plan and (right) floor plans of the building

Opposite: Night view of the complex

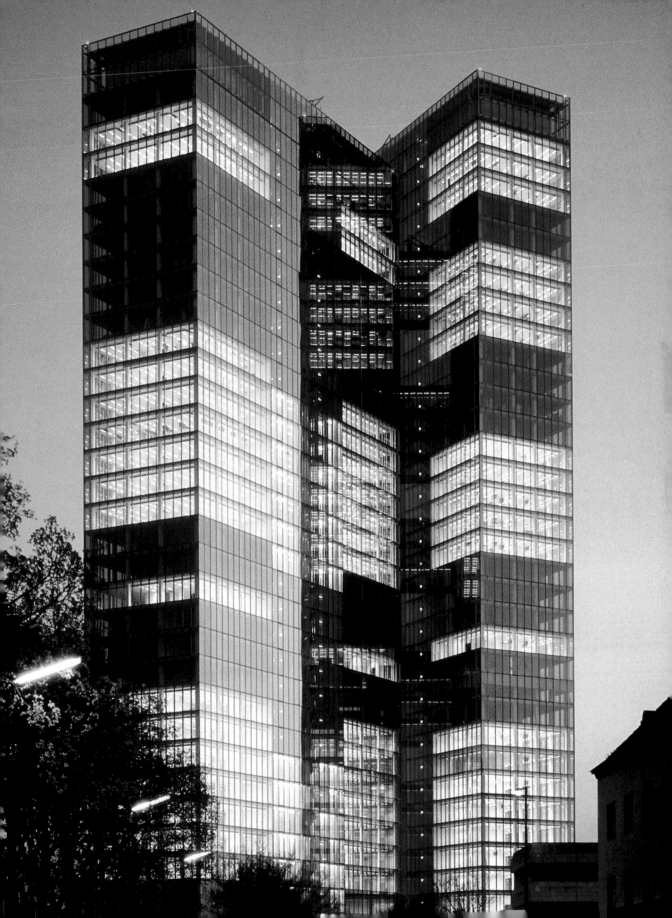

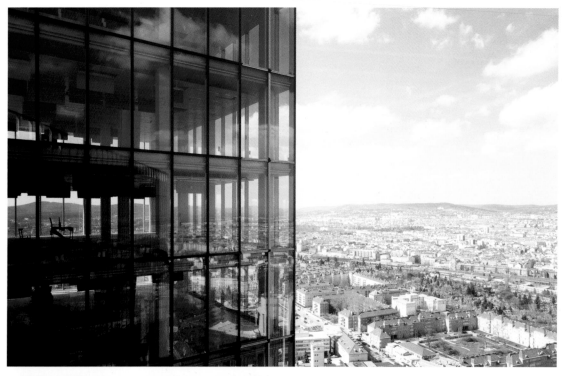

Above and top: Details showing the transparency of the building and the activity within it

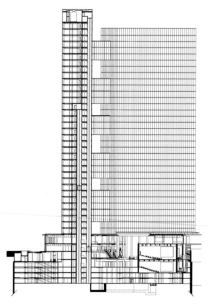

Above: Section of the building

Opposite: Perspective of the towers and their surroundings

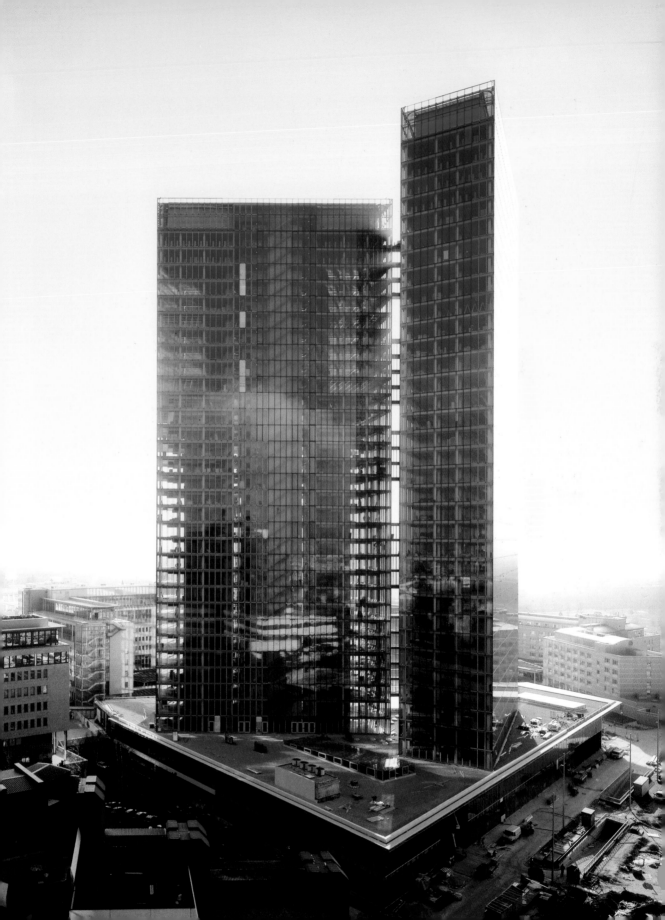

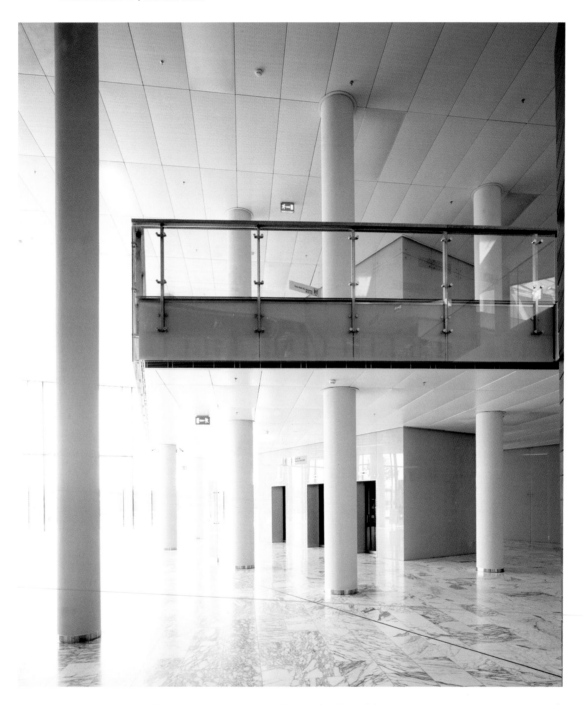

Above: Interior view of the building showing the use of light-colored materials

Opposite: Interior view of the building showing the transparent glass surface that admits light into the entrances and transit areas

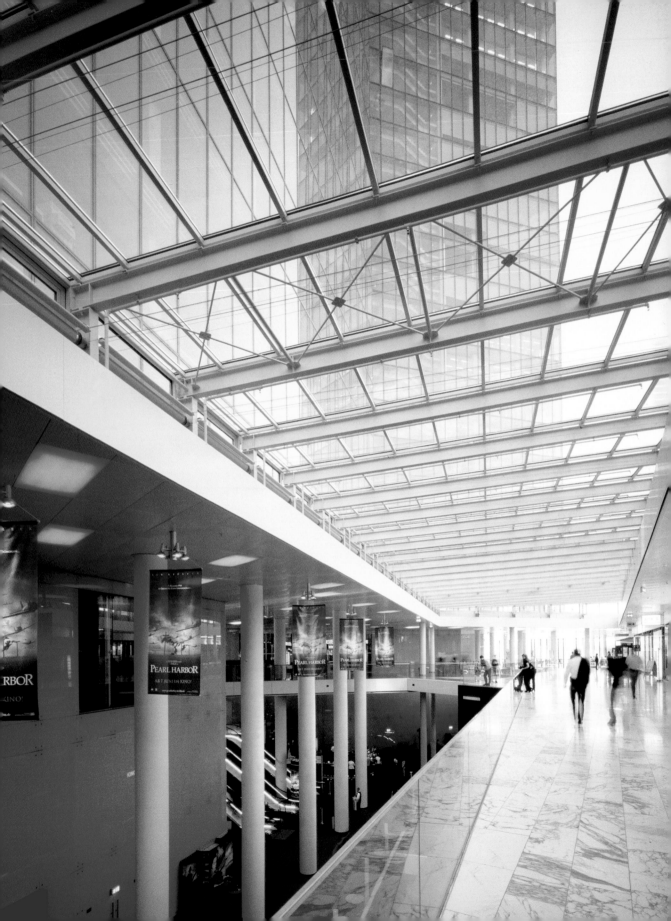

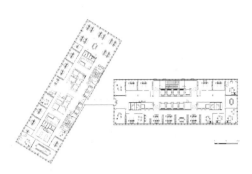

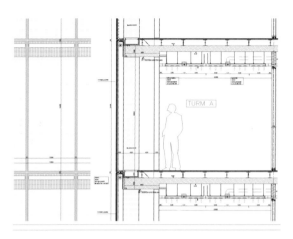

Above left: Standard floor of the building

Top: Constructive detail of the glass façade

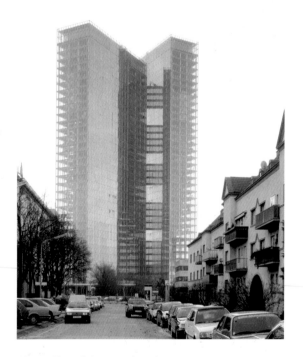

Located in the transition zone between the densely built areas and the surrounding open spaces, the twin towers of thirty-four and thirty-seven floors have become a new landmark. The southern square, a public space, has been treated as natural space in the form of a winding rural street designed by the architect using Land Art concepts. The building is entered through an architectural promenade that introduces the spectator to the mixed-use complex within two clearly differentiated, juxtaposed volumes—"towers" and "bars." The different activities are arranged in independent spaces: the leisure zone on the ground floor, adjacent to the public space; and offices in the towers, at a distance from the street but connected to it by means of glazed walkways. The leisure-retail center consists of multi-screen cinemas, bars, restaurants, and underground parking facilities with a capacity for 1,000 vehicles. The towers are arranged around a central core, with the perimeter space reserved for offices. The structure is clad in transparent glass.

This project illustrates themes that recur in Fuksas's work, such as development of the urban landscape, the transition and connection between the center and periphery, and the relationship between art and architecture.

Above: View of the tower from the street

Opposite: View showing the use of dark materials and discontinuous illumination of the leisure areas

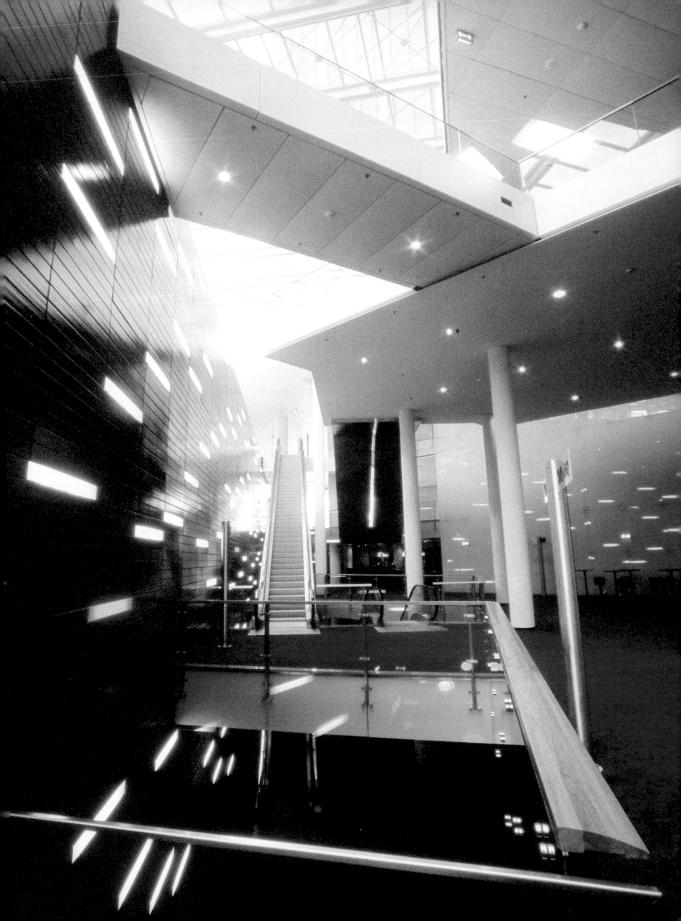

Turning white

Cultural Center of Sant Cugat

ARTIGUES/SANABRIA

Sant Cugat del Vallès, Barcelona, Spain
Photographs: David Cardelús

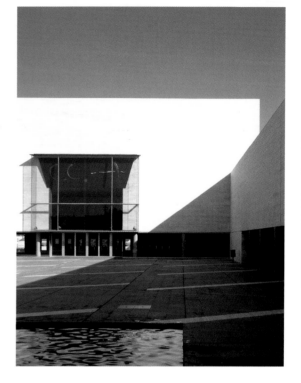

Situated in Sant Cugat del Vallès, a municipality of some 60,000 inhabitants that is part of the greater metropolitan area of Barcelona, less than 50 kilometers (31 miles) from the capital, the Cultural Center is located away from the city center and adjacent to Arboretum Park. The design of the project employs curved lines and organic volumes that are an integrated part of the landscape.

The architects integrated the building into the town so as to consolidate it as a unique and important public building and thus break away from the tradition of going to Barcelona to enjoy leisure activities.

The square fronting the building is as important as the theater itself, allowing events to be held outside in the

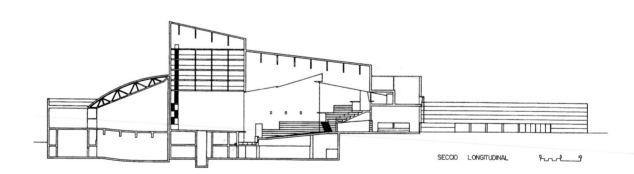

SECCIO LONGITUDINAL

Above: Longitudinal section of the complex

Opposite: Exterior view of the complex in which the colors, textures, and lighting effects can be appreciated

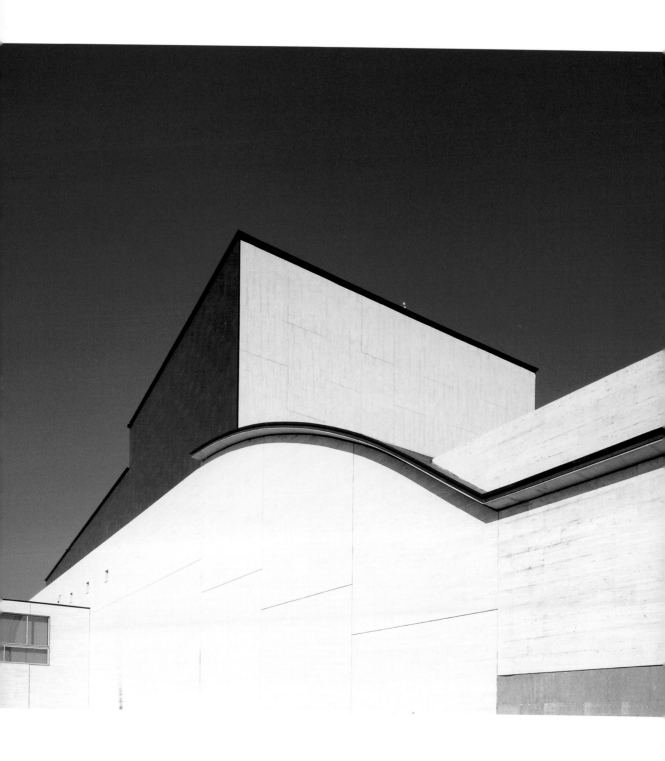

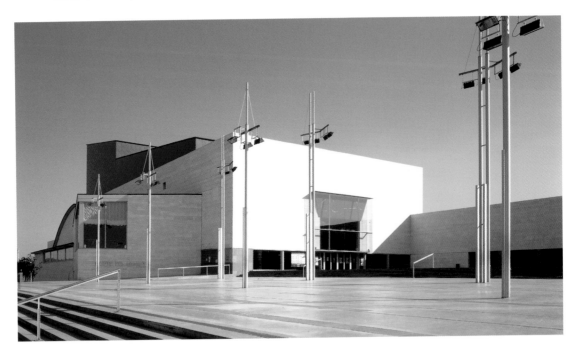

Top: View of the complex facing the square

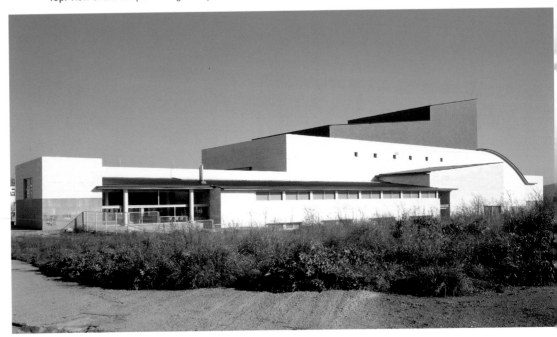

Above: Rear view of the complex from the park and conservatory

Opposite: Detail showing glass tumbler in the entrance to the theater

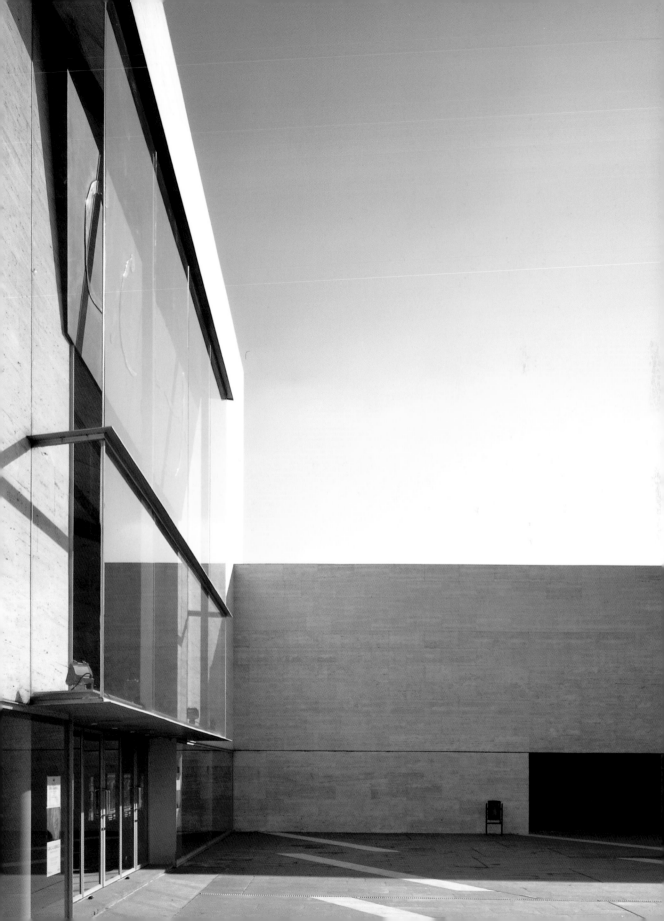

Detail of porticos in the auditorium corridor

Opposite: Detail of the entrance lobby to the theater

open air during the summer and functioning as a local meeting place. The center accommodates a theater, music conservatory, and various projection rooms. Although every facility enjoys an independent access, they all are integral parts of the same building. Externally, the different functions are distinguished by the use of a different height for each activity, a device that enriches the overall form. The theater lobby forms the central element of the group, organizing the annexing rooms and spaces around the main hall. These spaces include a café, which functions independently of the theater timetables. The projection rooms are situated on the lowest level; the highest, and with an access from the square, houses the two-floor-high conservatory, a long corridor with porticos, which leads through the conservatory rooms. The gray brick walls reflect the sunlight that enters through the skylights. The façades are in travertine. The conservatory façades and those that give onto the square are solid, with the exception of the theater entrance that includes a glass tumbler engraved with a piece by Aragó. The upper portion of the audition rooms and the roofs are clad in copper sheeting.

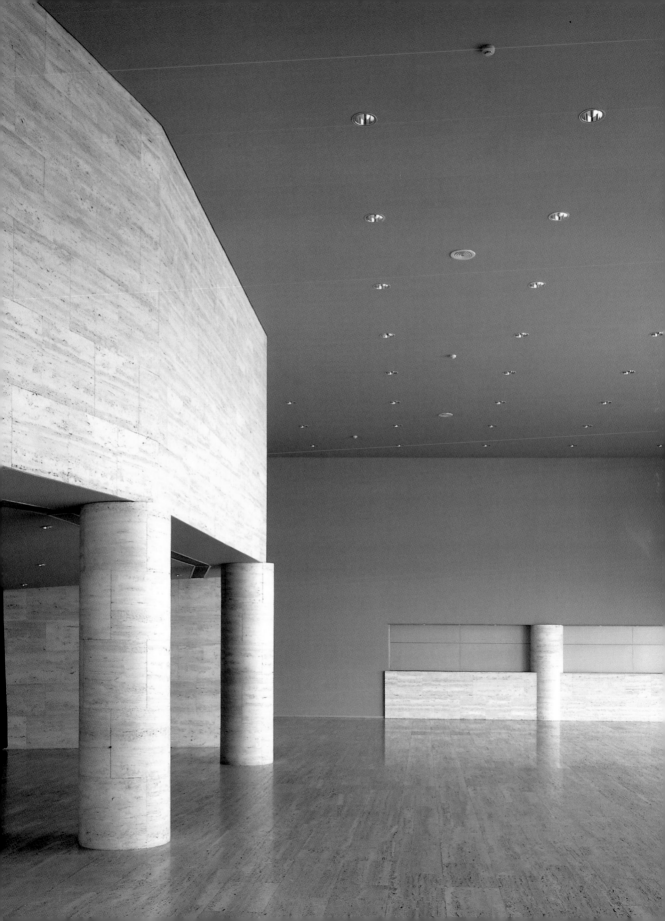

Barcelona between the ropes

The Bac de Roda Bridge: Felipe II

SANTIAGO CALATRAVA

Barcelona, Spain
Photographs: Emilio Rodríguez Ferrer

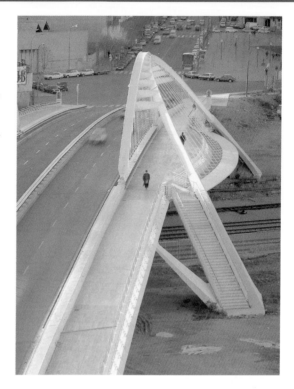

This bridge arises from the need to re-establish the connection—for both pedestrians and wheeled traffic—between two districts of Barcelona that had been cut off from each other. Though it was an indispensable part of the Cerdà Plan itself, it was not built until the architect and engineer Santiago Calatrava designed and executed the bridge between 1985 and 1987. The strong personality with which his works are marked have brought him international fame, although he has not escaped controversy, especially in Spain.

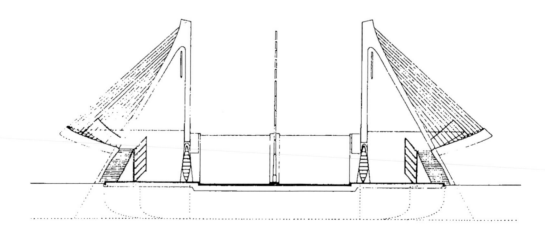

Above: Elevation of the bridge, showing the two pairs of arches and the viewing platforms formed within the tie-beams

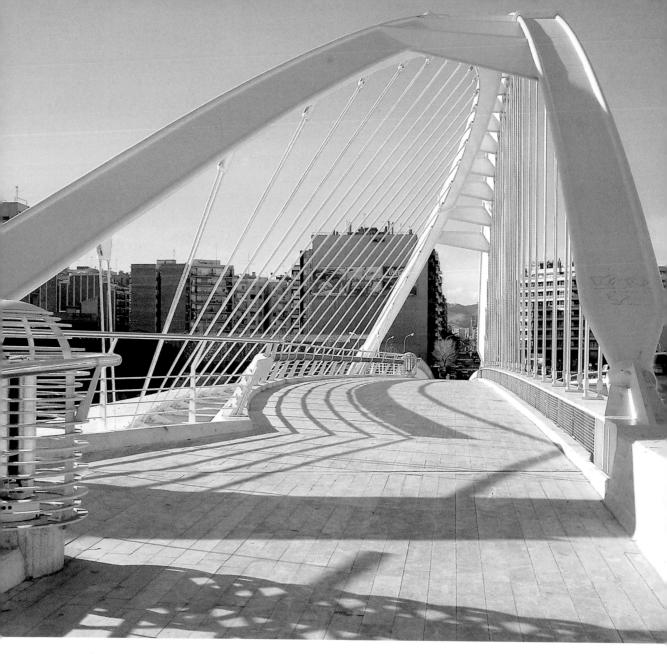

View of the bridge along one of its footpaths under the pair of arches that form the viewing platform

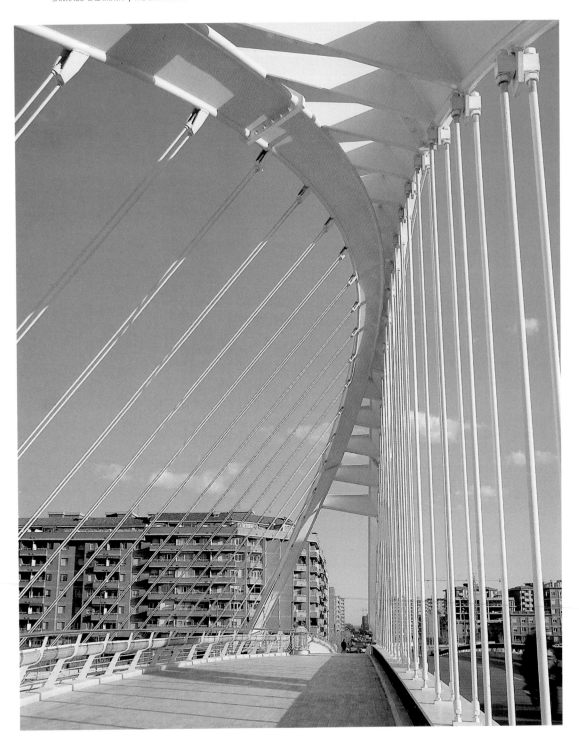

Detail showing the anchoring of the tie-beams to the arches

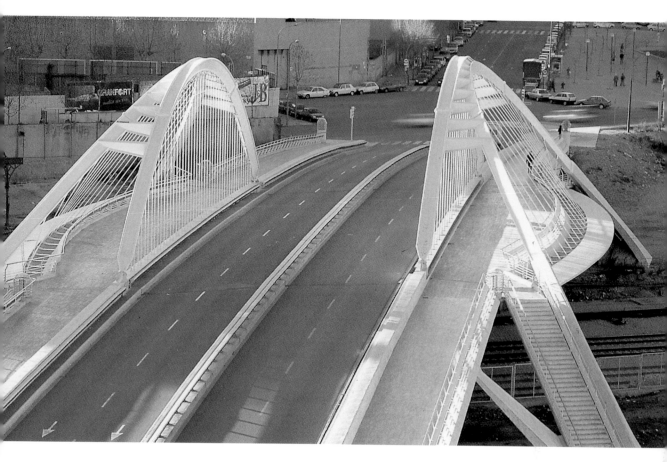

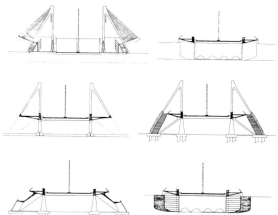

Top: Aerial view of the bridge showing the two pairs of arches and the access staircases leading from the lower level to the viewing platforms

Above: Sections of different segments of the bridge

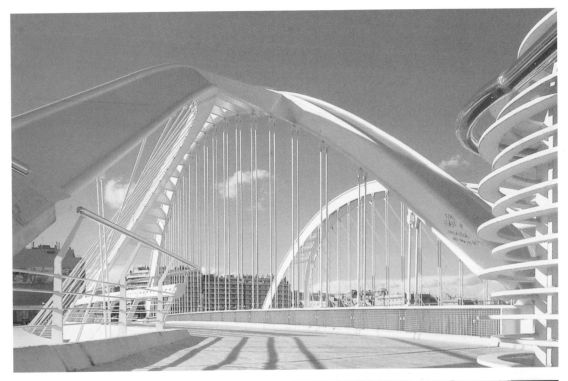

Above: Image of the bridge with a view of the parallel pair of arches through the tie-beams of the platform

Right: View of the bridge at night

Opposite: View of the bridge at night, showing its traffic

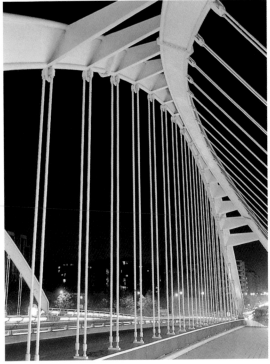

The Bac de Roda bridge crosses an important railway route that formed a barrier between the districts of Sant Marti and Poble Nou. The main streets of those districts, Sant Marti and Felipe II, are important thoroughfares that connect to the center of Barcelona. The structure consists of two pairs of arches that secure the platform, flanked by two footpaths. In the middle of the latter, a widening of the platform creates a large space—framed in the opening between the arches—constitutes a viewing platform. The lighting of the project emphasizes the presence of these platforms, which acquire a strong prominence both for the bridge's users and spectators.

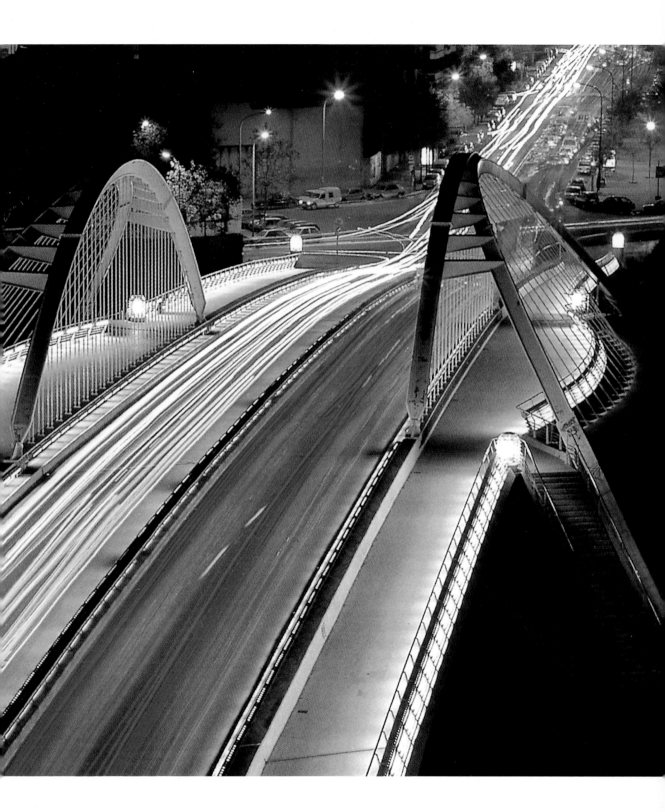

Facing bodies

Westfalen Cultural Forum

ULRICH KÖNIGS &
JÖRG REKITTKE

Münster, Westphalia, Germany

The building stands on one of the most emblematic sites in Hindenburg, divided into two prismatic blocks fronting each other on their entrance façades, on either side of the square, leaving free as much space as possible to keep its amplitude, and leaving as a backdrop the profile of the old Kalkmarktes marketplace. The two blocks complement each other formally and conceptually, setting up a constant dialectic between them.

The art gallery is at the north end of the square, extending its layout beyond its borders, permeable, participative, open, fluid. The narrower fringes are exploited to house the more private premises, liberating the central space inside. By contrast, the concert hall stands on the south side of the square, establishing a direct dialogue with the built-up townscape. It is a compact, static, introverted

Above: Site plan of the setting of the complex

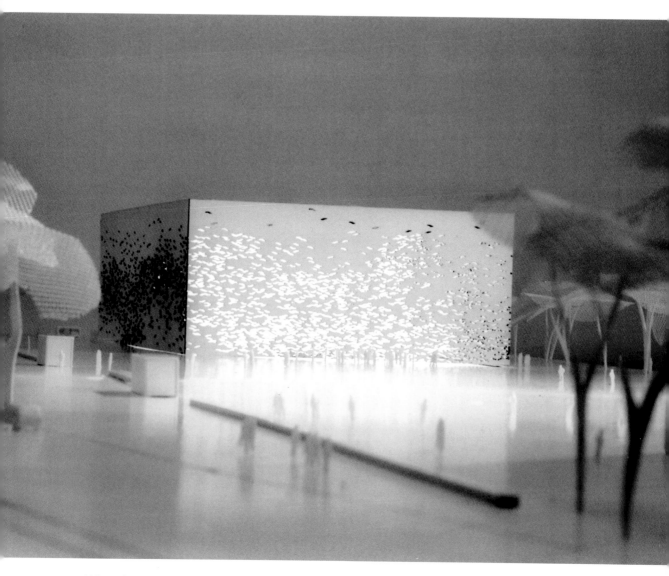

Volumetric model of the concert hall exterior

Top: Ground floor and access to the auditorium

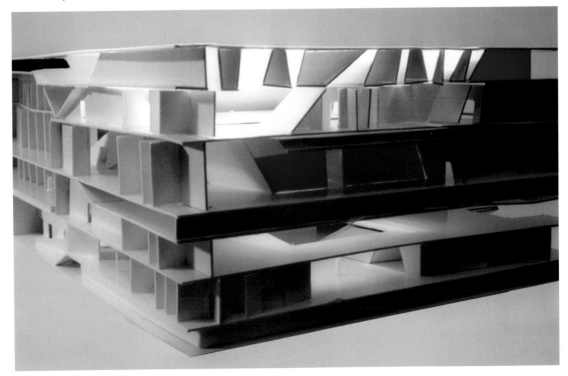

volume, which conceals its layout, isolating itself as much as possible from the outside world. Inside, the concert hall is capable of housing a large number of spectators and possesses an excellent acoustic, technical, and functional arrangement. The auditorium, situated in the middle, generates an almost symmetrical distribution of entrances and complementary uses. A large vertical lobby organizes access to the upper level, which contains the auditorium with upper balconies, surrounding the hall. The design formally expresses the functions of creative freedom and exchange of experiences, vis-à-vis the introspection and sensory perception required by each of the activities to which the complex is devoted.

Above: The interior structure, stripped of its covering skin

Opposite top: The large art gallery lobby frames the façade of the auditorium as the masterwork of the exhibition

Opposite below: Cross section of the art gallery

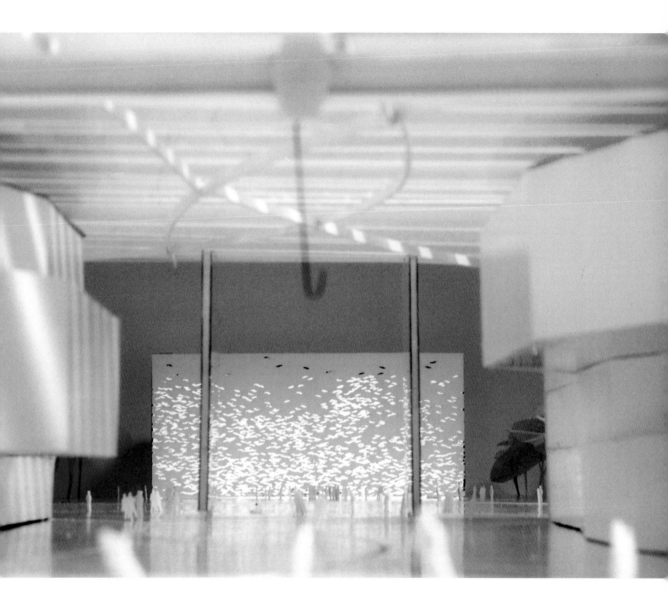

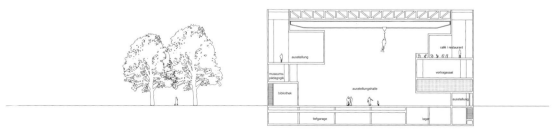

schnitt 02 m1:200

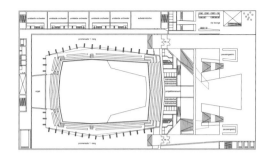

Top: First floor of the concert hall

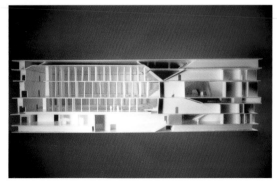

Above: Covering skin of the auditorium

Left: Model of interior of the gallery block

Opposite: At night the building appears dematerialized.

Opposite below: Second floor of the art gallery

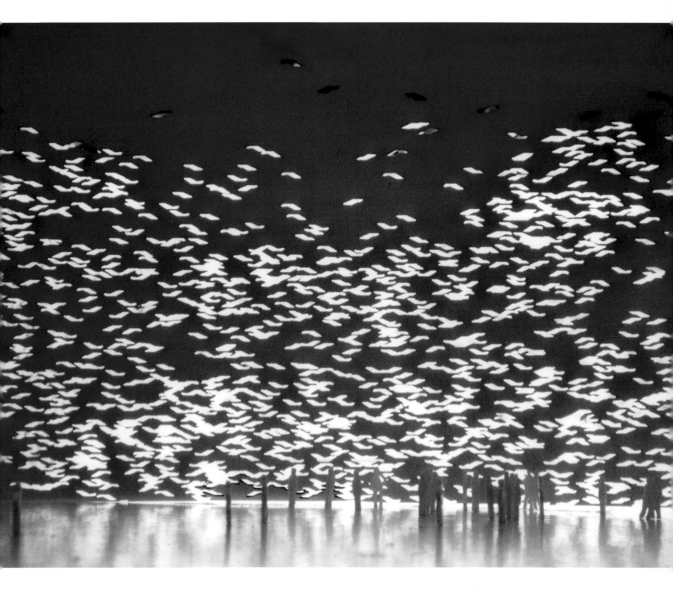

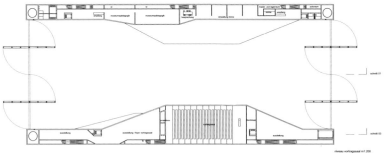

The new Olimpia Theater in Madrid

Olimpia Theater

IGNACIO GARCÍA PEDROSA + ÁNGELA GARCÍA de PAREDES

Madrid, Spain

This theater occupies the auditorium of the old Olimpia Theater, situated on a triangular site facing the Lavapiés district. The building is split into three parallel raised prisms, following the geometry of the place and aligned with the existing buildings of the same height, to preserve the volume of the city block. The prisms are concrete boxes with a façade fronting the square, providing views of theatergoers inside through the curtain wall.

The building contains a center for experimental theater, with a main auditorium, a place for dramatized readings, a rehearsal room, and spaces for public and theater use. The main auditorium, measuring 17 by 36 meters (56 by 118 feet), has a seating capacity of 500, with 130 retractable seats to give the room a greater versatility. Moving platforms enable the level and rake of the floor to be raised, thus permitting a variety of presentations. The rehearsal room is located below the amphitheater, and its use is not dependent on the main auditorium.

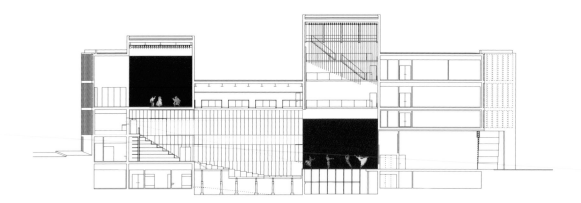

Above: Longitudinal section

Opposite: Detail of the curtain wall of the façade toward the square

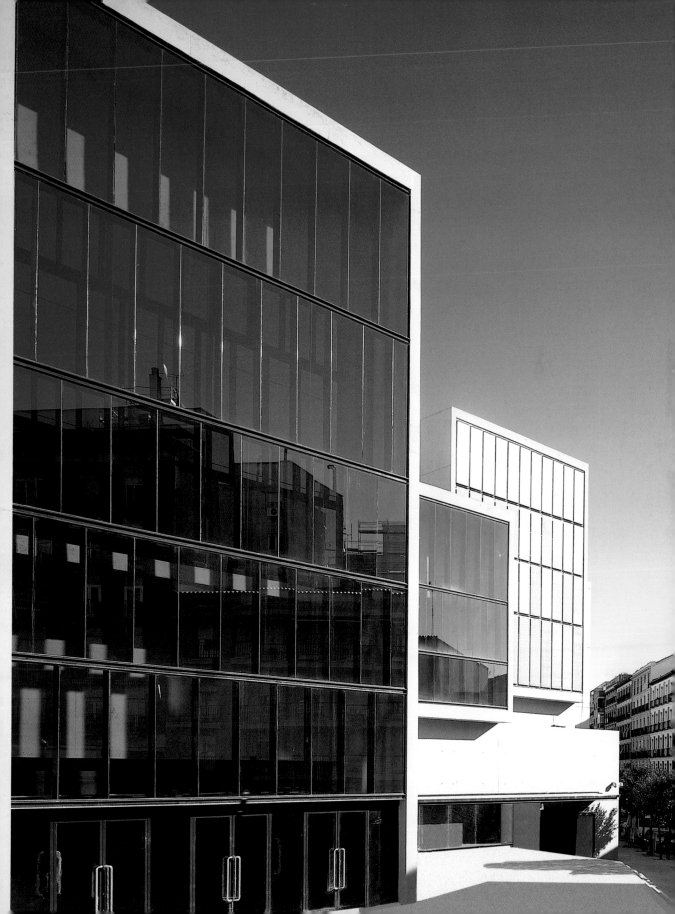

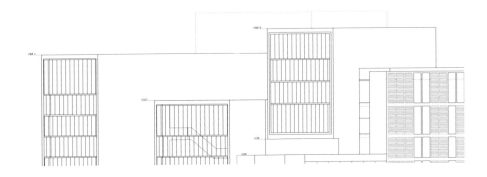

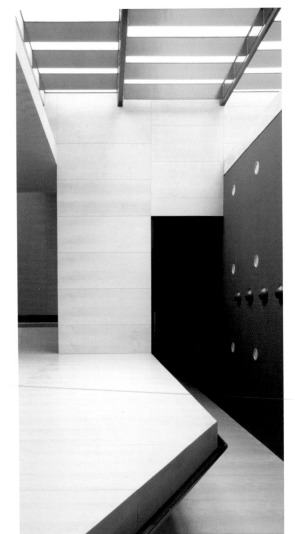

Top: Side façade

Left: Detail of the interior of the building

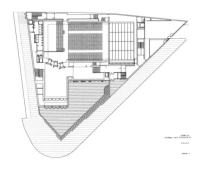

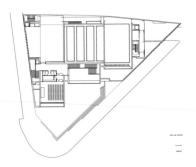

Above: Plan of the access level and (above) the first floor

Opposite: Detail of the finishing and facings in the staircase area

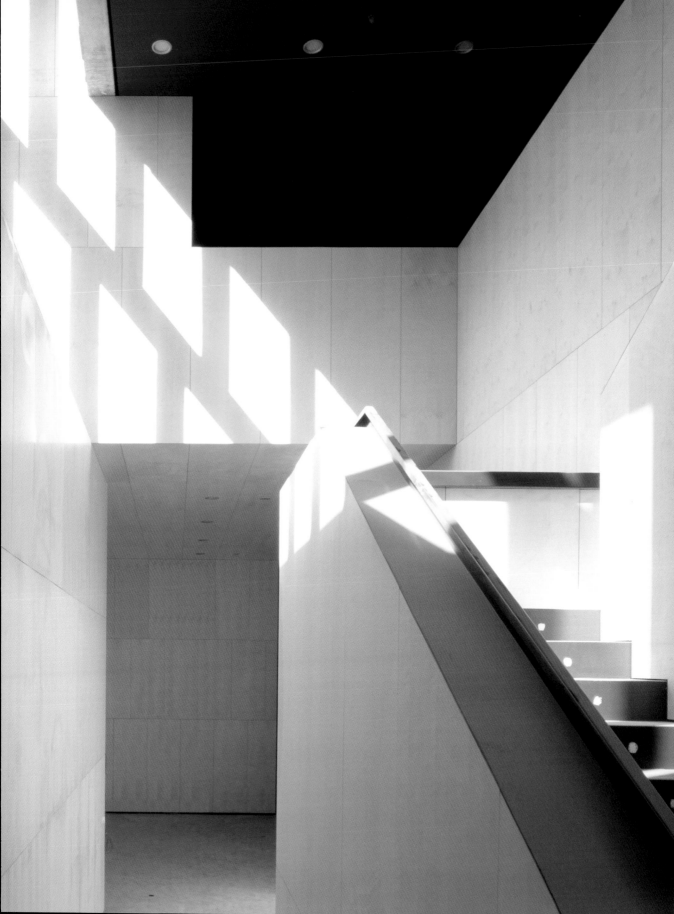

A house in a box

Pulitzer Foundation for The Arts

TADAO ANDO, ARCHITECT & ASSOCIATES

Saint Louis, Missouri, USA

This building was constructed in order to concentrate the contemporary art collection of the family that founded the Pulitzer Prize. It is located in the midwestern United States, in Saint Louis, a city whose center has been seriously downgraded through decades of suburban expansion. The site of the gallery is in a larger cultural context that which is undergoing development in this district. Its design takes account of its surroundings and needs, preserving the residential scale. From the beginning, the artists whose works were to be exhibited in the gallery took part in the project, exchanging ideas with the architect in the hope of setting a precedent for an ongoing dialogue between the public, the gallery, the artworks, and the artists.

Above: Site plan of the foundation

Opposite: View of the pool of water anchoring the courtyard between the two blocks

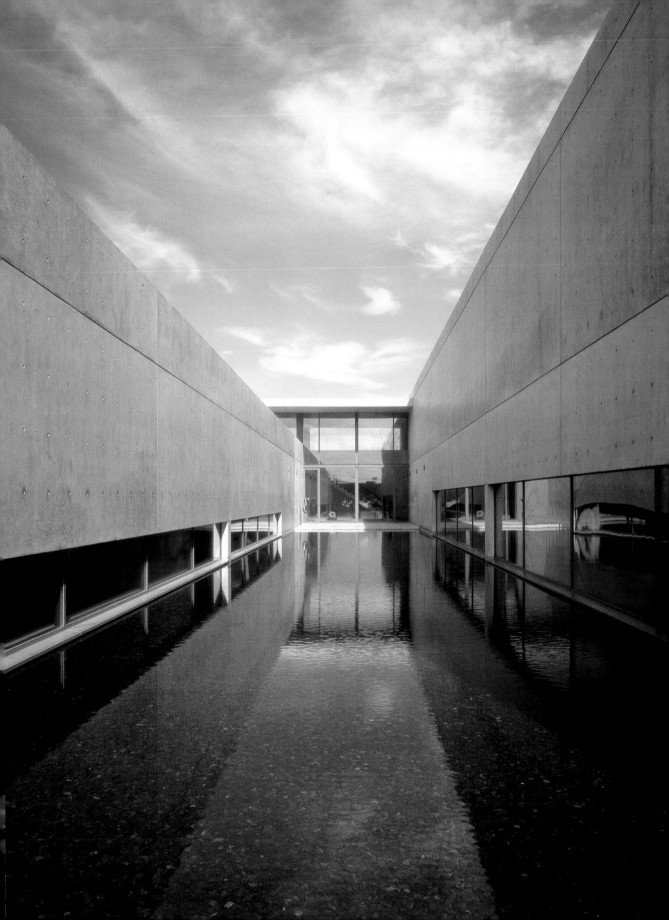

The building consists of two blocks: one rectangular, 7.3 meters (24 feet) in depth and height, on one side of the water courtyard, which has the same depth; the other block has different heights, generating the intermediate spaces with access to the gallery and hall. This second block, which has one floor less of space, contains the entrance lobby, library, offices, research areas, and other spaces. The spatial continuity between the interior and exterior is perceptible in the identical treatment of the surfaces, making these spaces to be used as open-air exhibition areas. The elimination of superfluous architectural elements and the geometrical manipulation of space—characteristics of all Tadao Ando's work—fix our attention on the works exhibited in the gallery.

Top: Image showing the spatial continuity between interior and exterior

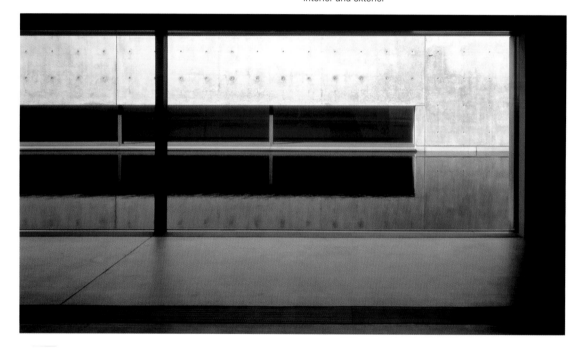

Above: Basement story of the foundation

Opposite: Framed view of water courtyard that shows the possibility of exhibiting works outside

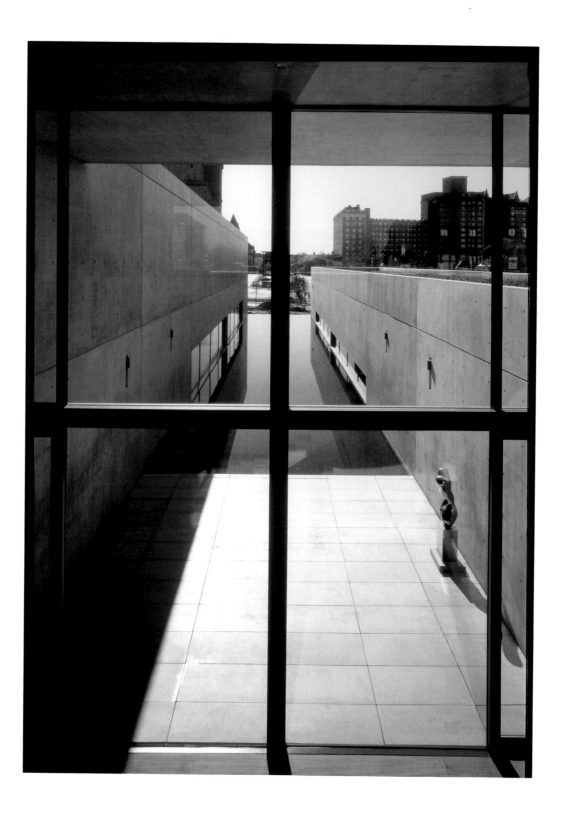

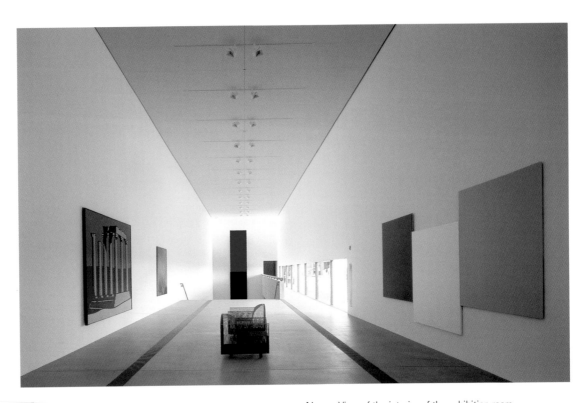

Above: View of the interior of the exhibition room

Left: First floor of the foundation

Opposite top: The sheet of water in the courtyard reflects the entire complex in its surface

Opposite bottom: Second floor of the foundation

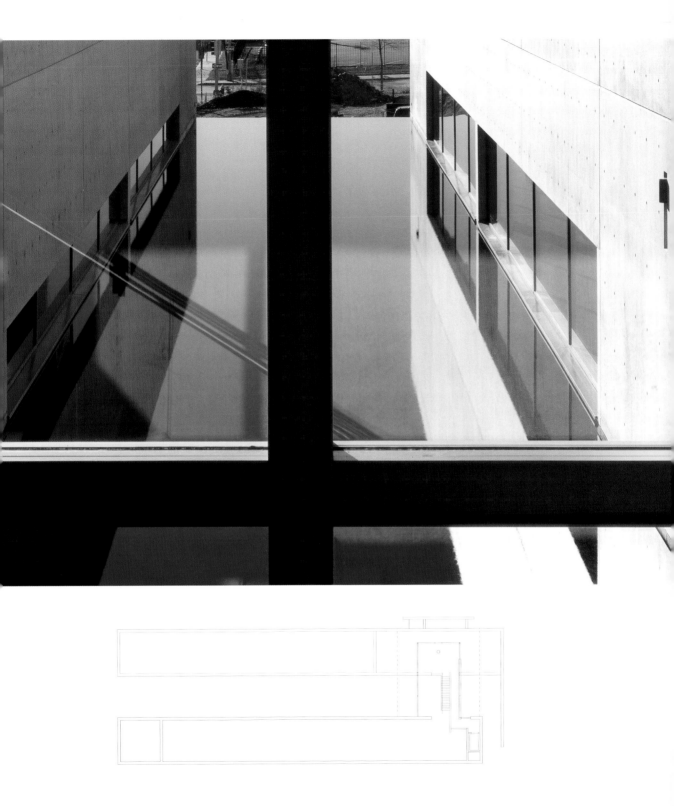

The fish of Bilbao

Urbitarte Footbridge

SANTIAGO CALATRAVA

Bilbao, Spain
Photographs: Jordi Miralles

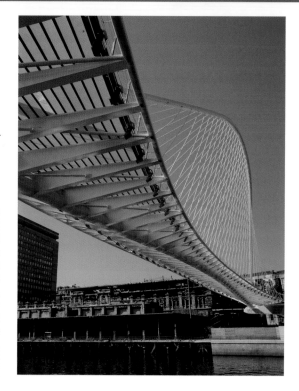

During the last few years, Bilbao has seen numerous changes that are exemplified by its new architectural works that have been undertaken by national as well as international teams. Examples of these projects are the Guggenheim Museum by Frank Gehry, the subway station by Norman Foster, or Sondika airport by the very same Santiago Calatrava. The eclectic author, architect, artist, and engineer undertook his primary and secondary education in Valencia. When he was eight years old, he enrolled in the Escola d'Arts i Oficis in that city, where he began his training in drawing and painting. When he was thirteen, he was sent to study in Paris and later in Switzerland. He failed to gain entrance to Beaux Arts in Paris, and returned

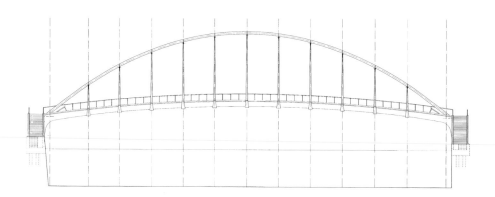

Above: Elevation of the footbridge

Opposite: View of the footbridge from its lower level, revealing the "fishbone" skeleton

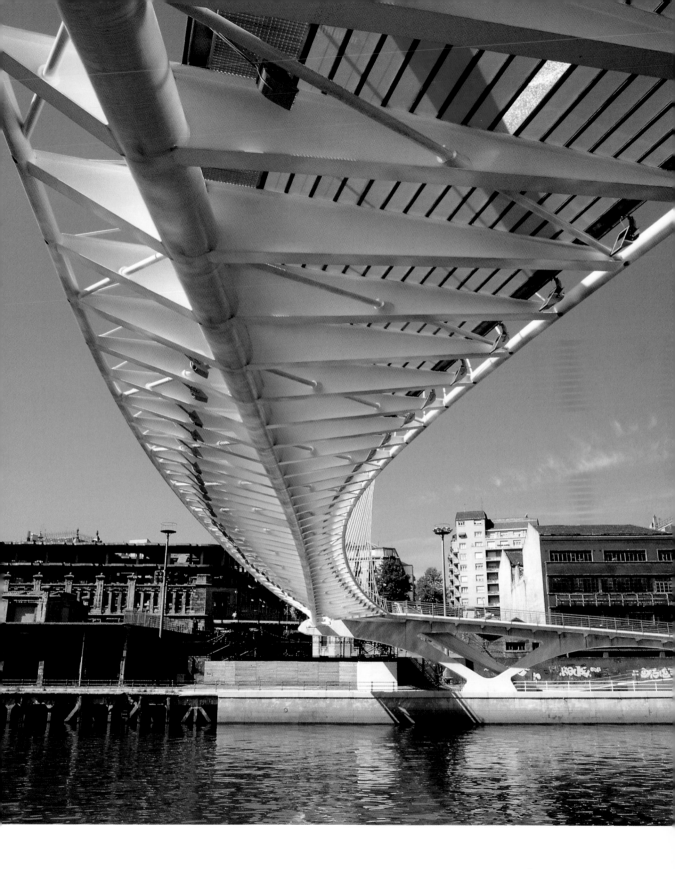

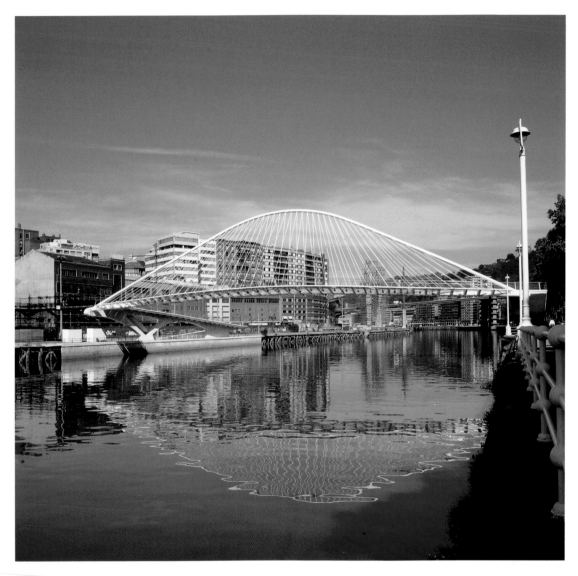

Above: View of the footbridge crossing the river with Bilbao in the background

to Valencia where he entered the city's Escuela Técnica Superior de Arquitectura. However, once qualified and attracted by the mathematical rigor of the great works of architecture, he started his studies in engineering at the ETH in Zurich, graduating in 1979.

The construction of this footbridge has created a new image of the city. Although it is simply a pedestrian walkway over the river, it reveals the strength and beauty characteristic of the works of this architect, displaying a structure that embraces living beings. It reminds us of more recent Calatrava projects such as the Alameda subway station or the Museum of Science and Technology in Valencia.

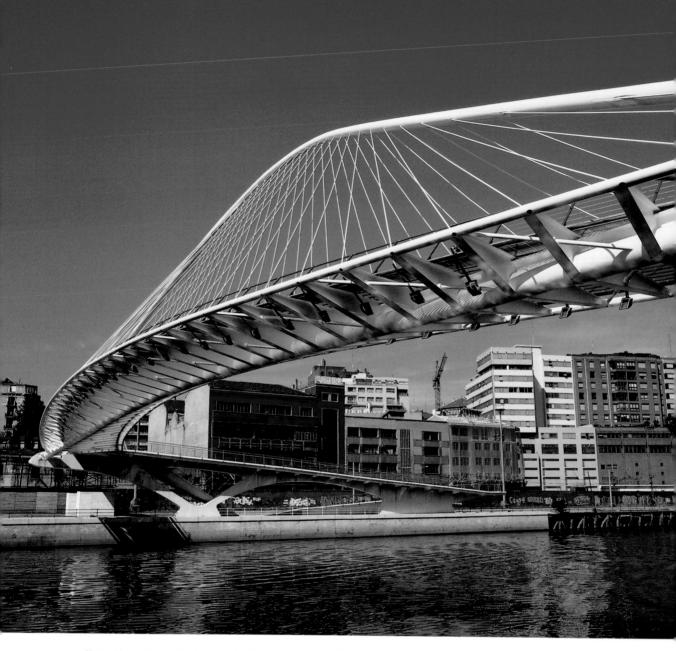

Above: View of the footbridge revealing the curvature of its skeleton

Below: Cross section and details of the footbridge

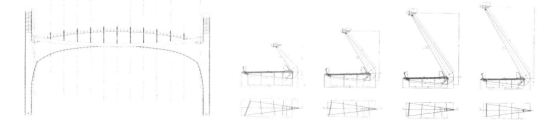

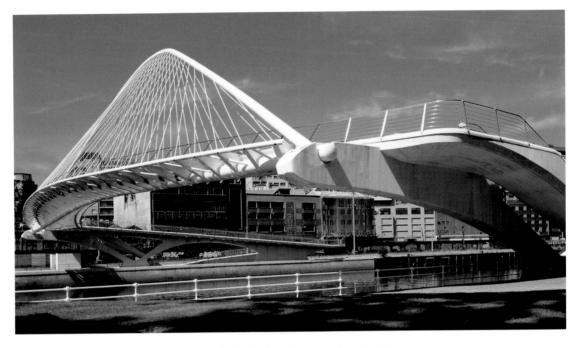

Above: The footbridge ascending from the riverbank and its span to the other side

Below: Nocturnal effect of the network of cables supporting the bridge

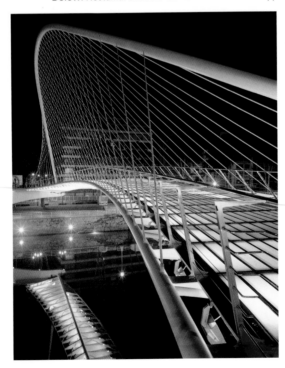

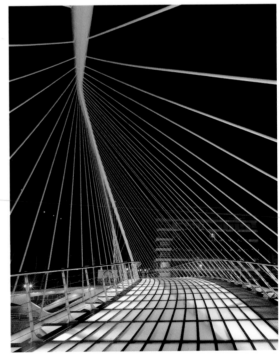

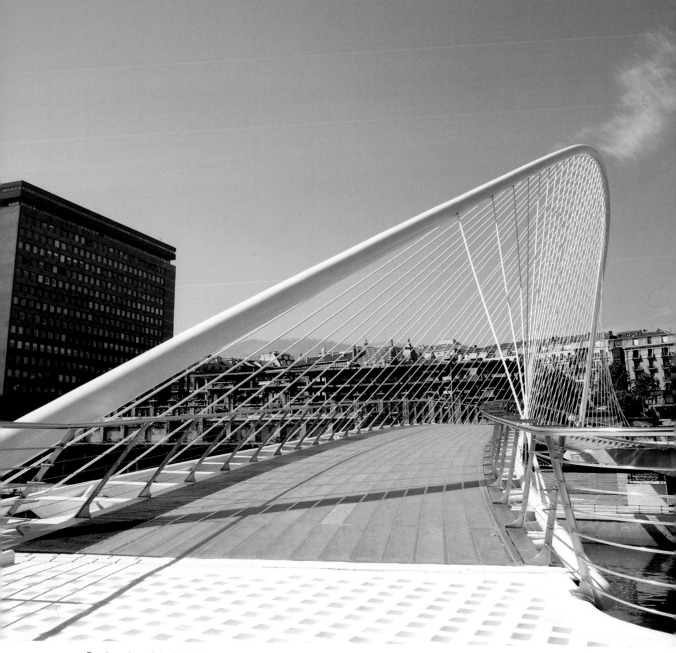

Daytime view of the footbridge with the city in the background

A garden in the station

Le Jardin Atlantique

FRANÇOIS BRUN + MICHEL PÉNA

Paris, France
Photographs: J.C. Ballot, P. Marechaux, M. Péna

Le Jardin Atlantique is situated above Montparnasse and Pasteur Station, occupying a surface area of 3.5 ha (377,000 square-feet) that have been won from the railway lines. With the original station completely freed of traffic and surrounded by newly constructed buildings, the project sought to resolve complex technical and environmental problems such as thickness of the layer of earth and the loads that are admissible; a parking lot for 700 vehicles underneath the garden; the ventilation systems; the shadows.

The garden is presented as a platform separated from the rest of the city and accessed by means of a flight of steps. The large construction that surrounds it is balanced by the garden's greenery and the open space for public

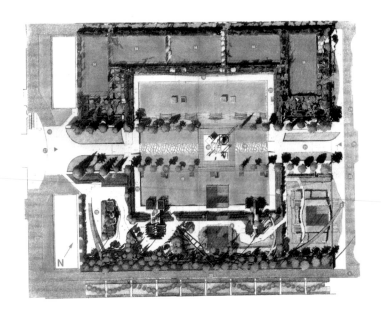

Above: Plan of the garden

Above: Interior view of the garden with its surrounding blocks

Below: Section of the original railroad station with the garden on top and parking lot below

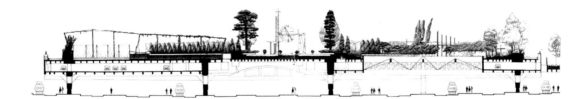

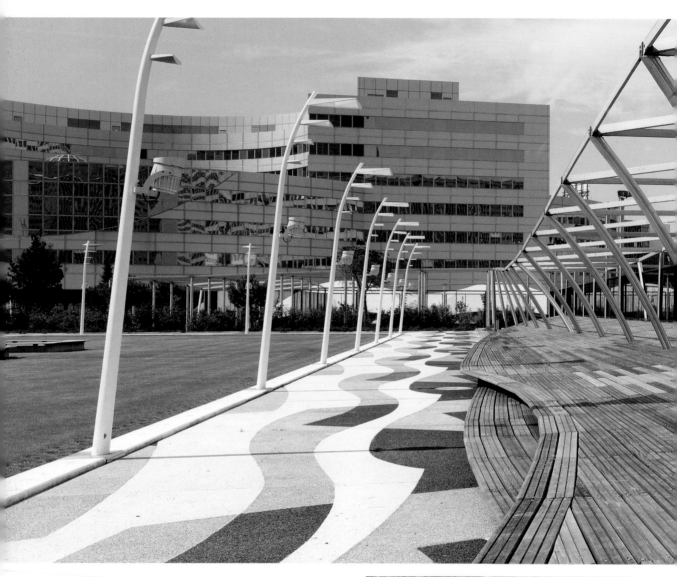

use. The architects intended to create a pedestrian space that would surprise the visitor at each step and seem far removed from the urban atmosphere. In order to achieve their goal, they have created spaces for introspection and activity. The garden includes paths, platforms, bridges, and open spaces along with pavilions identified with specific uses, such as the hall of silence, hall of reflections, hall of seashores. In another section, we find tennis courts, gymnastic apparatus, and a solarium located above the station's ventilation system. In order to provide a sense of security, the issue of illumination has received special consideration. At the center of the complex, the Isle des Hesperides is found along with a meteorological station.

Aerial view of the garden

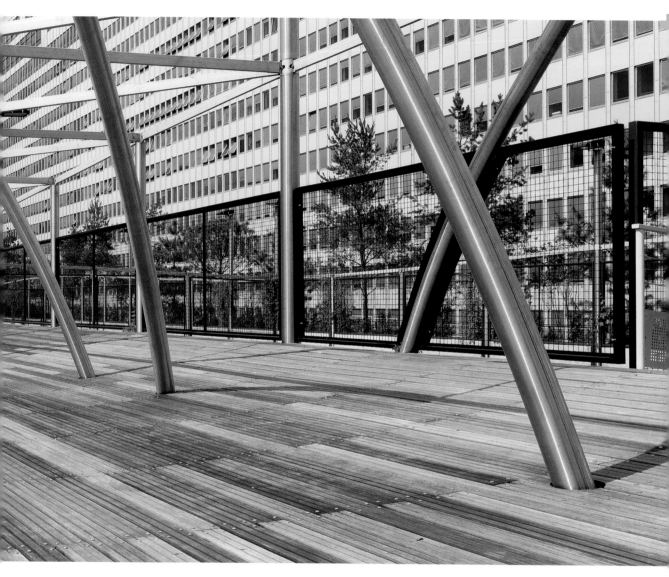

View of the wooden platform in the garden's northern perimeter that is used as a solarium

Above: Interior view of the garden

Right: Detail of the lawn and pavement

Opposite: View of the access to the children's play area that has been resolved with pieces of ceramic

Combing the mane

Bridge of Sancho El Mayor

CARLOS FERNÁNDEZ CASADO, ING. JAVIER MANTEROLA ARMISEN, LEONARDO FERNÁNDEZ TROYANO, ING.
Navarre, Spain
Photographs: Frances Tur

This bridge forms part of the road network of the Navarre region, where it crosses the Ebro River. Its construction, following a selection of proposals, fulfilled the stipulated requirements of functionality and visual harmony with its environment.

The bridge stands 500 meters (1,640 feet) from the start of the highway connecting the Basque country with Aragon, near Tudela. Its structure is based on a slender leaning concrete tower, which offers the principal charm of the composition without presenting an obstacle to traffic or to the wind. Three groups of tie beams extend to the tower: two groups extend to the counterweights at the sides, distributed symmetrically on both sides, and the third passes through the central axis of the bridge itself, forming a natural barrier between opposite traffic lanes.

The use of a single tower standing near the riverbank made it possible to cross the deepest part of the river without resting on it, obtaining a central span of 146.30 meters (480 feet). It was decided to situate the tower on the left bank in order to avoid the irregularities of the quaternary formation found on the right bank. To guard against the flooding river, a protection 170 meters (558 feet) wide was built at the base of the tower to absorb irregularities presented by the relief.

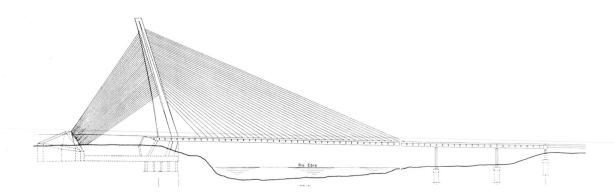

Above: Elevation of the bridge

Opposite: Head-on view of the bridge from the highway, showing the symmetrical distribution of the tie-beams toward the sides of the bridge

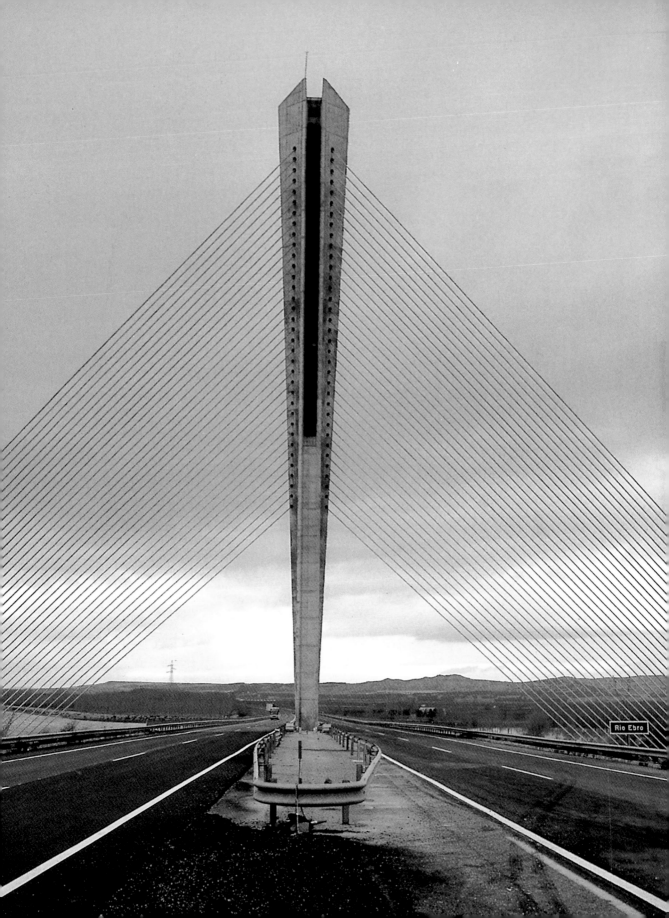

Rio Ebro

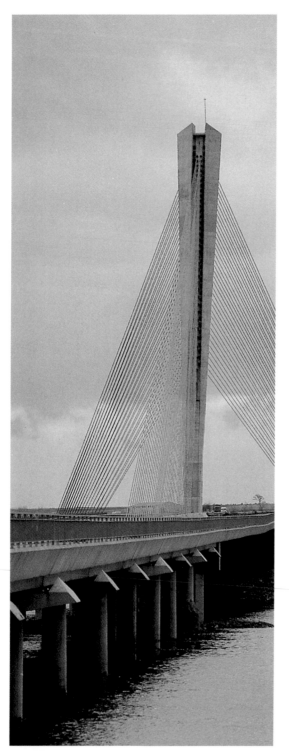

Left: Oblique view of the bridge, showing the end supports of the platform extending toward the opposite end of the tower

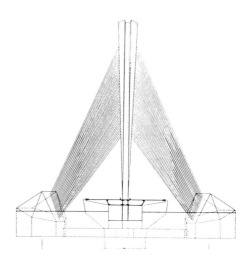

Above: Cross section of the bridge

Opposite: Detail showing anchoring of the tie-beams

Opposite below: Detail showing a section of the bridge's platform

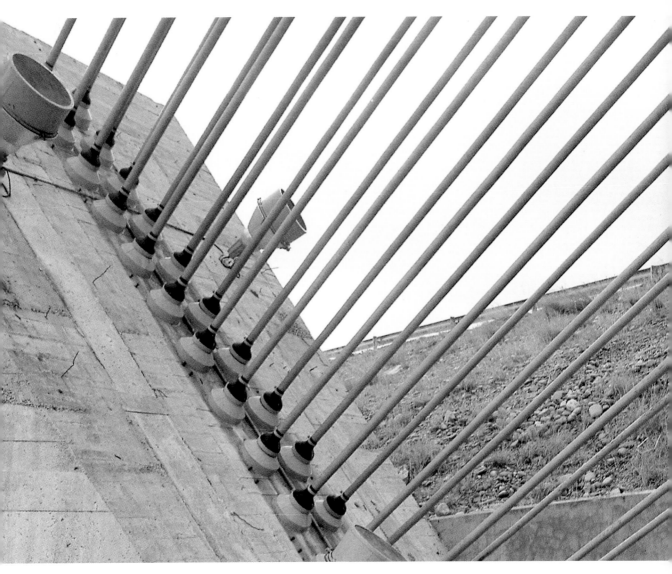

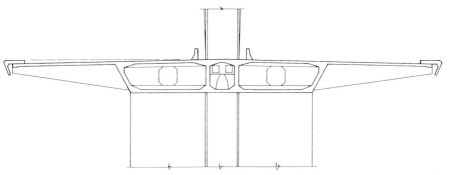

It's a Sony

Sony Center

MURPHY/JAHN INC. ARCHITECTS
Berlín, Germany
Photographs: A. A. Garreta, Engelhardt/Stelin +
Aschau i C.H., H.G. Esch, John Linden

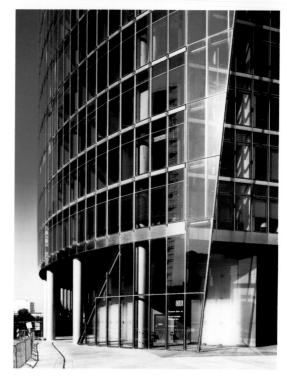

In 1991, after the Berlin Wall had fallen, a competition was announced soliciting ideas for a plan for the Potsdamer/Leipziger Platz that marked the beginning of a process of urban renewal. On a triangular plot, close to the Kulturforum area—where the Philharmonic and the National Library by Hans Scharoun and the National Gallery by Mies van der Rohe are located—the Sony Center was proposed as a complex of business buildings for the new millennium. The complex would have multiple uses: a cultural forum, a center of financial activity, and a residential zone; and it was to use the latest technology as much in its construction as in its installations.

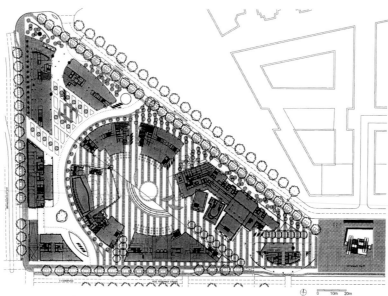

Above: Site plan of the Sony Center complex that occupies a triangular block of Potsdamer Platz

Opposite: The tower photographed from ground-floor level with a detail of one façade where the curtain wall is transformed into pure skin.

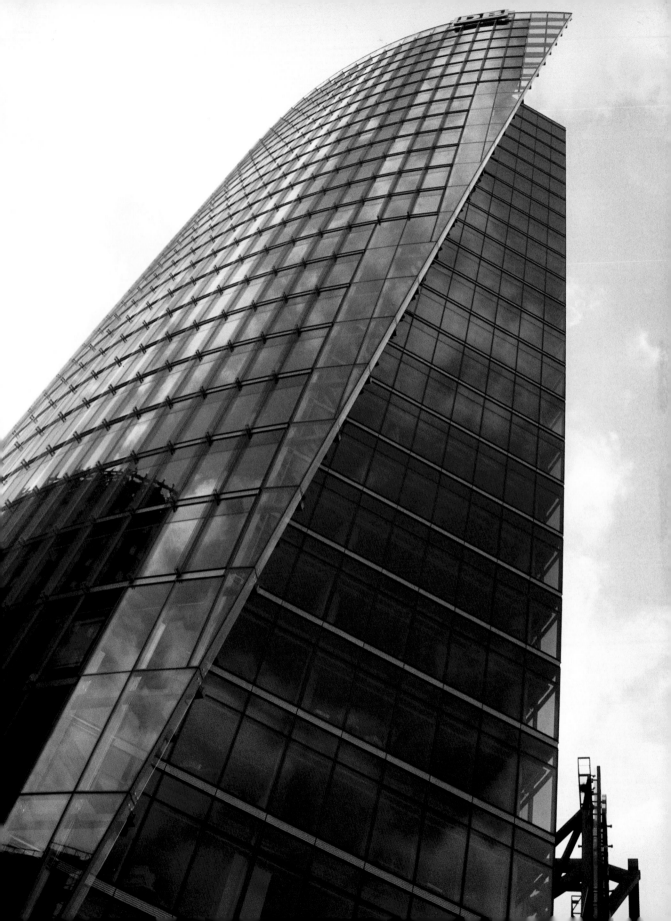

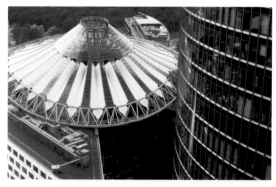

Above left: Aerial view of the dome covering the central square of the complex

Below: Exterior image of the complex with the tower in the background

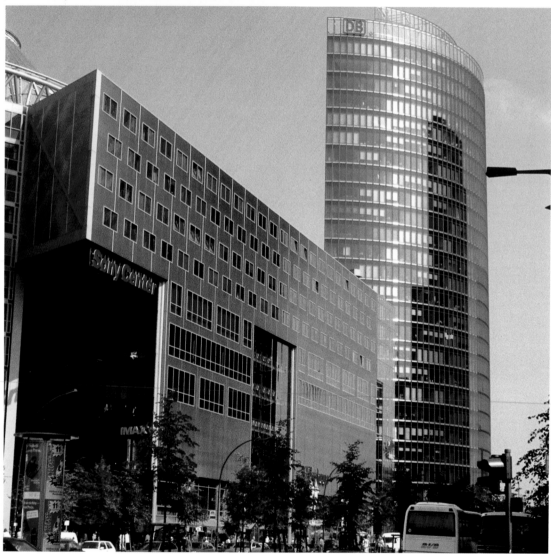

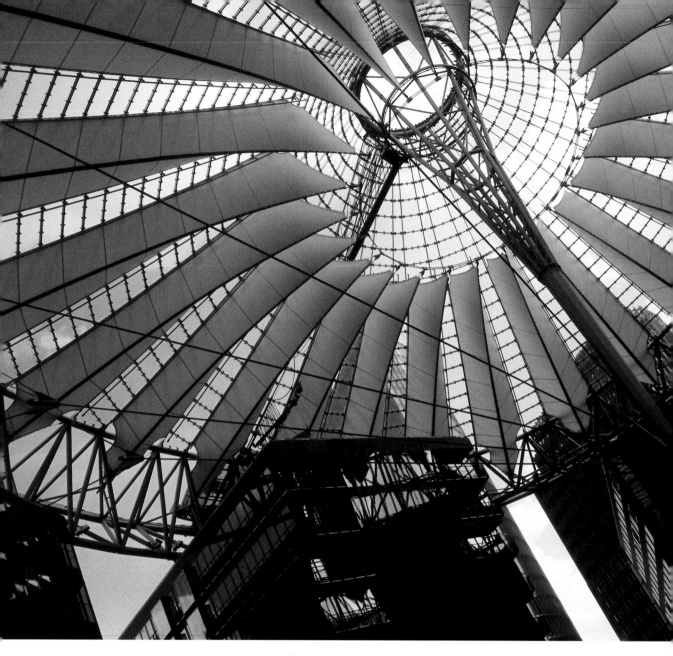

Image taken from the square, of the dome enveloping the central square of the Sony Center

Top: Detail of the Esplanade Residence, a residential building that conserves part of the old façade of the Grand Hotel Esplanade

Bottom: Detail of tower's curtain wall showing natural ventilation system that functions because of an opening in the curtain wall

The general plan determined the volumetric organization of the project situating the buildings parallel to the main streets. The buildings have been arranged so as to relate them to the surrounding architectural environment. As a result, the complex incorporates the ruins of the Grand Hotel Esplanade, an early twentieth-century luxury hotel, by situating a metal structure in the way of a bridge that supports the new residences on top of the hotel structure.

The building complex includes three basic elements: the Hochhaus Potsdamer Platz, the Sony headquarters skyscraper (one of the three towers contemplated in the general plan, the other two by Renzo Piano and Hans Kollhof), and the Sony Forum building. The buildings form the Sony Plaza, a central oval space surrounded by bars and restaurants, and covered by a large dome of metal, glass, and canvas that screens the light. The Sony Headquarters tower interprets the classical mixed-use skyscraper by organizing its functions hierarchically and vertically, situating retail areas on lower floors and residential areas on upper floors. In short, the Sony Center aspires to be a virtual city within an actual city; as the Potsdamer Platz, it has become the new center of Berlin, assuming the activities of the old Berlin-Mitte. As opposed to the Renzo Piano complex, the Sony Center presents a technological image due to the use of materials such as stainless steel and glass; the play on transparencies and reflections; the open display of structure and the effects created by natural and artificial light.

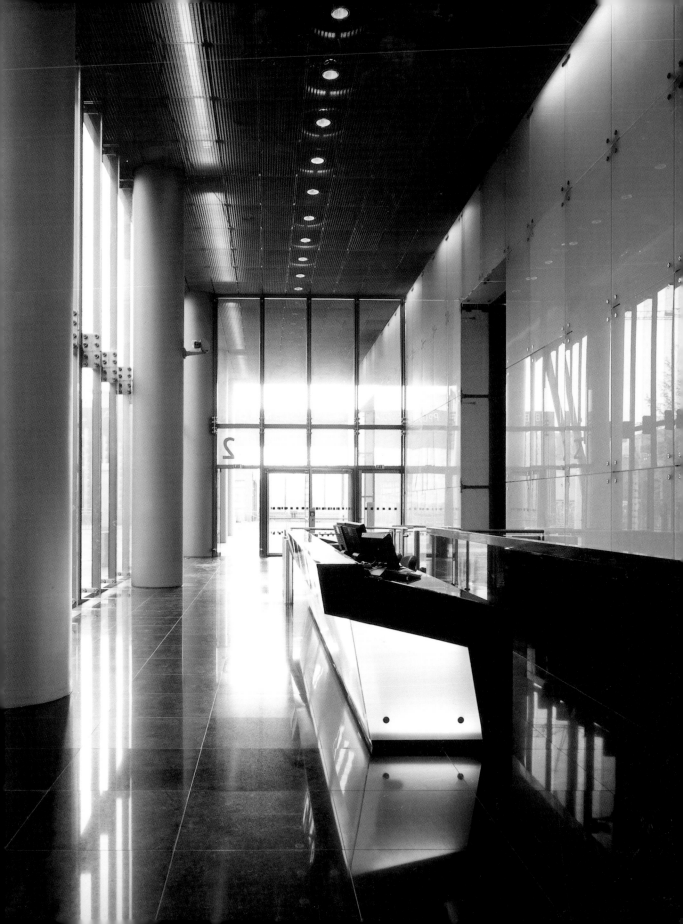

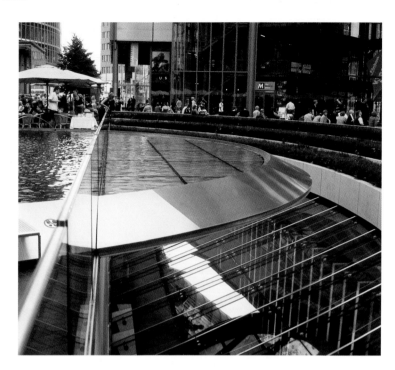

Above left: Detail showing the façade and the intersection of floors and curtain wall
Above right: Detail of the fountain at the center of the square overlapping the circular stainless-steel platform

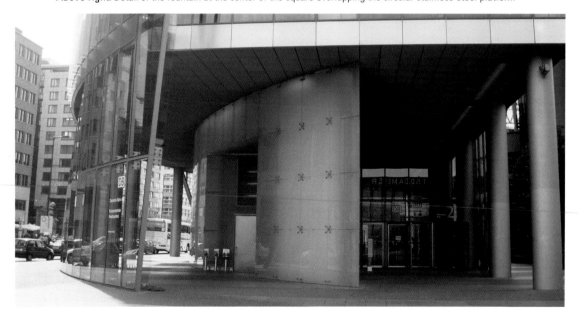

Above: Detail of the entrance hall to the Sony Center complex

Opposite: Detail showing the junction of the dome with one of the towers

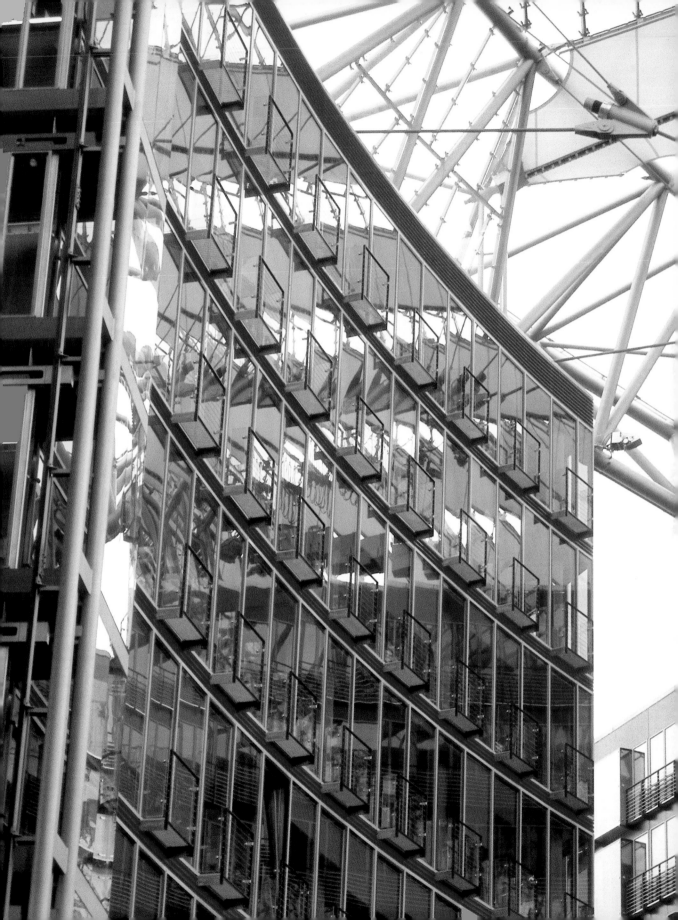

Fukuoka at the level of Pelli

Hotel Sea Hawk

CÉSAR PELLI
Fukuoka, Japan
Photographs: Taizo Kurukawa, Osamu Murai,
César Pelli Associates, Yukio Yoshimura

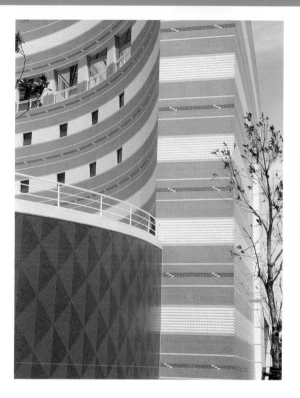

As in all of Pelli's projects, the Hotel Sea Hawk clearly responds to the characteristics of its surroundings. The volumes of the architectural complex also come together to create a particular outline that is strong and defined. The materials employ the textures and colors of the urban context. The hotel is situated on the seashore, like a lighthouse visible from all parts of the city. Its sculptural forms, the curves in the roof and walls interact with the elements of wind and water in the bay. The ceramic-tile finishes create a complex texture of colors and designs. The hotel's activities have a Japanese flavor, with an emphasis on wedding receptions, luxurious restaurants, bars, and meeting rooms.

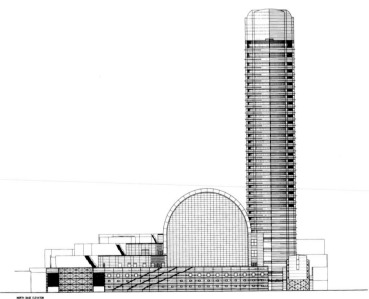

Above: Seaside façade

Opposite: Perspective of the complex from the shore

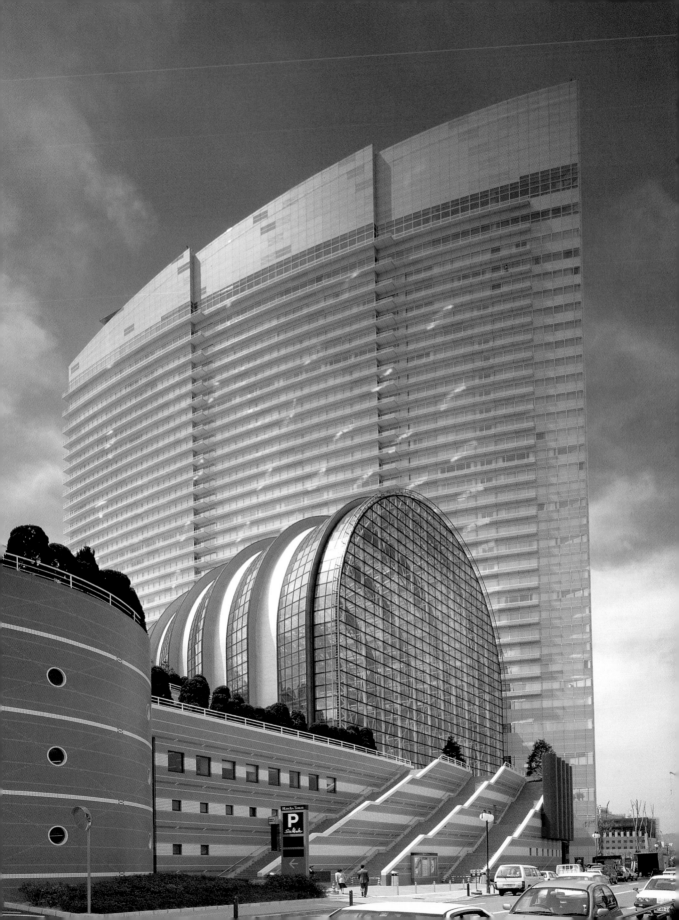

Below: Perspective of the complex from the city

Opposite: Detail of the glazed maritime façade

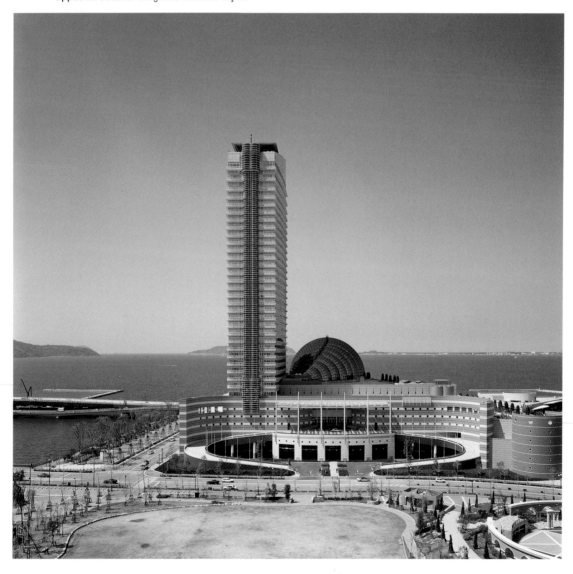

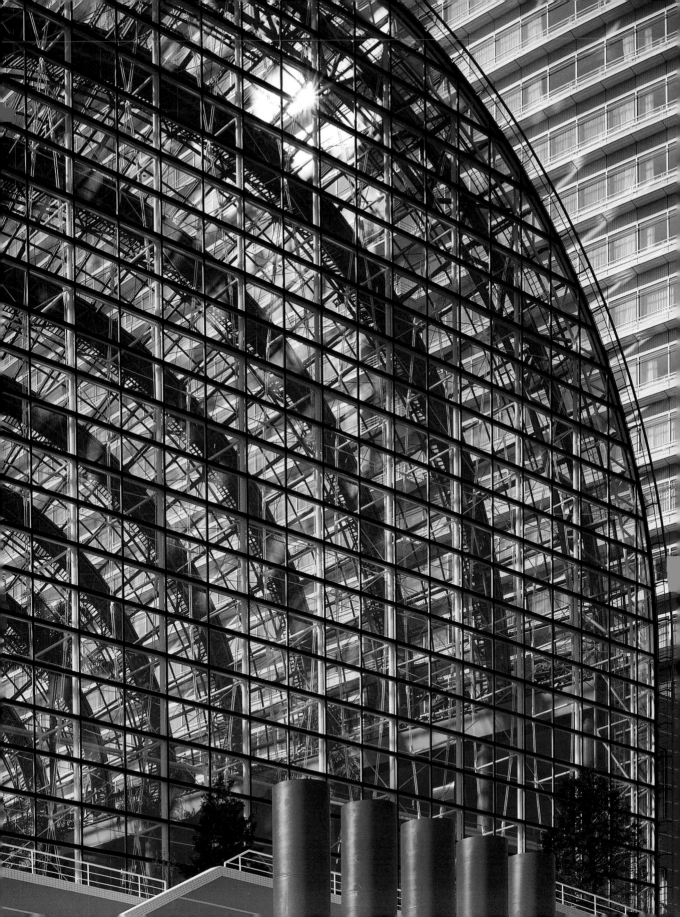

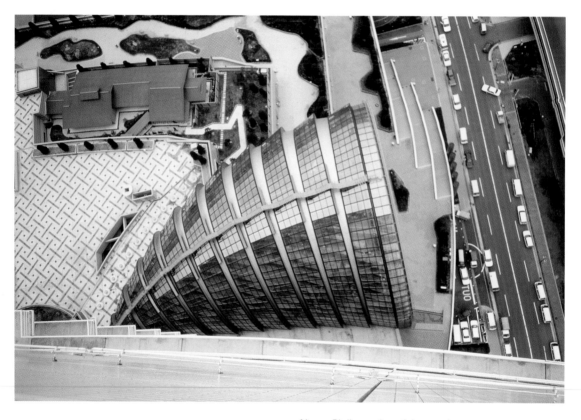

Above: Bird's-eye view of the complex

Opposite: Night view of the complex from the seashore

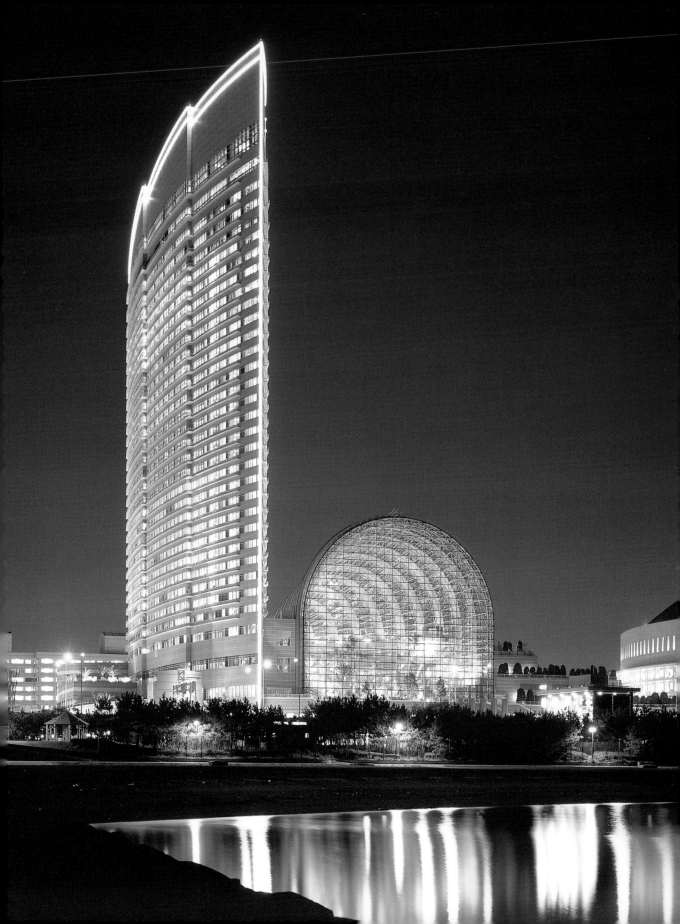

A double harp

Shima-Maruyama Bridge

MITSUNORI KATOH & SHINICHI KONDOH
PREFECTURA DE MIE, SUMITIMO CONSTRUCTION

Tokyo, Japan

Despite its simplicity of form, like every bridge built in Japan, the Shima-Maruyama Bridge neglects no detail in its structural design, given the dangerous seismic location and complicated mountainous terrain. Situated on Ago Bay, to the southwest of Tokyo, in the Ise-Shima national park—an area famous for its pearl cultivation—this is the seventeenth bridge of its type to be built in Japan.

Formally, the bridge is centered on a single tower, from which the entire structure extends. The tower consists of two feet that flank the platform and join together in the upper part to stiffen it. The cables are attached to these feet symmetrically, distributed in the form of parallel triangles from the tower to the platform. The structure of the platform is of prestressed concrete, and each of its spans measures 114 meters (374 feet) from the central support. The design of the tower, with its two arms meeting above, forms an A shape, to secure stability against the horizontal strains characteristic of earthquakes. Each tensor takes the form of three cables that, before reaching the support, separate and spread out in a triangle shape.

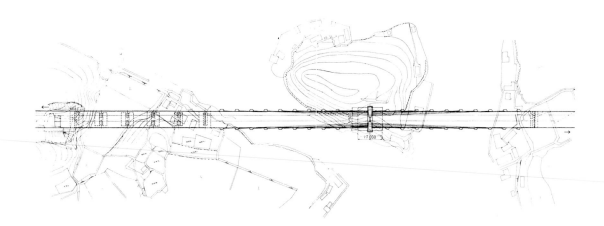

Above: Site plan of the bridge

Opposite: Aerial view of the bridge showing the tower and its cables

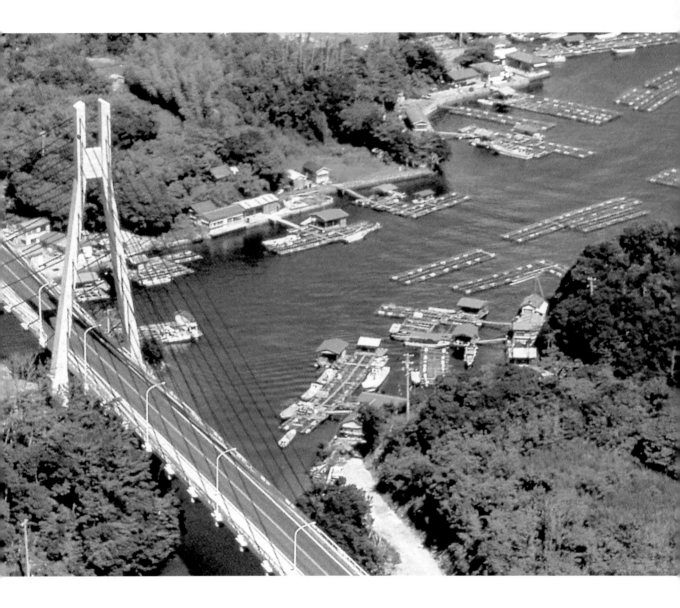

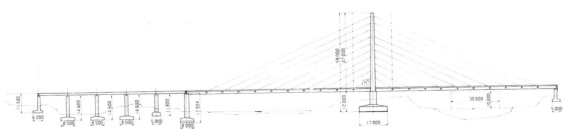

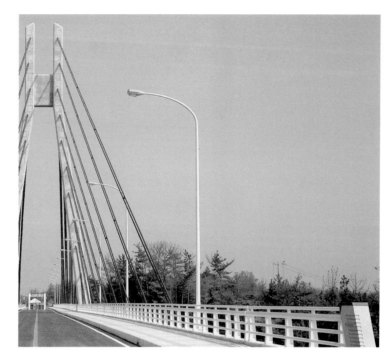

Views of the bridge at road level (above) and water level (below)

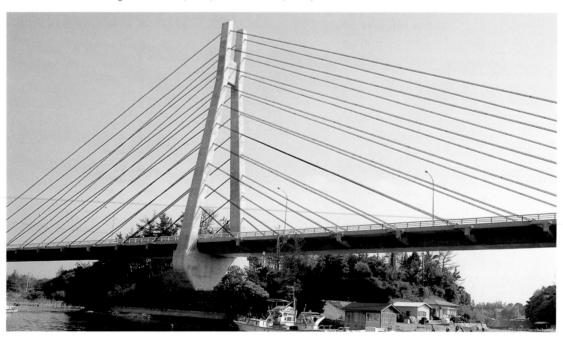

Opposite: Detail of the central pillar showing the anchoring of the tensors onto the bridge's platform and their subdivision into three separate cables

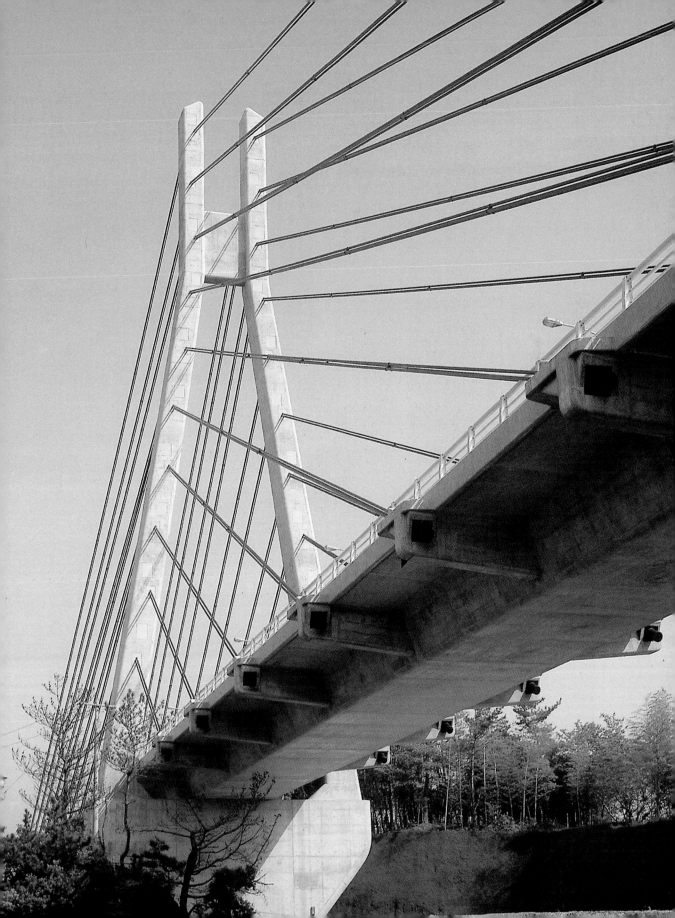

The new motor behind BMW

Central Building of the BMW Plant

ZAHA HADID

Leipzig, Germany
Photographs: Zaha Hadid Architects

The Central Building, completed in 2005, was conceived as the new corporate symbol of the BMW brand, not only of its cars but also of its component industries that would be administered from these headquarters. In response to the architect's interest in spatial innovations and the developing concept of architecture as a field of forces and flows that generates new landscapes, the building converts the movements and pathways used by workers, visitors, and plant production into a leitmotif of the project's overall design. The building is a central structure that connects all internal movements and activities, which intersect in the three main production facilities: Body in White (which manufactures auto bodies); Paint

Below: Detail of construction in progress

Opposite: The architect's scissor-like forms establish a connection between the ground and first floors

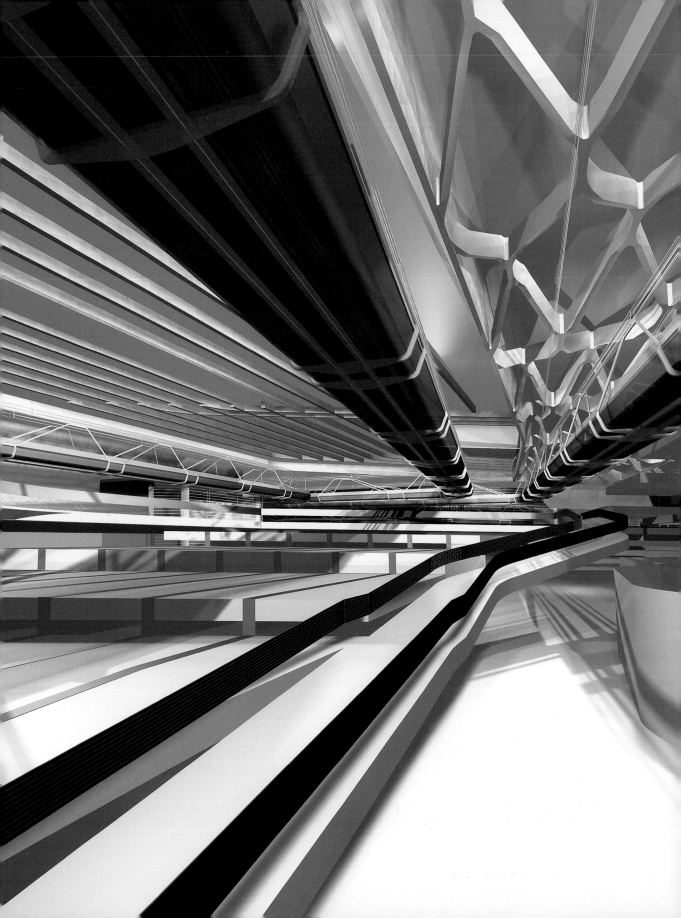

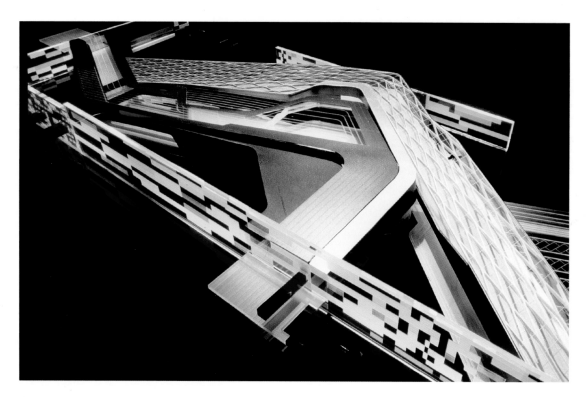

Shop; and Assembly. Activities within the building follow a logical sequence of sound, silence, and confinement.

The building has a generous lobby that provides deep views into the heart of the complex. A series of courtyards ventilate and provide natural light to the interior. Part of an open plan of multilevel floors and platforms, a scissor-like form connects the ground and first floors by means of one continuous surface, while two gigantic platforms linked by staircases manage to articulate spaces with different functions without a loss of visual communication between the areas. The parking zone is well landscaped, and the dynamic distribution and illumination of parking places enhances the complex.

Above: Perspective of the complex

Opposite: Bird's-eye view of the complex

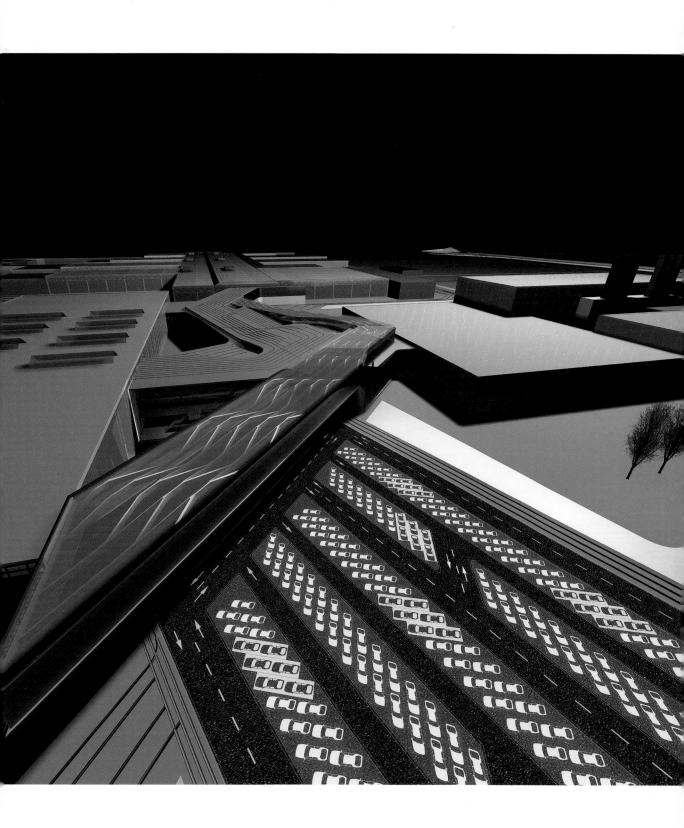

The trilogy

Centraal Beheer

HERMAN HERTZBERGER

Apeldoorn, The Netherlands
Photographs: Lock Images

The architect constructed the Central Beheer office building in 1972. However, it had been subjected to modifications over the years, until in 1990 it was decided to integrate the previous operations (CB1 and CB2 by Kaman and Davidse) into a new project that would include new office space. It was necessary to resolve a common reception area and single access for the different departments. This project sought to create a new emblematic entrance to the office complex that would display the new company image.

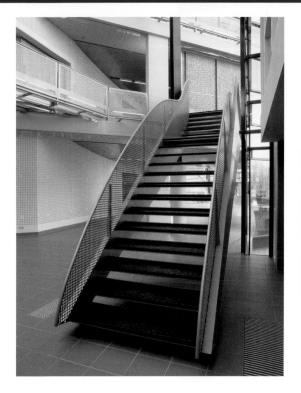

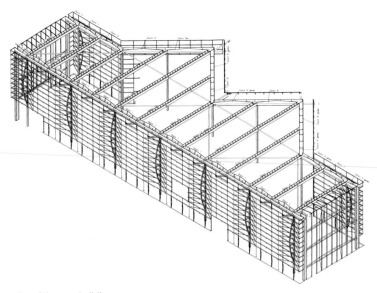

Above: Perspective of the new building

Opposite: Detail of the exterior staircase

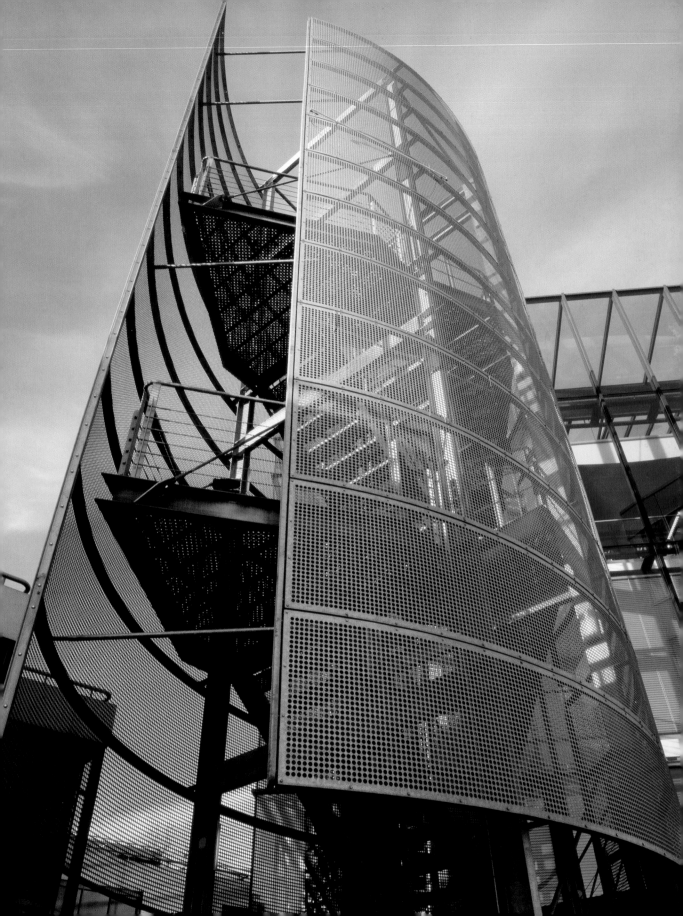

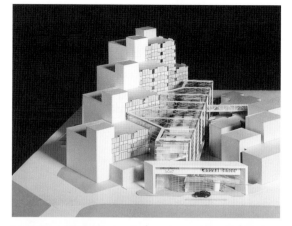

Right: Scale model of the office complex

Below: Detail of the curtainwall at ground-floor level

Opposite: Detail of the interior metal staircase

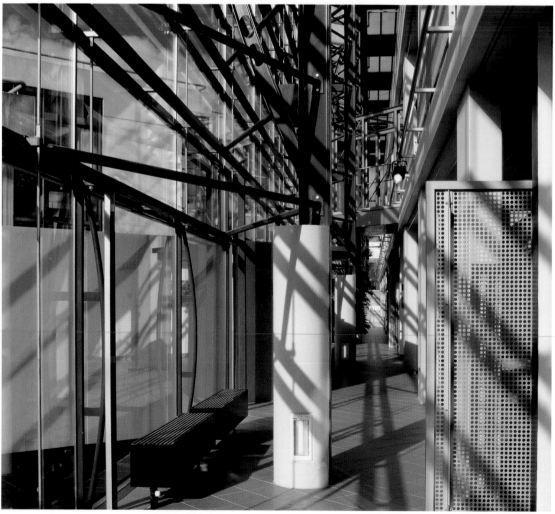

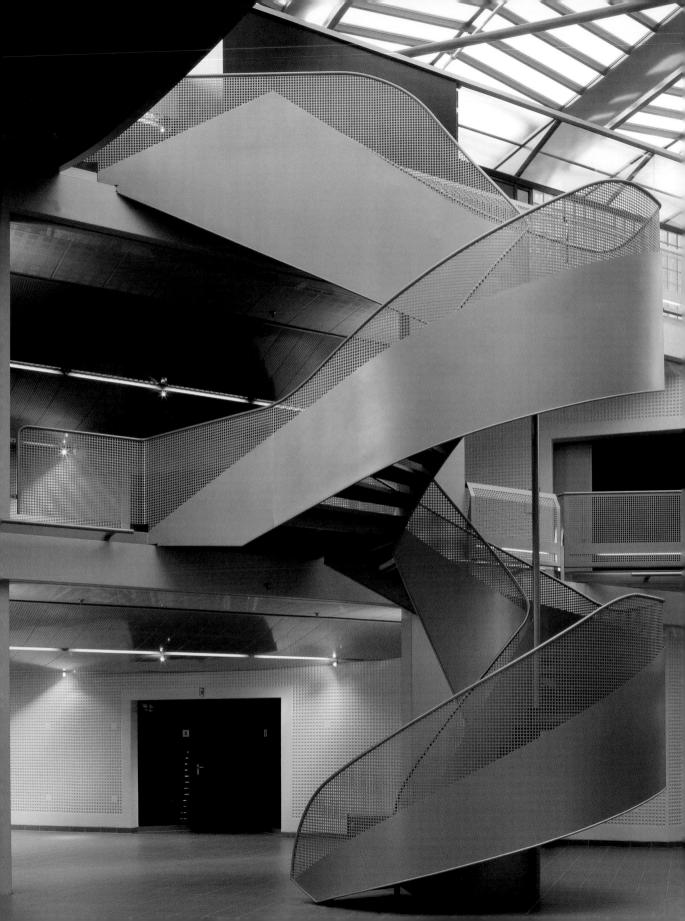

Top: Detail of the curtain wall at an upper floor level

Bottom: Detail of the staircase in the lobby

Opposite: Perspective of the three-floor lobby

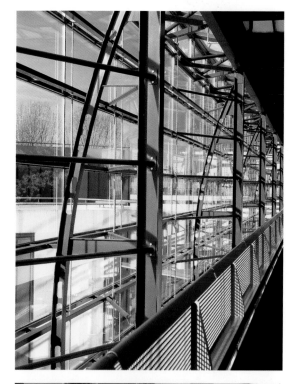

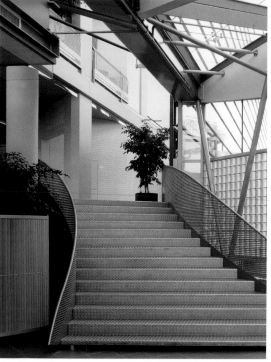

Hertzberger's project is based on a large entrance through a concrete portico that displays company name and supports a large metal hood extending to the hall. The new transparent building is constituted by a framework of pillars and metal trusses that support a curtain wall and glazed roof. The 45-degree turn of the new building with respect to CB1 also manages to bring it into relationship with CB2. Within the new structure, another independent volume forms the heart of the new complex, housing, the reception area, meeting rooms, and a small congress center. The final result exploits the ambiguity of an interior-exterior space in which the metal staircase, balconies, halls, and rooms form a heterogeneous succession of spaces within a common framework imposed by the grid of the façade's curtain wall. The new program has been distributed on three floors. On the first floor are a reception area and large conference hall. The second floor houses various conference rooms and related halls. These two lower floors are connected to the original building. The third floor contains different meeting rooms and common hallways.

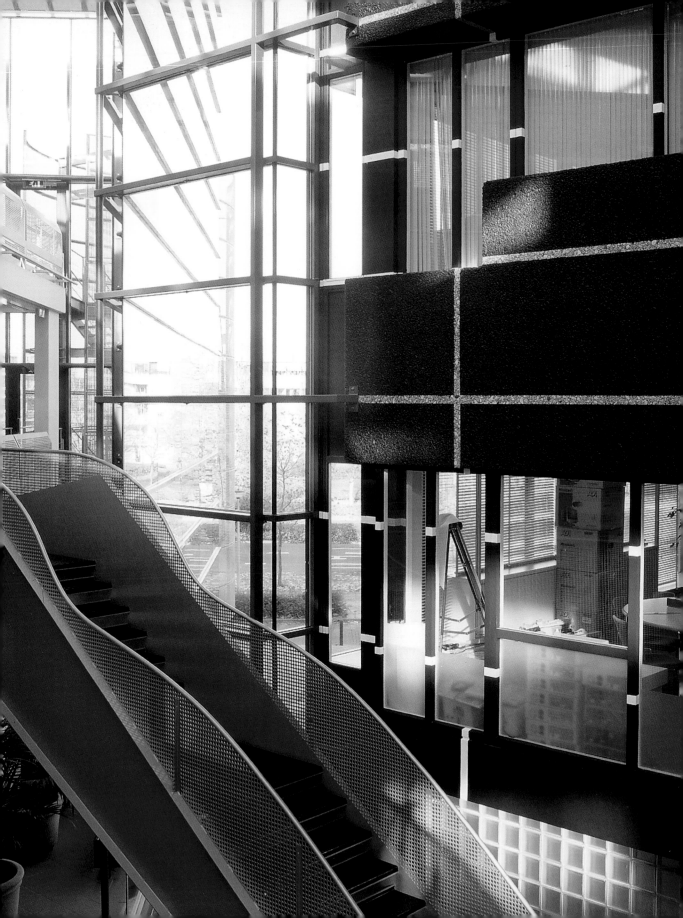

The third eye

Charles de Gaulle Airport: Interchange module for the high-speed train

PAUL ANDRÉU, JEAN MARIE DUTHILLEUL
Paris, France
Photographs: Paul Maurer

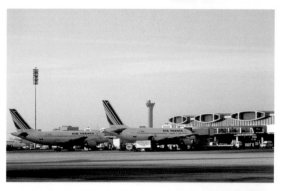

In a century of great transformations and major discoveries, in which extremes appear to meet, the Roissy-Charles de Gaulle Airport seems to be the living representation of an era. As if it were a living creature, the airport grows with the passing of time, responding to flux and movement by creating new forms to express it.

The new high-speed train station has been integrated into Terminal 2 by means of an interchange module that will become the center of the terminal once the expansion is complete. The interchange makes use of common accesses to the terminal, allowing for interaction between the two networks, which leads to new interchanges. In addition, it is connected by rail to the most important

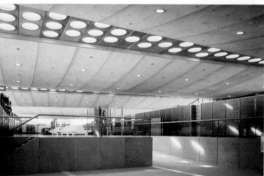

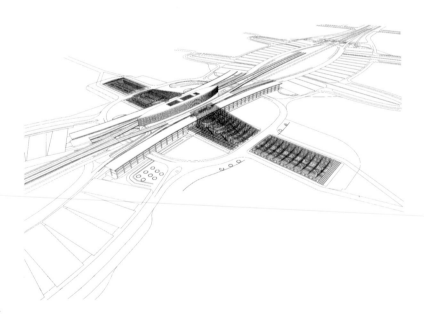

Above: Aerial view of the interchange with the hotel

Opposite: Interior view of the interchange showing the spectacular glass roof as well as the structure supporting it

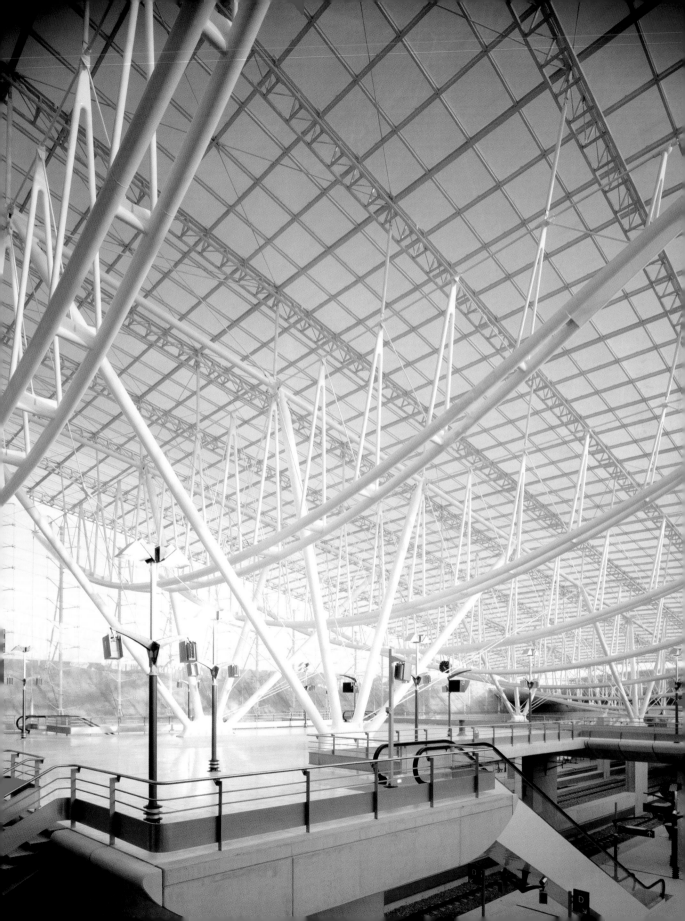

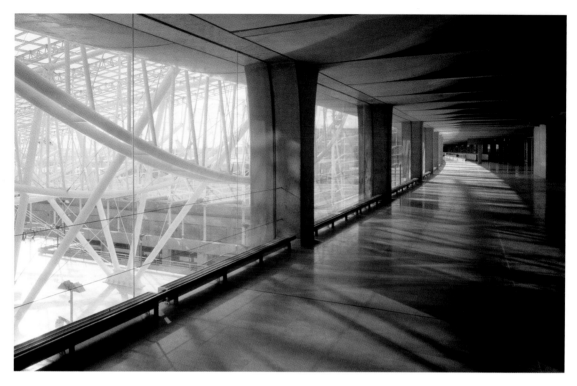

Above: View of an interior gallery of the station

Below and bottom: Detail of the roof structure showing the inverted lattices

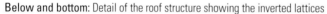

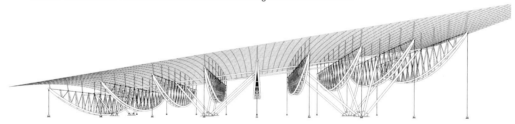

French cities as well as to European capitals such as London, Brussels, and Amsterdam. Situated in the center of the airport, it is also connected to the most important cities in the world.

The new station should completely resolve the airport's communications network, including all functions that have been added over the years: Terminal 1, Terminal 2, the successive modules, stations for the Regional Express Network (RER) express, parking zones, and so on. The new construction involves a junction in which the high-speed train lines intersect with the axis of Terminal 2 as well as the curves and complex lines of its existing transportation systems, secondary roads, and service galleries. The roads

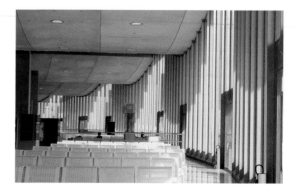

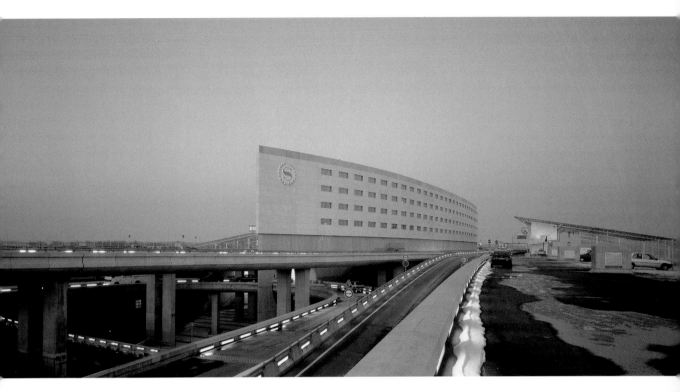

Above: View of the interchange with a hotel in the foreground

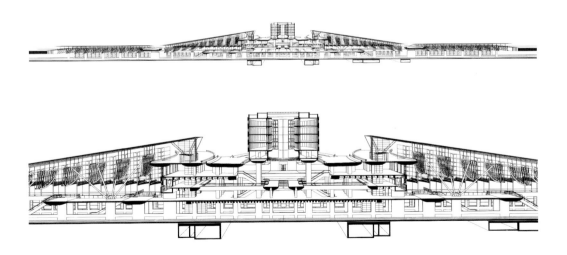

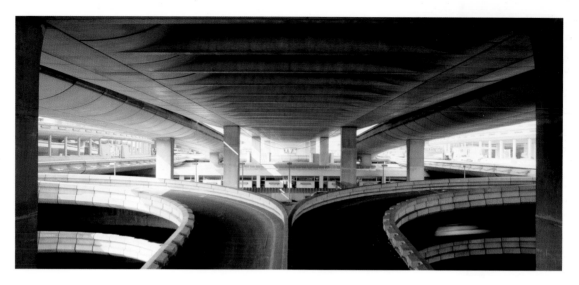

Image showing the intersection of different traffic flows

Above: Plans of the project, with a hotel on the central axis

Opposite: View of the hall interior with platforms on the lower level

are situated on the upper level; below we find the service level, the level devoted to the interior communication systems, the station itself, and, finally, the platforms situated below ground level. The hotel rises among these itineraries an opaque mass within the project. The station's design elements—the glass surfaces, the presence of large tubes in the central body—make it a space that is easily intelligible and spatially coherent. The visual relationships established among the different architectural elements are intimately tied to the light that, along with the steel and metal, is the project's major feature. The distribution of space achieves an aesthetic effect that goes beyond function.

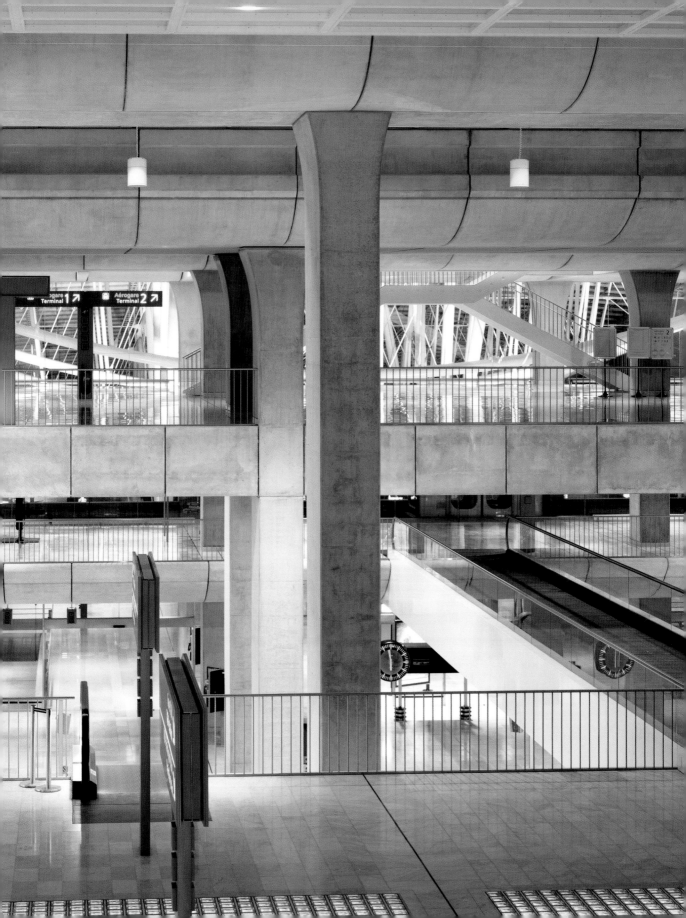